"Thomas Turner's tremendous new book adds significant depth to our understanding of the history of sports shoes. It offers an extremely well-researched, wide-ranging, and engaging look at one of today's most important forms of footwear."

—Elizabeth Semmelhack, author of *Out of the Box: The Rise of Sneaker Culture* and *Shoes: The Meaning of Style*, and Senior Curator, Bata Shoe Museum, Canada

"This engaging story of how the sports shoe went from functional to fashionable reveals changing attitudes toward sport, leisure, sex roles, and especially how so many of us came to long for the latest in footwear. It will appeal to a wide audience."

—Gary Cross, author of *Consumed Nostalgia: Memory in the Age of Fast Capitalism* and *An All Consuming Century: Why Commercialism Won in Modern America*, and Penn State University, USA

"Taking you on the fascinating journey of the sports shoe, this book charts trends in sport from the elitism of tennis in the late 19th century to the blurred lines of what sport is in the 21st century. It provides sound insight into the essential relationship between form, function, and innovation in design in response to changing backgrounds of society, culture, and technology. Beyond sports shoe fans, this is a great read for anyone interested in fashion, product design, history, or frankly anyone who has felt the liberation of wearing sports shoes in everyday life."

—Claudine Rousseau, Head of Atelier, Rapha Racing

"The rise of sports shoes to their central position as an iconic fashion item in the 21st century is a fascinating story, told here with enthusiasm and in-depth knowledge. Whether you are a student of fashion, a sports enthusiast, or a 'sneakerhead,' you will enjoy this excellent book."

—Chris Hill, Northampton University, UK

"With his thorough scholarship and wide-ranging research, Thomas has written a definitive history of the sports shoe. This is a book to be enjoyed by historians of dress, economics, and technology, as well as sport enthusiasts and sneaker aficionados alike."

—Amber Butchart, fashion historian and author, and presenter of the BBC's *A Stitch in Time*

"For anyone who doubted the importance of the sports shoe to contemporary fashion, Thomas Turner's comprehensive study is essential reading. The historical origins of the contemporary training shoe are vividly traced here, alongside a detailed exploration of the training shoe as a contemporary object of desire for a wide range of consumers, in a text that is not only rigorous and intellectual, but also entertaining and accessible."

—Janice Miller, author of *Fashion and Music*, and Kingston University London, UK

The Sports Shoe

BLOOMSBURY VISUAL ARTS
Bloomsbury Publishing Plc
50 Bedford Square, London, WC1B 3DP, UK
1385 Broadway, New York, NY 10018, USA

BLOOMSBURY, BLOOMSBURY VISUAL ARTS and the Diana logo
are trademarks of Bloomsbury Publishing Plc

First published in Great Britain 2019

A catalogue record for this book is available from the British Library.

A catalog record for this book is available from the Library of Congress.
Library of Congress Cataloging in Publication Control Number: 2018041888

ISBN: HB: 978-1-4742-8179-9
ePDF: 978-1-4742-8180-5
eBook: 978-1-4742-8181-2

Typeset by Lachina
Printed and bound in China

This book was produced with the help of a grant from Isobel Thornley's
Bequest to the University of London.

To find out more about our authors and books visit
www.bloomsbury.com and sign up for our newsletters.

The Sports Shoe

A History from Field to Fashion

Thomas Turner

BLOOMSBURY VISUAL ARTS
LONDON • NEW YORK • OXFORD • NEW DELHI • SYDNEY

Contents

Introduction

I remember my first pair of proper trainers. My parents bought them some time in 1986, when I was seven years old. White, with three stripes in graded tones of blue on the side, plastic D-ring lace loops, and a blue heel tab bearing the adidas logo, they were a marker of my ascent into maturity, a symbol that—despite being only seven—I was moving into a more grown-up world. They were, of course, the best thing in my wardrobe and I wore them with pride. I was not alone in my beliefs. Among my male classmates, shoes and clothing bearing the brand-names adidas, Puma, Reebok, or Nike had a cachet unmatched by almost anything else, certainly not the lesser, cheaper brands that were the norm for many of us until we could persuade our parents otherwise. We looked and made careful, detailed assessments of the footwear we saw around us; without really understanding why, we thought sports shoes were simply better, more desirable. For me, those first adidas were followed by a pair of Nike runners, red and white, nylon and suede, with a chunky foam sole and blue swooshes on the side. After that came not one, but two pairs of Reebok: the first a pair of gray, black, and green running shoes with the evocative name, Rapide, the second a white tennis model with red and navy trim. Both came with an assurance stitched into the tongue that they were the same as those worn by the best athletes. In the years that followed, a steady stream of other shoes and brands came and went, a personal timeline against which I can track the major events of my childhood.

It is hard to determine why these shoes held such a strong attraction, why sports brands were elevated over others. In my memory, it was a complex mix of fashion, style, aesthetics, the influence of sports and other celebrities, cost, and status. Certain moments stand out. At some point in the late 1980s, I remember standing in amazement before a pair of Nike Air Max in a sports shop, astounded that it was possible to have a shoe with windows into and out of the midsole. Going up to secondary school, my friends and I spoke in similar awe of the Nike Air Jordan worn by one of our new classmates, this despite our never having set foot on a basketball court and knowing little of Michael Jordan or his signature shoes. It was the model's clear plastic sole, space-age Air window, and high price that stunned us. It was an indication of things to come. During the early 1990s, we watched Nike's ascendancy, as a series of innovations took trainer design in fascinating new directions. I, like many of my friends, felt pangs of desire for expensive shoes laden with gimmicky technology—not just from Nike—that at times appeared to have come directly from a schoolboy's sketchpad. At weekends, we traipsed around local sports shops assessing the models on display, rarely, if ever, buying anything. In the middle of the

0.1 Serve children's shoes, adidas catalogue (UK), 1986.

decade, while others still sought technical wizardry, I embraced the trend for older, simpler models and wore the same Converse, Puma, and adidas as my musical heroes. Toward the end of the 1990s, as skateboard style became mainstream fashion, my small collection became a mix of skate shoes, retro models, and advanced sneaker technology. Although popular styles shifted and changed, throughout my childhood and adolescence, trainers were always the most significant part of my outfit.

This enthusiasm for sports shoes continued into adulthood and the twenty-first century. My first proper pay packets coincided with the big brands' tentative attempts to capitalize on their back catalogues. I was finally able to buy the Air Maxes I wanted as a schoolboy. And the Air Jordans. At the same time, the spread of the internet and the development of online selling platforms afforded the opportunity to hunt secondhand shoes from previous eras. I amassed a small collection of obscure and forgotten models from the past, all of which were eventually sold on to other collectors and enthusiasts. It is now over thirty years since those first adidas, but my passion, though tempered by more adult concerns and not as intense as it once was, remains. The right pair of trainers still has the power to evoke feelings similar to those felt so many years ago.

The sports shoe market today is big business. In 2015 retail sales of sports shoes were estimated to be worth $2.8 billion in the United Kingdom, $9.4 billion in

Germany, France, Italy, and Spain combined, and $36.3 billion in the United States.[1] In recent years, major brands, retailers, press, and social media have combined to create a new and complex sneaker culture. Sneakers now connect the worlds of sports, fashion, celebrity, and everyday life in a way matched by few, if any, other products. They feature regularly in the fashion and style press, and are sold in the same way and are as susceptible to trends as other forms of clothing. Indeed, data suggest around only a quarter of sports shoes sold are worn for sports.[2] What began as specialist products for niche markets are now worn everywhere, by everyone.

Yet few of us pause to ask where these shoes came from, or how they became so popular. How sports shoes moved from the sports field into the mainstream of everyday life is seldom considered. This book seeks to do just that, to explain how shoes designed for sporting activities came about, and how they came to be used for other, often far less strenuous, purposes than those for which they were initially intended. It considers how in the past sports shoes were made, sold, and worn, and examines how the ways in which people understand and understood them were generated, nurtured, and forgotten.[3] It looks at how sports footwear was integrated into social practices, both sporting and otherwise, and at the relationships that existed between producers, sellers, and consumers.[4] By exploring how new and unexpected ways of thinking about sports shoes influenced the processes of design and manufacture, it emphasizes that sports footwear has always been open to reinterpretation and recontextualization.[5] The ways in which people used and thought about sports shoes were often not those anticipated by makers and sellers. Schoolboys in 1980s Britain were not the first, and were certainly not the last, to attach great importance to this type of footwear, nor were they the first to wear them outside the narrow confines of sport.

This book also seeks to show how sports shoes were part of broader historical narratives. Sneakers are often analyzed and celebrated as stylistic or symbolic objects, yet these are only two of the ways in which they can be interpreted.[6] This book considers them too as manufactured, globally traded goods, and as examples of technological innovation. To do this, it takes into account the rise of sports, the industrialization of the footwear industry, the discovery of new materials, shifts in global trade, and the growth of new forms of consumer culture. By looking at sports shoes from different perspectives and in different contexts, it shows how social, cultural, and industrial phenomena were connected, and how both the physical reality of shoes and the ways in which people thought about them were affected by

0.2 The author in Nike
Roadrunner, 1987.

larger historical forces.[7] It is only by considering how sports shoes fitted into wider
networks of technology, fashion, commerce, politics, and shared attitudes that we can
come to a true appreciation of their cultural significance.

Although many people remember their old sneakers with nostalgic warmth,
reconstructing the history of sports footwear is an ambitious task. Few shoes from
previous eras survive, with those that do now prized by collectors around the world.
Barely any are held in museum collections. The big brands guard their archives
closely. Ephemeral marketing materials are similarly hard to come by, as is reliable
production or sales data. Production has always been spread around the world, and as
manufacturers and retailers have disappeared and brand-names have passed between
owners, what scant records existed in the first place have been lost. The problems
inherent in what Phil Knight, the founder of Nike, in 1985 called "an industry with
a high consumer profile but poor statistics, so that everyone has an opinion but no
one is precisely sure what is going on," are compounded for the historian.[8] This book
therefore casts the net wide for source material. It draws on a variety of documentary
and physical evidence, with the traces of sports shoes left in photographs, drawings,
catalogues, and advertising descriptions at its heart. The trade press, corporate
material, popular and niche journalism, and material from film, television, and music
are brought together to establish popular attitudes toward sneakers.

Special shoes have, of course, been worn for almost as long as people have played sports and games. Court records show English king Charles II spent extravagantly on "tennis shoos slippers & Bootes" in 1679.[9] The sports shoe has never been a static or singular entity. It has evolved according to popular tastes, available materials, changing patterns of use, and the machinery of production. A multiplicity of styles have always been available. This book focuses, however, on shoes created since the mid-nineteenth century, when modern manufacturing techniques and sports as we know them came into being. It focuses, too, on footwear that could be worn away from the sports field. Effectively, this means concentrating on shoes with flat soles, mainly those produced for court sports, running, and general training, rather than the studded, cleated, spiked, and specially shaped shoes worn in other disciplines.

This is, then, a personal history, informed in part by my own experiences. In writing it, inevitably, I have been selective. It is not an account of the very recent past, of neither the hype-driven sneaker culture of the internet or the huge, fashion-oriented mass market of the high street. Instead, it traces the long history of this category of footwear and our enthusiasm for it. The point at which the current market starts to take off is where this history ends. Ultimately, it seeks to show how the current situation came about. Countless people, most of them lost to history, designed, made, sold, bought, wore, and collected sports shoes over the past century and a half. It would be impossible to include them all. The people, shoes, and stories I focus on are those that affected sports shoes' physical reality and the more imaginative ways in which they were understood. It is a selection that I hope illustrates wider trends and sheds light on the development of the market as a whole. These are the forces— human and otherwise—that transformed what began as a relatively mundane garment designed for practical purposes into the symbolically and culturally complex, often highly desirable objects we know today.

0.3 Air Max, Nike advertisement, 1990.

Nike Air Max

1

Lawn tennis and the origins of modern sports shoes

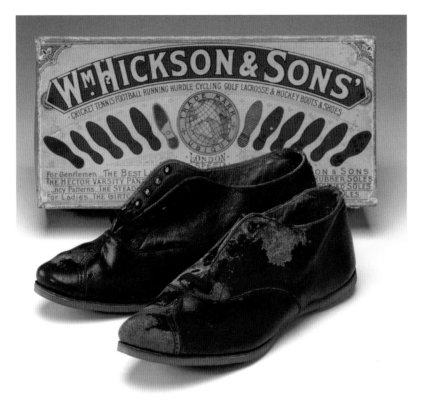

1.1 Men's lawn tennis shoes, William Hickson and Sons, c. 1890.

In spring 1889, a reporter from the London sports weekly, *Pastime*, toured the "huge warehouse" of William Hickson and Sons, a Northamptonshire shoe manufacturer. There he was shown "lawn-tennis shoes in endless variety ready for the coming season." This was not unusual. The following year, at Manfield and Sons, he was almost overwhelmed: a "descriptive catalogue of all the varieties of lawn-tennis shoes to be found at the showrooms of this firm would more than exhaust the space at disposal," he wrote. "Every kind of rubber sole is united with canvas, buckskin, calf, and Russia [leather], in combinations innumerable, ranging in price from under three shillings to nearly ten times that amount." Competition between manufacturers was fierce. As *Pastime* had noted in 1888, "[y]ear by year the task of visiting show-rooms and manufactories becomes more laborious, owing to the great number of makers that are continually entering the field."[1] Rival firms fought for consumers' business, driving sports shoemaking to new heights.

The modern sports shoe was born in the final decades of the nineteenth century. Social, industrial, and commercial changes in Britain prompted widespread enthusiasm for a variety of games and athletic activities. Sports created physical and social needs that were answered by a newly industrialized shoe industry. In seeking to cater to the demands of sportsmen and sportswomen, shoemakers drew on ideas of how footwear would be used within sporting practice, and exploited modern manufacturing and commercial processes.

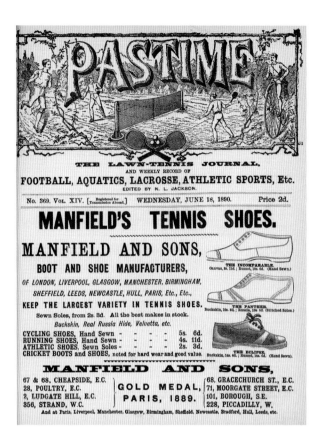

1.2 Manfield and Sons advertisement, 1890.

Special shoes used new materials and production techniques and were a category in which producers could experiment and innovate. They were sold in department stores, sports outfitters, and shoe shops and were marketed heavily, displayed prominently in windows and advertised in the popular, sporting, and trade press. This wide availability led to them being incorporated into the everyday wardrobe, both overtly, in the sense that they were worn for everyday use, and more covertly, in the sense that innovations associated with and introduced for sports were quickly adapted for other types of footwear. Sports shoes and clothing were associated with informality, youthful vigor, and—most especially—modern masculinity, and contrasted with more sober visions of frock-coated Victorian manhood. By the end of the century, sports shoes were closely linked to youth styles, but had also begun to seep into mainstream popular fashion.

❊ ❊ ❊

Lawn tennis was one of several sports to emerge in the latter half of the nineteenth century. In Britain and the United States, the period was marked by the growth of new forms of physical recreation. Traditional folk games like football and cricket were developed into their modern forms, while entrepreneurial manufacturers produced a raft of inventions that sought to capture the imagination of a consuming public with time and money to spend on leisure.[2] Lawn tennis developed in the late 1860s

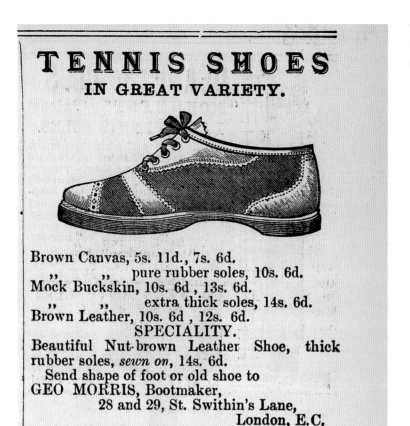

1.3 George Norris
advertisement, 1888.

as an informal, outdoor adaptation of older bat and ball games, most obviously royal tennis.[3] Credit for its invention is usually given to Major Walter Clopton Wingfield, a well-connected retired army officer who in 1874 launched its first commercially successful version. Boxed sets of rackets, rubber balls, court markers, a net, support poles, and an instruction booklet were sold by Wingfield's agent, the sporting goods supplier French and Co., in Pimlico, London. They cost between five and ten guineas, a price that made them accessible only to the very wealthiest in society. Nevertheless, through canny promotion and his unwillingness to challenge rival manufacturers who launched their own versions of the game, Wingfield succeeded in creating an upper-middle-class fad. *The Illustrated London News* noted in summer 1880 that "[t]his popular and fashionable game, which is readily organised in small family parties, or at social visits wherever there is a good-sized piece of open turf, players being from two to eight in number, ladies and gentlemen together if they please, seems likely to hold its place in public favour." Their predictions were correct. The author of the almanac *Lawn Tennis for 1883* observed that lawn tennis was "followed with ardour by those that move in the highest social circles," and by "any thousands of well-conditioned households that can boast sufficient garden space around their country house or suburban villa to afford the luxury of a 'court.'" Within a few years of its launch, the game was well established within the fabric of middle class society.[4]

Late-Victorian lawn tennis encompassed more than the game defined by Wingfield and others. It blended physical movement with commodities, environments, and systems of social display and interaction. The rules, court, and implements of the game, as well as the social implications, conventions of behavior, and ways of thinking that surrounded it, constituted lawn tennis as a social practice. During its infancy, physical and competitive play were of less significance than sociability. For most Victorian players, it was an entertaining outdoor party game redolent of lazy afternoons and comfortable, bourgeois leisure. In new upper-middle-class suburbs, the relaxed tennis party was a key part of the summer season. It was, as one devotee claimed in 1881, best played on "a well-kept lawn [with] a bright warm sun overhead, and just sufficient breeze whispering through the trees and stirring the petals of the flowers to prevent the day from being sultry." Arthur Balfour, later Prime Minister, was an early enthusiast. Looking back, he wrote that it was "not easy . . . to exaggerate the importance" of the tennis party, which, he thought, "profoundly affected the social life of the period." Yet informality masked an event heavy with symbolic meaning. Participation in this new ritual required an array of costly implements, sufficient space, carefully maintained playing surfaces, and often membership of exclusive clubs. Participation was a demonstration of considerable resources—an example of what the American sociologist Thorstein Veblen identified in 1899 as "conspicuous consumption" and "conspicuous leisure." Social interaction and codified displays of wealth and status were integral elements of the Victorian game.[5]

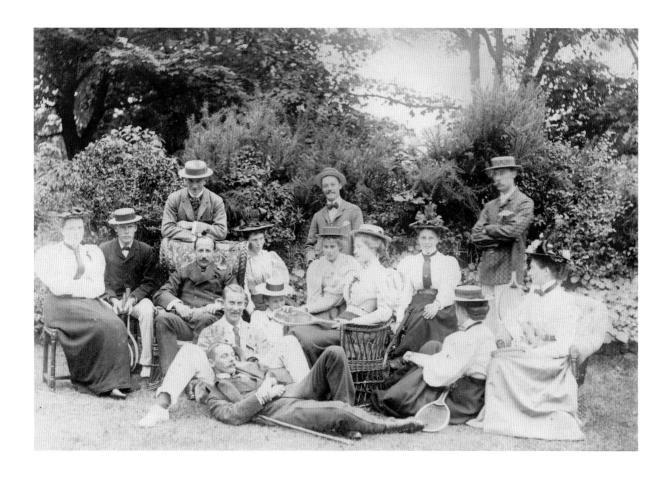

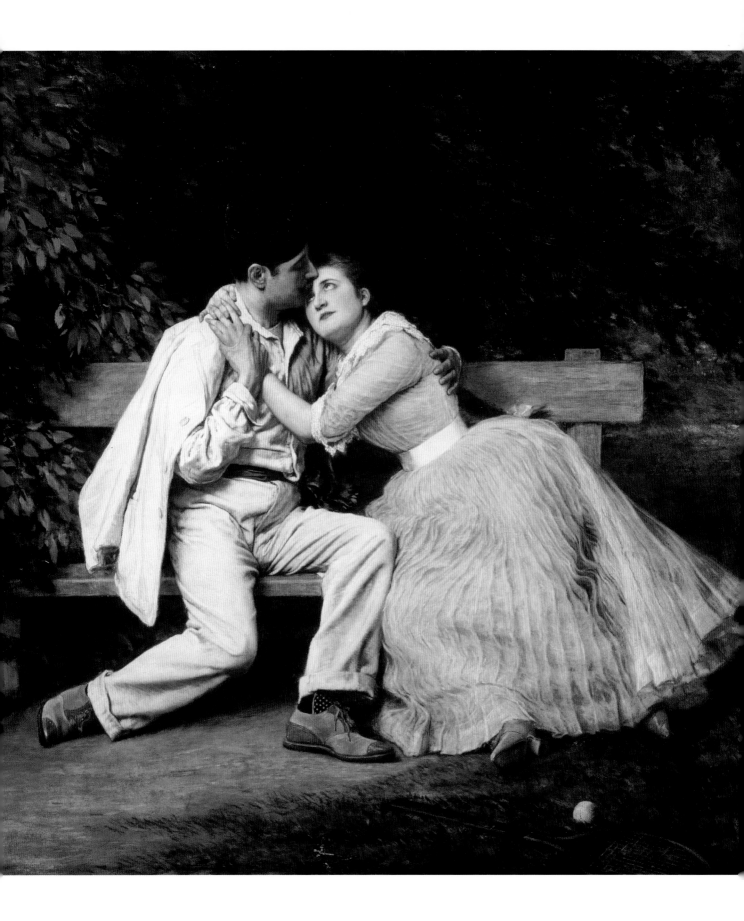

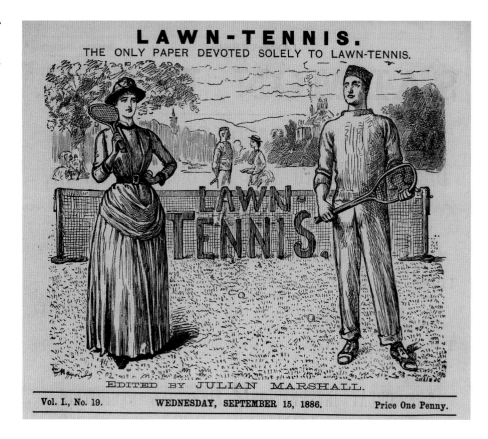

1.5 (Opposite) Jan Van Beers, *A Love Match*, c. 1890.

1.6 (Right) *Lawn-Tennis* magazine masthead, 1886.

In an era of strict gender segregation, lawn tennis was also significant in that it enabled middle class men and women to play with and against one another. It was welcomed by *The Sporting Gazette* for adding "another to that too limited list of pastimes in which ladies and gentlemen can join." The journal thought it ideal for "ordinary loungers of both sexes, who care only for something which will . . . enable them to enjoy fresh air and flirtation in agreeable combination." By bringing the sexes together, lawn tennis had a social culture distinct from sports like football and cricket. It introduced a new form of courtship, and the possibility of romance was a recognized—and frequently satirized—feature of the late-Victorian game. *The Graphic* claimed women played in "the hope of finding opportunities . . . of exhibiting their social charms, of posing in graceful attitudes, and indulging in the intervals of the game in flirtation with their partners." *The Bristol Mercury and Daily Post* suggested "the chance of hearing 'love' from pretty lips" was part of its appeal for men. Even the masthead of the sports journal *Lawn-Tennis* showed two young couples breaking from a game of mixed doubles, gazing coyly at one another. It was in this form that the game was most commonly played; although the sports press focused on the competitive men's game, garden parties often revolved around the social institution of the mixed double.[6]

❊ ❊ ❊

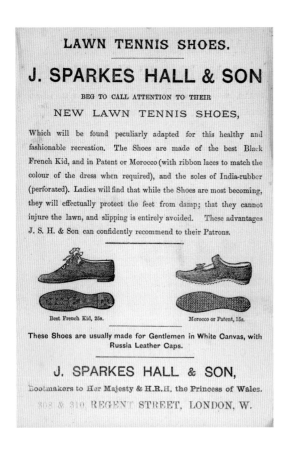

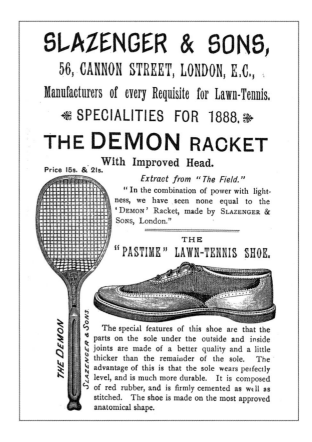

The advent of lawn tennis created a need for suitable footwear. The game was usually played on large, flat grass courts. These were expensive to install, and for the ball to bounce consistently, had to be regularly mown and rolled with costly machinery. To play properly and avoid embarrassment, participants had to run, turn, and stop relatively quickly without falling or slipping. Tennis shoes had to allow players to move effectively while also preserving the integrity of the court. The uppers were therefore made of lightweight, flexible materials, usually soft leathers or canvas, but the spiked or studded soles that provided grip in other grass sports like cricket and football were unsuitable as they damaged the surface. Flat soles of soft leather, although they were easier on the turf, were slippery and liable to become soaked with moisture. Shoemakers instead looked to vulcanized rubber (also known as India rubber and red rubber), a material that had only recently become available. Durable, moldable, heat- and water-resistant, it was ideally suited to players' needs. It could be fashioned into flat, heel-less soles that gripped well and did not damage the court. Manufacturers tried different patterns— including dimples, pyramids, ridges, and cut-outs—and soles of varying thicknesses as they sought the perfect mix of flexibility, grip, and protection.[7]

Rubber-soled lawn tennis shoes were deemed essential almost immediately. A French and Co. pricelist advertising "Tennis shoes with India-rubber soles, which will not cut up the turf" was included with Wingfield's sets. In 1877 an early

1.7 (Above left) J. Sparkes Hall and Son advertisement, 1882.

1.8 (Above right) The Pastime lawn tennis shoe, Slazenger and Sons advertisement, 1888.

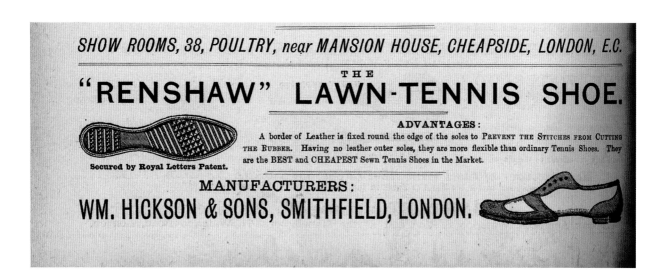

guidebook urged potential players to "have pity on your own body and on the turf of
your friend's tennis ground, and cast aside your heels (viz., wear racquet shoes, with
India rubber soles and no heels)." It described a player in "leather boots with heels,"
who "makes a stroke, slips, and almost goes down, then rushes forward, strikes at a
ball, misses it, and slides a foot or so, until his heels check his course, much to the
detriment of the grass; thus he goes on until he really does fall, and with a wry face
gets up rubbing his wrist." A player in rubber-soled shoes, could, by contrast, "run
. . . about on the slippery surface with the greatest of ease, never once missing his
footing, or slipping an inch." The guide recommended shoes from "Messrs. Sparkes
Hall and Co., of 308 Regent-street," which was, conveniently, advertised on the
endpaper. Men's lawn tennis shoes were designed to facilitate movement. Vigorous
play highlighted Victorian ideals of the athletic male physique, but as the guidebooks
warned, inappropriate footwear could literally upset the body's balance, undermining
the poise that might otherwise be achieved.[8]

Just as there was more to lawn tennis than physical movement and manicured
lawns, there was more to the lawn tennis shoe than its rubber sole. This was indicated
when Herbert Wilberforce, an early doubles champion and later president of the All
England Lawn Tennis and Croquet Club, addressed the question of footwear. In a
booklet published in 1891, Wilberforce praised "shoes with thick, smooth, red rubber

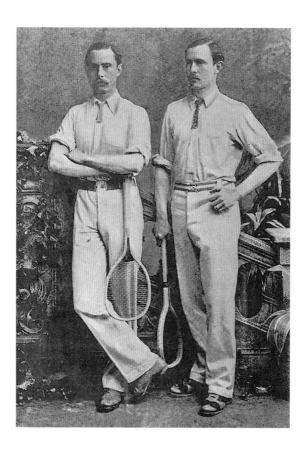

1.10 (Left) William and Ernest Renshaw, c. 1880.

1.11 (Opposite) American lawn tennis player Richard Dudley Sears, 1886.

soles" that, he said, "last an immense time, give a sure foothold" and were "not uncomfortable." Yet he confessed a preference for what he called an "ordinary canvas shoe with a ribbed sole" because "of its extreme lightness." As a dedicated player, Wilberforce wanted to move on court as quickly as possible. He recognized, however, that many players disliked his choice, as it was "not ornamental." Style and aesthetics, and their social connotations, were considerations manufacturers could not ignore. For many late-Victorian players, how shoes looked was as important as how they performed physically. Ornament mattered.[9]

Men's shoes varied from simple canvas designs like those worn by Wilberforce to those of fine, imported leathers. Several manufacturers produced models with two-tone, intricately detailed uppers. One of the most popular was Hickson and Sons' Renshaw, named after William and Ernest Renshaw, the most successful players of the era. It was made using modern production technology, and had a rubber sole attached using an innovative welt system. Launched in 1885, it was advertised in the sports press for several years. *Pastime* described it as "capitally finished in the usual careful style," with rubber soles "fluted at different angles, so as to give a firm hold on the turf in every direction." Illustrations showed a neat blend of practicality and style, with eye-catching, two-color, elaborately patterned uppers. The Renshaw was part of a trend. Slazenger and Sons' Pastime was of similarly robust construction, but also similarly striking. An 1888

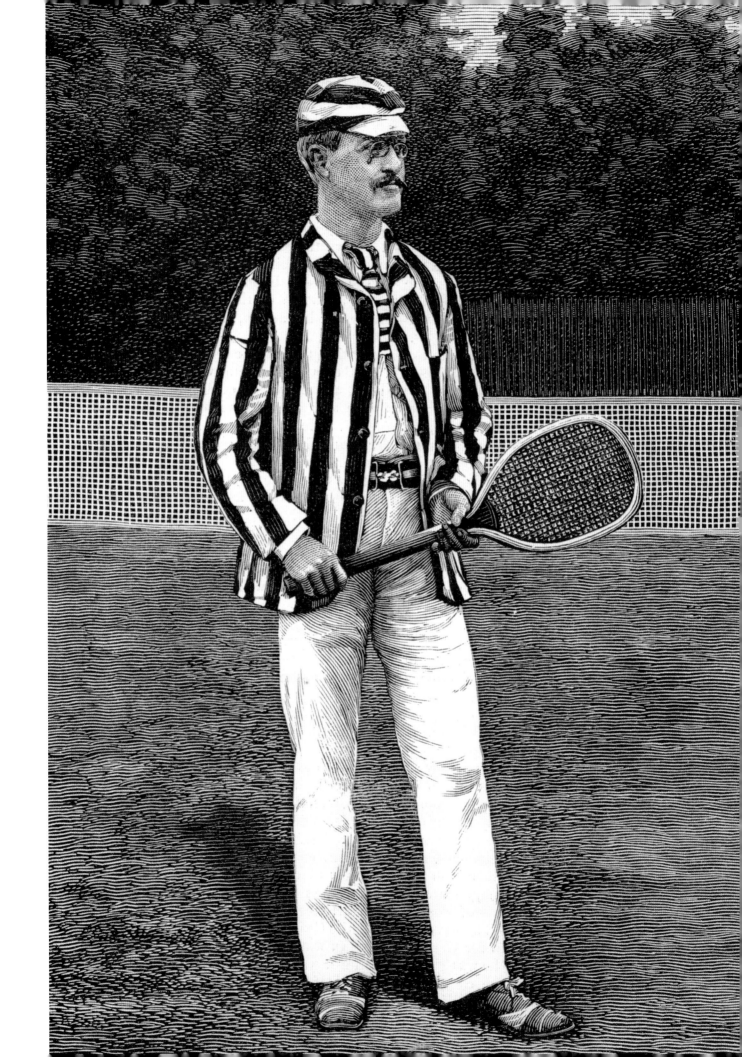

advertisement explained that "the parts on the sole under the outside and inside joints are made of a better quality and a little thicker than the remainder of the sole" so that it "wears perfectly level, and is much more durable." It was "made on the most approved anatomical shape." A large, detailed image showed an elegant shoe with an upper of contrasting panels, and a wing-tip with gimped edges and decorative punching. In both cases, functional language provided a stereotypically masculine approach to shoes that were sold as much on aesthetics as on athletic performance.[10]

Contemporary images and advertisements suggest shoes like the Renshaw and Pastime were popular with both garden players and the elite. A photographic portrait of the Renshaws in the 1880s shows William wearing plain, probably buckskin, shoes, and Ernest in a two-tone model, much like those sold by Hickson and Slazenger. By 1888 almost a quarter of a million pairs of the Renshaw had been sold. On one level, the variety in price and styling in the men's lawn tennis shoe market testified to manufacturers' technical ingenuity. On another, it was a way by which male consumers made clear their position within the complex hierarchies of wealth, taste, and social status that characterized the late-Victorian lawn tennis party. Yet the popularity of "ornamental" footwear also shows the importance male players placed upon style and aesthetics. Boots and shoes produced for other sports tended to be uniform in color: white for cricket, black or brown for football. The distinctive, dandified styling of lawn tennis shoes highlights the game's significance as a performance of masculinity, but also the possibility inherent within it for the cultivation of novel ideas of manhood. The informal, casual elegance of the masculine lawn tennis shoe went along with new ideas of the athletic male body and was part of a broader rejection of stiff social codes. For an expanding constituency of young middle class men, working in city offices and living in the surrounding suburbs, sports and their associated dress provided a powerful new model of modern masculinity.[11]

For women, tennis both reinforced and challenged traditional gender ideals. Female players were not expected to play as energetically as their male counterparts (and opponents). Those who came to tennis parties in the hope of romance dressed in accordance with prevailing notions of feminine beauty, in a manner that would make them appealing to men. During the garden party era, most dressed as they would for any other summer social occasion: in long skirts, tight corsets, bustles, gloves, and hats. One young woman complained to *Pastime* that "there are nearly always young ladies who come to [tennis parties] with the object not of playing tennis, but of making the best of their opportunity." She wrote that the smaller band of more

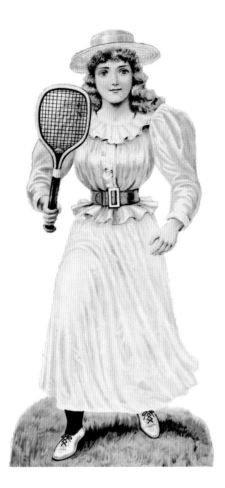

1.12 Chromolithograph of female lawn tennis player, c. 1890.

active female players, likely to be "rumpled rather in dress and somewhat red in the face," compromised on clothing and wore garments that were unsuited to the game because they did not want to be compared unfavorably by male guests against the "serenely undisturbed . . . sitters-out." For most female players at the end of the nineteenth century, tennis costume was about social display rather than bodily freedom; incapacitated female players in impractical clothing were conspicuous demonstrations of the male wealth that afforded such leisured lifestyles. Most women conformed to gender stereotypes, preferring to look smart and dress "correctly" than to be comfortably attired for athletic movement.[12]

When it came to women's tennis footwear, physical practicality took a back seat to appearance and protecting lawn. Women's shoes were as varied in style and price as men's, but in almost all other respects were distinct. They were produced in stereotypically feminine designs, made with lightweight, luxury materials suitable only for the daintiest of movements. Slazenger offered "Waterproof Black or Blue Cashmere, Canvas Lining, Strasbourg Morocco Strap and Toe Cap," and "Glace Kid, Open Front, One Strap and Button." Harrod's sold women's shoes of canvas, Morocco leather, and tan leather. While men's footwear was considered as "equipment" by reviewers in the sports press, women's was discussed in the fashion columns of popular newspapers. A journalist in Birmingham, for instance, gushed

1.13 El Dorado lawn tennis shoe, H. Dunkley advertisement, 1889.

over the "lovely . . . tennis shoes in willow calf, and in white buckskin and canvas" on offer to women at Bird's department store, but quickly skipped over those in the "less interesting but equally necessary gent's department." Looks were deemed of far greater significance than durability or how a shoe aided sporting performance.[13]

The importance of fashion and ideas of femininity were apparent in the debate about heels. Despite loud and frequent advice in favor of flat soles, many women seem to have regarded them as an ugly nuisance. In 1888, "Fashion's Oracle" wrote in *The Hampshire Telegraph and Sussex Chronicle* that "[t]he absence of heels on tennis shoes has long been an objection to many people." High heels had re-emerged as a fashion for women in the middle of the nineteenth century and by the end of the century were widely popular. That they were rich in erotic significance, signals of femininity, possibly explains their appeal to female tennis players more interested in the social and romantic elements of the game. So too, perhaps, does the fact that they physically enforced the inhibited style of play thought appropriate for women. Appearance and the desire to look appropriately feminine duly took precedence over movement, or the fate of the turf. Kelsey of Oxford Street advertised "Glacé Tennis Shoes, with and without heels" in 1894, and in 1897 Harrod's listed three heeled shoes. A distinctive solution to the desire for a feminine, high-heeled shoe that would not sink into the grass was Dunkley's El Dorado, which had a two-inch heel and a corrugated flat

rubber sole bridging the heel and the forefoot. Advertising claimed it could not be surpassed for comfort and elegance, and explained, "a moderate heel is supplied, but is prevented from injuring the essential smoothness of the tennis lawn by the interposed rubber soles stretching from the heel to the front of the shoe." Soon after its launch in 1888, "Fashion's Oracle" reported it was "rapidly gaining favour." The author of "Things Worth Buying" in *The Ladies Monthly Magazine* called it "[o]ne of the prettiest and most satisfactory [tennis shoes], which I have seen up to now," "a charming combination of flat sole and moderate heel, strong and elegant-looking," that "can be worn with the greatest of comfort." Whether it enabled women to move with greater ease, or to play the game any better, was of little consequence.[14]

Not all women adopted the garden-party style of play. For red-faced, more physically active players, shoes with flat rubber soles enabled them to move in a manner that was otherwise entirely proscribed, helping cultivate new notions of what it meant to be a woman. In girls' schools and colleges, a new vision of the physically active young woman—the female collegiate athlete—emerged that countered the frail femininity of the mid-Victorian period. Crucially, this occurred in an environment in which men were largely absent. The small band of elite female players at the end of the nineteenth century were similarly pioneering, and their adoption of less restrictive, more comfortable clothing cleared a path that was followed more widely after the First World War. For some women, flat-soled lawn tennis shoes were part of a new, more active idea of beauty. Yet they represented a tiny subset of female lawn tennis players. In public, even the most athletic women thought tennis dress needed to conform to feminine ideals. Lottie Dod, whose youthful athleticism entertained crowds and brought her five Wimbledon titles, in 1897 asked for a "practical, comfortable, and withal becoming costume. It *must* be becoming, or very few of us would care to wear it."[15]

Lawn tennis was not solely a British phenomenon. Wingfield's boxed sets were easy to transport. British military regiments and imperial administrators stationed around the globe were among his first customers. The game was introduced to the United States after Mary Ewing Outerbridge, a young New York socialite, played it with British soldiers in Bermuda and returned home with a Wingfield set. The first games were played in 1874 at the Staten Island Cricket Club; the first tournament was held in 1880; and by 1887, 450 tennis clubs used courts in Brooklyn's Prospect Park. Imported and American-made shoes and equipment were soon available. In the 1880s, the New York firm I. E. Horsman launched its own version of the game and advertised prize-winning "Best Tennis Shoes, White or Coloured Canvas, with Corrugated Rubber

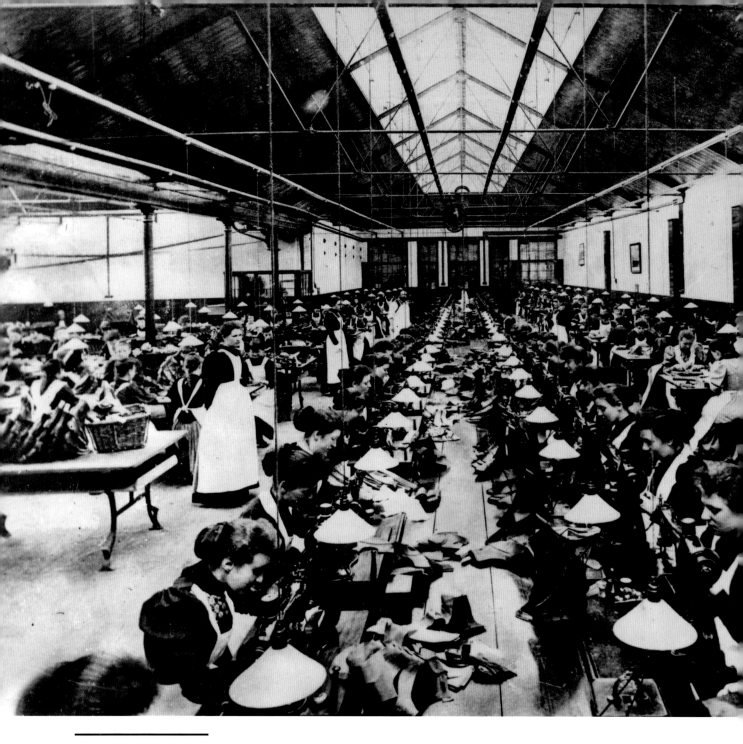

1.14 The closing room,
Manfield and Sons factory,
Northampton, c. 1898.

The Sports Shoe

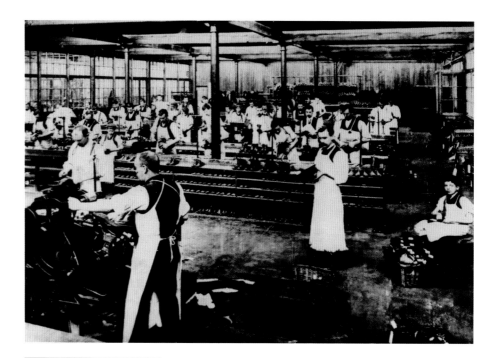

1.15 The making room,
Manfield and Sons factory,
Northampton, c. 1898.

Soles." The firm advised that "[b]y wearing rubber-soled shoes, the player will secure a sure footing, and save the court, since ordinary heels cut the turf." Peck and Snyder, another New York store, sold domestic and imported models, and by the 1890s a variety of shoes were available by mail order from Sears, Roebuck in Chicago. During this period, the game remained largely the preserve of a monied middle class and performed much the same social function as it did in Britain. Similarly gendered ideas of sartorial and behavioral decorum governed male and female participation and found expression in men's and women's lawn tennis shoes.[16]

❊ ❊ ❊

The arrival of lawn tennis in the 1870s coincided with the transformation of the footwear trade, which in Britain moved from domestic handicraft to factory-based mechanized mass production. It had been customary since the seventeenth century for workers to specialize on one stage of the shoemaking process, and the subdivision of labor within the industry was well established. The introduction of American machinery in the second half of the nineteenth century, however, was transformational. During the 1880s large shoe factories were constructed throughout the east Midlands, long the heart of the British trade, and by the early 1890s industrial production was the norm. The

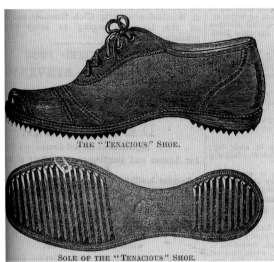

Leicester correspondent of *The Times* noted in 1894 that "[a]lmost all the operations in the manufacture of boots and shoes are now performed by machinery" and "hand labour is being largely and very rapidly displaced."[17] This allowed the industry to expand and output to increase, meaning shoes were available in greater numbers at lower costs than ever before. Sports footwear was an important market segment that allowed shoemakers to experiment with new materials and production processes. Manufacturers of lawn tennis shoes, including Hickson and Manfield, were industrialized concerns, housed in modern factories using newly developed machinery and production techniques. *The Times* noted that tennis shoes "proved very successful" and that large orders were placed "very freely."[18] Working in a new product category, seeking to answer sporting needs, manufacturers could innovate without the constraints imposed by previously established products or definitive ideas of what a sports shoe should be; from a design and production perspective, a traditional sports shoe simply did not exist.[19]

One of the most successful tennis shoes of the era was the Tenacious, a model made by H. E. Randall of Northampton, a firm renowned for high quality products made with modern technology. Its founder, Henry Edward Randall, was an archetypal Victorian industrialist. Born in 1849, he established a shoemaking factory in Northampton in 1870, aged twenty-one. By the time of his death in his eighties, he had been knighted, served as Northampton's mayor, and was celebrated as a major

1.16 Tenacious lawn tennis shoe, H. E. Randall advertisement, 1884.

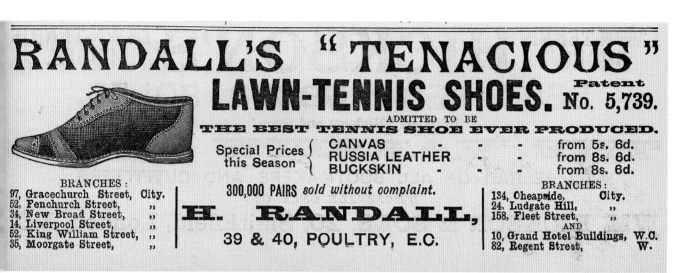

RANDALL'S "TENACIOUS" LAWN-TENNIS SHOES. Patent No. 5,739.

ADMITTED TO BE THE BEST TENNIS SHOE EVER PRODUCED.

Special Prices this Season
{ CANVAS - - - from 5s. 6d.
RUSSIA LEATHER - - from 8s. 6d.
BUCKSKIN - - - from 8s. 6d.

BRANCHES:
97, Gracechurch Street, City.
52, Fenchurch Street, ,,
34, New Broad Street, ,,
14, Liverpool Street, ,,
52, King William Street, ,,
35, Moorgate Street, ,,

300,000 PAIRS *sold without complaint.*

H. RANDALL,
39 & 40, POULTRY, E.C.

BRANCHES:
134, Cheapside, City.
24, Ludgate Hill, ,,
158, Fleet Street, ,,
AND
10, Grand Hotel Buildings, W.C.
82, Regent Street, W.

1.17 Tenacious lawn tennis shoes, H. E. Randall advertisement, 1890.

civic benefactor. His first shop opened in 1873 in the City of London, and in the 1880s production moved to a factory that at the time was the largest in Europe. The firm described it as "the most up-to-date in the trade," "[f]itted throughout with the latest labour-saving machines, and controlled by the foremost experts in shoemaking." Another three factories were in operation by 1896, and by the First World War the firm had over fifty shops, many in London's most fashionable shopping districts.[20]

The Tenacious was launched in the early 1880s. Its design was inspired by a common problem: the soles of early tennis shoes had a tendency to come off. Enthusiastic play caused glue to eventually work loose, while stitches cut through rubber, allowing the sole to fall away. Neither method coped well with the physical demands of the game. Randall's solution was an extra thick vulcanized rubber sole glued and sewn to the upper, most likely using tooling recently introduced by American machine companies. The greater durability and reliability this promised were the shoe's principal selling points, but concern was nevertheless taken to ensure it appealed on an aesthetic level. It was made for men and women, in "a sufficiently large assortment to satisfy the most fastidious taste." Buyers could choose from around thirty differently styled, differently priced uppers of canvas or a variety of leathers. Illustrated advertisements drew attention to the shoe's "stylish appearance" and showed a low-cut men's model with fashionable contrasting panels, decorative gimping and punching, and a corrugated sole.[21]

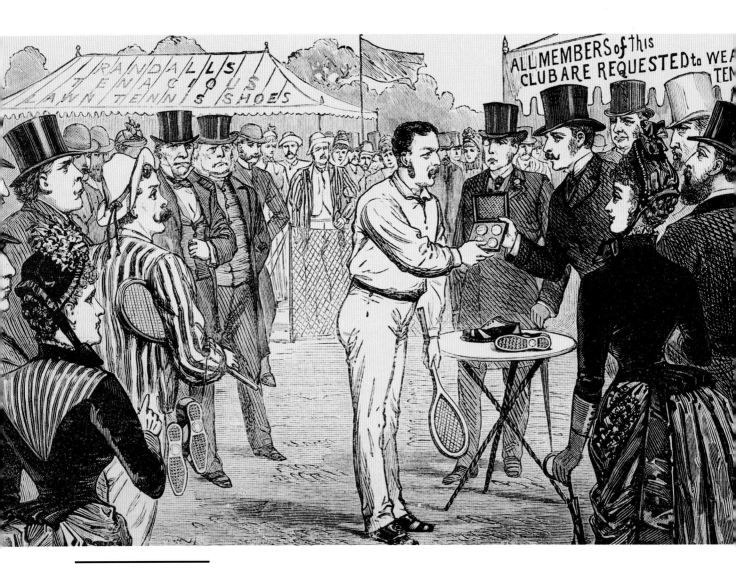

1.18 "A Pleasing
Ceremony", H. E. Randall
advertisement, *The Graphic*,
1886.

H. E. Randall took advantage of the promotional opportunities offered by Britain's burgeoning consumer culture. The firm advertised in sports journals and guidebooks intended for final consumers, and in trade newspapers read by retailers and producers. It issued promotional leaflets and flyers. It adopted new methods of product display made possible by developments in construction and glass technology. Illustrations of its London stores showed passers-by gazing at products behind enormous plate-glass windows plastered with advertising. *The Shoe and Leather Record* described the firm's displays as "unquestionably the finest [. . .] in London." Their reporter was amazed by a "marvel of ingenuity": "Walking boots and shoes, tan and patent, and cycling, cricket, and tennis goods, all contribute to the fine effect produced, and interspersed in the most artful manner are cricket bats, balls, and wickets set in position, tennis rackets, balls &c." Randall's advertising was attuned to the complex mix of physical action, social aspiration, and display that characterized Victorian lawn tennis. This was most apparent in *Victory of the Tenacious Lawn Tennis Shoes: A Romance,* a throwaway comic strip that told the story of Jones, a fashionable young gentleman, and his attempts to win the favor of a Miss de Ponsonby. After a successful game of mixed doubles and an intimate moment at a first tennis party, Jones faces embarrassment at a second, when the sole of his shoe—"not Randall's"—flies off and strikes Miss de Ponsonby on the nose. He is saved from social exclusion only after his friend advises him to try "RANDALL'S TENACIOUS LAWN TENNIS SHOES as peacemakers" (though how he does this is not made clear). After resolving "never again to buy Boots or Shoes elsewhere," the final frame shows him getting married, one assumes to Miss de Ponsonby. The strip neatly satirizes the role of tennis in middle class courtship, but it nevertheless indicates the social importance of the tennis party, and the wider implications of the game as a practice. Randall understood this and tailored his products and marketing accordingly.[22]

The sensitivity H. E. Randall showed to players' desires may well have stemmed from the founder's own experiences. An illustrated advertisement in *The Graphic* in 1886 showed Henry Randall receiving prize medals at a well-attended tennis tournament. In contrast to the frock-coated, top-hatted "leaders of Society, Politics and Art" around him, he was drawn with a racket in hand, dressed in a loose-fitting white shirt, fitted trousers, and a pair of Tenacious. Extracts from a speech supposedly given by the presiding official explained that he was "looked upon as a benefactor to Lawn Tennis Players generally, as previous to the advent of the 'TENACIOUS,' they often experienced great discomfort from the soles of their shoes coming off." The shoe was so well suited to the game that "many of the leading clubs insist upon

[it] being worn by all the members." The image implies that, as a member of the commercial middle class, Randall played lawn tennis himself, and that his knowledge of the game fed into the design and construction of the Tenacious.[23]

The introduction of more reliable and hardwearing footwear like Randall's Tenacious, Hickson's Renshaw, and Slazenger's Pastime allowed male participants to develop the sporting aspects of lawn tennis, moving it away from the garden party and closer to its current incarnation. During the 1880s men adopted a more aggressive, athletic playing style that distinguished lawn tennis from older bat and ball games. This would have been difficult had they been overly concerned about the soles of their shoes. Shifts within the game fed back into the design process, as manufacturers responded to participants' changing expectations and needs. Male players were drawn to the Tenacious almost immediately, probably as a result of H. E. Randall's insistent advertising. In spring 1884 one wrote from London to the editor of *Pastime*:

Sir,—I am desirous, as a tennis player, of obtaining either from you or some of your subscribers information as to whether shoes of which the soles are attached by stitching are really successful, and stand satisfactorily the wear and tear of play. I believe the correct name of the shoes I mean is the "Patent Tenacious," and if you will be so good as to insert this short letter no doubt some who have by hard wear thoroughly tested the shoe will kindly, also through your columns, furnish me with the information I desire.—I am, Sir, yours faithfully,

J. W. Heaton
8, St Bartholemew's-Road, Tufnell Park, N.[24]

Sports journals like *Pastime* enabled readers to consider the latest products, offer guidance, and share opinions that challenged or confirmed the claims made in advertising. Mr. A. Myers of Regent's Park, London, duly wrote in response that "[t]ennis shoes have not tended to bring joy to my troubled soul," due to the "certainty . . . that at some untimely moment the soles and bodies will part company." The Tenacious was "a good thing, and a step in the right direction" as it wore "as no shoes ever did before." Thomas Shepard of St. Edmunds similarly considered them "the best lawn-tennis shoes I have ever seen." Unsurprisingly, H. E. Randall seized the sales opportunity this discussion presented; an advertisement for the Tenacious appeared in *Pastime* three weeks later.[25]

Randall's smart advertising and the ready availability of the firm's products no doubt contributed to the success of the Tenacious. The firm claimed in *The Graphic* that over

200,000 pairs were sold between 1883 and 1886, and *Pastime* noted in 1890 that it had "for some time past enjoyed a well-merited popularity." Advertising declared it was "admitted to be the best tennis shoe ever produced" with "300,000 pairs sold without complaint." It is impossible to find detailed sales or production data, so any figures must be treated with caution, but they suggest the Tenacious was among the best-selling shoes of the era. Like the Renshaw, it was successful because it catered to the desire for sports footwear that looked good and was physically functional, and because its marketing tapped into potential buyers' social fears and concerns.[26]

<p align="center">❊ ❊ ❊</p>

Tennis shoes' rubber soles, lightweight uppers, and aesthetic details were all determined by their function within lawn tennis, but this did not tie them to the tennis court. Things travel in ways that practices do not. Goods can be appropriated and reconsidered, incorporated into new practices and used in ways not envisaged by their producers. Mr. P. Hayman of Kilburn, for example, told *Pastime* that after two months wearing his Tenacious for tennis and walking, the soles "stood at least as well as the leather soles usually worn." Hugh Browne from Nottingham wore his for "tennis, bicycling, tricycling, and walking . . . without a flaw," and found they "proved themselves far better than the ordinary tennis shoes, whose . . . soles are fastened(?) [*sic*] with cement."[27] Rising involvement in sport of all kinds created a need for suitable footwear, and lawn tennis shoes, with their flat soles and lightweight, functional design, proved highly adaptable. Their ready availability meant they were adopted for a wide variety of popular activities: reports appeared of them being worn for boxing, fencing, cycling, golf, cross-country running, pedestrianism, and big game hunting.[28] The creation of basketball in 1891 provided another use, and as the game's popularity increased manufacturers began to sell specialist footwear derived from that designed for tennis; in 1907 the American sporting goods merchant A. G. Spalding advertised rubber-soled canvas basketball shoes almost indistinguishable from high-cut tennis shoes sold in the 1880s and 1890s.[29] Tennis shoes also encouraged and enabled the development of sporting practice. Ballplayers could move with confidence on wooden courts; cross-country athletes could run greater distances on hard ground; climbers were able to tackle more challenging terrain. Reports of an 1878 ascent of the Pieter Both mountain in Mauritius described how those involved changed into tennis shoes just before the summit, "as it would have been impossible to scale the rocks in leather boots." Rubber soles, they found, gave "a much better hold."[30] The

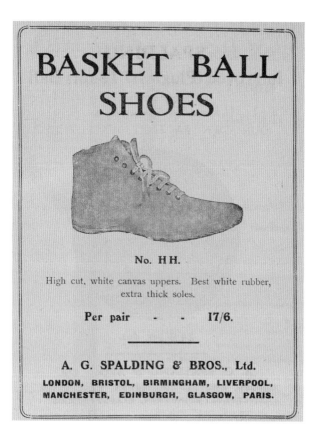

1.19 Basket ball shoes,
A. G. Spalding
advertisement, 1907.

advent of flexible shoes with soft, grippy rubber soles allowed participants in a variety of sports to increase the scope of what was possible.

By integrating lawn tennis shoes into a range of sports, consumers caused ideas about the product to shift. Manufacturers, perhaps concerned about the faddishness of late-Victorian sports, soon began to promote lawn tennis shoes as multi-purpose footwear. Golding, Bexfield and Co. in 1883 described their pyramid pattern rubber soles as suitable for "lawn-tennis, cricket, and all outdoor games" and by 1889 Hickson advertised tennis shoes it claimed were unequaled "for mountain climbing, yachting, and boating." Lawn tennis shoes moved from being associated with a single game to be linked to sports and physical activity more generally. At the same time, manufacturers developed new, hybrid products that combined the tennis shoe's rubber sole with other types of footwear. In 1888 *The Fishing Gazette and Railway Supplies Journal* reported the creation by a Leeds bootmaker of heavy leather boots with sports-style rubber soles. They predicted that rubber's waterproof qualities would make them suitable for anglers, but noted that because the rubber soles gave "noiseless" footsteps, they were being worn by police in Yorkshire and tested by Scotland Yard. They welcomed this, in the hope that "the night policeman" would no longer "advertise his coming and going for the benefit of the wily burglar shod in gum shoes." In this way, producers encouraged and reproduced consumers' creative re-imaginings of how and where sports shoes could be worn.[31]

The Sports Shoe

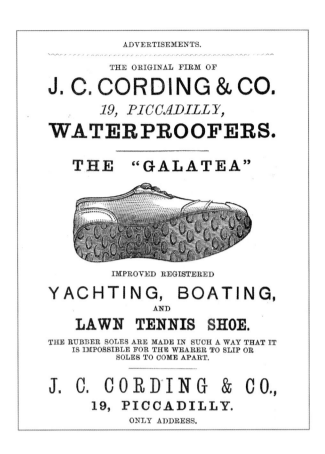

1.20 Galatea yachting, boating, and lawn tennis shoe, J. C. Cording & Co. advertisement, 1880.

Manufacturers may have focused primarily on potential sporting uses for their products, but lawn tennis shoes quickly moved beyond the sports field entirely. For middle class young men, they were part of a style that emphasized informality and relaxation over the sobriety and stiffness of the mid-Victorian era. By wearing the lighter materials, more relaxed fit, and brighter colors associated with sports outside the narrow bounds of prescribed use, middle class men engaged in an act of aesthetic rebellion. Lawn tennis shoes were a lighter—in color, weight, and cut— and more comfortable alternative to the dark leather boots worn at other times or by older men. They were a stylistic challenge to older notions of acceptability and an assertion of new concepts of youthful, informal masculinity. *The Daily News* in 1884 reported that young men at Brighton, keen to impress "young ladies in sailor hats," were, "like other young men by the seaside, much given to flannels, to boating and lawn-tennis shoes." For journalists, tennis shoes became a kind of shorthand for wealthy, carefree, middle class youth. During the London dock strike of 1889, for instance, *Lloyd's Weekly Newspaper* noted that replacements for the striking dockers included "several young fellows in striped boating jackets, flannel trowsers [*sic*], and lawn tennis shoes, who appeared to think that the fun of the thing was wearing off." The symbolic value these shoes had within lawn tennis carried over into everyday life.[32]

Perhaps the most unfortunate devotee of this new style was a young man called George Tinley Naylor. Out walking the cliffs near Cromer, Norfolk while on holiday in summer 1896, the eighteen-year-old was struck on the leg with a scythe by a man mowing barley. Bleeding badly, he was rushed to the house in which he was staying, and later to his grandfather's flat in Kensington, west London, where, despite the attention of several doctors, he died of blood poisoning. At the inquest into his death, the jury decided the mower could not be blamed; Naylor was "was wearing tennis shoes" and because of this, the mower "could not hear his approach [and] did not make sufficient allowance for the sweep of the scythe." As the *Daily News* complained a few years earlier, "the noiseless way in which the wearers of [tennis shoes], with their India-rubber soles, come unawares upon harmless folk strolling along a country road is only less startling than the bicycle rider with his terribly sharp and sudden bell." Naylor's choice of footwear was not unusual. He was the son of a traveling merchant and nephew of a bank director, holidaying at a fashionable seaside resort. He was an ordinary middle class young man, dressed in the casual fashion of the day.[33]

Sports-inspired styles may initially have been associated with youthful recreation, but they became more widespread and gained respectability during a series of hot summers in the 1890s. While London sweltered in 1893, the correspondent of the *Cardiff Western Mail* noted the "great change" that had occurred in attitudes to masculine dress. "This is the kind of weather," he wrote, "when we do not shy at tennis-shoes and whites in Piccadilly and Bond-street." This was quite a revolution: "[f]our or five years ago a man about town would, even at this time of year, and with the thermometer well into three figures, as soon have thought of resorting to this form of attire as of marching into the stalls of a London theatre in a shooting coat and gaiters." The spread of informality was illustrated two years later, when the London correspondent of the Dublin *Freeman's Journal* was surprised to see Arthur Balfour, by then First Lord of the Treasury, taking a Saturday stroll along Piccadilly "in a light blue serge suit, a flannel shirt, a soft felt hat and tennis shoes." Balfour, like many of his generation, refused to abandon the comfortable, elegant clothing he had worn as a tennis-mad youth. Shifting standards were highlighted again in June 1900, when *The Leeds Mercury* watched Sir Robert Peel sell his more famous grandfather's library while "[a]ttired in an easy-fitting lounge suit, with a light grey felt hat and white tennis shoes." Balfour and Peel were not social revolutionaries; their clothing showed the rise and growing acceptability of a much more casual masculine style.[34]

* * *

The Sports Shoe

PASTIME

THE LAWN-TENNIS JOURNAL,
AND WEEKLY RECORD OF
OTBALL, AQUATICS, CYCLING, & ATHLETIC SPORTS.
EDITED BY N. L. JACKSON.

258. Vol. X. [Registered for Transmission Abroad.] WEDNESDAY, MAY 2, 1888. Price 2d.

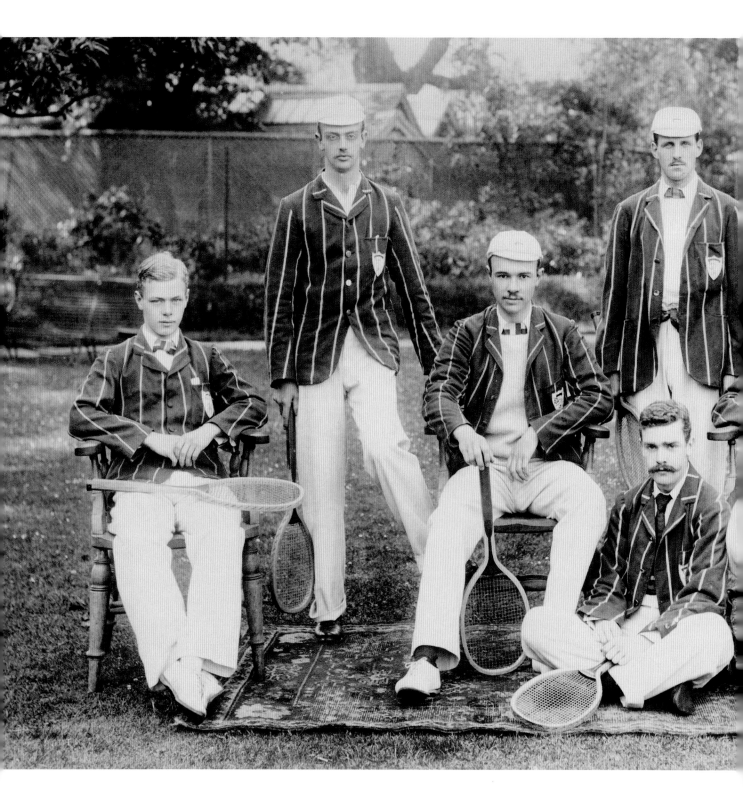

1.22 Emmanuel College
Cambridge tennis team,
c. 1896.

By the beginning of the twentieth century, for many people lawn tennis shoes were already everyday casualwear. Their creation reflected broader structural changes in the nature of Victorian society, including the availability of new raw commodities, the rise of a culture of consumption, the growing wealth of the middle class, and the increasing popularity of organized sports. Their form was determined by the physical practicalities of lawn tennis and the social significance of the game in middle class life, particularly among the young. What happened to them as they became readily and widely available illustrates the fluidity of products. Tennis shoes were created for specific practical and social needs yet were used for other games and formed the basis of footwear designed for other sports. Perhaps more significantly, rubber-soled tennis shoes were absorbed into a process of wider cultural change, as young middle class men redefined the parameters of acceptable dress and introduced a practical, relaxed, sporty style to everyday clothing. Here, sports shoes became part of a movement that demonstrated generational differences and which asserted more youthful, modern attitudes to life. As they entered the new century, many of the qualities that would become associated with sports shoes were already established.

2

Sports style, youth, and modernity

In a guide for aspiring shoemakers published in London in 1913, William Dooley noted the importance of tennis shoes to the footwear trade. The variety available in the 1880s and 1890s had continued to increase as ever more manufacturers entered the market. "Many different styles are made," he wrote, "and each year shows some improvements in the shapes, in the textiles which are used, in the colours and combinations of soles and uppers." He took care, however, to warn readers not to be confused by terminology. The name "tennis shoes," he noted, had become "a generic term . . . applied to all kinds of footwear having cloth tops and rubber soles." These had originally been worn for lawn tennis, "but have come into very general use as warm weather and vacation shoes, and every year shows an increased popularity."[1]

By the start of the twentieth century, tennis and other sports shoes were, as Dooley recognized, firmly established within the casual wardrobe. In the decades that followed sports and sports-inspired footwear became an increasingly common presence in everyday settings. Sports shoes remained an important component of middle class youth fashion, especially in the United States where they became a potent symbol of an emerging teenage market, while mass participation in sports and physical recreation ensured a ready market for all types of sportswear. Yet during this period significant changes occurred in the nature of production. In the tennis market, shoemakers like Randall, Manfield, and Hickson were gradually displaced by large rubber firms, which came to dominate the manufacture of tennis and other rubber-soled sports shoes. Looking to increase consumption of the raw material, they took innovation from the sports market into mass fashion. At the same time, the connection to the rubber industry meant sports shoes took on an aura of science, through the promise of performance and their link to new materials and methods of mass production. By linking shoes implicitly to ideas about progress and scientific modernism, manufacturers harnessed popular enthusiasm for technology to stimulate sales. Rubber-soled shoes were targeted at a broad customer base and as a result the distinctions between fashion and sports, specific and general, grew ever more blurred, continuing a trend that began in the 1870s with the first lawn tennis shoes.

* * *

During the nineteenth century, it became, as one Victorian author suggested, "pretty well established that indiarubber soles are a *sine quâ non*" for tennis. To understand the sports shoes of the early twentieth century, it is therefore necessary to understand the rubber industry. Rubber comes from latex, a milky secretion produced when the

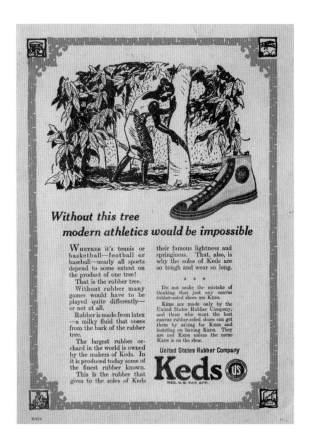

bark of certain tropical plants is cut that can be dried to form a waterproof, elastic material. In its raw state, however, rubber is unstable, likely to become brittle when cold and soft when hot. It is only by adding sulfur and heat—the process known as vulcanization—that a more stable compound can be created. This discovery in the 1840s caused an explosion in demand; as the first modern plastic, rubber was put to countless industrial and domestic uses. Yet the most bountiful source of latex—the *Hevea brasiliensis* tree—was found only in a small area of the Brazilian rainforest. An army of poorly treated rubber hunter-gatherers collected latex from the wild and global supplies were controlled almost entirely by Brazilian merchants. Exports from Brazil grew from around 2,500 tons in 1851 to nearly 20,000 tons in 1881, but the circumstances of collection meant quality was inconsistent and supply unpredictable.[2]

In Britain, the vital role played by rubber in industry made the government increasingly eager to secure a reliable, consistent supply. To this end, in 1876, Clements Markham, an official in the India Office, arranged for several thousand seed pods to be gathered in Brazil and taken to Britain. They were sent first to Kew Gardens, where they were germinated, and then onto Ceylon and Singapore—British colonies—where they were cultivated by British growers. Markham's plan was a success. The exported plants formed the basis of rubber plantations in Ceylon and later in Borneo and Malaya. Rubber cultivation grew steadily in Asia through the

1880s and 1890s, and in 1899 the first commercial exports left Ceylon. Plantation rubber quickly gained favor with manufacturers and virtually destroyed the Brazilian trade. Because growers controlled every aspect of growth and collection, they produced a material noted for its cleanliness, uniformity, and low cost.[3] The area under cultivation in Ceylon increased from 1,000 acres in 1900 to 258,000 in 1910 and 433,000 in 1920. Plantations in Malaya grew from 6,000 acres in 1900 to 54,000 in 1910 and 2,180,000 in 1920. To circumvent British control the United States Rubber Company established a plantation in Sumatra in 1911; Goodyear followed a few years later. By 1913 plantation exports equaled those of wild rubber, and by 1920 it was the dominant global source.[4] In 1933, 98.6% of the total world rubber output came from plantations, of which 62% were in British colonies.[5]

The rise of plantation rubber was spurred by the maturation of the automobile industry, which created demand for tires and other components. This in turn stimulated the growth of rubber companies like B. F. Goodrich, Firestone, Goodyear, and Dunlop, which channeled money into research and development. William Geer, the scientist who led B. F. Goodrich's efforts, in 1922 described how "the chemist, the physicist, and the engineer have brought real knowledge into rubber making," and how "each of the larger rubber companies have organized laboratories, in which highly trained chemists study new materials, and . . . learn how each material performs in a rubber mixture." With the application of science and technology the industry became more sophisticated and the range of rubber compounds available increased. Yet despite the rise of the automobile, the supply of plantation rubber exceeded demand. Manufacturers diversified production and sought new uses for the material, looking to replace traditional materials and apply rubber in a wider range of situations.[6]

The impact of the plantation system on sports shoes became evident in the early 1920s. British plantation managers had taken tennis with them to Asia and, far from department and sporting goods stores, used raw rubber as an improvised soling material when their shoes became worn. Unvulcanized rubber had previously been thought unsuitable for footwear due to its instability, but the introduction of new processing treatments made for a superior raw product that could be used in more varied ways. According to a report in *The New York Times*, to their surprise, the tennis-playing plantation managers found "they got much better wear . . . than they did from [soles] which had been put through the vulcanizing process." This discovery was seized upon as an inexpensive means to reduce the rubber surplus, which, with

2.2 Crepe rubber soles, Rubber Growers' Association advertisement, 1923.

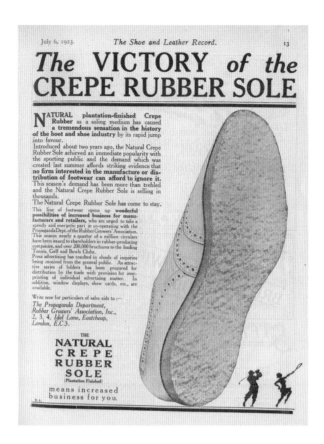

the automobile industry in its infancy and Europe suffering the after-effects of war, was a pressing concern. In a review of the challenges facing growers, the British trade journal *The Rubber Age* predicted that unvulcanized rubber (known as crepe) soles could be used "for all kinds of sports" and that they might "provide for a big consumption of rubber" without "the intervention of the costly processes . . . considered necessary in ordinary rubber manufacture." To many within the industry, sports offered a means to support the rubber market.[7]

Crepe soles for tennis, golf, yachting, and indoor sports were launched in Britain in summer 1920. A campaign organized by the Propaganda Department of the Rubber Growers' Association sought to build awareness and increase consumption. The Association produced an instructional pamphlet for shoe repairers, and a range of colorful promotional cards and posters for display by retailers. These showed groups of smiling, relaxed young people dressed in the latest sports fashions playing tennis, bowls, golf, and cricket against the slogan "Plantation Finished CREPE RUBBER SOLES." The same images were shown alongside crepe-soled tennis shoes on the Association's stands at trade exhibitions, like the annual London Shoe and Leather Fair, the British Empire Exhibition, and the Schoolboy's Own Exhibition. Advertisements appeared in the press and hundreds of thousands of brochures were distributed to leading tennis, golf, and bowls clubs.[8]

Perhaps because of the Rubber Growers' Association's aggressive campaign, crepe was an instant success. In August 1922, *The Rubber Age* reported that "large stores have taken up the sole with enthusiasm, and several firms state that they are inundated with orders." The journal found "ample evidence that the popularity of the crepe rubber sole is increasing daily" and declared it "a most promising medium for increased consumption of rubber." The Australian Davis Cup tennis team endorsed crepe, saying it was "unequalled for firmness of grip on any court and under any conditions" and that its "wonderful lightness and resiliency are great assets to fast play, while its toughness should secure great durability." The following summer, a large advertisement by the Rubber Growers' Association in the British trade journal *The Shoe and Leather Record* said crepe had "achieved an immediate popularity with the sporting public" and had "caused a tremendous sensation in the history of the boot and shoe industry with its rapid jump into favour." Crepe-soled sports footwear, the Association claimed, offered "wonderful possibilities of increased business for manufacturers and retailers." Demand was such that "no firm interested in the manufacture or distribution of footwear can afford to ignore it." Marketing played a part, but the product's instant popularity could also be pinned on how well it met the needs of sports men and women. According to the Association, "[t]he peculiarly tenacious grip, the responsiveness to foot movement, the lightness and resilient flexibility of crepe rubber appealed to them as no other soling material had ever done before." The changing nature of Victorian sports like tennis, which had developed from a gentle party pastime into a serious athletic contest, ensured a demand for more resilient shoes that was answered well by crepe.[9]

The market was soon flooded with crepe-soled sports shoes and shoes with processed rubber soles that aimed to replicate or improve on the raw material. John Carter and Sons, an east London shoe wholesaler, in 1930 offered forty-four models with crepe or imitation-crepe soles, including shoes produced by North British Rubber, Hood Rubber, Dominion Rubber, Tretorn, the Greengate and Irwell Rubber Company, and the Miner Rubber Company. Dominion made a "Wimbledon" model that was said to be "the most popular shoe on the market." Advertising claimed the "springy toughness" of its "special vulcanized crepe rubber" sole would help achieve fast footwork on grass and hard courts, cushion the feet and relieve fatigue, not split or chip, and remain unaffected by the weather. In the United States, Sears, Roebuck asked its catalogue readers: "Ever wear Sport Shoes with vulcanized crepe rubber soles? If you have, you know what they are, what they'll do. If you haven't, you've

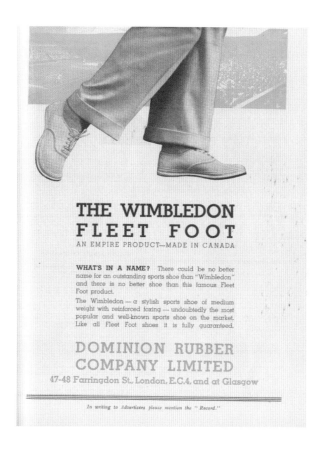

surely missed a lot of comfort and confidence of good footing." Five of the firm's canvas sports shoes came with either vulcanized crepe or imitation-crepe soles. In the early 1930s, the American edition of *The Rubber Age* reported the launch of crepe-soled sports shoes by Cambridge Rubber, the Cuban American Shoe Company, and Hood Rubber.[10]

At first, crepe soles were targeted specifically at sports, but, like Victorian lawn tennis shoes, were soon found suitable for wider use. The Rubber Growers' Association was particularly keen to introduce them to the general wearer. At the London Shoe and Leather Fair in October 1924 reporters from *The Rubber Age* found suggested uses for crepe had been "considerably extended." Alongside sports shoes, the Association also displayed "heavy Derbys suitable for postmen, police-men and outdoor workers, boys' school-boots, and all types of ladies' footwear." British shoe manufacturers combined "to form an interesting range of samples in footwear of various types where the crepe sole can be employed." At the 1930 fair, the Association promoted "crepe soled footwear for all occasions." The organization's Propaganda Department presented this as a shift instigated by consumers, rather than the result of a marketing campaign. Pamphlets observed that crepe soles had "achieved rapid popularity in the sporting world" and were "extending to everyday footwear," as though the Association itself was uninvolved in the process. The "ever growing popularity of

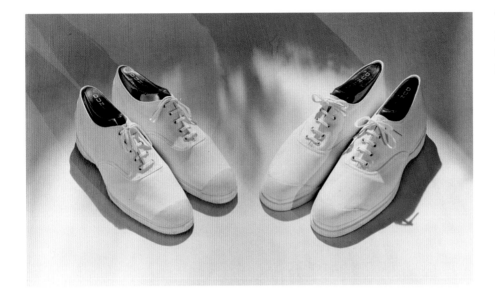

crepe rubber for all kinds of outdoor footwear" was based, the Association claimed, on "public recognition of its great superiority over the other types of soles," and came from its "durability," "elasticity," "[l]ightness," "[n]oiselessness," and "[a]bsolute waterproofness." This may have been true, but the popularity of crepe soles was also testament to the Association's desire to increase overall consumption of rubber and ensure the economic survival of the growers it represented.[11]

<p style="text-align:center">❊ ❊ ❊</p>

While rubber growers sought new outlets for their product, large processing and manufacturing firms similarly began to explore new possibilities. *The Rubber Age* noted in 1922 that American tire manufacturers were drawn to "[t]he earning capacity of the shoe business." Around this time, several large rubber companies moved into the sports footwear market. One of the newcomers was Dunlop, developers of the pneumatic tire in the 1890s, which had grown to become Britain's largest tire and rubber goods manufacturer. During the 1920s Dunlop sought to move into new markets. To diversify its product line, it acquired several smaller businesses, including the Liverpool Rubber Company, a firm that had produced rubber-soled sports footwear since the mid-nineteenth century. The first Dunlop-branded sports shoes were launched in October 1930; a special supplement to the footwear weekly

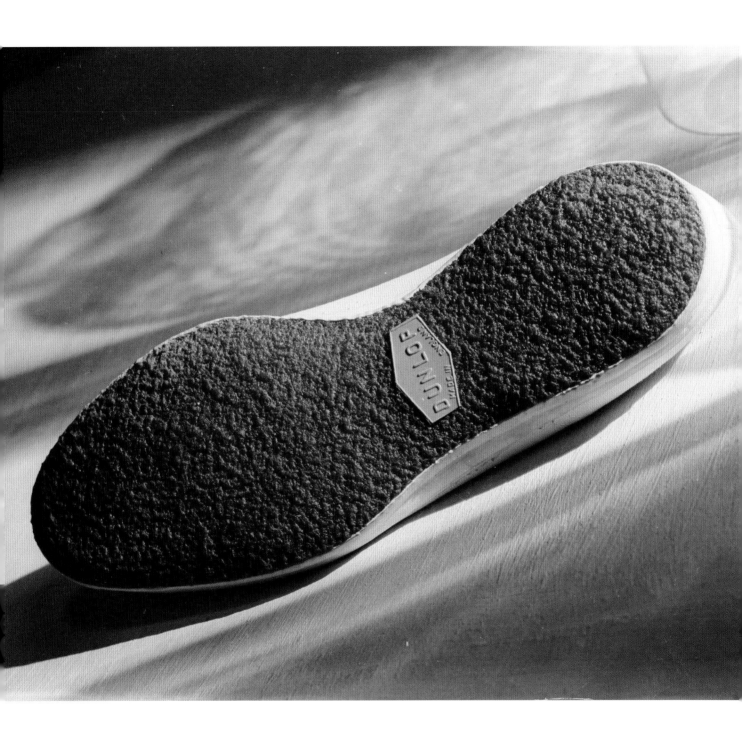

Sports style, youth, and modernity

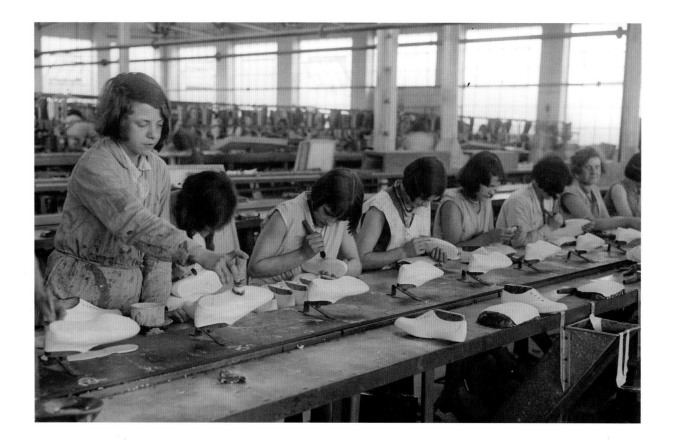

2.6 Dunlop sports shoe production, Liverpool, 1930.

The Shoe and Leather Record marked the occasion. Men's and women's models were offered, both made of light cotton canvas with soles of traditional crepe or a "white crepe" alternative, said to be "wonderfully durable, and ideal for hard court tennis." Dunlop drew the attention of potential retailers to details such as the "uppers . . . made of a special flexible cotton fabric, evolved by the textile technologists of the Dunlop Cotton Mills, the largest self-contained cotton mills in the world," and the "SOLE LOCKING STRIP (Non-discolourable)" that "locks the sole and heel to the uppers, strengthens the whole shoe and makes it smarter." The shoes were "constructed to allow correct heel pitch and toe spring" to "provide adequate foot support to give comfort throughout the hardest games . . . without in any way detracting from the perfect shape and appearance of the shoe." Marketing material established a connection between the Dunlop's wider reputation, what the firm called its "unrivalled knowledge . . . [i]n rubber, cotton, and manufacturing processes," and shoe production. The Dunlop name, the firm declared, was "a hall mark of quality and value," "the firmest guarantee of satisfaction," that was "only applied to products of proved excellence."[12]

Dunlop's new models were typical of the type of sports shoe produced by rubber manufacturers. Gutta Percha and Rubber's Garagard and Demon models, Dominion Rubber's Fleet Foot Wimbledon, and Miner Rubber's Pal were all similar. By the

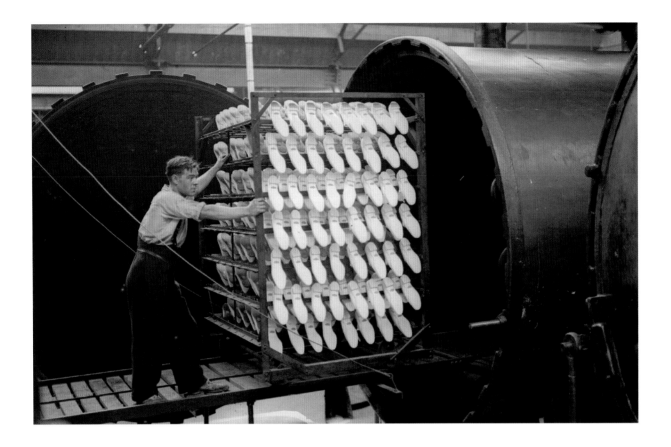

2.7 Dunlop sports shoe production, the vulcanizing cylinder, Liverpool, 1930.

1920s, the complicated, ornate leather and buckskin models popular in the late nineteenth century had been largely forgotten, replaced by sleeker, simpler canvas shoes that echoed the functionality of modernist architecture. Tennis shoes tended to be white, sometimes offset with colored trim. Basketball shoes were black or tan until the Converse Rubber Company introduced an all white shoe for the American team at the 1936 Olympics. This shift was driven by changes in technology. During the nineteenth century, rubber was vulcanized over several hours in dry, hot air ovens. Soles were cut from sheets of rubber and attached to leather or canvas uppers using standard soling methods. The introduction of new machinery meant the vulcanization process itself could be used to bond soles and uppers. In 1920, *The Rubber Age* reported on the introduction of a shoe by Hood Rubber, a subsidiary of B. F. Goodrich, the American tire manufacturer, that was "cured by live steam and pressure in exactly the same way as a motor tyre." This resulted in a shoe with "great wear-resisting properties, and resilience" that would "wear like iron." Just as significantly, it removed a stage in the shoemaking process: soles no longer needed to be stitched into place, or attached using complicated welts as they were in the 1880s by H. E. Randall and William Hickson and Sons. This lowered production costs and meant shoes could be produced in greater volumes; output was limited largely by the pace at which machinists could stitch together the uppers. This, in turn, explains the

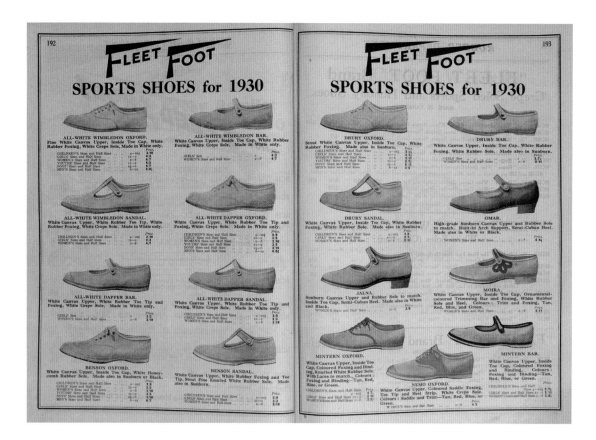

192

move away from leather toward simpler styles. As a uniform, lighter material, canvas could be worked more quickly and easily by less skilled workers than leather. The basic styles of tennis and basketball shoes leant themselves to production on a large scale.[13]

During the early decades of the twentieth century, shoe manufacturers refined the processes of mechanized mass production introduced in the 1870s. The various tasks involved in shoemaking continued to be highly segmented: it was said in 1922 that in American factories "the separate operations have been so divided up that the finished article is the product of five or six different hands, each one of whom has performed a special operation upon it." The moving assembly line and principles of time management were adopted at many firms. In 1936, the American edition of *The Rubber Age* reported the installation of a production conveyor by "a leading shoe company" that the journal thought would "speed up manufacturing schedules and . . . create economies not possible heretofore." The highly mechanized nature of the work led the Red Cross after the First World War to advise that making tennis shoes was particularly suited to men with disabilities that disqualified them from heavier labor. These developments were all in effect at Dunlop, which in 1930 released a promotional film that recorded production of sports shoes at its factory in Walton, near Liverpool, England. The film showed men working the various machines used

2.8 (Above) Dominion Rubber Fleet Foot sports shoes, 1930.

2.9 (Opposite) Tennis shoes, Gutta Percha & Rubber advertisement, 1934.

G.P. shoes for SPRING

Gutta Percha & Rubber (London) Ltd.,
30, 31 & 32, Bolsover Street,
Great Portland Street,
London, W.1.

GARAGARD.
Worn by the leading professional and amateur tennis players. Unconditionally guaranteed for six months.

DOREEN.
Three-eyelet tie-bar Tennis Shoe; natural crepe or white compound sole.

DEMON.
A high-class Sports Shoe at a medium price. Designed to meet the demands of every class of player.

to process rubber and prepare soles, and ranks of bob-haired young women sitting at sewing machines stitching together various canvas parts. Other women were shown working at a moving conveyor pulling completed uppers over wooden lasts, sticking rubber soles in place, and nervously checking and moving completed shoes to large portable racks. The work appears relentless, the pace rapid. Racks of finished shoes were finally moved by male workers to a "great vulcanizing cylinder" that cured the rubber of four thousand pairs at once.[14]

The scale of production at Dunlop's Walton factory was illustrative of the sports shoe industry as a whole. Reliable data are hard to find, but production was greater than in the nineteenth century. William Geer claimed that in 1919, 19,896,000 pairs of tennis shoes were produced in the United States. The press suggested that the average factory produced 20,000 pairs per day in the early 1920s, and that shipments of rubber boots and shoes were worth $91,086,200 in 1921. The Rubber Growers' Association estimated in 1926 that 26,114,075 pairs of canvas shoes with rubber soles were produced in the United States and that around twenty million pairs were exported by manufacturers around the world. By the end of the 1920s estimates suggested worldwide exports had risen to more than 36,500,000 pairs. Dunlop's marketing suggested that between 1923 and 1930, over 40,000,000 pairs of rubber shoes were imported into Britain, many of them from Canada. David Baptie, an executive at North British Rubber, wrote in 1928 of the "great expansion in the production of the rubber-soled tennis shoe." The varieties available were "too numerous to mention," and "[t]he shapes, fittings and styles . . . increased to such an extent" that manufacturers, he thought, faced the same problems of keeping up with changing fashions as those in the women's shoe trade. By the end of the 1920s, rubber manufacturers sold countless sports models tailored to different niche markets.[15]

* * *

The sports shoe market was driven in the 1920s and 1930s by the growing significance of sport in society. In the years after the First World War, Victorian games spread from the British empire and the United States around the world. Organized sporting competition became a popular form of mass entertainment. International events became established fixtures: tennis tournaments at Wimbledon (established 1877), New York (established 1881), Paris (established 1891), and Melbourne (established 1905) gained international attention; the modern Olympic movement (established 1894) became increasingly formalized and ceremonially spectacular after the

1920 Antwerp Games; the soccer World Cup was initiated in 1930; and cycling's three annual grand tours, the Tour de France (established 1903), the Giro d'Italia (established 1909), and the Vuelta a España (established 1935) attracted massive public interest. Domestic sports were similarly important. Professional and college baseball, football, hockey, and basketball games drew huge crowds in the United States; in Britain large numbers attended soccer, cricket, and tennis matches. It was an era of sporting heroes, as new mass media like the radio and newsreel brought events to more people and added an immediacy absent from earlier newspaper coverage.

At the same time, mass participation in sport increased. Tennis and golf became popular leisure pursuits enjoyed by large middle class audiences. In Britain, the construction of three million private suburban homes between the wars expanded tennis's constituency; by the end of the 1930s three thousand clubs were affiliated to the Lawn Tennis Federation and tennis was an integral part of middle class suburban social life.[16] Basketball's popularity grew in the United States and soccer became internationally popular. Systems of mandatory mass education in the United States and Europe, the growth of higher education, particularly in the United States, and organized youth movements in Europe and America engaged many young people in sports and physical recreation. War undoubtedly cast a shadow over these developments. International competition gave expression to feelings of nationalism while sports and fitness programs maintained physically fit populations that could be enlisted in the event of war. Yet the popularity of sport also reflected the rise of modern bureaucracies and the changing nature of, most especially, middle class work. In Britain, the years between the wars have been described as a golden age of sports provision, as large businesses instituted sports programs for their workers.[17] In 1927, *The New York Times* claimed that a "growing army of indoor sportsmen" had stimulated demand for gymnasiums and other facilities in New York, and that "thousands" more exercised in the privacy of their homes and bedrooms. Indoor golf, tennis, hockey, basketball, bowling, squash, fencing, and archery were said to be popular and over a million boys and men were reported to use YMCA gymnasiums and other facilities. Like the clerks who enjoyed sports in the 1880s and 1890s, it was "[t]he ordinary business man" and "ambitious persons, generally of the white collar class" who participated in sports and exercise.[18]

The rise of sport translated into a need for suitable footwear. Mass participation created a need for a product that could be differentiated according to potential buyers' income, seriousness about competition, and the games they played. Manufacturers

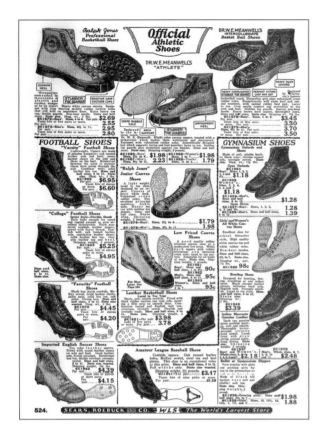

continued to offer a wide range of broadly similar, minutely different shoes. Yet the ready availability of sports clothing necessary for wide involvement meant sports shoes were turned to more prosaic uses away from the sports field, and that sports clothing increasingly influenced mainstream fashions. *The New York Times* in 1923 reported on the popularity of what it called the "sporty" look in the city. With his tongue firmly in his cheek, the paper's reporter described Broadway as "the sports centre of the world," "if you take it from the clothes angle." Women, he noted, "began wearing sport hats and sports shoes with everything" around 1918, while men rejected the "light-soled leather heels of yore" for "golfing shoes with gum or rubber soles an inch thick on the flagged sidewalks." The trend, he suggested, went back to the rise of tennis fashions in the 1880s and showed few signs of waning: "[t]he only sports togs they don't wear on the street, behind counters and in offices are bathing and baseball suits, and their day will come if the present trend continues." The popularity of sports shoes and clothing could be explained in many ways. *The New York Times* reporter suggested it was because they "spell ease and freedom of movement and in name associate themselves with luxury and relaxation from the daily grind." They were a practical, comfortable choice that enabled desk-bound workers to feel "at least one of the prerequisites of the idle elect." This connection with wealth and leisure was affirmed by popular cinema and movie magazines; the

2.10 (Above left) Sports shoes, Sears, Roebuck catalogue, 1927.

2.11 (Above right) Scientifically Lasted Keds, United States Rubber advertisement, 1934.

2.12 (Opposite) "Sneaker Smell", Hood Rubber advertisement, 1934.

Here's The Famous Hygeen Insole

that's *stopped* all this

"How I hate that Sneaker Smell!"

FOR years mothers all over the United States were troubled about the disagreeable perspiration odor which clings to ordinary sneakers. *Then came the Hygeen Insole* and put a stop to all this! For, as enthusiastic reports from thousands of parents prove, this amazing new insole prevents offensive "sneaker smell" from developing!

How does Hygeen Insole "work"? Instead of soaking up perspiration, it permits it to *evaporate quickly*, leaving Hood Canvas Shoes free from offensive odor!

Then there are Hood Shoes—made by the patented Xtrulock process—that are *molded* in one smooth unit. No stitches to break—no seams to chafe feet or wear holes in socks. The scientifically *ventilated** uppers provide tiny air spaces which let cool air shoot right through the canvas. Besides, Hood Shoes are *washable*. No artificial stiffening to wash out and leave the canvas limp! *Patent Pending.

Xtrulock Shoes give extra wear without extra weight.

This summer be sure your children enjoy these extra comfortable Hood Canvas Shoes. Look inside for the green insole with this mark.

HOOD CANVAS SHOES

Adv. Copyright
Hood Rubber Co., Inc., 1934.

HOOD RUBBER COMPANY, INC., WATERTOWN, MASS.

association between Californian sportswear and Hollywood glamor contributed to its growing popularity across the United States.[19]

For American students and young people sports shoes were part of a broader palette of casual clothing by which they differentiated themselves from non-students and the adult world. In his loosely autobiographical first novel, *This Side of Paradise*, F. Scott Fitzgerald described the "white-flanneled . . . white-shod, book-laden throng" that he—and the novel's main character—met at Princeton in 1913. In the novel, adopting this uniform of tennis shoes, flannels, and insouciance is a first step towards an idealized notion of eastern sophistication. Sports-inspired fashions remained popular among young people after the First World War. Data collected by *The New York Times* in 1923 indicated that canvas rubber-soled sports shoes were most frequently worn by people aged between six and twenty-two. Girls at the exclusive Smith College in Massachusetts were reported to favor "[t]he golf shoe or tennis shoe or anything in the way of footwear that has rounded toes and flat soles—and preferably rubber soles" and wore them until "cold Fall days really made them unbearable." Their peers at Bennington, in Vermont, and Vassar, the elite women's college in upstate New York, were shown by *Life* in 1937 to have adopted sports shoes as part of an informal uniform of comfortable, practical clothing originally designed for sports, hunting, or physical work. At Vassar "the classic campus dress" comprised "a tweed skirt,

2.13 (Above) Williams College students picnic in Vermont, *Life*, 1937.

2.14 (Opposite) Couple in tennis shoes, with man in saddle Oxfords, c. 1930.

The Sports Shoe

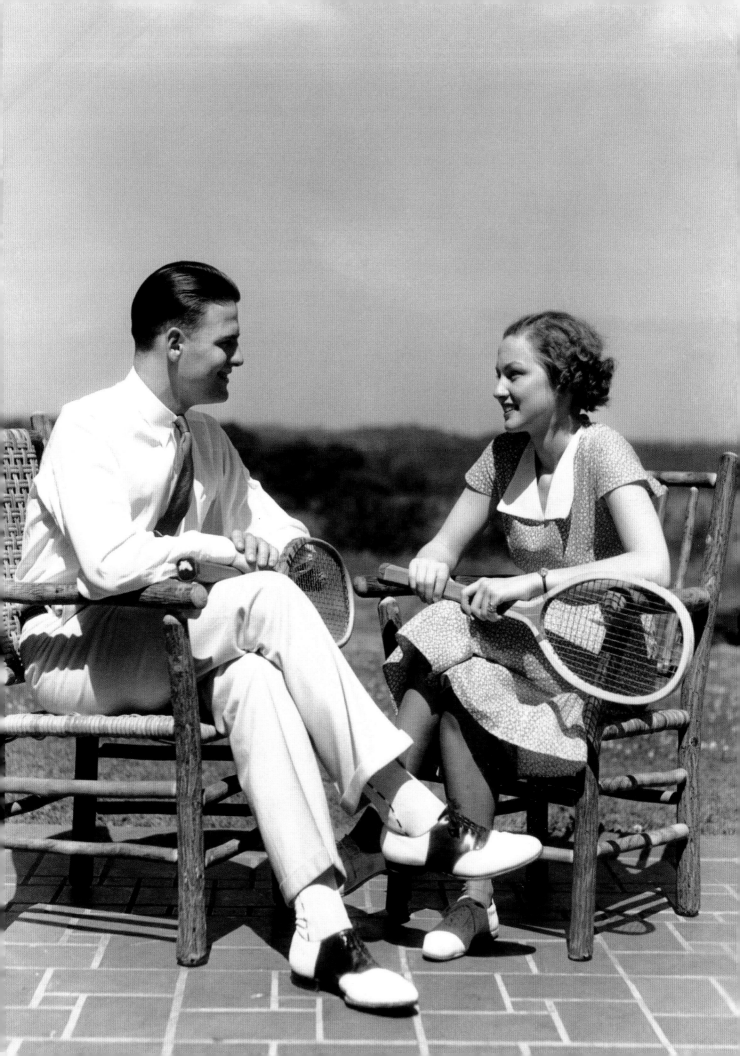

Brooks Brothers sweater, saddle strap or tennis shoes, and polo coat." When *Life* photographers visited American universities in 1937, they found male and female students wearing a mix of sweatshirts, jeans, button-down shirts, and tennis shoes; for men at eastern colleges, *Life* wrote, "dirty sports shoes are almost a uniform." Sportswear was lent significance by schools' celebration of athletic achievement, but it was also a functional alternative to traditional or formal clothing. The symbolic value should not be overstated; girls at Smith College preferred soft rubber-soled tennis shoes, *The New York Times* said, because they "walk a great deal during [the] college day." Variations on the same style were popular with young men and women across the United States, an indication of students' freedom from the sartorial expectations of the workplace and the importance of sports in campus life.[20]

2.15 Saddle shoes, *Life*, 1937.

Student fashions perhaps showed the enduring appeal of childhood habits. American rubber manufacturers started to pitch canvas sneakers as multi-purpose children's footwear in the 1920s, with lace-to-toe, high-top shoes inspired by basketball the most common design. *The New York Times* reported in 1927 that "rubber-sole canvas-top tennis shoes . . . with corrugated rubber soles, and . . . circular ankle patches in black" were "preponderantly in demand," and that they made up 90 percent of men's canvas footwear and 85 percent of women's. A large proportion of shoes of this type would have been bought for children as inexpensive schoolwear. Sears, Roebuck sold a Mickey Mouse canvas high top. Advertising targeted mothers. Hood Rubber claimed its shoes allowed the barefoot freedom necessary for proper foot development, while also "guard[ing] against cuts, heel bruises, and pavement shocks." During the 1930s the firm issued a series of advertisements that showed young mothers disgusted by "Offensive Sneaker Smell," an ailment it claimed could be avoided with its "Hood Hygeen Insole." United States Rubber promoted its "new scientifically lasted" Keds as ideal starter footwear for young feet, and as an inexpensive alternative to more formal dress shoes. The firm also built brand awareness among young consumers by placing advertisements that linked Keds to champion tennis, basketball, and baseball players in magazines like *American Boy*, and by publishing a series of sports handbooks aimed at energetic boys and girls. In this way simplified, cheaper versions of the shoes worn by basketball players became everyday footwear for millions of American schoolchildren.[21]

The shoe most closely identified with American youth, however, was the saddle oxford, or saddle shoe. These had lightweight uppers of white canvas or buckskin with a black or brown saddle around the instep. The sole was usually of rubber and was

LIFE

THE CLASS OF 1937

JUNE 7, 1937 **10** CENTS

attached with a welt. It is said they were introduced in 1906 by the American sporting goods company A. G. Spalding as tennis shoes, but they proved unpopular with tennis players and were designated golfing shoes, at which they achieved moderate success. During the 1920s they became fashionable among young Americans, and by the 1930s they were worn by teenagers across the country. *The New York Times* noted that Smith College girls wore them. *Life* photographs showed them worn at Bennington and Vassar. When Lord and Taylor, a New York fashion store, ran a competition in 1937 "to determine the most beautiful and sensible wardrobe that could be purchased for a maximum of $250" they received entries from over ten thousand schoolgirls. The winning entry, by a sixteen-year-old from Hackensack, New Jersey, included not one but two pairs of $5.95 saddle shoes. Their popularity crossed racial and gender lines. Several *Life* photo essays during the 1930s and 1940s revealed their enduring popularity among school and college students. When *Life* editors chose the cover of the 1937 special on universities they opted for Alfred Eisenstadt's tightly framed photograph of a young woman's saddle shoes. By the mid-1930s these shoes' association with sports was almost entirely lost. Instead, they were casual everyday wear, more commonly associated with the exuberance of American youth than with athleticism.[22]

* * *

For manufacturers, the wide popularity of sports shoes was a gift. Fashion-oriented buyers, however, did not necessarily have the same requirements as those who bought sports footwear for use on the sports field. In 1922, Chester C. Burnham wrote in the American trade journal *India Rubber World* that "[u]nexpectedly and out of a clear sky as it were, an unusual demand for rubber soles has come among us." This he attributed to "the greatly increased interest in all sports since the war," which had created "a very sizeable demand for suitable sporting footwear." Crucially, buyers could be divided into two classes: "(1) Those who used such footwear for sports. (2) Those who wore such footwear because it was modish and comfortable." Retailers, Burnham reported, "found that a very large percentage of sales on [*sic*] this class of footwear was to those who had no interest in sports but merely wore this type of shoe because it went well with the short skirts, sport clothing and bobbed hair styles of the day." They also found that among fashion buyers some styles were favored over others; "in seeking for a reason it was discovered that certain types of soles were decidedly uncomfortable when worn for office or every day wear." The knobs, pyramids, and suction cups molded into

sports soles were not well suited to everyday use. Burnham argued that if manufacturers were to benefit from the popularity of sports footwear, they needed to design "types of soles that will serve the purposes best and wisely" and "pay special attention to the requirements of the wearer," whether these were on the tennis court, golf course, dance floor, or in the office. He urged manufacturers to tailor products to specific markets, in effect recommending the production of shoes that looked like sports shoes but which were designed for everyday use. For "ordinary sport wear, the wearer having no intention to participate in sports" he suggested a sole that would "permit of dancing, bowling and hiking" would find the greatest favor.[23]

A multitude of sports and sports-inspired shoes were produced. At the lower end of the everyday market, particularly in Britain, was the simple canvas plimsoll. With rudimentary canvas uppers and thin rubber soles, it was one of the cheapest and easiest rubber-soled shoes to manufacture. It could be worn for sport but, according to the Rubber Growers' Association, was more widely worn as holiday or beach footwear and as everyday wear "in industrial areas where owing to its low cost it is more economical than ordinary footwear in hard times." In his memoir of unemployment during the 1930s, Max Cohen wrote of how he bought a pair of tennis shoes, but, because he was sensitive about his appearance, dyed the canvas uppers black so they "gave a good imitation (from a distance) of ordinary black leather." Several models were sold by John

Carter and Sons in London, including North British Rubber's Thistle, and Greengate and Irwell's Irwell and King. In the United States the generic high-top basketball shoe performed a similar role and became popular as informal or children's wear. Several manufacturers responded to the situation Burnham described with sports-inspired shoes targeted at the youth market. The 1927 catalogue of Tanners Shoe Manufacturing Company of Massachusetts included a model called the Plus Four that was described as "a rare combination of dress and sports shoe," "[e]qually at home on the golf links, the tennis court and the pavements of Fifth Avenue." It promised to "provide . . . the man who would stay young with the utmost in style and comfort." It combined fashionable features inspired by sports shoes, including pure crepe rubber soles—"[l]ike treading on air"—and a saddle strap instep, and was made of calf leather. The model may have looked to sports from an aesthetic or technological perspective, but like many others it was aimed squarely at fashionable young men.[24]

2.17 Jesse Owens meets sneaker-wearing fans, Chicago, 1936.

❊ ❊ ❊

Sports shoe manufacturers encouraged more informal styles, presumably as a means to increase sales. Marketing developed associations between youth, leisure, and sportswear and recast the rubber-soled canvas sports shoe as an item of fashionable summer wear that was suitable for all. Advertising reinforced the message that it was socially and

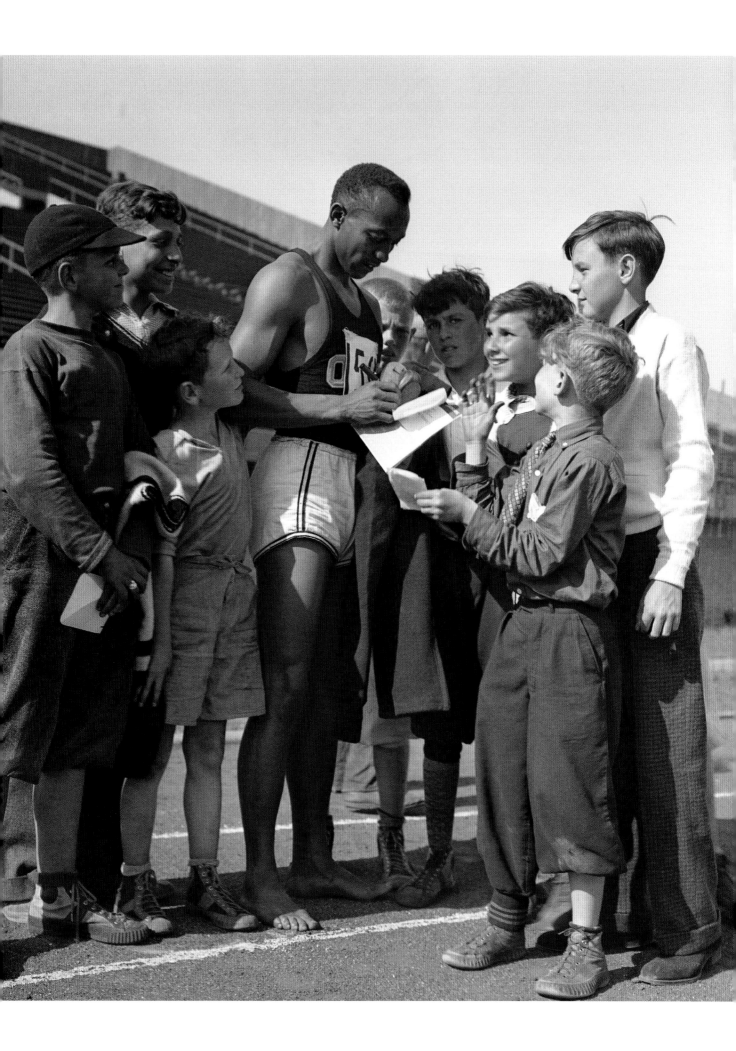

fashionably acceptable to wear rubber soles for general use and declared the supposed merits of rubber over traditional soling materials. In the United States, the United States Rubber Company worked to position its Keds brand as the *de facto* choice for Americans at play, not just the young, sporting, or fashion conscious. Advertisements were placed in popular mass market magazines, including America's biggest selling weekly, *The Saturday Evening Post*, that claimed rubber shoes were essential to the leisure or summer wardrobe, and that "[h]ot, heavy shoes for summer are a thing of the past."[25] With images of young men and women in casual, sports-inspired fashions, advertising sung the praises of canvas and rubber and hinted that older, heavier styles of footwear were unfashionable and out of step with modern ideas about American life:

Light, cool, comfortable—Keds have become universal summer shoes
In the smallest country towns and in the largest cities you find them, out-of-doors and in the house.
. . . Boys and girls, men and women, at work and at play, everywhere they are wearing Keds.[26]

This basic message was repeated with slight variation for several years. Potential buyers were told that "millions of pairs were worn by men, women and children," and that Keds were "the ideal footwear for warm weather," suitable for "outing, tennis and everyday use." Sports shoes were no longer "the custom of a lucky few," but "the summer habit of all America." United States Rubber linked them to changes in American society, including the popularity of sports and growing sales of automobiles, that had brought "new comfort to summer dress." Readers were assured that "In the last few years . . . ideas have changed about summer shoes," and that Americans were "learning to look fresh and cool and summery and be relaxed and comfortable." If the illustrations of relaxed young people were not sufficient, the breathless copy reinforced connections between rubber-soled canvas shoes and other items of fashionable sportswear. Men were told Keds were "a shoe of style and distinction—the very shoe you have needed to wear with your flannels or Palm Beach suit." Women's Keds were "Comfortable and Modish" and would "add to the daintiness of the prettiest white frocks." In 1939, a *Saturday Evening Post* advertisement drew a parallel between the life of the American family man and his choice of shoes: "fabric and rubber-soled shoes are in keeping with his mood," "his feet are as relaxed as his soul." In this way, sports-inspired styles were packaged as part of a relaxed, open, and vigorous approach to life, synonymous with a vision of confident, modern, twentieth-century America.[27]

Vulcanized rubber products were also linked to notions of industrial modernity and connected to technological advances that transformed ordinary lives. Rubber could be classed alongside electricity, radio, the automobile, the phonograph, cinema, and the aeroplane as symbols of the machine age. The physical properties of rubber—machine-molded, smooth, colored, flexible, waterproof—emphasized that it was manmade, a result of developments in science, agriculture, industry, and transportation. Rubber manufacturers used enthusiasm for innovation as a way to sell products. The names, descriptions, and imagery surrounding rubber-soled sports shoes rhetorically positioned them as modern wonders. Catalogues and advertising used language more commonly applied to machinery: "shock absorbing insoles," "'motor-tyre' sole," "the shoe with a spring in it." Hood Rubber's Speed Shoes used a logo with lightning marks and elongated lettering to give a graphic sensation of speed. In 1931, a double-page spread in *The Saturday Evening Post* for United States Rubber juxtaposed Keds shoes against an ocean liner and presented them as products of the same laboratory testing used for the Graf Zeppelin airship, associating the brand with two of the greatest symbols of the modern age. By the early 1940s the rhetoric of technology was well-established in sports shoe marketing, and companies launched a constant stream of "new" developments. Although the relationship between industrial science and the rubber footwear industry was real, from a sales perspective, the argot of popular science served as a means to invent and emphasize slight differences to distinguish essentially very similar products. Sports shoe advertising blurred the line between fact and fiction. The rhetoric of the modern wonder allowed manufacturers to negotiate the lack of popular understanding about the origins of rubber goods, and built on popular fervor for new technological products.[28]

* * *

Pseudo-scientific language situated sports shoes at the forefront of technological change and exploited popular enthusiasm for the emblematic creations of the machine age. This was not simply a sales technique. Rubber was a new, evolving product and the plantation-based rubber industry was one of the most technologically advanced in the world. Rubber-soled shoes were shaped by scientific, agricultural, processing, and manufacturing techniques and were directly related to other more obviously technological products, notably the automobile. Marketing material talked up the scientific credentials and innovative qualities of different shoes, but it reflected the increasingly scientific nature of the industry that produced them.

From the woods of Maine to the beaches of California

One of the children's Keds—made on a nature last. Similar models both with the strap and without it—for women and young girls.

This new summer habit has swept the country

No longer is vacation comfort confined to two short weeks out of the whole sizzling summer.

With five times as many country clubs as we had ten years ago—with twelve million automobiles—with two million golf and tennis players—with camps multiplying upon every mountain side—with the opening of great new parks and beaches—every day, every week, millions of Americans are living out-of-doors!

No wonder outdoor comfort has become the keynote of summer dress!

The amazing growth of Keds is the natural result of this great change in American life. Everywhere you'll see them—on city streets, in the home, at the seashore, in the mountains.

Light, cool, easy-fitting, Keds let the feet, cramped by months of stiff shoes, return to their natural form and breathe. The uppers are made

of fine white or colored canvas—the soles of tough, springy rubber from our own Sumatra plantations. Keds combine comfort and wear with attractive appearance. The details of their finish—the stitching and reinforcements—the careful workmanship throughout—put Keds in a class by themselves.

Why it will pay you to insist on Keds

Keds are the standard by which all canvas rubber-soled shoes are judged. Their quality is backed by the skill and experience of the largest rubber organization in the world.

Keds are made in many styles, both for sports and general all-summer wear. There are high shoes and low, pumps, oxfords, and sandals,

etc
Bo
and
bo
179

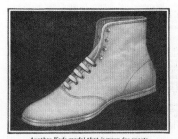

One of the most popular all-purpose Keds. Suitable for picnicking, boating, tennis and general outdoor wear.

A sturdy sport shoe. Athletic trim and lace-to-toe features. Smooth, corrugated or suction soles.

Another Keds model that is worn for sports as well as for general outing purposes. In tan as well as in white.

A Keds model that appeal everywhere. Appropriate with frocks. White or colored trim

They are not Keds unless the name Keds is on the shoe

Keds

Trademark Reg. U. S. Pat. Off.

2.18 United States Rubber
advertisement, 1923.

r men and women, girls and

of course, vary in price ac-
to type. But no matter what
Keds you buy, every pair gives
highest possible value at the

mber — while there are other
at may at first glance *look*
ds, no other shoe can give
Keds value. Keds are made
the United States Rubber
y. If the name Keds isn't on
s, they aren't real Keds.

le hints on camping, radio,
in the Keds Hand-book for
recipes, vacation suggestions,
formation in the Keds Hand-
er sent free. Address Dept. F-3,
ew York City.

tes Rubber Company

During this period, notions of what a sports shoe could be shifted and expanded. The growth of the rubber industry, the ongoing rise of sports, and the enduring popularity of sports-inspired fashions led to a proliferation of new designs. Victorian-styled shoes became everyday casual footwear. Mass production on a grand scale made rubber-soled canvas shoes accessible and affordable to very nearly everyone, and encouraged manufacturers—most especially in the United States—to promote them for as many uses as possible. In doing this, the language of scientific modernism was established as an enduring theme of sports shoe marketing. The importance attached to sports pushed manufacturers to incorporate the latest technical advances into sports shoes, but with the term "tennis shoes" applied to all kinds of rubber-soled footwear and fashion adopting styling cues taken from sports, it became increasingly important for manufacturers who were not able to cater to the mass market to distinguish authentic sports shoes from those intended for other purposes. The problems that would arise from attempting to cater to both the general market and the sports market were not clear in the 1930s, but would come to prominence with the rebirth of the sporting goods market after the Second World War.

3
Sports shoes reborn

In the decades after the Second World War, sports shoes underwent a radical change. The simple, multi-purpose canvas and rubber models of the first half of the century were replaced by an array of complex shoes made from a variety of synthetic materials. Greg Donaldson, a writer in *The New York Times*, described them in 1979 as "the mutants, sneakers in strange colors and bizarre shapes . . . [s]ilk and fiberglass spaceshoes with treads curling up over the toe and heel, rubber studs staring at the sky for no earthly purpose." Sneakers were, he suggested, "out of control."[1] Heavily branded and increasingly specialized, these new kinds of shoe were marketed as technologically advanced products for discerning sports buyers. Changes in shoes' material character were accompanied by shifts in the nature of production. The rubber companies that had come to dominate in the 1920s and 1930s were challenged by specialist firms focused on the provision of athletic footwear. By the 1970s, their products were widely available, and popular conceptions of what a sports shoe could be had broadened considerably.

The drive toward more technical sports shoes came from various sources. Changing patterns of international trade, new materials and production technologies, shifting attitudes to sports, and individual manufacturers all played important roles. Like other man-made artifacts, and like the sports shoes of previous eras, postwar sports shoes were shaped and acquired meaning through a wide range of social and technological pressures. They came to exist because broader historical forces coalesced. Modern sports shoes were not from outer space. Rather, they were products of very specific conditions in different postwar markets. Developments in the United States, Germany, and Britain all contributed to new conceptions of the sports shoe.

<p style="text-align:center">❊ ❊ ❊</p>

The Second World War profoundly affected sports shoe production in Britain. Rubber supplies were prioritized for military use. Across the country, footwear factories made boots and shoes for the armed forces, or were requisitioned for other purposes: Dunlop's was used to build bombers. Industrial creativity went into special boots for airmen and rubber soles for commandos, and not meeting the more frivolous needs of sports men and women. In a time of war, sports footwear was side-lined. Nevertheless, sports shoe manufacturers played an important wartime role. In October 1940, Dunlop placed an advertisement in the trade press that explained how "[e]ssential war production" prevented the firm "from fully supplying civilian needs." The accompanying image, of young recruits engaged in physical training, implied that Dunlop's rubber-soled sports shoes were being directed toward the military. The advertisement promised that "when

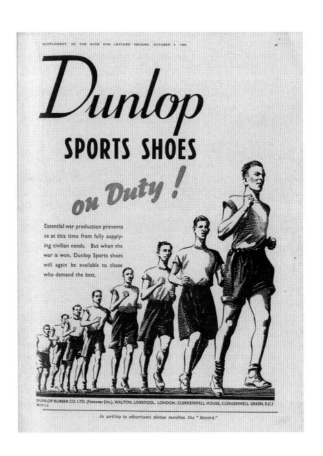

3.1 Dunlop sports shoes advertisement, 1940.

the war is won, Dunlop Sports shoes will again be available to those who demand the best." The war was far from won in 1940, however, and the rubber footwear trade faced further challenges as the war progressed. Most significantly, the Japanese invasion and occupation of British Malaya (1942–1945) and the fall of Singapore in 1942 disrupted the rubber trade and meant Britain lost control of—and access to—many plantations. Officials at Dunlop estimated that the production of one hundred million pairs of canvas and rubber footwear were held up by the war. It was not until it ended that sports shoe production could resume on a meaningful scale.[2]

The years immediately after the war presented further difficulties. An advertisement in July 1945 predicted optimistically that "Dunlop will set the quality standard in post-war footwear," but, with the war won, British firms struggled to re-establish themselves against a backdrop of rationing, labor and material shortages, and general austerity. In the late 1940s, *The Shoe and Leather News* lamented the decline of a once significant industry. At one time, Britain had led the world in sports shoe production but the war, the anonymous writer said, had "put an end to that trade . . . and the aftermath of war, with depleted staffs and absences or scarcities of the materials that were wanted, still further prolonged the period during which it was impossible for manufacturers to get back into their stride and start meeting the pent-up demand of a period of nearly ten years." His words suggested doubts about the viability of British manufacturers in the

THE STRIKING SELLING FEATURES OF Dunlop SPORTS SHOES

'WHITE FLASH'

Self-ventilating Dunlopillo cushion insole adds live-liness to footwork and protects against shock.

"DUNLOP VENTILEX" upper canvas, porous yet wet resisting, allows the foot to breathe, reduces perspiration—a revolution in sports shoe comfort.

Self-induced air flow through special ventilated "DUNLOP VENTILEX" upper canvas.

Flexible reinforcing foot support.

Semi-rigid reinforcement.

Substantial layer of super quality black outsole rubber, having special abrasion resisting qualities.

Its customer-tested features, amazing comfort and length of life make this the most sought-after sports shoe ever known.

To stock, display and say you have DUNLOP Sports Shoes is an automatic assurance of a speedy and profitable turnover.

The foundation of good tennis

immediate postwar period, but he remained hopeful. British firms were overcoming
their difficulties with supplies and trade licenses, and, he said, "getting to a point
where they can cope successfully with enquiries." Despite his positivity, the recovery
of British shoe manufacturing remained fragile.[3]

The war also paused innovation within the sports shoe trade. Although many
products and materials developed for the military emerged on the civilian market in
the 1940s and 1950s, British sports shoe manufacturers returned to prewar styles and
production methods. Dunlop advertised a range of white "Flash" canvas and rubber
sports shoes that were broadly similar to those introduced in 1930. North British
Rubber, a Scottish firm, in 1951 sold canvas sports shoes identical to those it offered in
1930. Illustrations and advertisements in the trade press showed leather football, rugby,
cricket, and running shoes that were virtually indistinguishable from models produced
a decade or more earlier. In one sense, this continuity could be viewed as a return to
normality after the upheaval of the previous years; in another, it was a reflection of the
difficult circumstances in which the industry found itself at the war's close. After years
of military production many footwear producers lacked new designs and machinery.
With little else to fall back upon, a revival of prewar styles was perhaps inevitable.[4]

Life was made harder for British manufacturers by the rise of international
competitors. By the late 1920s, Japan, Malaya, and Czechoslovakia had joined the

3.4 Sports footwear,
Greengate and Irwell
advertisement, 1956.

United States, Britain, Canada, and France as leading exporters of rubber-soled shoes. Concerns about British competitiveness first surfaced in the early 1930s, when inexpensive imports began to threaten domestic manufacturers in the home market; Dunlop's sports shoes were launched with the tagline "As British as the flag." Increased tariffs on imports provided some protection from 1933, but Britain's policy of imperial preference meant British manufacturers were still challenged by those based elsewhere in the empire. The difficulties intensified after the war. Factories in Hong Kong took advantage of favorable trading relations and flooded the British market with rubber-soled tennis shoes and plimsolls, which, because labor costs were lower, far undersold those produced in Britain. By the mid-1950s, upward of fourteen million pairs were imported into Britain annually.[5]

Producers in Britain struggled to compete against this rising tide of Asian imports. During the 1950s and 1960s, the directors of Greengate and Irwell, a firm in Manchester that had made rubber-soled sports shoes since the 1920s, turned frequently to what they called the "menace of so-called Empire produced footwear products." As they sought to save their business, they increased spending on advertising, invested in new machinery, introduced new sales methods, increased then regulated production, dropped unprofitable lines, and attempted to diversify into new products. Yet despite these efforts, the footwear department continued to lose money. In 1958, directors

noted that the market "was saturated and the low prices for plimsolls and ordinary double texture Tennis Shoes necessary to meet Hong Kong competition" made it impossible for them to remain viable. It was decided the following year to cease production of plimsolls and other "lines which might easily become subject to Hong Kong competition," and instead to concentrate on "sports shoes," an area the directors hoped would be profitable. The firm made a range of specialist canvas and rubber shoes for squash and badminton, basketball, soccer, field hockey, lacrosse, and cross-country running. Advertising claimed "Everyone's going for GREENGATE Sports Footwear." Everyone was not. Directors bemoaned the poor performance of the footwear department, which incurred "continual losses . . . despite the efforts . . . to cut out unprofitable lines," an unhappy situation that led the company to withdraw from the footwear trade in 1966.[6]

Dunlop faced similar problems and responded in a similar manner. At the company's annual general meeting in 1953, Lord Baillieu, the chairman, drew attention to "severe competition from Hong Kong, Japan and Czechoslovakia" and its adverse effect on footwear exports. Thereafter, his annual reports returned with depressing regularity to Dunlop's difficulties in the shoe business. By the mid-1950s it was apparent that Dunlop's basic canvas and rubber shoes could not compete with cheaper versions made elsewhere. Baillieu admitted in 1953 that because of "increased competition from Hong Kong imports, and abroad from such low cost producers as Japan" production of plimsolls and ordinary tennis shoes was to cease and "development [be] directed to the more specialised fields of industrial boots, informal footwear and sports shoes." There was, he suggested, "a large potential market for this type of product and considerable scope for imagination and enterprise." During the second half of the 1950s, Dunlop invested in manufacturing processes, reorganized production, and opened a factory "devoted solely to the manufacture of leather and canvas footwear with moulded rubber soles." The firm aimed to apply "specialised techniques and up-to-date methods" to its expanding range of footwear. This effort resulted in new sports models, which Baillieu reported in 1955 "have met with general consumer approval."[7]

The Green Flash tennis shoe, a model introduced in the late 1950s and one of "the first new products to be manufactured by highly mechanised manufacturing techniques," was the flagship of Dunlop's sports range. Made of white canvas uppers with white rubber foxing and a distinctive green rubber sole, *The Shoe and Leather Record* noted that it boasted "sponge padding on the tongue, no seams inside, special moulded

sole and Dunlopillo arch support insole." Advertising claimed its "new construction features give unique comfort in action"; that the "seamless foreparts mean snugger, chafe-free fitting"; and that its "[s]lip-resistant moulded soles give more grip." It was presented as a product for dedicated players that made the most of new technology. It was shown to shareholders in the 1961 annual report, which included a photograph of a white-coated young woman surrounded by racks of neatly arranged Green Flash, carefully checking a shoe's sole. Photographs in 1963 showed a large room of female machinists "employed on the 'closing' of the uppers . . . served by conveyors which carry work boxes along the rows of operators." In the foreground, a large illuminated control panel suggested modern methods of computerized production management had been adopted. Another image showed a white-coated workman operating a line of complex machinery producing Green Flash. Shareholders were assured that "[n]ew manufacturing methods have resulted in lighter sports footwear." Dunlop's portrayal of the Green Flash in production fostered an image of the company as a forward thinking business, using scientific methods to improve its products. Like the sports shoes made by Greengate and Irwell, the Green Flash was positioned as a specialized, technological sports shoe, very different from Hong Kong imports. Advertising in the late 1950s stressed that Dunlop was the choice of most Wimbledon players, and in 1964 the company reported that the Green Flash was "well received" by consumers.

3.5 (Above left) Dunlop Green Flash production, the closing room, 1960s.

3.6 (Above right) Dunlop Green Flash production, quality control, 1960s.

3.7 Dunlop Green Flash production, sole moulding machinery, 1960s.

It remained one of the most popular tennis shoes on the British market well into the 1970s.[8]

The moves by Greengate and Irwell and Dunlop to cater to a more discerning, demanding sports consumer reflected changing attitudes to sport in Britain. As in the late nineteenth century, rising postwar incomes and shorter working hours created a public with time and money to spend on recreational leisure activities. Participation in sports of all kinds at all levels increased. In 1955, *The Shoe and Leather Record* noted that "[s]port has become as much a part of life these days as eating and drinking," and that "[p]eople are meeting every week-end of the year for sporting purposes." This was good news for footwear manufacturers and retailers, for whom it promised increased custom. All these active people, the *Record* suggested, "have one particular thing in common: every man, woman or young person . . . must dress properly for the part, and standards become increasingly higher." Footwear was especially important: "[f]ootballers, cricketers, hikers, cyclists, horse back riders, runners – every one needs special boots or shoes for the job, with most likely a pair in reserve." In itself, this was nothing new. The crucial shift, which the journal recognized, was "that the volume of youngsters and others taking part in these occupations has been steadily increasing since the war, and that these youngsters are usually in good jobs, with a prosperous background; and they are prepared to spend money on their hobby,

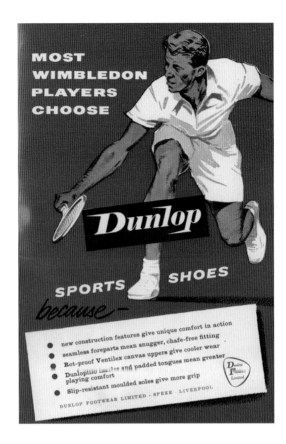

3.8 Dunlop sports shoes advertisement, 1958.

in order to gain efficiency and comfort." Wider and more serious participation in sports when combined with increases in disposable income created a market for more sophisticated, performance-oriented sports footwear that Dunlop and others sought to capture.[9]

Dunlop's Green Flash and Greengate and Irwell's sports models replaced shoes that were designed and marketed as sports footwear in the 1920s. Innovation was spurred by the pressure of imports, but rubber manufacturers worked within long-established industrial parameters. The British sports shoes of the 1950s and 1960s were sold as modern alternatives to inexpensive "Empire-made" shoes and were pitched as technical solutions to the requirements of dedicated sportsmen and women. Yet like the shoes of the 1920s and 1930s, they were produced by firms focused on rubber. Sports had opened as a possible market for these companies because it was thought in the late nineteenth century that rubber was an ideal material for sports soles. Canvas and rubber shoes had gained prominence after the First World War, but they were made by firms that were rubber manufacturers first and shoemakers second. Despite the scientific progress of the rubber industry, marketing and advertising could do little to conceal that the sports models of the 1950s and 1960s were, still, in essence, canvas and rubber shoes much like those produced a generation earlier, and not dissimilar to those produced cheaply in Asia. They relied on production techniques

The Sports Shoe

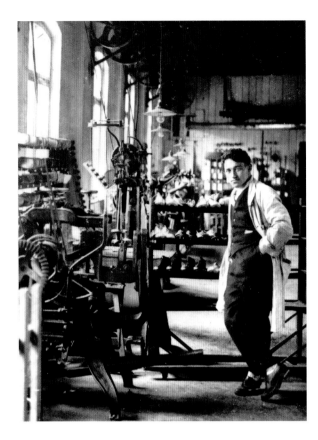

3.9 (Above left) Adolf
Dassler in his factory,
Herzogenaurach, Germany,
1920s.

3.10 (Above right)
Sportschuhfabrik Gebrüder
Dassler catalogue, 1937.

introduced almost half a century before. Yet the suitability of shoes like this for sporting endeavor in the postwar era, and whether rubber remained the best material available, was being challenged.

* * *

A different approach to sports footwear developed in postwar Germany. This was largely due to Adolf Dassler Spezial Sportschuhfabrik, a firm established in 1948 by Adolf Dassler, a forty-eight-year-old shoemaker and entrepreneur, in Herzogenaurach, a small town in southern Germany.[10] It was better known as adidas, the brand Dassler registered in August 1949 in the nearby city of Fürth. Dassler was by then a veteran of the German footwear industry. He started making and selling experimental sports shoes in his spare time after the First World War, and in 1924 formed a partnership with his older brother Rudolf to manufacture and sell footwear to the sports clubs and federations then springing up across Germany. Their firm, Sportschuhfabrik Gebrüder Dassler, grew steadily. It was noticed by Josef Waitzer, the coach of the German athletics team, who helped develop shoes for the 1928 Amsterdam Olympic squad, which in turn raised its profile among elite athletes. After the Nazis came to power, Gebrüder Dassler supplied sports shoes to the expanding Wehrmacht and benefitted from the emphasis the regime placed on school and company sports and

3.11 Training shoes, adidas catalogue, 1950.

other forms of physical exercise. By 1936, it was one of Germany's biggest producers of sports footwear. It catered to eleven sports; many athletes at the Berlin Olympics wore its shoes (including Jesse Owens, who was given a pair by Dassler); and annual turnover amounted to 480,000RM. The firm expanded into a second factory in Herzogenaurach in 1939, only for the war to disrupt production and bring the run of success to an end. Production resumed in 1945 after Herzogenaurach surrendered to American troops; some of the first postwar products were training shoes made from recycled military tent canvas for GIs stationed nearby. The war, however, exacerbated differences between the brothers, and in 1948 their partnership was dissolved. The reasons for their feud have never become entirely clear; one suggestion is that Adolf discovered his brother had conducted an affair with his wife, Käthe, in the early 1940s.[11] Gebrüder Dassler's employees were asked to choose who they wanted to work for: the bulk of the sales and promotional staff stayed with Rudolf, the salesman, while the technical staff opted for Adolf, the shoemaker. In one Dassler factory, Rudolf formed the business that became Puma. In the other, Adolf and Käthe set about building adidas. Thereafter, the brothers' bitter rivalry was channeled into business, spurring sports shoe development to new heights.

Dassler's approach was encapsulated in the slogan adidas used in the late 1940s: "*Das Beste für den Sportler!*" As an enthusiastic amateur, he enjoyed a variety of athletic

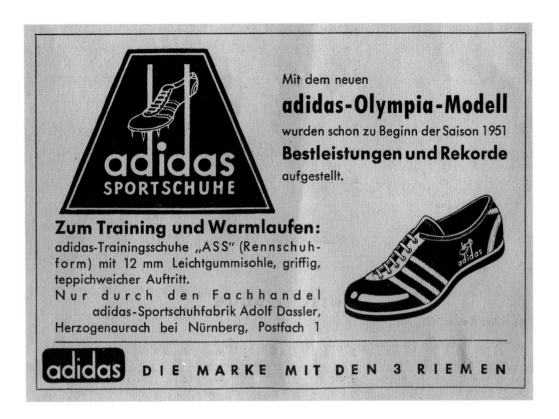

3.12 Training shoes, adidas
advertisement, 1951.

pursuits throughout his life. He was, by many accounts, fascinated by sports. He also had a detailed understanding of the craft of shoemaking, learned at the renowned German *Schuhfachschule* in Pirmasens in the 1930s. By applying his knowledge of design, orthopedics, materials, and manufacturing, he sought to craft the best possible footwear for participants in various sports. Athletes were quizzed about their needs and asked to test new designs. In the pursuit of marginal performance gains, Dassler experimented with materials, patterns, and production methods. A *Sports Illustrated* reporter in 1969 described him as in love with shoes, "quick-witted but rather shy, more gratified by the entries he makes in the idea book he keeps on his nightstand than by the figures in the company ledger." It was an approach that combined the athlete's quest for better performance with engineering. Shoes were envisaged as technical equipment, and, much like the components of an automobile, were seen as being open to almost infinite improvement.[12]

Dassler outlined his principles in a catalogue printed in summer 1949. "As a sports shoe manufacturer" he wrote, "I consider it particularly important to maintain continuous contact with athletes. The lessons learnt from them indicate the direction of my work." He promised that constant cooperation with the heads of German athletics would ensure adidas shoes remained always up-to-date, and that, despite postwar difficulties in obtaining special leathers, they would always be the best

3.13 adidas shoe production
and marketing, c. 1960.

available. Photographs of him helping competitors at a track and field event indicated his active engagement with sportsmen and sportswomen. That almost all top German athletes in 1948 wore his shoes was cited as proof of their superiority. His approach—and enthusiasm for sports—necessitated a highly specialized range. In 1950 adidas offered seven soccer boots, two track and field spikes, two handball shoes, five ice-skates, shoes for hockey, boxing, wrestling, cycling, fencing, basketball, and tennis, and four models intended to be worn during training. They were positioned as functional equipment, designed to enable better sporting performance.[13]

As was indicated by the firm's name, Adolf Dassler Spezial Sportschuhfabrik was established to make sports shoes. It was not bound by any particular material or manufacturing process. Instead, Dassler pursued what he believed were the most appropriate, and available, solutions to sporting needs. Adidas shoes were carefully lasted to ensure a good fit. They were made of fine and lightweight leathers, expensive materials that provided greater support and held their form better than the canvas used by other manufacturers. They incorporated patented plastic heel stiffeners that held the foot securely in place, seams designed to avoid chafing, and ventilated panels that allowed feet to breathe. The soles were attached by various methods and shaped from a variety of leathers, rubbers, and plastics. Perhaps most significantly, adidas drew upon Germany's wider technological and industrial expertise and applied it

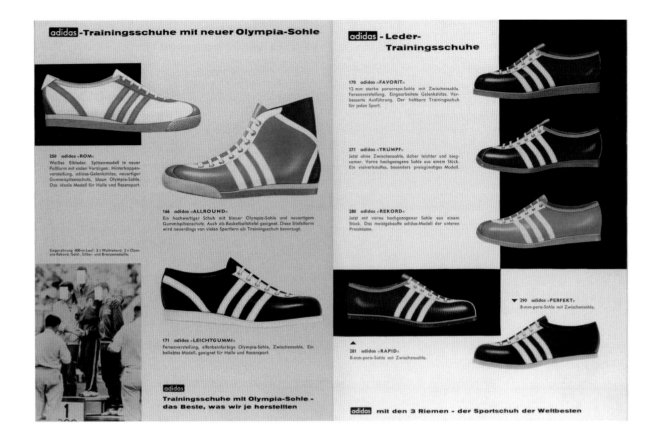

3.14 Training shoes, adidas catalogue, 1960.

to sports footwear. German chemical firms had led the world since the nineteenth century and in the 1940s pioneered the production of synthetic rubber- and oil-based plastics. Their recovery and renewed prosperity was a major component of West German postwar economic revival.[14] Adidas was an early adopter of new materials and used a range of synthetic compounds and plastics that would eventually transform the appearance of sports shoes almost entirely. The firm was also one of the first to use manufacturing methods that transformed the footwear industry as a whole after the Second World War, most notably the use of soles attached with adhesives and, later, fully molded sole units. As the firm grew, automated production machinery was developed especially for it. The creative flexibility in the firm's approach resulted in real change and tangible benefits to consumers.

During the 1950s and 1960s adidas shoes developed rapidly (as did those of Puma, which followed its sibling rival closely). Individual models were constantly updated and flagship shoes were superseded every few years. In 1968, *Sports Illustrated* estimated that 132 changes were made to the firm's top of the range shoes between the 1964 and 1968 Olympics.[15] The top adidas training shoe in 1950 was known as the Ass (Ace). It had a "leather insole, leather midsole . . . 9mm lightweight rubber sole, toe and heel protection and patented heel stiffener." It was described as being of the highest quality, durable, and "extremely grippy."[16] Dassler eschewed the derby

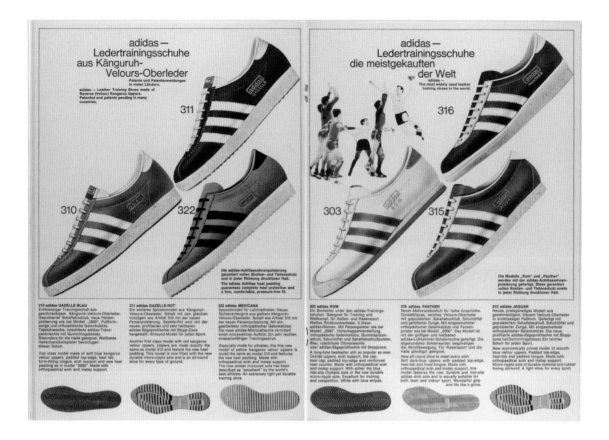

and oxford styles commonly used for canvas shoes; instead, the Ass had a vamp that extended around the foot to the heel, a design more commonly seen on running spikes. By 1956, it was joined by the similarly constructed Zukunft (Future), a shoe the firm described as "the training shoe of the future." Made of white leather with blue trim, a leather midsole, and a "12mm porocrepe outsole," it had an orthopedic footbed that "supports the foot arch, prevents fatigue and improves performance." Adidas called it a "decisive improvement for the overworked athletes foot."[17] These were superseded before the 1960 Rome Olympics by the Rom and Italia, models made on a new streamlined last. The Rom had white elk leather uppers with blue stripes, while the white and green Italia was made of soft, lightweight Australian kangaroo leather. Both incorporated a reinforced heel counter, an arch support, "novel rubber toe cap protection," and what adidas described as an "Olympia sole of magic-carpet softness."[18] They were replaced by the Olympiade, a model with a "new transparent [rubber] sole," a "foot-form tongue and built-in arch," a "well-cushioned heel," and padded kangaroo leather uppers, described as "The hit of the Tokyo Olympics."[19] In 1965, the Olympiade was replaced by the Gazelle. Available in red and blue velour kangaroo leather, this was a "new special model for top athletes" with lightweight soles that was made of the same material as the Tokyo 64, a spike worn by gold-medal-winning sprinters and advertised as the "The fastest shoe in the World!"[20]

3.15 (Above) Training shoes, adidas catalogue, c. 1968

3.16 (Opposite) American hurdlers Josh Culbreath, Glenn Davis, and Eddie Southern in adidas on the victory podium Melbourne Olympics, 1956.

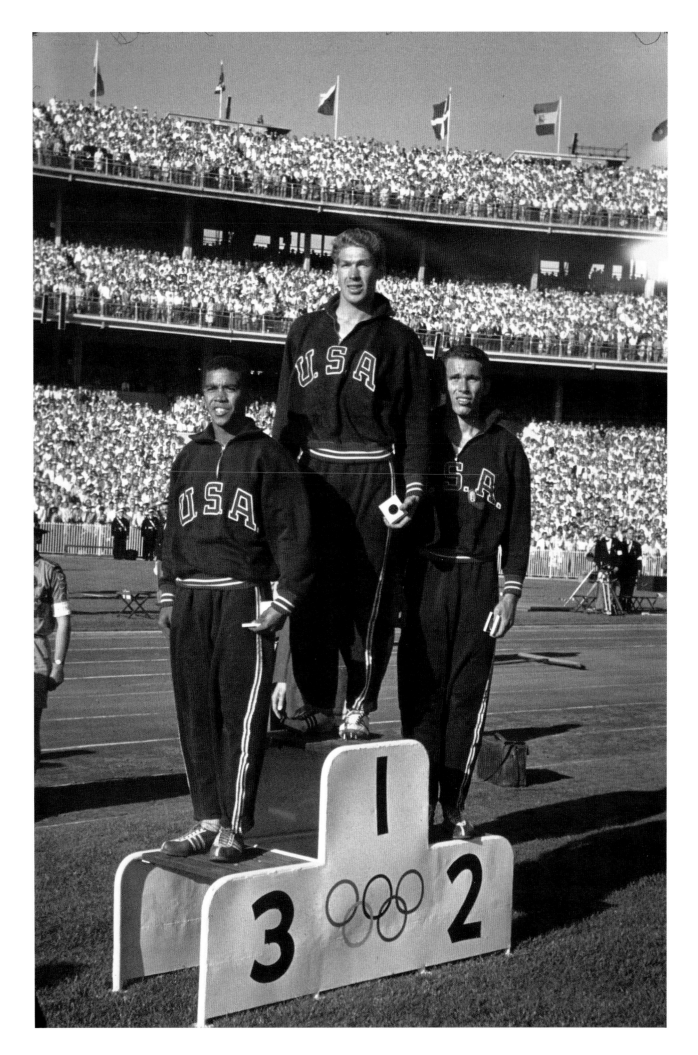

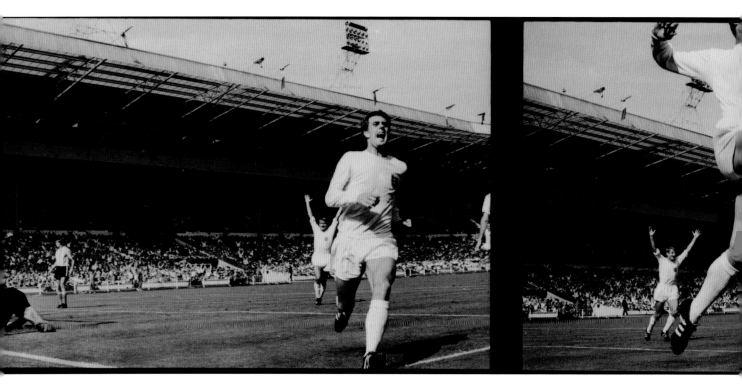

The pace at which adidas introduced new developments was intense, and, although in part driven by the rivalry with Puma, it stood in contrast to the lack of innovation elsewhere in the trade.

3.17 Geoff Hurst's adidas boots, World Cup 1966.

One of Dassler's most significant moves was his decision to brand adidas shoes with three distinctive stripes. Before this, sports shoes tended to be uniform in color, usually black or white. To an untrained eye, the differences between manufacturers were hard to perceive, and it was difficult to tell whose shoes any particular athlete wore. This changed in the postwar era. Although adidas liked to suggest the stripes provided support, they were in effect a clever marketing device that made adidas shoes instantly recognizable. Coverage of sports increased in the postwar era. The 1960 Rome Olympics were the first to be televised to a worldwide audience; the 1964 Tokyo games were the first broadcast using a telecommunications satellite. It was estimated that four hundred million people watched the 1966 soccer World Cup final, and that the figure doubled in 1970. Newspaper, magazine, and television pictures of top sporting events carried the adidas brand to a worldwide audience and cemented the firm's connection to the elite. After the 1956 Melbourne Olympics, *Life* published a photo-essay that showed several American medal-winners in adidas, including the cover star, 100m winner Bobby Morrow. One of the most famous images of the 1966 soccer World Cup was of Geoff Hurst leaping for joy after scoring in England's

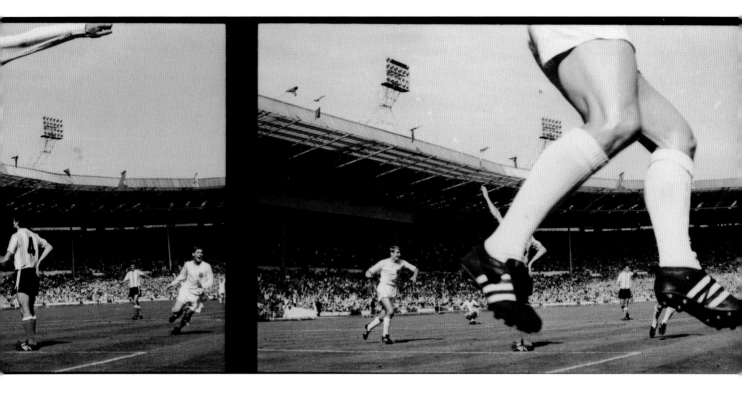

quarter-final against Argentina; Hurst is largely out of shot, only his adidas boots are in the frame. A plethora of branding devices indebted to the adidas and Puma stripes were launched by frightened rivals. These imitations were testament to the original's effectiveness in generating mass sales. The three stripes (and Puma's comparable curved "formstrip") transformed sports news into free advertising.[21]

Through relentless innovation, dedication to high quality manufacturing, and sensitivity to athletes' demands, Dassler built a successful business. The firm's shoes were popular among professional or top athletes. Adidas claimed that in 1960, 75 percent of Olympic athletes competed in their shoes, with the figure rising to 80 percent in 1964, and 85 percent in 1968. At the 1966 soccer World Cup, 75 percent of players, and twenty in the final, wore adidas boots.[22] By the mid-1960s many international sportsmen and women wore shoes produced by either adidas or Puma, which together achieved almost complete dominance of soccer and athletics and were prominent in tennis, basketball, baseball, and American football. This near ubiquity was achieved by stretching the rules governing amateur sport to near breaking point. Adidas gave shoes to many top athletes, a strategy Dassler had used since the 1930s. At the 1956 Melbourne Olympics, Adolf's twenty-year-old son, Horst, distributed shoes to medal prospects and is said to have bribed customs officials to stall the arrival of Puma products.[23] The dirty tricks were perhaps unnecessary; Puma's shoes

3.18 adidas promotional booth, Rome Olympics, 1960.

were generally less highly regarded, and given a choice between a free pair of Puma and a free pair of adidas, many top athletes opted for the latter. In desperation, Puma began to pay professional and amateur stars to wear their products; adidas duly responded, and during the 1960s a system of under-the-table payments was established as the two firms fought to get the elite into their shoes. It was estimated that at the 1968 Mexico City Olympics they gave away around $100,000 and equipment worth $350,000. Adidas was said to give away around 30,000 pairs of shoes in an Olympic year.[24]

✳ ✳ ✳

Adidas and Puma used their association with the elite to engineer desire among a mass market of lesser, aspiring athletes—a tried and tested formula used by sporting goods manufacturers since the late nineteenth century. Adolf Dassler's success after the war, however, and the shoes he created, owed much to social changes beyond the footwear and sporting goods industries. Just as Gebrüder Dassler benefitted from Nazi programs that commanded large sections of German society to engage in regular exercise—thereby necessitating the purchase of suitable footwear—adidas grew on the back of state-sponsored sports and fitness drives. These changed ideas about sports and created a vast market for all types of sports footwear.

3.19 *Trimm pfad*, woodland running trail, West Germany, 1975.

Germany has a history of state involvement in sports dating to the early nineteenth century. The Nazi government was particularly vociferous in the emphasis it placed on physical fitness.[25] In the decades after the Second World War, the Federal Republic led Europe in the implementation of popular sports programs, creating the conditions necessary for mass consumption of sports-related products. Formal competition and sports clubs were officially disregarded immediately after the war due to their link to discredited Nazi (and German) militarism. Nevertheless, in the late 1940s the Deutscher Sportbund (DSB) emerged as an umbrella organization for the Federal Republic's eighty-seven thousand voluntary sports clubs. In explicit contrast to the stress placed by the Nazis on competition and physical hardening, the DSB adopted an inclusive policy as a means to rebuild sport's discredited reputation. DSB-affiliated clubs were opened to all sections of society; different forms of physical recreation were introduced and encouraged; and efforts to persuade the public of the benefits of regular exercise started. In 1959, it launched *"der Zweiter Weg,"* a campaign that outlined the positive social and individual effects of mass sports, and which promoted a range of physical activities across a broad section of West German society.[26] Still, in the late 1960s West German health insurers warned that the children of the country's economic miracle were becoming unfit, with a third of men and 40 percent of women overweight.[27] The DSB responded with a series of wide-ranging "*Trimm*

adidas

So schön wie barfuß

ADRIA –
der moderne Leinenschuh für Freizeit-Genießer.
Leicht. Atmungsaktiv. Spezialsohle.
Und viel preiswerter als Sie denken.
In den Größen 30 – 35
VR-Preis nur DM 9,60
In den Größen 35 – 37
VR-Preis nur DM 10,90

3.20 Adria leisure shoes, adidas leaflet (West Germany), c. 1972.

Dich Durch Sport" campaigns that encouraged physical activities of all sorts as a way to improve public health. Television advertising, public information films, brochures, events, and other publicity material all sought to persuade West Germans to take up regular exercise.[28] Promotional activity was matched by investment in infrastructure. Starting in 1960, the German Olympic Society embarked on a fifteen-year project to overcome the shortage of facilities that existed after the war. It led to a DM 17 billion construction program that more than doubled the number of sports grounds and sports halls in the Federal Republic.[29] As part of the push for fitness in the 1970s, local administrations across West Germany created publicly accessible *Trimm Bahn* and *Trimm Pfad* in woodlands and parks. These outdoor gymnasia were open to all and provided signposted running trails and equipment for a variety of physical exercises. Initiatives by the DSB and German Olympic Society had a stark effect on participation rates in West Germany. Between 1960 and 1980, membership of sports clubs affiliated to the DSB increased from around three million to roughly seventeen million people, or 6.7 percent of the population to 27.6. Many more people enjoyed sports or physical recreation activities on an informal basis. With rising incomes and the arrival of the leisure society in the 1960s, a broad range of sports activities were embraced enthusiastically by many West Germans.[30]

Mass sports offered a way to extract further financial value from investment in product innovation and technology. Dassler's promise to keep his manufactures up-to-date, and the rapid turnover of elite models it entailed, meant adidas amassed machinery and expertise dedicated to products that were quickly deemed redundant from a professional sports perspective. Yet shoes that were seen as out-of-date at the highest level remained entirely functional and more than adequate for the demands of lesser athletes. As participation rates increased, adidas began to court consumers more concerned by fitness and health than sheer performance. During the 1970s, flat-soled, multipurpose leisure and training shoes became ever more significant within the range. The firm churned out basic, easily manufactured models in various materials, colors, and with different soles, creating the variety needed to suit different activities and consumer pockets. As manufactured objects, they recycled technology from the 1950s and 1960s. Shoes designed for Olympians were later sold to novice, less well off, and more occasional athletes. By 1972, the adidas catalogue included nineteen different training shoes and the Adria, an inexpensive canvas and rubber shoe said to be suitable for "vacationing, leisuretime, and camping." Model names reflected ideas of how adidas shoes might be worn. Alongside names that conjured images of speed (Gazelle), achievement (Rekord), and sporting events (Olympiade), a new Freizeit (Leisure) range emerged that introduced names redolent of holidays and leisurely fun: Tahiti, Miami, Riviera, Savane. One of the firm's bestselling models in the late 1970s was a simple brown and beige leisure shoe called Tobacco.[31]

<p style="text-align:center">❊ ❊ ❊</p>

The influence of German sports policy was felt across Europe, with "*der Zweiter Weg*" and other initiatives providing a model for similar programs later adopted by other nations. European governments were not alone in their concerns about physical health. The United States federal government also campaigned to raise activity levels. Concerns about the physical fitness of young Americans were first aired in the mid-1950s, when Dr. Hans Kraus suggested that the ease of postwar life was weakening American children. His research led in 1956 to the establishment of the President's Council on Youth Fitness, which was asked to educate the American public about fitness. These efforts intensified under John F. Kennedy, who outlined his desire for physical fitness to be a defining feature of his administration in "The Soft American," an article published in *Sports Illustrated* shortly before his inauguration. Under his direction, the renamed President's Council on Physical Fitness began to publish fitness information and offer

technical advice to schools and communities. A series of bestselling booklets suggested possible exercise regimes, while national television and radio campaigns raised awareness. After Kennedy's assassination, these and similar programs were continued by Lyndon Johnson, who increased the emphasis placed on involvement in sports, and his successors. Vast numbers of Americans became engaged, paving the way for the fitness fads and booms of the 1970s and 1980s.[32]

As it was in Britain and Germany, rising participation was a boon for sports shoe manufacturers. American producers, however, had been sheltered from the foreign competition that spurred their British counterparts. Rubber companies lobbied for protection against cheaper imported shoes in the early 1930s, and in 1933 President Hoover issued an executive order that dramatically increased the tariff on imported footwear with rubber soles and fabric uppers. The effect was a sharp reduction in imports, effectively granting American manufacturers a shared monopoly over their domestic market. Perhaps because of this, United States Rubber, Converse, and B.F. Goodrich produced rubber-soled canvas sneakers that remained virtually unchanged for over thirty years. The Converse All Star was a bestselling shoe through the 1950s and into the 1960s, but it altered little after a white version was introduced for the 1936 Olympics. The design dated to 1917, when the model was introduced. Shoes like these were worn as general purpose sports shoes but also as casual and school shoes, particularly by children and teenagers. By the 1960s, they were American icons that transcended generations. The growing emphasis placed by the federal government on physical fitness created a market for multi-purpose athletic footwear to which the canvas sneaker seemed well suited. Executives at B. F. Goodrich, owner of the P. F. Flyers brand, observed that the market doubled between 1958 and 1964. With sales of 103 million pairs of sneakers in 1964 and predictions of 146.3 million for 1970, the company invested in machinery that could produce old designs using fewer workers rather than alter a successful formula.[33]

The American market began to shift with the arrival of Blue Ribbon Sports (BRS) in 1964.[34] This was an import business established by Phil Knight, a twenty-six-year-old Stanford Business School and University of Oregon graduate, and Bill Bowerman, his former Oregon track coach. It developed from a paper Knight wrote at Stanford that asked "Can Japanese Sports Shoes Do to German Sports Shoes What Japanese Cameras Did to German Cameras?" As a college athlete in the late 1950s, Knight knew German shoes were lighter, more comfortable, and better suited to training than those made in the United States, but saw that high prices

converse

1965 BASKETBALL YEARBOOK

44th Edition

and poor distribution limited their success. He later remembered that a five-mile run in American-made sneakers made his feet bleed. Adidas were the preserve of the wealthiest, best-connected, or most dedicated track and field athletes. Knight therefore posited the possibility of a partnership between an American distributor and a Japanese manufacturer to make and sell athletic shoes in the United States. By copying German templates—as Japanese camera makers had done—Japanese manufacturers could make shoes better suited to the needs of American athletes than the elderly designs of American rubber companies. Because Japanese labor costs were lower, these shoes could be imported and sold in the United States for less than those made in Germany. In 1962, Knight visited Japan and formed a partnership with Onitsuka, a leading Japanese manufacturer of sports footwear. The firm was founded in 1949 by Kihachiro Onitsuka. It produced sixty-six models, mostly copied from American canvas and rubber basketball sneakers and adidas training shoes, and supplied footwear to the Japanese Olympic team in 1964. Like many other Japanese manufacturers, it was keen to expand into the vast American market. In February 1964, Knight placed his first order, for three hundred pairs of imitation adidas training shoes worth $1,107. From the outset, Knight sought to position his shoes as a cheaper alternative to those made in Germany. The Japanese shoes were launched at an Oregon track meet with a flyer that announced:

JAPAN CHALLENGES EUROPEAN TRACK SHOE DOMINATION

The Japanese are now producing as good a flat as any country in Europe—light, durable and comfortable. Bill Bowerman calls it "one helluva of fine shoe." Due to Japanese labor costs, price is only $6.95.[35]

American tariffs on rubber-soled footwear were lowered (but not removed) in 1966 as part of the Kennedy Round of trade negotiations. Foreign manufacturers were presented with an opportunity to increase their share of the American market. By 1969, Knight claimed to be the president of the "third and newest force in the U.S. track-shoe market" behind adidas and Puma. Yet the growth of Blue Ribbon Sports in the 1960s reflected more than shifts in trade agreements and the birth of off-shore manufacturing. The firm rode a wave of social and cultural change that deeply affected American sport. The individualism unleashed by the counterculture clashed with the values of organized sport and has been connected to the increasing popularity in the 1960s of forms of physical activity that were not traditional team games. The running subculture that emerged on the west coast—the spiritual home of the counterculture—was perhaps the most visible manifestation of these changes. It could be traced to Bill Bowerman, who in 1962 discovered that the New Zealand Olympic track coach, Arthur Lydiard, had developed a training regime based around gentle distance running. Lydiard's ideas spread to the wider New Zealand public, many of whom embraced Lydiard's technique—better known as jogging—as a form of recreational and social exercise. Bowerman established similar local jogging clubs on his return to Eugene, Oregon, and encouraged non-athletes to run as an accessible and inexpensive way to keep fit. In 1967 he co-authored a bestselling guide to jogging. His ideas spread as the decade progressed. In 1968 jogging drew the attention of *Life,* which questioned whether what it called "a nowhere sport" could ever take off. Nevertheless, the magazine joked that "the country is infested with secret joggers, a vast underground army." During the 1970s, as American society became more health- and image-conscious, ever greater numbers of people took to jogging. It was estimated that fifteen million Americans started running between 1972 and 1977.[36]

BRS was tightly woven into the fabric of the running subculture. The small group of men who built the business were former college athletes who had trained with Bowerman. As Knight said in 1979: "[w]e're mostly runners here . . . [t]hat's what we like best and what we do best." This intimacy gave them insight into what was required of footwear, and, just as Dassler worked with the elite of German sports, BRS worked closely with American runners. Bowerman had long been obsessed with

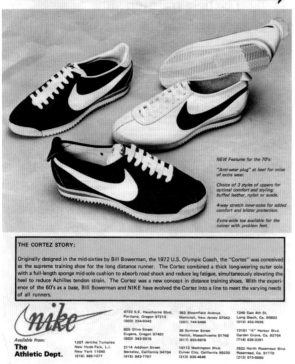

producing the lightest possible shoes for his athletes. He learned cobbling techniques, experimented with materials, and used his track and field team as guinea pigs to test his handcrafted shoes. During the 1950s he tried, unsuccessfully, to interest American manufacturers in his ideas. In the 1960s, some of them were put into production by Onitsuka. The Cortez, a bestselling leather running flat with a foam midsole, was launched in 1968 after he combined what he thought were the best features of two Onitsuka models into one. Nylon uppers were introduced after Onitsuka made a prototype using a foam-backed nylon material developed in Japan as a leather substitute and used on cold-weather boots. The runners at BRS liked the lightweight, quick-drying material and asked for the shoe to be put into production without alteration. Knight and others attended, organized, and sold shoes at running events along the west coast. BRS stores in Santa Monica, California, and Eugene, Oregon, provided an unofficial meeting place for runners, and the company advertised its early mail order business in low circulation, niche running magazines. In an interview with *Runner's World* in 1973, Geoff Hollister, another of Bowerman's athletes and a BRS employee, explained that "[w]ith the help of the neighboring shoe repair shop, I made shoes specifically for various local runners." He set up "a testing center" where he got "quick feedback from the athletes ... to make any corrections." The close relationship between the BRS and its customers allowed it to respond directly to runners' needs. Unlike runners in

3.23 (Above left) Cortez running shoes, Nike advertisement, 1973.

3.24 (Above right) *Runner's World*, 1973.

Germany, who could use wooded, semi-rural trails created as part of DSB initiatives, American runners tended to run on asphalt roads. They required—or preferred—shoes that provided a high degree of cushioning. Adidas and Puma shoes created primarily for the German fitness market did not need—or have—the soft soles preferred in the United States. As running became more popular, BRS prospered.[37]

<center>* * *</center>

By the mid-1970s, specialist sports shoes were widely available. The canvas and rubber shoes of an earlier era had, at least from a sporting perspective, been consigned to history. In *The New York Times*, a nostalgic obituary declared the canvas sneaker a piece of a bygone Americana, "gone the way of the Life magazine, convertibles and passenger trains." It was a "convenience shoe" to be worn when nothing better was available. For Greg Donaldson, the "pleasantly homely canvas shoe" of his youth had "traveled off into the sunset or a Norman Rockwell painting over the handlebars of some kid with freckles and flaming red hair." Many forces caused the demise of the prewar sports shoe and the rise of its more flamboyant, technical successor. New materials and manufacturing processes, the challenges of international trade, and changing ideas about sport were all significant factors. Ultimately, however, they were a sign of the growing affluence in the West that enabled and encouraged participation in sporting activities, and which also led to the ill health that motivated governmental sports initiatives. Without mass involvement in sports, the sports shoe industry is unlikely to have developed in the same manner.[38]

In Germany and the United States new designs were inspired by different attitudes to sport—and the popularity of different activities. In Britain, competition from low-priced imports contributed to notions of the sports shoes as a technically advanced, modern product, while in Germany similar rhetoric can be seen as part of a discourse about postwar renewal. American innovation stalled as a result of the dominance of major rubber companies and protectionist trade policies, yet the changing sports shoe market also reflected the strength and maturity of the Japanese manufacturing sector. The coming together of these diverse and disparate threads led to the creation of shoes that looked and felt unlike those made before the war. As these new shoes moved into the marketplace they were absorbed into the fashion mainstream. However, as they traveled beyond the sports field, the sheer variety available meant they accrued highly specific meanings and cultural associations. Ideas about sports shoes began to develop.

4

Skateboarding and reimagining sports shoes

In May 1964, the American magazine *Sports Illustrated* reported on the latest trend to affect the sporting goods industry. The skateboard, "a pint-sized cousin to the surfboard" that "looks like an ironing board with wheels," was, the magazine thought, "the wackiest new fad to come down the southern California pike in a long time." Riding a skateboard was "like skidding along a banana peel on a wet sidewalk." Nevertheless, sales were on the rise. Skateboarding was "catching on throughout the country." With several "firms hopping into the business on the spur of the moment," the popularity of this vigorous, youthful pastime looked set to "rival the dementia of the Hula Hoop" of the late 1950s.[1]

As a physical activity, skateboarding placed specific demands on footwear. Shoes needed to allow the skateboarder to maneuver the board, to protect his or her feet, and to survive frequent knocks and scrapes. The ideal footwear for skating was lightweight, flexible, and hardwearing and offered very little intermediary between the feet and the board. Skateboarding developed, however, in a world in which shoes like this already existed. Greater participation in sports and the leisured lifestyles associated with postwar affluence meant that by the mid-1960s a variety of casual and increasingly sophisticated sports shoes were widely available in the United States and Europe. Almost any of them could become improvised skateboard shoes. Yet over the next thirty years, the skate shoe gradually emerged as an identifiable segment within the sports shoe market. This happened largely without the attention of the major producers of specialist sports footwear. Skate shoes were the result of collaboration between producers of more generic footwear and skateboarders themselves, who, together, rethought and adapted existing products and production technologies to meet the demands of skateboarding.

❊ ❊ ❊

The first skateboards were homemade contraptions, improvised from broken roller skates and scavenged timber, used for fun by American children. Basic, commercially manufactured boards became available in the late 1950s. More sophisticated boards appeared in California, where surfers took to skating as a land-based alternative to surfing. Among the business pioneers were Val Surf, a shop in North Hollywood that started selling skateboards in 1962, and Larry Stevenson, a Santa Monica surfer who in 1963 began selling Makaha skateboards through sporting goods and department stores in California, New York, Miami, and St. Louis and promoting them through his magazine, *Surf Guide*. Popular enthusiasm for surf culture and wider distribution of skateboards propelled skateboarding into the mainstream. In 1965, after it acquired a

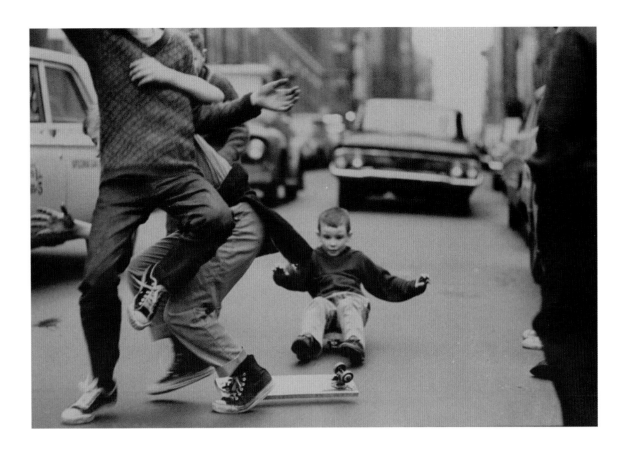

roller skate manufacturer and one of its executives noticed skateboarders at the beach, the Vita-Pakt Juice Company of Covina, California, launched a skateboard endorsed by the surfer Hobie Alter. The firm soon had orders for twenty thousand boards a day; it made over six million in 1965. In March that year, *The New York Times* reported that skateboarding was "becoming increasingly popular" among "youths in the 12 to 15 age bracket." It is claimed that over fifty million skateboards were sold within three years. Encouraged and enabled by this easy availability, during the 1960s millions of American children and teenagers took to skateboarding.[2]

For the majority of this first wave of skateboarders, skateboarding was not an activity that required special footwear. Most of the young daredevils who rode homemade and toy skateboards did so in the same ordinary, everyday shoes as they wore for other playful activities. This generally meant inexpensive rubber-soled canvas sneakers mass-produced by Converse, United States Rubber, and other American manufacturers. Although these had originated as basketball and tennis shoes, by the 1950s they were staple footwear for American boys and, to a lesser extent, girls. *The New York Times* in 1962 declared them "a symbol of admission to full-fledged boyhood" and in 1966 published the results of a survey that showed sneakers were popular among boys in New York's public schools. Perhaps unsurprisingly, when Bill Eppridge photographed skateboarders in Manhattan for *Life* magazine, almost all of those he captured wore high-topped basketball sneakers.

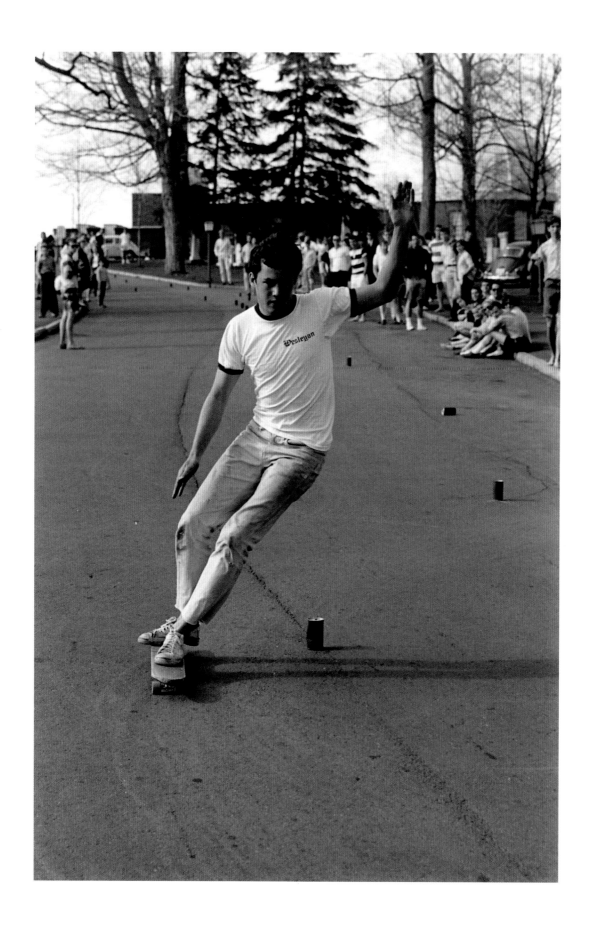

Similarly, when in May 1965 students from Wesleyan, Amherst, and Williams universities engaged in a light-hearted skateboard competition, reports noted that they "donned their oldest sneakers." Flexible uppers and thin, flat soles made sneakers as well suited to skating as they were to other physical pursuits, while their relatively low cost and ready availability meant they could be easily replaced. For most of those who attempted skateboarding in the 1960s, they were perfectly adequate.[3]

Among more serious or committed skateboarders, like those employed in the first professional demonstration teams, footwear was a greater concern. Some even questioned whether shoes were necessary, seeing them as a hindrance that made skating more difficult. For surfers, being able to feel and control the board was paramount; many surf-inspired skateboarders skated barefoot, a choice made easier by California's warm climate. In Noel Black's 1965 Oscar-nominated, Palme D'Or-winning short film *Skaterdater*, a group of top skateboarders are filmed riding without shoes through the southern California suburbs, performing tricks, and generally getting up to mischief. It is only when one of the group abandons his skateboard to be with a girl that he dons rubber-soled sneakers. Many of the elite Californian skateboarders who in 1964 and 1965 appeared in Surfer Publications' *The Quarterly Skateboarder* (known later as *Skateboarder Magazine*) and *Life* were similarly barefoot. This was not a universal choice, however, and many other top skateboarders wore shoes, choosing to protect against what *Life* called the "scraped toes common among skateboard enthusiasts." At the first (ambitiously named) International Skateboard Championships in Anaheim in

4.2 (Opposite) Skateboarder at the intercollegiate skateboarding championship at Wesleyan University, 1965.

4.3 (Below) Skateboarders in suburban New York, 1965.

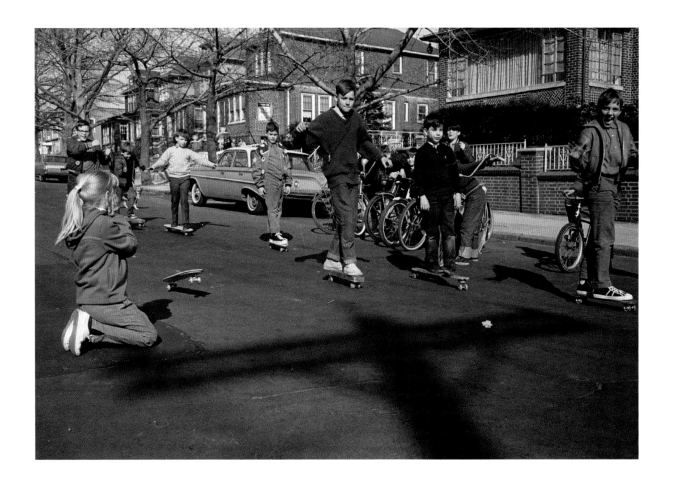

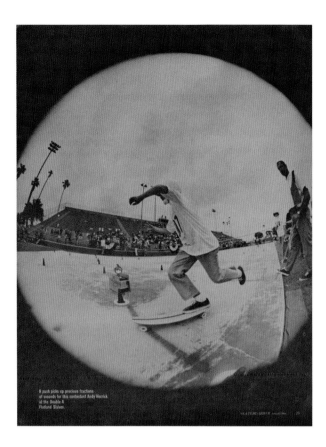

4.4 (Left) International
Skateboard Championships,
Anaheim, California, 1965.

4.5 (Opposite) Randy 720
skateboard shoe, Randolph
Rubber advertisement, 1965.

1965 several competitors wore canvas shoes. Most opted for low, rubber-soled canvas oxfords, a classic design that had been sold for tennis and boating since the beginning of the twentieth century, but which had long since passed into more general use. All of the big rubber companies produced a version, and California's warm weather and relaxed, sporting culture meant they were widely available. As with high-topped basketball sneakers, their flat rubber soles and low, flexible canvas uppers meant they were well suited to the needs of skateboarders.[4]

Although their shoes were embraced by skateboarders, in the 1960s the rubber companies that dominated the American sports shoe market largely ignored skateboarding. The only firm to take note was the Randolph Rubber Company, a footwear manufacturer with factories in Massachusetts and California. In 1965, it launched the Randy 720, a model targeted directly at skateboarders. The new shoe was a low-topped, rubber-soled oxford, with "army duck" uppers, thick white rubber foxing, and a distinctive red and blue rubber sole. It was available in "white, navy, and loden green." The name referenced a popular trick: the 720 degree spin. Randolph had the endorsement of the National Skateboard Championships, a newly formed organization that worked to promote skateboarding as a sport, which made the Randy 720 its "official sneaker." In an advertisement in *Skateboarder Magazine*, the firm made grand claims for the new model: "Today's increased performance on Skateboards

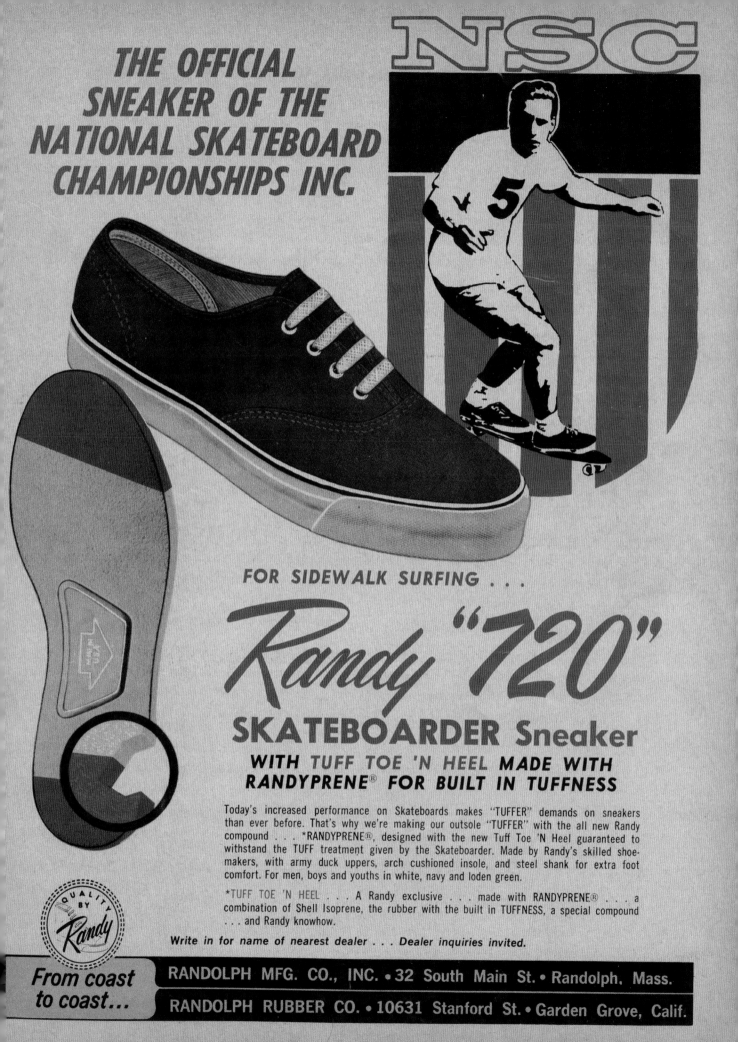

makes 'TUFFER' demands on sneakers than ever before. That's why we're making our outsole 'TUFFER' with the all new Randy compound . . . RANDYPRENE®, designed with the new Tuff Toe N' Heel guaranteed to withstand the TUFF treatment given by the Skateboarder." It was a shoe designed, so the firm claimed, especially "for sidewalk surfing."[5]

Randolph targeted the small minority of serious and competitive skateboarders, not the majority for whom skateboarding was simply a youthful game. According to the advertisements, the Randy 720 was sold through specialist "surfing and marine stores everywhere," but it achieved only limited success. The shoe appeared in photographs of the 1965 Anaheim Championships, including one used on the cover of *Skateboarder Magazine*, but it was more often on the feet of officials than competitors. In a photograph of the South East Bay skateboard team taken around 1965, only one member has Randolph's distinctive red and blue soles. The rest wear deck shoes or low-top basketball sneakers. Many skateboarders, including the team assembled by Vita-Pakt, wore shoes similar in style to the Randy 720, but it is impossible to tell whether they were made by Randolph or another manufacturer. The likelihood is that most skateboarders wore shoes that were more readily available.[6]

What motivated Randolph Rubber to make a shoe aimed at skateboarders remains unclear. The firm was the third largest casual shoe manufacturer in the United States, behind Converse and United States Rubber. As *Sports Illustrated* reported, in the mid-1960s the skateboard market appeared to promise significant sales for manufacturers of skateboard-related products. With a production base in southern California, company executives must have been aware of the growing popularity of skateboards through the early 1960s. By embracing skateboarding before its bigger rivals and establishing links to the bodies that looked set to shape its future, Randolph perhaps hoped to become as closely associated with skateboarding as Converse was by then with basketball. By producing a specialist model comparable to the shoes sold for other sports, Randolph offered a challenge to prevailing conceptions of skateboarding as a youthful fad. More tellingly, perhaps, Randolph was happy to exploit novelties and cater to short-term popular tastes. During the 1960s similar rubber-soled deck shoes were produced to tie in with the *Batman* and *Mighty Mouse* television shows. In 1965, the firm briefly sold aloha-print slip-on deck shoes associated with the surfer Duke Kahanamoku. The Randy 720 was, perhaps, just another attempt to capitalize on youthful, Californian tastes.[7]

4.6 Typical 1960s skate footwear with Hobie Super Surfer skateboard, Vita-Pakt advertisement, 1965.

From a material or production perspective, the Randy 720 required little out of the ordinary from the manufacturer. Although the shoe was advertised as being for skateboarding, in construction terms it varied hardly at all from many of the firm's other casual styles. Tougher materials aside, it was essentially the same as countless leisure and tennis shoes made since the 1920s. The vulcanized rubber sole was attached by processes used across the industry for decades. The patterns, molds, and "Randy knowhow" it required, even the special "Randyprene" sole, could have been used for other Randolph models. The Randy 720 bore little resemblance to the specialist sports shoes being developed in West Germany. It was, in effect, a standard shoe repackaged to appeal to a new market. Yet by doing this, Randolph built upon the actions of skateboarders who wore leisure shoes for skateboarding, and so reinforced imaginative transformations that had already begun.

Randolph's attempts to cater to the needs of skateboarders had a limited impact. The most dedicated skaters in the 1960s could determine which shoes best suited their needs and situation through experience and experimentation, but most were content to improvise with footwear produced for other sports and leisure activities. That there were no fixed ideas about what should be worn was clear from an advertisement for Vita-Pakt's "Hobie" 27-inch Fibreglass Competition Model. It showed seven pairs of feet around a board: five wore battered canvas oxfords, one a pair of beat-up

basketball sneakers, and one was barefoot. The popularity of boating, basketball, and tennis shoes suggested broad similarities in need: skateboarders, sailors, and tennis and ball players all required lightweight shoes that provided good grip. Indeed, a comparison can be drawn between wooden yacht decks, basketball courts, and the wooden decks of early skateboards.[8]

The mid-1960s skateboard boom proved short-lived. Skateboarding faded from view during 1966, victim of legislation banning skateboarders from city streets, concerns over safety, and cheap, unreliable skateboards that put off novices. For many, especially those in positions of authority or influence, skateboarding was a public menace. The skateboard market collapsed and manufacturers bailed out. Vita-Pakt was left with unsold equipment worth $4 million.[9] The Randy 720 disappeared. If any of the other big shoe firms had hoped to exploit the skateboard market, those hopes were quickly quashed. Yet skateboarding did not die completely. Through the late 1960s, it was kept alive by small groups of surfers and dedicated skaters. Away from mainstream attention, they pursued their hobby served by a handful of small manufacturers.

<center>* * *</center>

By 1970, the skateboard market in the United States had shrunk to around $1 million, a fraction of its size in the mid-1960s.[10] A revival began in 1973 with the introduction of polyurethane skateboard wheels. When compared to the hard steel or clay wheels fitted to boards in the 1960s, the soft plastic provided superior grip and a smoother ride. Crucially, it was forgiving to novices and allowed experts to ride terrain that was previously near-impossible: banked surfaces, drainage pipes, and, in California, empty swimming pools. Manufacturers brought out redesigned boards and trucks (the axles on which wheels are mounted), and with improved products opening greater possibilities within the activity itself, skateboarding's popularity, first in California and then across the United States, increased dramatically. By 1975, 150 skateboard manufacturers together grossed $100 million.[11] Sales of $300 million—or fifteen million skateboards—were predicted for 1976.[12] Estimates suggested there were around twenty million skateboarders in the United States in 1977 and 1978.[13] Once again, skateboarding boomed.[14]

Skateboarding's revival was tracked and encouraged by specialist magazines, which were instrumental in defining skateboard culture and the principal means by which it spread to a global audience.[15] The most influential of them, *SkateBoarder*, was launched in June 1975. Within a year it sold around 125,000 copies per issue, and by 1978 its

4.7 Radials skateboard shoes, Makaha advertisement, 1978.

worldwide circulation was around half a million, with an estimated readership of two million.[16] A mixture of reportage, photography, interviews, product reviews, and advertisements, it was, as one British retailer suggested, "packed with action, colour and news" that kept readers "in touch with all that's new and hot!"[17] It made stars of a handful of Californian skateboarders, most notably the Z-Boys, a loose group associated with the Zephyr surfboard shop in Santa Monica who were the subject of several early articles.[18] Their photogenic, aggressive, and surf-inspired style of skating was hugely influential, as were their rebellious, countercultural attitudes and preference for skating empty pools. By the end of the decade, former Z-Boys like Stacy Peralta, Tony Alva, Shogo Kubo, and Jay Adams were internationally celebrated, considered "among the sport's vanguard," and frequently cited as inspirational figures.[19] The way they skated, the clothes and shoes they wore, and the poses they struck, all of which could be seen in magazines, influenced skateboarders around the world.

With the market for skateboard-related equipment on the rise, surf and skate companies launched a handful of shoes aimed at skateboarders. In 1976, Hang Ten advertised the Skateboarder, "the first shoe designed exclusively for the sport." Despite assurances that it was "designed for skateboarders by skateboarders," the new model was made of leather and had a thick rubber sole stiffened with a steel shank. It looked as though the designers had prioritized toughness over flexibility and skateboarders' need to feel the board beneath their feet. Despite the advertising claims, it appeared to be a style borrowed from elsewhere, hastily adapted to capture a new market. Makaha and Hobie branded shoes appeared in 1978. The Makaha Radial had nylon and suede uppers similar to those on Nike running shoes, and a rounded, molded sole intended to allow movement on a board. Makaha's advertising made familiar claims: "Now, you don't have to wear a remade sneaker or deck shoe . . . because we've built Radials for skating instead of walking. Radials' unique sole configuration (Patent Pending) is designed to achieve the ultimate responsiveness with maximum body flow. You get a faster new feel for your board. Try the REAL skateboard shoe." The Hobie, by contrast, was a rubber-soled canvas high-top that had the warning, "FOR SKATEBOARDING USE ONLY NOT DESIGNED FOR OTHER ACTIVITIES" stitched into the tongue label. Despite the label, bright blue uppers, and yellow and red trim, the Hobie was similar to simple canvas shoes from adidas, Puma, and Nike, all of which were sold for other activities. Cosmetic differences aside, the Nike All Court, a model intended for basketball and racket sports, was almost identical.[20]

4.8 (Above left) Skateboard shoes, Hobie advertisement, 1978.

4.9 (Above right) Skateboarder in Makaha Radials, Denver, Colorado, 1978.

The shoes from Hang Ten, Makaha, and Hobie reflected a trend toward increased specialization across the sports shoe industry and drew upon growing manufacturing expertise, particularly in Asia. By the early 1970s, factories in Japan, Taiwan, and South Korea offered generic sneaker and sports shoe designs that could be modified to meet wholesale buyers' specifications. Equipped with the machinery necessary for both traditional rubber-soled shoes and modern sports footwear, Asian producers were eager to find lucrative export markets and adept at transforming customers' ideas into fully realized shoes. As Blue Ribbon Sports (BRS) had discovered, low labor and production costs in Asia and cheap shipping meant shoes could be sold at an affordable price in the United States while maintaining high profit margins. Emerging skate companies followed the same offshore model adopted by BRS, improvising and making do with available designs but tweaking them to suit their customers' needs. Generic tennis, basketball, or training shoes were rebranded and remarketed as skateboard footwear after minor changes: a little more padding, tougher rubber compounds, and brighter colors. The Hobie shoe, for instance, was made in Taiwan and was most likely an adaptation of a standard high-top sneaker. A later Hang Ten shoe was virtually the same as a Nike model.[21] Imitation and copying were rife, and it was common for similar models to be produced for different brands.

Changes in the sports shoe industry meant the second generation of skateboarders had a wide selection of shoes from which to choose. *SkateBoarder* addressed the question of footwear in 1979. Buying a new pair of "tennis shoes," wrote Doug Schneider, was "[o]ne of the major dilemmas in the life of any skateboarder." He noted the existence of some "shoes that are made especially for skateboarding," but admitted that "[m]ost of the well known shoe companies, such as Adidas, Converse, Nike, Puma, have several styles which are ideal for skateboarders." He advised readers to consider price, materials, and the flexibility and tread pattern of different soles. In the final analysis, he urged readers not to "buy a shoe because it works for someone else—buy it because it fits your own style and needs. They're *your* feet—treat them right!" Similar advice was provided by the authors of a series of guidebooks that introduced young readers to the basics of skateboarding. Howard Reiser recommended "rubber-soled shoes or athletic shoes that do not have any heels." LaVada Weir suggested "shoes with non-slip soles. You can't beat sneakers. If your ankle needs more strength, wear high sneakers." Adrian Ball told novices to avoid "everyday shoes or boots" and wear "plimsolls—provided they offer a good grip—or the now popular 'training' shoes with high lace-ups which give some ankle protection." He also suggested "[l]eisure footwear intended to be worn when sailing." Glenn and Eve Bunting recommended tennis shoes, so long as the laces were tied. As all this advice suggested, for the majority of skateboarders, readily available shoes were good enough for skating.[22]

Films and photographs suggest the Hang Ten, Makaha, and Hobie shoes were less popular among skateboarders than those designed for other sports. The Makaha and Hobie models were worn by some elite Californian skaters, most likely recipients of free shoes, but were largely absent from images taken elsewhere. Either they were hard to find outside California or ordinary skaters preferred shoes made by other companies. For most, as the magazines and guidebooks suggested, shoes from adidas, Puma, Onitsuka, Converse, Pro-Keds, Nike, and a host of brands were acceptable alternatives. Pictures in magazines showed that shoes designed for tennis, basketball, or casual wear were reimagined as skateboarding footwear, and were just as suitable as those offered by Hang Ten, Makaha, and Hobie.

* * *

Among the many shoes pictured in *SkateBoarder* and other magazines, two brands appeared more often than any other. Vans and Nike shoes were worn by celebrities like Stacy Peralta, Tony Alva, Shogo Kubo, and Jay Adams and appeared regularly in

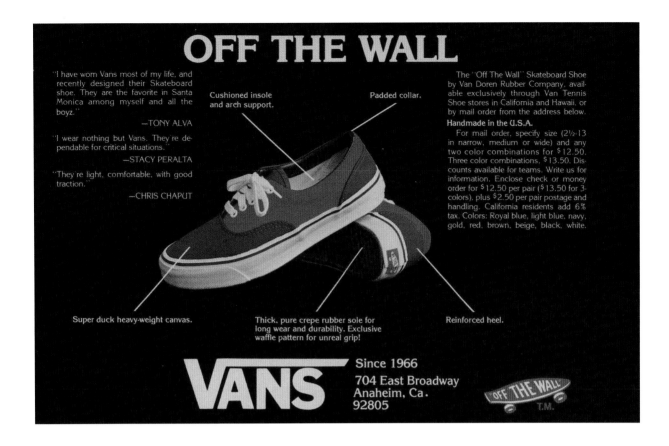

4.10 Vans #95, Van Doren advertisement, 1977.

action photographs and advertisements for other equipment manufacturers. For the southern Californian elite, they were almost a uniform. Yet the companies behind these shoes, the Van Doren Rubber Company and Blue Ribbon Sports, initially had little connection with skateboarding and did not produce shoes with skateboarders in mind. Their responses to skateboarders were instrumental in shaping perceptions of existing shoes and helped create the skate shoe as a distinct product category.

Paul Van Doren established the Van Doren Rubber Company in 1965 in Anaheim, California.[23] Born in 1930, Van Doren was raised in Massachusetts, the heartland of the American shoe industry, and began his working life on the floor of Randolph Rubber's Boston factory. He worked through the ranks to become an executive vice president and in the early 1960s was made responsible for the firm's Californian factory. He quit soon after and moved west permanently to establish his own business. His goal was to make shoes and sell them direct to the public, integrating manufacturing and retail. By doing this he could lower prices and increase profits. With backing from his partners, Serge D'Elia, an investor based in Japan, and Gordy Lee, who also had shoe manufacturing experience, Van Doren built a factory equipped with the sewing machines, rubber molds, and vulcanizing oven needed to make rubber-soled leisure shoes. In March 1966 he began trading from an attached store. The business expanded quickly, with Van Doren opening a new store almost

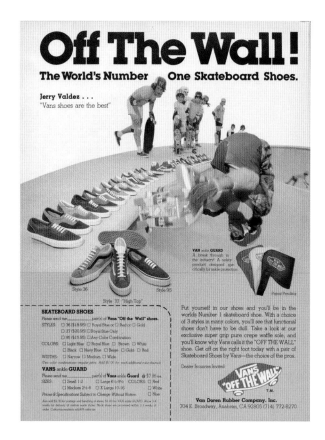

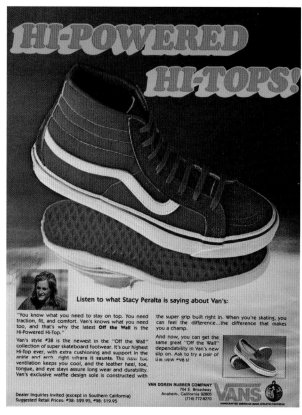

every week. Within eighteen months there were fifty across the region. By 1974, there were almost seventy. In promotional leaflets, the company advertised that customers could "save up to 50% at Vans' factory-direct prices," and for the next decade, Van Doren (or Vans) shoes were available only through Californian "House of Van" stores or by mail order.[24]

Southern California's warm weather and relaxed, sporting culture created a year-round market for casual footwear like Van Doren's. The range offered was simple: classic canvas and leather leisure shoes with chunky vulcanized rubber soles. The core men's shoe, the #44, was a simple, lightweight, canvas oxford deck shoe, similar to others produced since the 1920s. Climate and social habits shaped the Van Doren range, as did the plant installed in the firm's factory. Yet within the parameters set by its production capabilities, the firm catered to its Californian customers' desires. Different styles could be made by altering the size, shape, and pattern of the uppers, and by selecting differently composed and patterned rubber soles. The firm's stores allowed it to get close to its customers. Shoes were produced in small batches in response to individual whims and short-lived fashions. Personalized orders were taken from a palette of colors and fabrics. If certain combinations proved popular, larger batches were made and offered for direct sale. When Van Doren noticed people rejecting shoes because they did not like the materials from which they were made, he invited

4.11 (Above left) Vans #36, #37, and #95, Van Doren advertisement, 1978.

4.12 (Above right) Vans #38, Van Doren advertisement, 1979.

4.13 (Opposite) Van Doren advertisement, 1979.

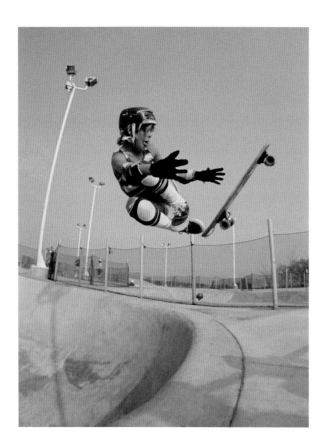

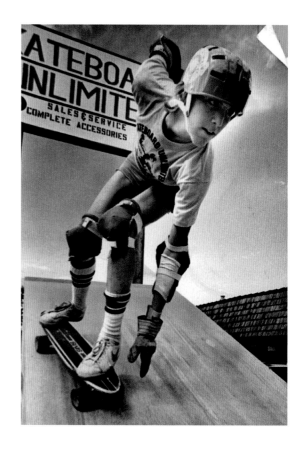

customers to supply their own fabrics. Similarly, complaints about the sole cracking easily led to the design being altered. Podiatrists recommended the firm because pairs could be made in different widths and sizes, and a specialty was made of multicolored shoes for high school, cheerleading, band, and drill team uniforms. This responsive business model—similar to that of adidas or Blue Ribbon Sports—contributed to the firm's regional success and allowed it to respond to new opportunities.

Van Doren's stores in southern California were ideally placed for young skateboarders seeking inexpensive flat-soled shoes. Tony Alva has said he wore Vans because "there was a little shop two blocks from my junior high school . . . and we were able to buy one shoe at a time." The influential Zephyr team of which he was a member wore dark blue Van Doren #44 for their public debut at the 1974 National Championships partly because Vans were popular among teenagers in the Santa Monica neighborhood where many of the team lived. That Vans shoes were easily obtained goes some way to explain their popularity among skateboarders, but the firm also unwittingly created shoes that were well-equipped for skateboarding. Van Doren's soft rubber soles provided just the right amount of grip and flexibility needed for skateboarding, while the shoes' robust construction meant they withstood abuse reasonably well. In *SkateBoarder*, Doug Schneider declared them almost perfectly suited to skating on account of their "fairly soft sole[s]," which enabled "more 'feel'

4.14 (Above left)
Skateboarder in Vans
at Skatopia skatepark,
Beuna Park, Los Angeles,
California, 1978.

4.15 (Above right)
Skateboarder in Nike
Denver, Colorado, 1977.

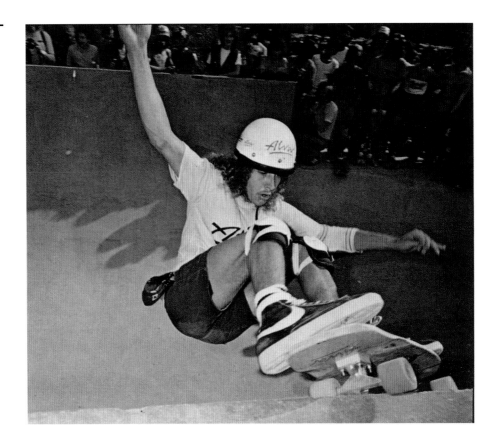

4.16 Tony Alva in Nike
Blazer, 1978.

of the board." Proximity, availability, and the physical nature of the Van Doren shoes
all contributed to the firm's popularity among the Californians who set the tone of
1970s skating.[25]

Van Doren responded to skateboarders as it did to its other customers, working
with them to create shoes tailored to their needs and desires. When Jim Van Doren,
Paul's brother and partner, was interviewed by *SkateBoarder* in 1978, he suggested the
firm "became involved in the skateboarding industry because it became apparent [it]
was already making a shoe that had proved itself with the skaters in California." He
put the popularity of Vans down "to their long-wearing and excellent grip features—
plus the fact that [skaters] could get them in different color combinations." Yet the
firm went further to cater to this new market. Its first skateboard-specific model, the
#95, was launched in 1976. Designed with Alva, it added foam and a reinforced heel
counter to the standard #44. Alva said he wanted to create "a more distinctive style"
for skateboarders, and that he "asked for a little more padding around the ankle and
some cool colors, that's all." The sole was the same as ever, but the shoe was offered
in eye-catching two-tone color combinations. A new skateboard logo and the slogan
"Off the Wall," a phrase Peralta and Alva used to describe pool skating, replaced the
standard "Van Doren" label on the heel. In advertisements in *SkateBoarder* the shoe
was endorsed by Stacy Peralta, Tony Alva, and Chris Chaput.[26]

The #95 was the first in a long series of Vans shoes designed with and marketed at skateboarders. In 1978, the #36 introduced a different upper with a "leather cap toe and heel, leather eyelets [and a] wild leather racing stripe" to Van Doren's standard rubber sole. The #38, in 1979, had a high top, extra cushioning in the ankle, and a hardwearing leather toecap and heel. Advertising claimed the "exclusive waffle sole design is constructed with super grip built right in" and suggested that "[w]hen you're skating, you can feel the difference . . . the difference that makes you a champ." By working closely with skateboarders, Van Doren identified which parts of the shoe were prone to wear when skateboarding and where extra support or cushioning was required. It saw, too, what was fashionable within skate culture. Through the simple use of additional padding and tougher, colorful materials, Van Doren created shoes uniquely tailored to skateboarders' needs. From a material perspective, these alterations were minimal. Yet through the imaginative application of its existing production capacities, and by carefully targeted marketing, Van Doren was able to transform fairly standard shoes into skateboarding shoes.[27]

Through its willingness to give shoes to top skateboarders, and as a result of its location in California, Van Doren ensured its products featured heavily in magazines like *SkateBoarder*. Even when only the bottom of the sole was visible, the firm's distinctive waffle tread meant Vans could be identified easily. Mail order coupons made this very local product available to a wider, global customer base. In this way, the firm became closely associated with skateboarding. By the end of the decade Van Doren was often considered a manufacturer of specialist skateboard shoes, which had become a sizable chunk of the company's business. Despite the company's accidental route into skateboarding, *SkateBoarder* dubbed Jim Van Doren the "[p]atron saint of skatefeet." By echoing the imaginative transformations already effected by skateboarders, Van Doren encouraged the spread of new ways of using and thinking about its products. Casual shoes from California came to be seen and used as specialist skateboarding footwear by skaters elsewhere.[28]

The parallel case of Blue Ribbon Sports (BRS) highlights producers' role in the diffusion of new ways of thinking about shoes. By the late 1970s, BRS was riding high on the popularity of jogging, and in the United States set the standard by which other running shoes were judged. Like Van Doren, Nike shoes were readily available in California. BRS had opened its first store in Santa Monica in 1966, and by the mid-1970s, Nike shoes were sold by a variety of footwear and sporting goods retailers. Among skateboarders, the most popular Nike models were the Blazer and

4.17 Shogo Kubo in Nike Blazer, Oxnard skatepark, Oxnard, California, 1978.

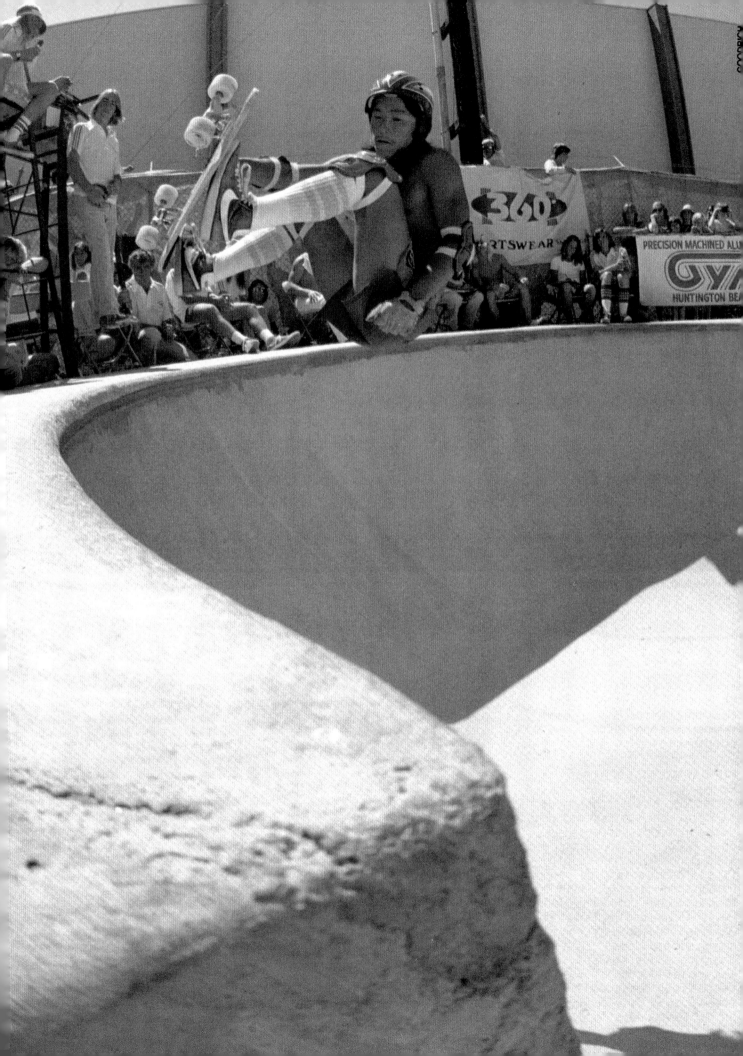

JANUARY 1981

$1.00

THRASHER

SKATEBOARD MAGAZINE ™

IN THE STREET TODAY

DOWNHILL SKATEBOARD RACING

GOLD CUP FINAL

Bruin, basketball models added to the range when the Nike brand was created in 1971. Unlike BRS's running shoes, these were generic, off-the-shelf designs made by Japanese manufacturers branded with the Nike swoosh logo. In basketball terms they were less advanced than rival adidas or Puma models, but their lightweight suede and canvas uppers, thin vulcanized rubber soles, and supportive ankle padding made them well suited to the needs of skateboarders, particularly as vertical skating in empty swimming pools, drainage pipes, and skateparks became popular. They were judged by *SkateBoarder* to be on a level with Van Doren. Alva called his "high-top Nike shoes" his "favorite safety equipment," because they protected his ankles when he fell and his board tumbled behind him. He wore Nike Blazers during a 1978 tour of Europe, in the movie *Skateboard*, and during the filming of *Skateboard Kings*, a BBC documentary. Shogo Kubo was another prominent skater frequently photographed in Blazers. During the late 1970s boom, Nike shoes appeared in countless magazine photographs and were worn by skaters around the United States. In 1981, the cover illustration of the first issue of *Thrasher*, the magazine that defined 1980s underground skate culture, was of a skater wearing a pair of Blazers.[29]

Unlike Van Doren, Blue Ribbon Sports did little to encourage their connection to skateboarders. Executives at the company were certainly not ignorant of skateboarding. Shoes were given to the cast of a skateboard film and in 1976 sales of Señorita Cortez,

YOUR SKATEBOARD.
A DOWNHILL SLALOM.
AND DUNLOP.

Skateboard Superstars* are the special skateboard shoe from the sports shoe specialist. Dunlop.

You get a sucker sole pattern for extra grip on the board. A vinyl collar for ankle support and protection. Strong 'Duralon' uppers and tough toe guard and toecap protection.

And from £5.50 they really are value for money. And the colours are really free. Ride on!

a women's running shoe, boomed after Farah Fawcett was filmed wearing them on a skateboard in *Charlie's Angels*. Yet despite this, BRS did not adapt its shoes for skateboarders or advertise in skateboard magazines. Instead, during the late 1970s, promotional work focused on strengthening the Nike brand with college and professional basketball players and coaches. Advertising for the Blazer concentrated on the connection with top ballplayers, not skateboarders. The firm instead reinforced its image as a supplier to more traditional, recognized sports. Although Nike shoes were popular with skateboarders, they were pitched primarily as basketball shoes, not skate shoes. While Van Doren embraced skate culture and skateboarders, Nike remained on the outside.[30]

❊ ❊ ❊

Southern California may have been its spiritual home, but in the 1970s skateboarding was not confined to America. In Britain, demand for skateboards began to be felt in 1976. Over two million were sold in 1977, and by 1978 forty-six commercial and municipal skateparks had been created.[31] This explosion of interest raised the possibility of additional sales for British footwear manufacturers and retailers. In August 1976, the trade journal *Footwear World* noted the growing popularity of skateboards and wondered whether there might be "a chance for the footwear industry to get in on what could

4.19 (Above) Skateboard Superstars, Dunlop advertisement, 1978.

4.20 (Opposite) Stunter skateboard shoes, Clarks advertisement, 1978.

These Boots are made for Skateboarding

When we decided to make a skateboarding boot we gave ourselves some headaches.

Because we didn't just take an ordinary boot and say it's for skateboarding.

Instead, we consulted two Sports Science Professors who analysed what was needed in a skateboarding boot.

Then we designed and made one to their specifications.

Around the vulnerable ankle bone we put shock-absorbing ribbed padding. For real protection and flexibility.

Inside the boots we built an arch support and padded tongue. After all, who needs bruised, flat feet?

Our natural rubber soles were given special forward ridging. For highly flexible gripping-power and positive contact with your board.

We also developed a specially strengthened wrap-around toe and heel. And extended the rubber to protect the sides and front of the foot.

Finally, we put together some really sharp styling in rugged natural canvas. To make you look as good as you feel.

See the result at your Clarksport Stockist.

Wrap Around Toe

Ribbed Ankle Padding

Wrap Around Heel

Forward Ridging

Clarks Sport

be a boom thing?" It urged the trade to capitalize on what might be a passing, but lucrative fad: skateboarding, it thought, "could be relatively short-lived" but "could be a splendid vehicle for promotional purposes." A handful of shoes aimed at skateboarders were launched by British manufacturers. Dunlop's Skateboard Superstars had a "sucker sole pattern," vinyl ankle collar, "Strong 'Duralon' uppers," and "tough toe guard and toe protection." They were similar in construction to the firm's other canvas and rubber sports models like the Green Flash. The British Bata Shoe Company introduced Marbot SpeedRites, canvas and rubber high-tops that were described in advertising as "specially designed for skateboarding" despite being broadly similar to the inexpensive rubber-soled canvas leisure shoes the firm made in its Essex factory. Clarks launched the Stunter, another canvas shoe with a padded ankle and tongue, a distinctive, "specially strengthened wrap-around toe and heel" and a rubber toecap. It was designed, Clarks claimed, in collaboration with "two Sports Science Professors who analysed what was needed in a skateboarding boot." In each case, these were simple vulcanized rubber-soled canvas models, modified to withstand the rougher wear of skateboarding. Marketing that cast them as specialist skateboard shoes gave them extra life, just as shoes like this were challenged in other sports by more sophisticated models.[32]

It could be debated whether the shoes produced by Dunlop, Bata, and Clarks served skateboarders well. To some observers, they looked like cynical attempts to cash in on a popular fad. When David Larder, the Director of Safety Education at the Royal Society for the Prevention of Accidents, was interviewed by *Footwear World*, he questioned whether there was any "real hard evidence that these new skateboard shoes are of any greater value." All a skateboarder needed, he thought, was "a good, well-fitting flat sports shoe with a non-slip sole." Those manufacturers "bringing out so-called skateboard shoes," he suggested, "are simply jumping on the commercial bandwagon." The British magazine *Skateboard!* offered its thoughts in October 1978. In a review of shoes available to British buyers, it compared the Clarks and Dunlop models against a Pro-Keds basketball sneaker, a Rucanor windsurfing shoe, and a Van Doren #95. Dunlop's shoe was described as "tough and well put together" and "worth considering." The Clarks shoe, however, was criticized for being "not very grippy" and having a "knobbly feel." The reviewers found it "hard to believe that a major manufacturer could get it so wrong." The Pro-Keds and Rucanor shoes were well received, but the ultimate praise was reserved for the Californian shoe. Vans were commended for their "ultra-grip," "sensitive contact," "classic style," and "good quality." The reviewers noted that they were "fairly pricey" but also that they were "widely used by the pros." In the end,

4.21 British skater John Sablosky in Dunlop Green Flash, 1978.

The Sports Shoe

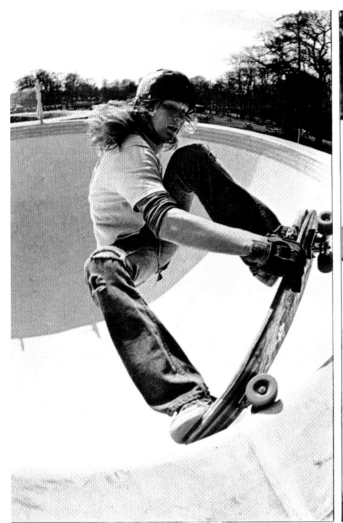

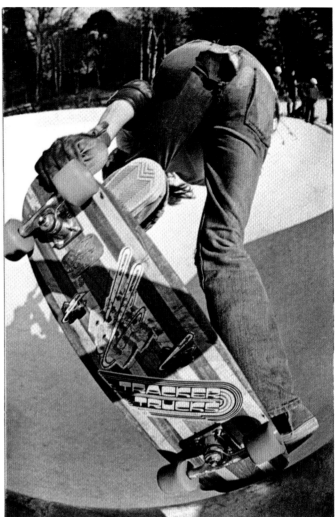

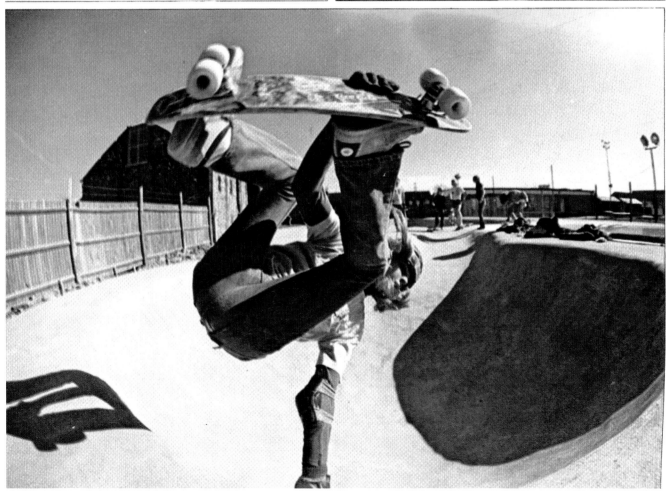

they were "worth buying." As *Footwear World* had recognized, the "youngsters buying shoes specifically for skateboarding are likely to be much more attracted to a padded, colourful California-style boot than to a traditional tennis shoe." Style and performance were of equal significance. British skateboarders aped Californian fashions despite the conspicuous absence of Californian sunshine.[33]

When it came to footwear, skateboarders in Britain needed to improvise just as much as their counterparts in the United States. The supply of skateboard-related products was limited, even when skateboarding was at its height, and Van Doren and other American shoes were hard to obtain or prohibitively expensive. *Skateboard!* advised readers that it was "not essential to purchase custom-made skateboard shoes" and that "a pair of standard tennis shoes" could "do the job very well." Those who wanted "maximum 'feel' when skating" were told to "go for thin soles." Most British skaters wore shoes that were available on the domestic market; in magazines, they were pictured in a variety of inexpensive canvas and rubber plimsolls and training shoes. One of the most popular was Dunlop's Green Flash tennis shoe, which in 1977 was widely available at "competitive prices." It was produced using the same vulcanization process as Van Doren shoes and had the flat, grippy sole and ankle padding preferred by riders. Retailers encouraged the reevaluation of existing sports footwear. One of Britain's leading suppliers of skateboard equipment advertised "two ideal skateboard shoes both featuring flat, flexible soles and extra reinforcements" specially "selected" for skateboarding. One, the blue suede Lotto Magic, was a sports training shoe produced by an Italian firm. The other, the nylon and suede Patrick Road Runner, was a French firm's attempt at an American-style running shoe. Neither was designed with the skateboarder in mind.[34]

By 1978, when British shoes became available, the popularity of skateboarding in Britain was fading. Clarks, Dunlop, and Bata skateboard shoes were short-lived attempts to capitalize on a booming market. With the exception of adidas, which launched the short-lived Superskate and Skate models in 1979, just as skateboarding in Europe declined, the larger sports shoe companies ignored skateboarding. As interest collapsed the small dedicated hardcore of British skateboarders were left to adopt shoes created for other purposes and resorted to inexpensive models available in British sports shops. For those who had the money, a pair of Vans imported from the United States were a mark of dedication; for those who did not, especially in the early 1980s, inexpensive training shoes produced by Dunlop, adidas, Puma, and other companies were an adequate alternative.[35]

✳ ✳ ✳

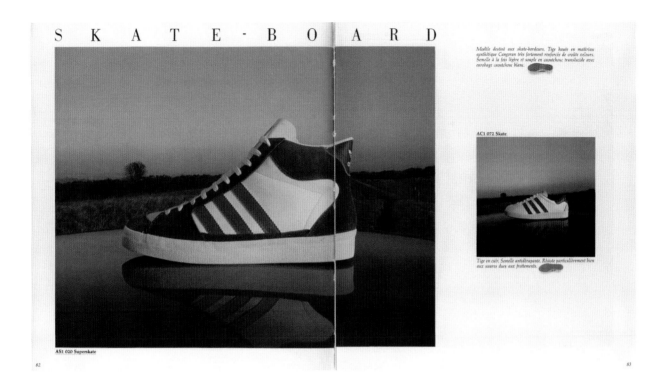

SKATE·BOARD

Modèle destiné aux skate-bordeurs. Tige haute en matériau synthétique Cangoran très fortement renforcée de croûte velours. Semelle à la fois légère et souple en caoutchouc translucide avec enrobage caoutchouc blanc.

AC1 072 Skate

Tige en cuir. Semelle antidérapante. Résiste particulièrement bien aux usures dues aux frottements.

AS1 020 Superskate

82 83

4.22 Superskate and Skate, adidas catalogue (France), 1979.

Through the 1980s and 1990s, skateboarding survived as a self contained underground youth subculture, largely outside the mainstream of popular sport. In 1983, the English Skateboard Association estimated there were just five thousand skateboarders in Britain; *Skateline*, the magazine of the Scottish Skateboard Association, had a circulation of fourteen hundred copies in Britain and Europe. Skateboarding receded to the margins, kept alive by what the Sports Council described as "a steady following of young enthusiasts." Skateboarders around the world continued to wear shoes designed for other sports, including the bestselling, but over-ordered, Nike Air Jordan and the Converse All Star. Van Doren, meanwhile, continued to work closely with skateboarders and produced several shoes tailored to new styles of skating, becoming ever more closely identified with skateboarding. According to the celebrated skateboarder Tony Hawk, in the mid-1980s, "you could tell a skater by sight. They might . . . have been wearing dirty jeans and Vans . . . if you were wearing Vans in '86, you were a skater." In Britain too Vans were a way by which skaters identified each other. As the firm struggled to compete with cheaper imported shoes, the skateboard market became ever more important in its survival.[36]

During the 1980s, Van Doren was joined in the skateboard market by a series of newer rivals. The most significant was Airwalk, a brand launched in 1986 by the footwear company Items International. The company's owner, George Yohn,

had been in the footwear industry for over thirty years, and since 1977 had worked with Asian factories to supply unbranded shoes to American department stores and footwear chains. Its president, Bill Mann, had been a buyer for athletic equipment and women's shoes at large footwear retailers. In the early 1980s, the two decided to build a line of branded shoes, which offered double the profit margins of the company's other business. Inspired by the growth of the athletic shoe market, they first attempted shoes for aerobics, running, and tennis before, through Mann's wife and eleven-year-old son, they came to skateboarding. Collaborating with an Australian skateboarder who worked at the Carlsbad skatepark in California, Mann and Yohn created a brand designed to appeal to young, male skateboarders.[37]

The first Airwalk shoes were similar to Vans, with chunky vulcanized soles and brightly colored uppers, but were made in Asia at a fraction of the cost. They were reinforced and padded in the places most likely to get worn when skating, and, because Mann's son had complained of being bored by white sneakers, were distinctively styled, with an arresting mix of graphic prints and colored materials. The later Prototype series used the same production techniques as was used on specialist basketball and tennis models and drew inspiration from basketball shoes like the Nike Air Jordan. The new brand was sold through specialist skate and surf shops and was advertised heavily in skate magazines. With the endorsement of Tony Hawk, the top skater of his generation, and a professional team, the brand was an almost immediate success. Within a year, Items International was selling millions of pairs around the world.[38]

Airwalk was among the first of a series of brands that in the late 1980s and early 1990s targeted skateboarders. While the larger sports shoe producers ignored skateboarding, smaller companies, many of them rooted in skate culture, defined the skate shoe. Vision Street Wear, Etnies, DuFFS, and the DC Shoe Company embraced offshore production and contracted Asian factories to make shoes to their designs. Existing production methods and popular sports styles were harnessed for skateboarding. New features and design elements were added to meet skateboarders' tastes and physical requirements. Playing around with cushioning and padding, the skate brands worked with the parameters of what was possible, pushing at the edges to create styles and functional shoes that appealed to the skateboard market. The resulting shoes blended styling with technicality. Like Vans and Airwalk, they were designed to look different from those created for more traditional sports, reflecting skateboarding's outsider status and attitudes. The shoes were available in specialist, independent shops, helping create a culture of consumption that existed almost entirely separate from the mainstream.

4.23 Mike McGill in Vans, 1985.

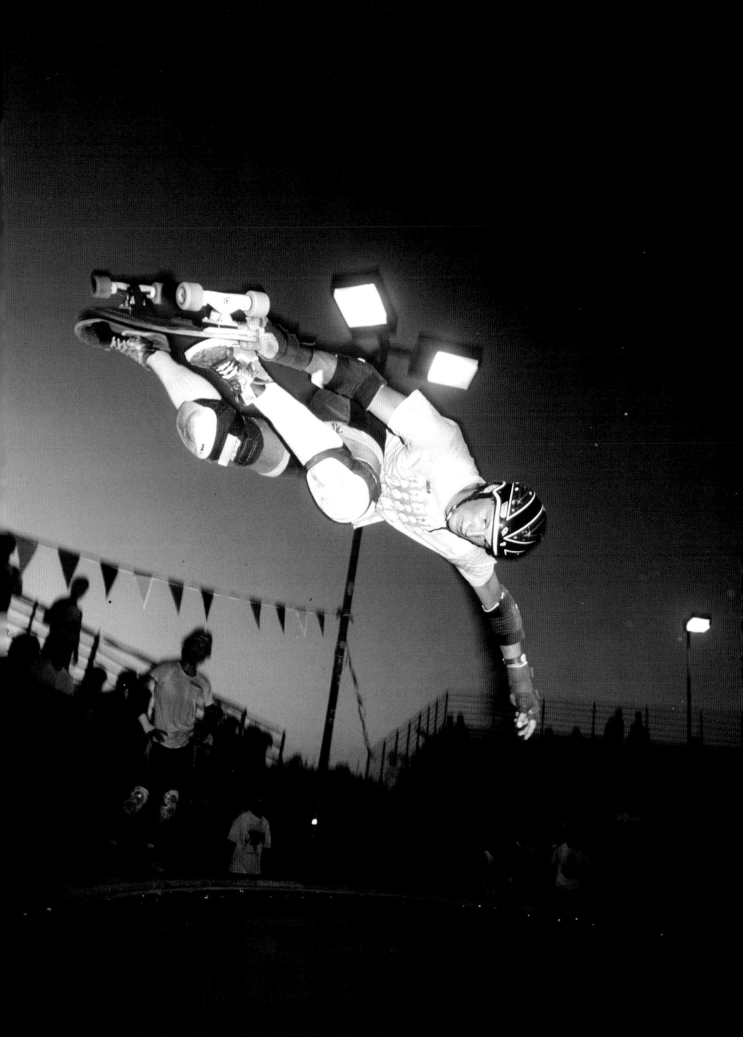

Although the skateboard shoe market became as crowded as that for tennis, basketball, or jogging, the brand names and producers within it were not those that dominated other sports, while the popular aesthetics bore almost no resemblance at all.[39]

During the early 1990s, skate shoes were gradually incorporated into mainstream fashions. Skate style was associated with a wave of bands with roots in the American punk scene and in 1995 featured in *Kids*, Larry Clark's controversial film. Style magazines like *The Face* featured brands that were available only through specialist shops, bringing them to the attention of wider audiences outside skateboarding. In London, the youth fashion trade show 40 Degrees incorporated skate displays. The companies that produced skate shoes embraced the opportunities offered by the mainstream, and models from Airwalk, DC Shoes, and Vans achieved wide sales.[40] The outsider aesthetics and edgy cool cultivated by these brands meant they were easily appropriated as a symbol of youthful rebellion, or a rejection of more conventional styles, especially those associated with mainstream sport. For the shoes, however, this move toward everyday, nonspecific use was perhaps a return to the roots of the skateboard shoe. They had evolved from basic leisure and casual shoes, and so could be returned easily to everyday use.

❋ ❋ ❋

As Victorian tennis shoemakers recognized, by moving products from one practice to another and using things in new contexts, consumers generate new ways to understand objects. The development of the skateboard shoe as a category within the sports footwear industry demonstrates, however, that the spread and diffusion of these meanings is to a large degree dependent on them being echoed and restated by producers. Skateboard shoes grew out of shoes made for other purposes; the earliest examples were simply existing models, intended for other activities and consumer groups, given a slight makeover and repackaged to appeal to the skate market. Yet by doing this, producers replicated and commodified what skateboarders had themselves begun. By using and thinking about existing shoes in new ways, assessing them by criteria that had not been considered by their makers, skateboarders reconceived ordinary shoes as skate shoes. Producers followed their lead. The imaginative transformation of products and the subsequent creation of new product categories and specially designed products begins with the actions of consumer-practitioners, but it is reinforced and completed with producers' complicity. As skateboarders demonstrated, by improvising with available products and production methods, the originators of practices initiate processes by which new ideas and specially designed products are established. A similar process was underway elsewhere in the United States in the 1970s, though in this case the ways of thinking about shoes moved beyond physical recreation entirely.

4.25 Skateboarder in Airwalk Prototype shoes, Portland, Maine, 1989.

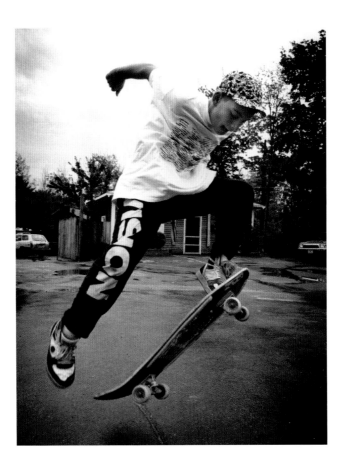

5

Sneakers, basketball, and hip hop

Christmas Rap was released by Profile Records in late 1987. A compilation of festive rap songs, it was designed to cash in on the popularity of Profile's biggest act, Run-D.M.C., and the international success of rap music. Like most compilation albums, the sleeve was something of a compromise. None of the artists involved were shown; instead, a pair of adidas Superstar basketball shoes were photographed amid the detritus of Christmas Day.[1] This was a reference to Run-D.M.C., who were known for wearing adidas. Yet, and as the label's white bosses would have appreciated, these shoes, made in France by the German firm, were also visual shorthand for hip hop in general. To many potential buyers, they signified the music of a largely African American and Hispanic youth culture that emerged from New York City in the late 1970s. Somehow, the connection to basketball, the game for which the model was initially intended, had faded into the background.

Sports shoes had, of course, long been associated with ideals of youth and adolescence, but these links to music and a specific cultural movement were new. They occurred as part of a wider process of appropriation and repositioning. Through the 1970s and 1980s, as sales of sports footwear increased in western markets, technically advanced models slipped into general use. Modern, specialist shoes joined older, more traditional forms of sports footwear as fashionable everyday shoes, creating conditions in which a broader set of cultural associations could accrue around the product. Sports shoes developed a symbolic power beyond that imagined and cultivated by producers, and became desirable in ways sports shoe companies could barely have envisaged. In a global marketplace, firms selling sports shoes were frequently left behind, if not bewildered, by the values consumers attached to their products.

In New York City in the 1970s and 1980s, adidas and Puma shoes became more than sports equipment. For many teenagers, they were highly desirable status symbols, visual expressions of cultural alignment, a crucial element of an idiosyncratic urban style. These shifts in perception took place against a backdrop of rising consumption and the prominence of sport as leisure and professional entertainment. They were unintended consequences of sports-based marketing, and an outcome of changes within sport and industry. When consumers came into contact with German sports shoes, the associations cultivated and encouraged by the companies that made them often mutated into something quite different. Shoe producers were made to adapt by consumer actions, but ultimately incorporated new ideas about sports shoes into their promotional strategies.

* * *

5.1 *Christmas Rap*, Profile Records, 1987.

RUN-D.M.C. · DANA DANE · KING SUN-D MOËT · SWEET TEE SPYDER-D · DEREK B · DISCO 4 · THE SHOWBOYS · SURF M.C.'S

Adidas and Puma came late to basketball. The game was invented in 1891 by Dr. James Naismith, a phys-ed instructor at the School for Christian Workers in Springfield, Massachusetts, who sought a competitive indoor game for the New England winter that also took advantage of the YMCA's recent building boom. It required relatively little equipment—a ball and two baskets—and could be played in gymnasiums and dance halls. Promoted by the YMCA, basketball spread quickly through the industrial cities of the north and midwestern United States, where limited space and cold winters made outdoor sports difficult. Professional teams played in dance halls and other venues, but most commonly it was played informally or in local contests organized by high schools, colleges, and the YMCA. The game had a wide appeal, and, partially because even the smallest schools could field a five-person team, for most of the twentieth century it attracted more participants than any other American sport. Yet it was not until the 1930s that professional basketball began to rival the popularity of the amateur game, and only with the creation of the National Basketball Association (NBA) in 1949 that a professional competition commanded the same respect as college tournaments. The arrival of television in the 1960s raised the profile of both sides of the game, and by the end of the decade it was firmly embedded within national TV schedules, moving gradually to the heart of American popular culture.[2]

The game was especially important in New York City, which was a national hub for the college game. The New York Knickerbockers were one of the oldest, most respected teams in the professional game, and the amateur, informal game was celebrated as an essential part of city life. By the early 1970s hundreds of amateur leagues had been established in cities across the United States. In New York, the construction of outdoor public courts, often attached to postwar housing projects, made the game easily accessible and meant in summer it could be played outside. In the postwar years, basketball players became local heroes, and thousands flocked to see tournaments at the Harlem Rucker and other playgrounds across the city. Countless players graduated from the city's public courts to the college and professional leagues, becoming role models for younger generations.[3]

Basketball players needed to be able to run, turn, and stop at speed on slippery surfaces. Like tennis players, they needed shoes that provided support and grip. At first players wore the soft leather-soled shoes that were standard in gymnasiums, but by the late 1890s many had swapped to high-cut rubber-soled tennis shoes. These provided better grip on wooden courts, more support, and greater protection against the rough and tumble of the early game.[4] Specialist basketball shoes were advertised in the 1900s but they remained similar to shoes marketed as for tennis. As basketball became firmly established, rubber manufacturers introduced the first basketball shoes with high

5.3 Basketball shoes, Converse Rubber Shoe Company leaflet, 1920.

canvas uppers, top-to-toe lacing, rubber toe caps, and vulcanized rubber soles encircled by strips of rubber foxing.

For the first half of the twentieth century, two manufacturers dominated the American basketball market: United States Rubber and Converse. According to United States Rubber advertising, Keds were worn during the 1920s by the Original Celtics, the dominant early professional team, and by the Hillyard Disinfectant Company Shine-Alls, the Amateur Athletic Union champions in 1926 and 1927. As the professional game expanded in the 1950s, the brand was promoted by George Mikan, the Minneapolis Lakers player who most shaped the early NBA.[5] Converse Rubber launched the All Star basketball shoe in 1917, and in 1922 published its first annual basketball yearbook. Teams from around the country submitted photographs of themselves, which were included so long as they showed the majority of players wearing Converse shoes. From 1932 it included Charles "Chuck" Taylor's selections of the nation's top players. Taylor was a player turned Converse salesman, who for more than twenty years worked tirelessly to promote the game and Converse around the country. His name was added to the All Star in 1934 in recognition of his efforts, and it was partly because of him that the model became an industry standard, worn by almost all college and professional players. Converse worked closely with coaches to produce a shoe suited to the game. In 1924 the company declared it had "employed its resources in developing a type of

5.4 All-Star basketball shoes, Converse advertisement, 1929.

footwear that would make possible a better, faster game, so that Basketball might take its rightful place among the country's major sports." Supplements to the yearbook listed coaches' endorsements and showed features introduced for the game: cushioned heels and arches, a "Peg-Top" canvas upper, eight-ply toe construction, and a smooth toe lining. Almost fifty years after the model was introduced, advertising still proclaimed it "America's No. 1 Basketball Shoe . . . worn by winning U.S. teams for 8 straight world titles since the first Olympics of 1936." Neither Converse nor United States Rubber did much to alter the parameters of basketball shoe design once they were established, and with few alternatives available, basketball players and young, casual wearers made the canvas rubber-soled sneaker an enduring success.[6]

Executives within the rubber industry perhaps saw no need to tamper with a successful product, but by the 1960s elite players were becoming unhappy with shoes that had barely altered for half a century. Basketball began as a relatively regimented, floor-based sport that emphasized quick passing and shooting from a standing position. Rule changes, the development of the jump shot, and the arrival of black players who brought with them a flamboyant style of play honed on city public courts, meant that by the 1960s the elite game was quicker, more aerial, and more improvisatory than ever before. The rise of the professional game and the arrival of television meant basketball was becoming a serious business. As players became physically taller, heavier, and

stronger, and the play harder, the shortcomings of traditional basketball footwear were exposed. Foot and ankle injuries were endemic, and the uppers caused discomfort and pain; John Wooden, the most influential coach of the 1960s and one of Taylor's earliest all star selections, complained that on every pair of All Star he had to cut the seam over the little toe to prevent his players developing blisters. American manufacturers did little to accommodate players' shifting needs. Innovation was stymied by the rubber companies' focus on rubber, the high cost of machinery, and tariffs on imported footwear which ensured American firms dominated the domestic market. In comparison to the shoes being developed in Germany, American basketball shoes of the 1960s were relics from another era.[7]

❊ ❊ ❊

In Germany, the Dassler firms had shown a willingness to embrace new materials and technologies if they could be harnessed into shoes that aided athletic performance. The limited popularity of basketball as a spectator event and a participation sport in their principal European markets, however, meant basketball shoes offered neither the mass market sales of soccer and training products, nor the prestige that came of being linked to elite track and field athletes. Through the 1950s, the primary adidas shoe for basketball was the All Round, a multipurpose high-top blue leather training shoe with a welted sponge rubber sole intended—as the name implied—for a range of activities.

5.5 U.S. Keds, United States Rubber advertisement, 1957.

Adidas moved more fully into basketball in the 1960s, partly as a result of internal politics within the family business. In 1959 the firm bought a struggling shoe factory in Dettwiller, a village in French Alsace, to make soccer boots for the German market. It was managed by Adolf's twenty-three-year-old son, Horst. His ambitions were growing after his stint giving away shoes at the 1956 Melbourne Olympics, and out of sight of his parents he transformed the French factory into an almost entirely separate business. Additional plants were acquired from struggling local manufacturers, contacts with French sportsmen were cultivated, and an attack on the French market was launched. New models were introduced that rivaled those made in Germany, and independent production agreements were established with suppliers in Spain and eastern Europe. According to Karl-Heinz Lang, one of Adolf's assistants in the 1970s, the two sides "acted like two different companies challenging each other[;] there was a kind of competitive spirit going on." By 1968 Horst controlled a separate administrative hub and eight French factories.[8]

Horst pushed adidas in new directions. He started making shoes for sports that had been ignored by his parents, and began to embrace the growing leisure-oriented market. One of the first indications of his ambitions was the Haillet, a new tennis shoe developed in the mid-1960s with the French professional, Robert Haillet. Much like basketball, tennis was dominated by rubber companies, and tennis footwear had remained largely unchanged since the 1920s, when canvas shoes with vulcanized rubber soles became standard. Rival manufacturers produced models of various grades, but the materials and principles of construction remained the same. With the Haillet, adidas France introduced a new design paradigm, made possible by the use of new materials, machinery, and production techniques. The shoe had a white oxhide lace-to-toe upper (similar to American basketball shoes) with a reinforced heel support and padding around the collar. Instead of stripes, it had three lines of perforations on each side of the uppers. The sole was a newly developed molded unit, cemented and partially stitched to the upper. In terms of performance, the shoe was a revelation. It provided better grip and support than other shoes and quickly became the model of choice for serious players, including many professionals. Perhaps more significantly, it also offered a route into the vast American casual market. After the reduction of tariffs on imported footwear in 1966, adidas was presented with an opportunity to dramatically increase its share of the American market. The simply styled, flat-soled, white Haillet was perfect for leisure or everyday wear. Indeed, after Haillet retired in 1971, the model was renamed after Stan Smith, the American Wimbledon champion, and became one of the bestselling sports shoes of all time, a testament to the flexibility of its design.[9]

5.6 All Star basketball shoes, Converse advertisement, 1965.

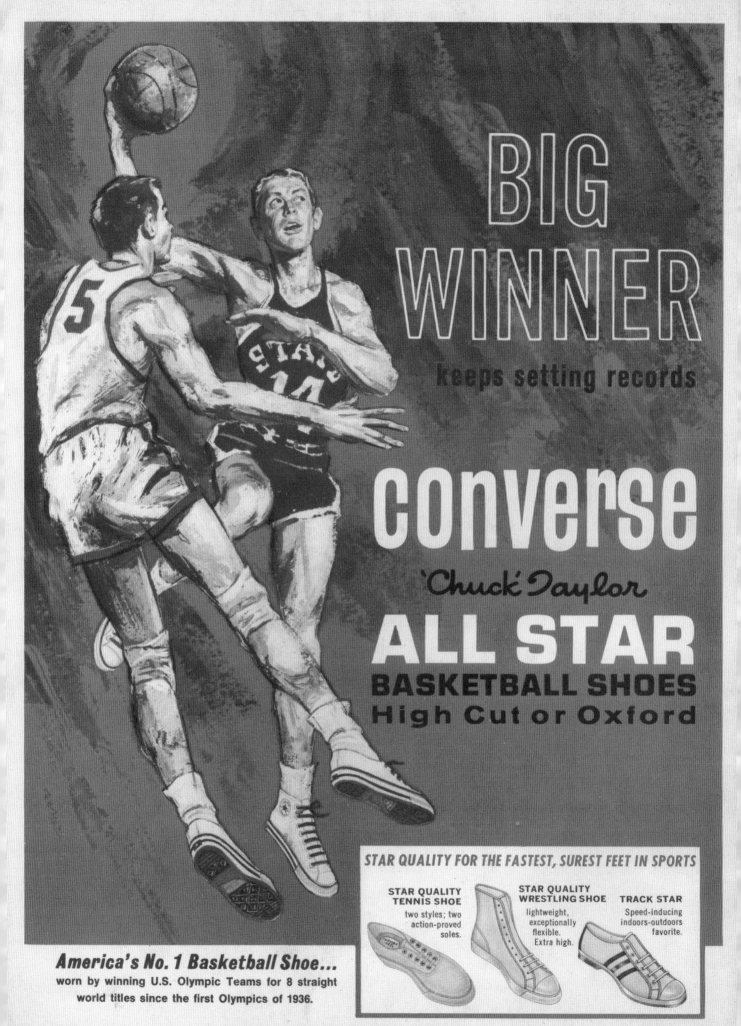

115030 "Haillet"
A top class leather tennis shoe worn by the world's best tennis players. Extremely light and comfortable soft white leather uppers form instantly to the shape of the foot.

Elegant styling with lace-to-toe derby cut (1). SOFT-PROTECT foam padding surrounds ankles (2) heel and achilles tendon (3). adidas has developed an extremely longwearing shell sole (4) with an unusual non-skidding design (5). Hundreds of tiny rubber nobs provide excellent footing on all types of tennis surfaces. Adjustable adidas arch support (6), elastic nylon heel counter (7). Look for the distinctive adidas heel patch (8) as your sure sign of quality.

USA DAVIS CUP TEAM
L-R Stan Smith, Donald Dell, Arthur Ashe, Bob Lutz.

5.7 Haillet tennis shoes, adidas catalogue, 1971.

Adidas France developed its first basketball shoes at the same time. As one of the "big three-and-a-half" of American sports, basketball promised prestige and significant sales, especially if the casual market was taken into account. Chris Severn, an adidas consultant in California, noted the lack of innovation among American manufacturers and urged Horst to respond to the latent desire for better footwear. Severn had played basketball and was aware of the shortcomings of shoes like the All Star; their soft rubber soles led to heel bruises and blisters, the canvas interiors became soaked with sweat, and they did not always provide the best support or grip on court. With Severn guiding the process and testing prototypes, the French factory set about creating shoes tailored to the needs of American basketball players. Firmer, herringbone-patterned rubber outsoles provided better traction. Chrome leather insoles were less likely to become wet with perspiration. Stiff plastic heel counters helped hold the foot in place. At first, the new shoes had soles cemented in place and reinforced with rubber foxing, but these were later replaced with all white molded rubber units, stitched and cemented to the uppers. As on the Haillet, a lace-to-toe design reminiscent of the All Star and Keds was used. Three stripes contrasted against the white uppers and ensured adidas advertised itself in press and television pictures. Eventually, a distinctive ribbed rubber "shell" toe-cap was added. This was developed for tennis—it protected against wear when players dragged their feet—and served a similar function within basketball. It

The Sports Shoe

was also a neat visual reference to the rubber toe-cap on traditional canvas basketball
shoes that helped make the shoes appeal to American tastes. The new basketball
models closely resembled the Haillet. The component pieces were alike, many of the
individual operations performed in their construction were identical, and they were
constructed around similar, if not the same, lasts. The similarities in design reflect the
comparable physical needs of players of basketball and tennis, but also showed adidas's
desire to make the most of its production equipment and expertise.[10]

The new basketball shoes, named the Supergrip and Pro Model, were introduced
in the mid-1960s. Although adidas described them in 1968 as "The most advanced
basketball shoe[s] yet produced!," in their intended market they received a hesitant
welcome from coaches and players more accustomed to American shoes. Severn pitched
them to NBA coaches, who were responsible for their players' footwear, but could only
persuade Jack McMahon of the newly formed San Diego Rockets to try them. The
Rockets duly wore adidas during the 1967–8 season, their first in the NBA. Out of
sixty-seven games, the team won only fifteen, making them the lowest placed and least
successful in the NBA. For adidas, it was hardly an auspicious start, yet it brought the
exposure the firm desired. The Supergrip and Pro Model were seen in professional
basketball arenas around the country, and when Rockets players recommended the
new shoes to their professional counterparts, demand started to grow. Amateur players

on the Olympic squad also saw German shoes at the 1968 games. A trial of the shoes checked many coaches' and players' doubts; as adidas claimed in 1971, "Most players are immediately surprised by the unusual lightness and instant comfort." The following season, the Boston Celtics, the leading professional team, wore adidas to victory in the 1969 NBA Championship, and John Wooden switched his similarly successful UCLA Bruins from All Star to adidas. These were watershed changes. Orders multiplied. In 1970 the Supergrip was lightly revised and renamed: if Converse had the All Star, adidas now had the Superstar. By 1970 adidas could legitimately claim it was "Worn by the best basketball players in the World." By 1973 around 85 percent of professional and many college players wore adidas. Around 10 percent of the firm's overall sales were basketball shoes. With it, Horst successfully launched adidas on the American market.[11]

5.9 (Above) San Diego Rockets, 1968.

5.10 (Opposite) San Diego Rockets v Los Angeles Lakers, December 1967.

* * *

As one side of the Dassler family extended its dominance to American basketball, the other sought to keep up. Rudolf Dassler's Puma was always the less successful of the two companies that in 1948 emerged from Sportsschuhfabrik Gebrüder Dassler. When John Underwood from *Sports Illustrated* visited Herzogenaurach in 1969 he compared the creaking floors of Puma's "big old building" to the "streamlined" adidas factory across town; it was easy to "tell [the] contrast in success." Perhaps because Adolf was a

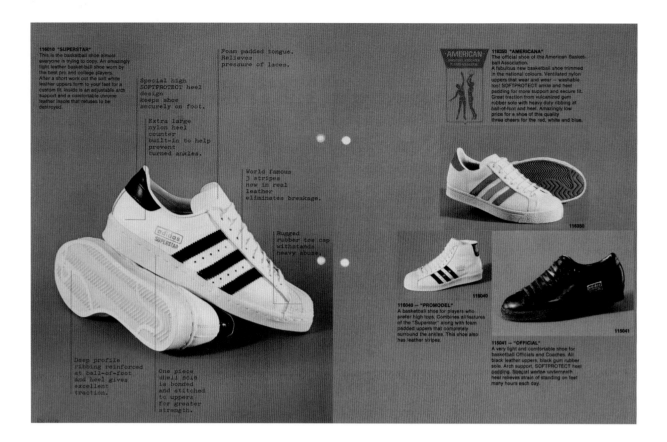

5.11 Basketball shoes, adidas
catalogue, 1972.

dedicated shoemaker, his firm had the edge when it came to technological innovation
and production expertise, and so found favor with elite sports men and women;
adidas could make shoes to a higher standard than Puma. Rudolf told Underwood
his company needed to "produce better shoes, new ideas and explore other areas" if
it wanted to match adidas. Puma had paid athletes as a way to retain a presence on
an elite level, but after posting a loss in 1968 and the *Sports Illustrated* exposé of huge
clandestine payments at the Mexico City Olympics, the firm developed an alternative
approach. While adidas kitted the majority of top athletes, in the 1970s Puma focused
on deals with a handful of high profile stars.[12]

Among the athletes Puma contracted was Walt "Clyde" Frazier of the New York
Knicks, who was given a sponsorship deal in 1970. Frazier has said his initial contract
was for $5,000 and as many shoes as he wanted; others have valued it at $25,000
per year, with a royalty of 25 cents on every pair of signature shoes sold. Whatever
the sums involved, it was a first for basketball. As Frazier later remembered, top
players "got lots of free shoes" but before Puma came along "no-one got paid for it."
Puma issued him with the Basket, the firm's answer to the Superstar. It was a leather
lace-to-toe model with a cemented molded sole unit and black Puma "formstrip."
More accustomed to canvas sneakers, Frazier complained that the shoe was heavy
and inflexible so Puma developed a lighter suede version that he wore from 1972.

Frazier had been known to customize his standard white All Star with orange and blue laces that matched his Knicks uniform. Puma went a step further and created shoes for him in combinations of orange, blue, and white suede. Clearly identifiable in color television and magazine pictures, Frazier's shoes were a wild contrast to the predominantly white shoes worn by most players.[13]

Clyde was a star. One of the best players of his generation, he was as celebrated for his extravagant dress sense off the court as he was for his skills on it. His nickname came from the 1967 film *Bonnie and Clyde* and referred to his calm, gangsterish demeanor and ability to steal the ball from opponents, but also to his penchant for 1920s-style headgear. *Rockin' Steady: A Guide to Basketball and Cool*, a book for young fans on which he collaborated in 1974, opened with a chapter on "Cool" and closed with a "general guide to looking good and other matters." Readers were treated to Frazier's views on clothing and personal grooming and a page of "Wardrobe Stats" that listed his suits, pants, shirts, shoes, belts, coats, hats, and jewelry. Yet Frazier remained rooted in the black experience. *Rockin' Steady* recounted memories of growing up as the eldest of nine, when "sneakers were the hottest thing in my wardrobe." The book began with a description of how as a child he washed his "sneakers with soap and brush almost every night so they would be bright and white by morning," and how he was "very exact how I laced them when I went to play basketball in the dirt schoolyard in Atlanta." Photographs showed him riding the subway and playing ball on New York's graffitied public courts. They were situations that would have been recognizable to many young readers. His image of cool, black hipsterdom drew on a heritage of African American style and found contemporary parallels in blaxploitation cinema, pulp fiction, television crime drama, and funk music. With the Black Power movement in full swing, he was an icon of African American success at a time of growing cultural awareness and pride.[14]

Frazier was the kind of superstar Puma needed to build its American presence and maintain parity with adidas. Even his name was a synonym for success; according to one journalist, on New York's public courts, "when guy[s] start to call you Clyde . . . that means you're a hot shot." His celebrity raised Puma's profile, and ensured its shoes appeared in television, newspaper, and magazine images. Brightly colored suede versions of the Basket—though not the Knicks colors worn by Frazier—were launched on the general market around 1972–3. The model was renamed Clyde in Frazier's honor. It had Frazier's signature gold-blocked on the side and was sold in boxes bearing his smiling portrait. Initially, catalogues referred to the shoe as the

"Clyde by Walt Frazier," as though he had designed and made it himself. Catalogues listed the shoe's technical features, but unlike adidas models, it was sold as an everyday casual shoe as much as specialist athletic footwear. Advertisements referred to it as a "leisure" shoe and suggested it was appropriate for on- and off-court wear. One, from 1973, showed a casually dressed Frazier with his arms around three white boys, with the caption: "On or off the court Clyde Frazier appreciates the comfort and support of Puma's full line of leisure and basketball shoes. Like the comfortable Clyde Frazier shoe shown here." Puma's greatest innovation was perhaps making the shoe in brightly colored suede. Although the colors were ostensibly to match on-court uniforms, they opened up a new realm of sartorial possibility. As advertising suggested, they could be worn off-court with the relaxed, casual, leisurewear becoming popular with men and women across the United States. European buyers may have become accustomed to red, blue, and green leathers of German sports shoes, but for American consumers raised on monochrome sneakers like the All Star, this was a startling development. The shoe was a means to get close to Clyde, to walk and run in his shoes, but also a new, more vibrant form of everyday footwear.[15]

American manufacturers were left reeling by the arrival of adidas and Puma. *Sports Illustrated* noted in 1969 that "Converse is concerned with the inroads adidas is making in basketball," and that American firms were struggling to cope with German competition. German shoes, particularly the Superstar, transformed basketball shoe design and construction (even though they borrowed stylistically from older shoes). With some accuracy, adidas described the Superstar as "the basketball shoe almost everyone is trying to copy." From a competitive sports perspective, canvas was dead. Converse and Uniroyal (United States Rubber renamed) introduced suede and leather versions of their traditional vulcanized models—both companies initially tried to copy adidas's trademarked three stripes—but it was not until the launch of the Converse All Star Professional in 1976 and the Pro-Keds Royal Master in 1977 that American companies started selling leather shoes with sole units like those on the Clyde and the Superstar. By this point, however, the German companies were at work on replacements for their aging basketball stalwarts. In 1979 adidas launched the Top Ten, a $100-shoe created in collaboration with basketball professionals. The model established a new template for basketball footwear, replacing the Superstar as the shoe to copy and leaving American manufacturers far behind.[16]

* * *

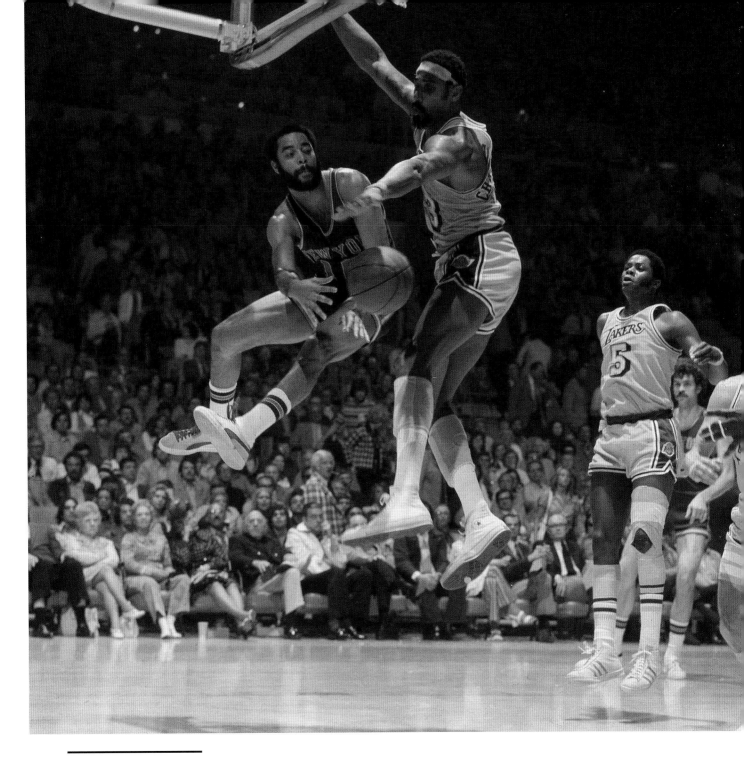

5.12 Walt Frazier (New
York Knicks) in Puma, Wilt
Chamberlain (Los Angeles
Lakers) in Converse,
and Jim McMillian (Los
Angeles Lakers) in adidas,
NBA Finals 1973.

5.13 Puma Clyde basketball
shoes, Beconta catalogue,
1974.

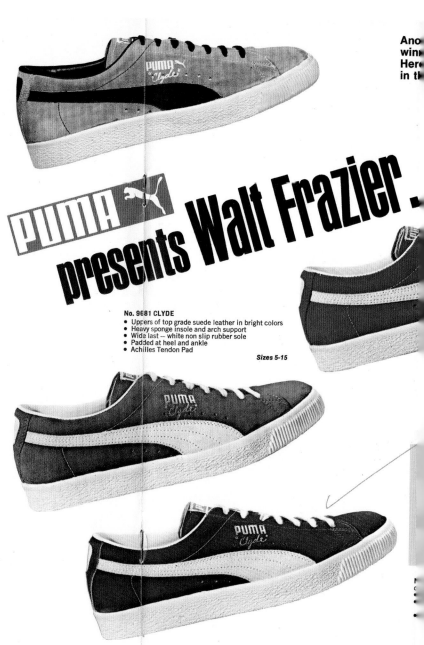

Ano
win
Her
in th

PUMA presents Walt Frazier

No. 9681 CLYDE
- Uppers of top grade suede leather in bright colors
- Heavy sponge insole and arch support
- Wide last — white non slip rubber sole
- Padded at heel and ankle
- Achilles Tendon Pad

Sizes 5-15

American buyers' responses to adidas and Puma shoes varied, largely due to differences in the way the two firms were positioned in the American market. Among basketball players, the Superstar was almost immediately recognized as the state-of-the-art sneaker for the modern game. With countless elite players—professional and otherwise—wearing three-striped shoes, television and magazine coverage acted as unofficial adidas commercials. This was especially true in New York City. Kareem Abdul-Jabbar, a New Yorker and one of the top stars of the early 1970s, wore the Superstar before adidas—following Puma's lead—introduced his signature model in 1978. According to testimony gathered by Robert "Bobbito" Garcia for his encyclopedic oral history of New York's basketball and sneaker subculture, the Superstar's desirability increased because it was worn by Joe "The Destroyer" Hammond, a local playground legend described by one admirer as "the Elvis of basketball." On the city's public courts, it was regarded as a shoe for serious ballplayers.[17]

Yet in the early 1970s, the Superstar was hard to find, even in New York City, arguably the most important basketball market in the world. Adidas's growth and global expansion in the 1950s and 1960s had been facilitated by a series of ad hoc agreements with local distributors. This allowed the company to gain a foothold in foreign markets, but as the business grew these haphazard arrangements began to cause difficulties. In the United States, sales were handled by four distributors, each responsible for securing orders with independent sporting goods stores across huge territories. The firm focused on supplying elite college and professional athletes over retail, and European factories struggled to meet rising demand. Distributors routinely complained that orders were filled late, partially, or not at all. The firm lacked the infrastructure needed to meet demand in the United States. In New York, the Superstar could only be found with the right knowledge or contacts. At first, it was sold only by Carlsen Imports on Lower Broadway, the adidas distributor for the northeastern United States. Supply was limited and buyers had to show school identification and prove they played basketball before they could buy a pair. Adidas's inability to bring the shoe to a wider consumer base meant for the first years of its life the model remained popular primarily within its core constituency of basketball players. Yet the shoe's elusive nature—and high cost—only made it more desirable among New York's growing subculture of sneaker fans.[18]

Puma, by contrast, had a distribution deal in place with Beconta, a New York–based importer and distributer of sports equipment. With a national network of sales representatives, and the ability to order Puma-branded products from suppliers in Asia, Beconta was able to respond to market trends and shifting patterns of demand.

The arrangement ensured American buyers found Puma products relatively easily. Moreover, unlike adidas, which confined its products to traditional sporting goods suppliers, Puma sold through regular shoe stores. While adidas became standard among elite ballplayers with the connections needed to get a pair, the Clyde was an almost instant success on the street. Frazier has suggested it flew out of stores in and around New York from the moment it was launched. It is estimated that over a million pairs were sold during the 1970s.[19]

Despite its easy availability, the Clyde, like the Superstar, was expensive: at $20–$25, twice the price of Converse or Pro-Keds and five to ten times more than the cheapest canvas sneakers. Advertising presented it as a premium product: "Should you wear Puma? Listen, it's going to cost you." For schoolboys, the high price only served to increase the shoe's allure, adding an extra dimension to the connection with Frazier. When in 1973 a *New York Times* reporter interviewed African American students at Sands Junior High, a public school "squeezed between the Fort Greene projects and the Brooklyn Navy Yard," he found sneakers were prized status symbols. His interviewees refused anything other than the costly models worn by their sporting heroes, and spoke "in tones of awe" of the Clydes on display at Modell's sporting goods store in Brooklyn, aware that the price made them virtually unobtainable. Nevertheless, many found a way, legal or otherwise, to get a pair. According to one retailer spoken to by *The New York Times*, it was not unusual "to see a raggedy kid in torn jeans and a sweatshirt come in and order a pair of $25 Puma Clyde sneakers." Garcia called it "unequivocally the most sought after shoe of this period" and "the first non-canvas basketball shoe to gain staying power as fashionable New York street wear." Photographs from the period show its popularity among young people growing up in the city. The easily dirtied, difficult-to-clean suede shoe was transformed into a status symbol, an impractical form of Veblenesque conspicuous consumption.[20]

By the end of the decade both the Superstar and the Clyde had become hugely popular casual shoes, especially among teenagers in New York City, who embraced them as fashionable everyday shoes. Adidas changed its American distribution arrangements in the late 1970s, thereby making its products easier to find. Within basketball, the launch of more technically advanced shoes meant the days of both on the professional and college basketball court were numbered. Both models remained in production, repositioned by their manufacturers as cheaper alternatives to costly new models. They were transformed into multipurpose gym shoes and casual wear. Garcia recalls starting at Brooklyn Tech High School in 1980 and discovering that

All Star Bc

4

ball Shoes

All Star Professional Basketball Shoes
· Professional basketball shoes from Converse are made on lasts specifically designed for basketball competition
· High quality, single unit outsole construction for top traction and wear characteristics
· Soft and strong leather upper with padded tongue and ankle collar helps to provide comfort and support
· Heel wedge helps reduce leg strain and an extended lip arch provides support and comfort in the toughest competition
· Technically designed to incorporate lightness and durability
· Available in sizes 5–14, 15, 16, 17

· **El Marco coloring kits are available for use on all natural trim All Stars. These are provided to help dealers fill team order colors quickly, and respond to individual color preferences.**
· Case weights: 25 lbs. (12 prs. per case)
19764 White Ox/Navy Trim
19102 White Ox/Red Trim
19106 White Ox/Green Trim
19108 White Ox/Lt. Blue Trim
19293 White Ox/Gold Trim
*19295 White Ox/Maroon Trim
*19297 White Ox/Orange Trim
*19299 White Ox/Purple Trim
19790 White Ox/Natural Trim
19763 White Hi/Navy Trim
19103 White Hi/Red Trim

19107 White Hi/Green Trim
19109 White Hi/Lt. Blue Trim
19294 White Hi/Gold Trim
*19296 White Hi/Maroon Trim
*19298 White Hi/Orange Trim
*19300 White Hi/Purple Trim
19791 White Hi/Natural Trim
0080 el Marco coloring kit in
 assorted colors (12 per box)
*Maroon, orange and purple for
team orders only; see your
Converse representative for details.

"about half the school (which included African American, Asian American, Latin American, and European American students from all 5 boroughs)" wore Superstars. Puma referred to the Clyde as its "perennial bestseller." It was this popularity that led to both shoes becoming identified with hip hop, a youth subculture that emerged in the late 1970s from the postindustrial ruins of New York's outer boroughs.[21]

* * *

Hip hop was created haphazardly during the late 1970s by teenagers from largely African American, Caribbean, and Puerto Rican backgrounds. It formed around the three pillars of rap music, breakdancing (also known as b-boying), and graffiti art. Like most youth subcultures, it was associated with its own sartorial style. Outfits were assembled from accessible sources—denim, army surplus, workwear, sportswear—but these basic ingredients were tweaked and personalized, with the aim of looking "fresh." An emphasis was placed on garments that looked new or visually striking. As one commentator wrote at the time, "Hip hoppers want to look sharp and perfect like an animated image." Clothing was a form of individual and group performance in which teenagers distinguished themselves from outsiders, and identified themselves both as individuals and part of a wider culture. Hip hop style, however, could be placed into a far longer tradition of African American sartorial

5.15 (Above left) adidas advertisement, 1973.

5.16 (Above right) Basketball shoes, adidas advertisement, 1976.

5.17 (Opposite) Puma Sports Beconta advertisement, c. 1973.

The Sports Shoe

We make Pumas for Frazier. And you.

5.18 Boys in Pro-Keds and Converse at Sands Junior High, Brooklyn, New York, 1973.

expression that expressed and reflected African Americans' complex relationship with mainstream white society.[22]

Basketball sneakers were a crucial component of hip hop style. Worn loose or with fat ribbon-like laces, shoes were chosen to match or complement other items. This was hardly surprising. Hip hop was created by teenagers who were already likely to wear them as everyday status symbols; it coalesced around informal dance parties at which comfort was important; and consumption of sports shoes was increasing across the board, as sports footwear gradually crossed into the fashion mainstream. Hip hop was also closely associated with basketball: many of the first parties took place in gymnasiums or on public courts, and alongside musicians, black players provided models of African American success. The popularity of the Clyde and Superstar in New York thus ensured their presence at countless hip hop events. They were not the only shoes on display. The jogging boom and shifts in manufacturing, international trade, and retailing meant sports footwear was more widely available than ever before. Shoes from Converse and Pro-Keds now sat alongside models made in Asia by American companies like Nike and Pony and those from a host of lesser-known brands, as well as those from Germany. Most of the brands experienced a degree of popularity among the kids who created hip hop, a fact shown by the variety of sneakers on show in contemporary photographs. Nevertheless, adidas and Puma

remained among the most desirable, a testament to their high price and hold among
elite athletes.

As hip hop became established, outsiders, many from New York's parallel music,
art, and film worlds, were attracted to its creative energy. Michael Holman, a graduate
of the University of San Francisco and participant in New York's experimental
music and art scenes, was typical of those who pushed hip hop to a wider audience.
After encountering hip hop, he became one of its most ardent advocates, eventually
producing *Graffiti Rock*, a cable television show that in 1984 was broadcast around
the United States. An hour-long extravaganza, the show introduced viewers to what
Holman considered the essence of hip hop. In a graffiti-covered studio, rappers,
DJs, and breakdancers performed while an audience of black, Hispanic, and white
teenagers dressed in typical hip hop style danced. As host, Holman asked the DJ
to explain his technique, invited rappers to demonstrate competitive rhyming, and
introduced breakdancers who performed various moves. The educational tone
extended to clothing. In one sequence, Holman introduced Rosemary and Dino,
audience members he presented as the archetypal b-boy and b-girl. Both wore
Superstar with loose, fat laces. Holman quizzed them:

*Holman: Y'all look kinda fresh. Tell me something about your fashion. What're you wearing? What
are these shoes?*

Rosemary: These are a pair of adidas with the fat laces. That's the way we sport them.

Holman: And what do you call your fashion overall?

Rosemary: Fresh!

Holman [turning to Dino]: What about your fashion? What about your look? How do you describe it?

Dino: You know, I call it b-boy threads . . . I got . . . a pair of white-on-white adidas with fat laces . . . I sport it fresh, homes.

At the same time as he pushed the TV show, Holman published *Breaking and the New York City Breakers*, a book he hoped would similarly transmit hip hop to a wider audience. Clearly aimed at young readers, it was illustrated with photographs of *Graffiti Rock* and other hip hop events. Adidas and Puma shoes appeared frequently and a pair of loose-laced Superstar graced the contents page, a representative image indicating what was to come. In a list of the essentials of hip hop fashion Holman included "adidas sneakers that are or at least look brand-new with fat laces, laced in perfect criss-cross design and never pulled tight . . . but left loose and stylized."[23]

Holman was not alone in taking hip hop to a larger audience. The Rock Steady Crew, a group of breakdancers from the South Bronx, featured in the video to Malcolm McLaren's 1982 single "Buffalo Gals" and were briefly pop stars when their single "(Hey You) The Rock Steady Crew" became a global hit. The single's sleeve featured caricatures of the group, four in stylized Superstar, two in Clyde. Hip hop was at the heart of the 1983 documentary and documentary-fiction films *Style Wars* and *Wild Style*, and Martha Cooper and Henry Chalfant's 1984 bestselling book on New York graffiti, *Subway Art*. Hollywood got in on the act in 1984 with *Beat Street*—for which Puma supplied the shoes and clothing worn by many of the lead actors—and other breakdancing movies. Publishers cashed in with cheap books like *Breakdance!*, which instructed readers on clothing "essentials you've got to have if you're going to look like the real thing." Holman and others transformed a highly localized culture into a global phenomenon, but the process of mediation and diffusion they initiated reduced stylistic variety into a more uniform "hip hop look." New York street style was codified into a series of easily reproduced images that erased much of the original meaning. In an era in which hip hop had not penetrated the mainstream, books and films provided images that could be copied far from New York City. Without easy access to the real thing, during the mid-1980s rap fans looked to scarce visual reproductions of the New York scene for a template of what it meant

5.20 "This homeboy and this homegirl are on the spot!", Rosemary and Dino in adidas Superstar, with Michael Homan, *Graffiti Rock*, 1984.

to be a true b-boy or b-girl. Shoes like the Clyde and the Superstar became totems. What they meant to male and female teenagers in New York was subsumed into a broader significance; they were no longer linked primarily to basketball, rather they became symbolic of hip hop culture in its entirety.[24]

* * *

After bubbling at the edges of pop culture through the early 1980s, the arrival of Run-D.M.C.—who made their television debut on *Graffiti Rock*—thrust hip hop style into the global limelight. A trio of African American teenagers from Queens, their 1984 debut, *Run-D.M.C.*, was the first rap album to achieve gold status. They were the first rap act nominated for a Grammy, the first to appear on MTV, *American Bandstand*, and the cover of *Rolling Stone*, and the only one to appear at Live Aid. Sartorially, the group drew inspiration from the streets, choosing to dress like their peers in New York, even after becoming international pop stars. Their uniform of black jeans, black leather jackets, and adidas sneakers—worn without laces in imitation of black prisoners whose shoelaces were removed in jail—broke with the flamboyant, theatrical style of earlier rap acts and was transmitted around the world via record sleeves, photo shoots, music videos, and personal appearances. The group's image signaled their direct connection to the street culture that spawned

5.21 (Hey You) The Rock
Steady Crew, Virgin
Records, 1983.

them; the Superstar was a symbol of the their authenticity. At the same time, the trio's sneakers also functioned as an easily recognizable—and easily copied—gimmick that identified them as they moved from underground to mainstream commercial success. Their look was carefully cultivated by their manager, Russell Simmons, one of the canniest entrepreneurs involved with hip hop. Like the Beatles' moptops, or the Bay City Rollers' tartan, Run-D.M.C.'s adidas were visually memorable and provided an accessible means by which fans could demonstrate their affinity for the group. Young fans began to seek this aging basketball shoe simply because it was worn by Run-D.M.C.[25]

Hip hop, and especially Run-D.M.C., presented retailers and producers of sports shoes with a clear marketing opportunity. Sporting goods stores, who benefited from and promoted the wider fashion for sportswear, noticed Run-D.M.C.'s effect and arranged in-store performances at which adidas products were sold alongside records and other merchandise. Puma had long recognized the importance of the casual, non-sports market, and the existence in Boston of Puma USA, a separate division with responsibility for distribution and marketing in the United States, ensured Puma's American management were close to developments in American popular culture. The division supplied shoes and clothing to the makers of *Beat Street*. The movie went on mainstream cinema and video release and became one of the most

The Sports Shoe

5.22 Members of the Rock
Steady Crew in Puma,
Pro-Keds, adidas, and Nike
in the yard of Booker T.
Washington Junior High
School, New York, 1983.

significant factors in the global spread of hip hop culture and style. It gained huge exposure for Puma and cemented the brand's connection to New York street culture. With Frazier in retirement, the 1985 Puma catalogue showed the Clyde (renamed as the Puma) being worn by the New York City Breakers. The connection to basketball literally faded into the background; the words "as featured in the motion picture BEAT STREET" were superimposed over an image of an outdoor basketball court. Potential buyers were urged to "Break into the shoe that has them dancing in the streets." The shoe was "perfect for basketball, casual wear, and breakdancing."[26]

Adidas, meanwhile, appeared unsure of how to handle this unexpected turn of events. Back in Germany, many were either unaware or bewildered by the shifting associations of one their most successful models. The bosses in Herzogenaurach were largely ignorant of hip hop and Run-D.M.C. To them, the Superstar was simply an old shoe that could be produced easily to generate the profits needed for further research and development.[27] The company was beginning to cultivate the leisure market, but many were concerned that an association with fashion might damage the brand's standing in the sports performance market. Run-D.M.C. were notably absent from *adidas News*, the customer newsletter adidas produced in Herzogenaurach, even after a section titled "Pop" was added in the mid-1980s. It was only in 1986, when Run-D.M.C. released the single "My Adidas," that adidas began to take note. The song was a nostalgic chronicle of hip hop's early years and was written at a time when adidas was being ousted from New York's streets and basketball courts by Nike and Reebok. With the lyric, "My adidas and me, close as can be / We make a mean team, my adidas and me," the song recounted the group's successes and stressed their roots in the New York street culture of the early 1980s. More cynically, the song was an attempt to attract adidas's attention and secure financial acknowledgment for the group's impact on sales. It prompted Angelo Anastasio, a product placement and endorsement manager in Los Angeles, to attend their triumphant homecoming show at Madison Square Garden, where he witnessed several thousand fans hoist their shoes into the air during "My Adidas." Any doubts were overcome. Horst later signed a contract that made Run-D.M.C. the first non-sports stars to formally endorse a sporting goods company.[28]

The Superstar, however, was nearing the end of its product cycle and was obsolete from a sports perspective. Senior staff at adidas welcomed the opportunity to

5.23 Joseph 'Run' Simmons and Darryl 'D.M.C.' McDaniels of Run-D.M.C. in adidas Superstar, New York, c. 1985.

Sneakers, basketball, and hip hop

eke out sales of an outdated model.[29] Moreover, as the 1980s drew to a close, the company faced serious financial difficulties as its market position was challenged and overtaken by rivals. Shoe deals had become rife in the NBA, with different firms paying players to wear their shoes. Nike had targeted high school basketball players and coaches since the late 1970s, aiming to get players accustomed to Nike shoes before they reached the college or professional leagues. By the mid-1980s the effects of this long-term strategy were beginning to show, as Nike replaced adidas on basketball courts around the country. The red and black Nike Air Jordan became the must-have casual shoe of the mid-1980s.[30] Facing a declining market share, adidas's deal with Run-D.M.C. promised a much-needed sales boost. A range of Run-D.M.C. adidas shoes and clothing was launched, including the Superstar-inspired Ultra Star, a leisure shoe designed to be worn without laces. The group appeared at trade shows and in promotional material; television advertising pushed band and brand; and the company helped promote the group's 1988 Tougher Than Leather tour. The deal paid off. Marketing said American fans were "crazy" for the range of "Run DMC T-shirts, sweatshirts, sleeveless sweaters and training suits" the firm launched in the United States. Run-D.M.C. generated sales estimated at more than $100 million.[31]

<p align="center">* * *</p>

The adidas Superstar and Puma Clyde grew from the ambitions and rivalries of the firms that made them. They began as basketball shoes, created to answer the need for more robust basketball footwear after the Second World War and to provide adidas and Puma with an entry into the lucrative American mass market. Their design and construction were shaped by players' physical needs, but also by the Dassler firms' willingness to embrace and invest in new means of production. Initially at least, they were regarded as top-of-the-range, technologically advanced basketball footwear, associated with elite players and were desirable on that account. As perhaps adidas and Puma hoped, however, their significance within basketball increased their desirability off-court and tapped into a longer trend within sports shoe marketing in the United States. The association with top players led to them becoming popular street wear, especially among teenagers in New York. It was this that led to them being worn by Run-D.M.C. and the creators of hip hop in the early 1980s, but it was the global spread of hip hop music that caused them to develop a symbolic power that overshadowed the connection to basketball. With the success of Run-D.M.C.

and other rap artists, and the popularity of films like *Beat Street*, they came primarily to represent a love of hip hop music and culture, particularly in Europe where neither model was heavily marketed or widely available.[32]

By the time *Christmas Rap* was released the connection between the Superstar and hip hop was well established—as executives at Profile Records must have realized. Indeed, the shoe was so closely associated with mid-eighties hip hop that within eighteen months "shell-toes" and "fat laces" were among a list of outdated fashion clichés ridiculed by De La Soul, a group who helped usher in a new era in rap music and hip hop style at the end of the decade.[33] Adidas and Puma had long sought to associate themselves with top athletes, but their connection to hip hop and New York street style developed more organically. It was an unintended consequence of their entry into the American basketball market in the 1960s and the importance of basketball among teenagers in New York. It was through the efforts of people outside the company, including those who sought to promote hip hop to wider audiences, a young band seeking to cultivate a distinctive look, and small retailers who hoped to cash in on the fashion for sportswear, that these associations spread. By the time adidas and Puma formally endorsed the hip hop connection, the link was well established. For many consumers the Superstar and the Clyde were already fashion garments, not sports equipment. By adapting their marketing strategies accordingly, adidas and Puma simply capitalized on changes that occurred outside their control.

Although adidas and Puma did all they could to associate these shoes with elite sports, they were never able to control how their products were received, nor how they were used by the people who bought them. Consumers had as much influence on the way people understood sports shoes as did manufacturers. The association with hip hop developed independently, and it was as result of this that both shoes became popular fashion items, still in production today, over forty years and millions of pairs since they were launched. This process, however, was not confined to the United States. In Britain, too, perceptions of sportswear changed during the 1980s. There, however, the shift took an altogether different form, as shoes moved into different frames of reference and were integrated into the bitter rivalries of British soccer.

6

Trainers on the soccer terraces

American teenagers were not alone in transforming ideas about sports footwear. In the early 1980s, in cities across Britain, working class boys were gripped by a passion for sportswear. Kevin Sampson, a young journalist from Merseyside, wrote in the popular style magazine, *The Face*, of how soccer fans, first in Liverpool and then around the country, had become "much more sports-image conscious, rather than club oriented." Sports shoes, worn with jeans, polo shirts, tracksuit tops, and anoraks, were part of a casual style associated with the rivalries of the soccer terraces. Technically advanced, sometimes highly specialized models became sought-after fashion items, with the most expensive, unusual, or hardest-to-find held in the highest esteem. By early 1981, Sampson wrote, "just about every team in the country was able to boast a collection of match-dudes, each trying to outdo the next city in terms of terrace cool." The fashion also caught the eye of two young academics in the social sciences. In 1985, Steve Redhead and Eugene McLaughlin wrote in *New Society*, a magazine that investigated social trends, that teenagers in "T-shirts, straight jeans (or tracksuits), trainers, and 'respectable' haircuts", were "engaged in a kind of style wars, the like of which has not been seen since the original 'mod' era of the 1960s." Competition was "intense, with acute rivalry over who is the most stylish", and was, they suggested, "[a]llied … to the emergence of the various inter-city 'fighting crews' connected with football clubs."[1]

6.1 Outside Anfield stadium, Liverpool, c. 1980.

The Sports Shoe

Among young soccer fans, shoes were valued in a way not anticipated by manufacturers or sports retailers. In itself, this was nothing unusual; something similar was happening in the United States around the same time. The increasing desirability of international sports brands off the sports field mirrored the rise of global, televised sports, and the dominance of certain footwear producers, most notably adidas and Puma, at an elite level. Yet in Britain, far more than elsewhere, perceptions of sports shoes were shaped by manufacturers' regionally varied sales and distribution tactics, and by major firms' desire to create increasingly specialized shoes for individual sporting events. Together, these resulted in an array of distinct sports shoes that could be reinterpreted from a perspective more concerned with aesthetics and status than sports performance. At the same time, and as Redhead and McLaughlin noted, the tribal and regional identities of British soccer provided the context in which these shoes took on new meaning. The rise of major brands on the soccer pitch contributed to their desirability on the stadium terraces, while the rivalries between supporters created conditions in which shoes could be appraised as fashionable status symbols. Independent entrepreneurs and fashion retailers spread the fashion to a wider audience, but it began among young soccer fans on the soccer terraces and was shaped by what was worn on the soccer field.

<p style="text-align:center">❉ ❉ ❉</p>

The modern game of Association Football, or soccer, originated and became established in Britain in the late nineteenth century. Perhaps understandably, British shoemakers led the world in soccer footwear. At the start of the twentieth century, British firms vied for a piece of a lucrative market: in 1910, Manfield alone sold over 100,000 pairs of its Hotspur model. Competition between manufacturers and within the sport prompted innovations intended to aid performance. In the 1900s, boots with ridged toecaps and rubber inserts on the instep increased players' ability to control the ball, while non-stretch linings were used to improve fit. M. J. Rice & Son, a manufacturer in Leicester, patented a stud and bar sole designed to improve grip and secured the endorsement of Steve Bloomer, the era's most celebrated striker: their boots were branded "Steve Bloomer's Lucky Goal Scorers". As in the parallel lawn tennis market, by experimenting with leathers, patterns, and lasts, and exploiting new production machinery and materials, British firms produced soccer footwear in immense variety. Yet these variations were made within a broader template; soccer boots tended to be made of tough leather, cut high, and have reinforced toecaps to cope with heavy leather balls and muddy pitches.[2]

The Edwardian period was the high point of the British soccer boot. The military was prioritized during the First World War and when civilian production resumed, many manufacturers reverted to prewar designs. In the soccer market, brands and models established in the Edwardian era lasted well into the twentieth century. High cut, heavy leather boots remained standard across the industry. Steve Bloomer's Lucky Goal Scorers were still on sale six years after he retired from playing aged forty. Production was interrupted again by the Second World War and, as they had before, tired manufacturers afterward returned to established models. In 1948, M. J. Rice & Son advertised Steve Bloomer's Lucky Goal Scorers alongside an image of the white-bearded, bald-headed late founder of the firm: hardly a picture of youthful sporting endeavor, though perhaps in keeping with a product that had changed little since it was introduced and whose endorser had been dead for a decade. Manfield's Hotspur of the 1950s was much the same as that of the early 1900s. Although advertising cast these boots as well-suited to the needs of players, in truth they reflected the interests and concerns of manufacturers more than the nature of postwar soccer. After the challenges of war and facing shortages of materials and labor, British manufacturers stuck to tried and tested designs that posed few challenges from a production perspective. The extent to which these worked for players was of less concern than simply getting boots onto the market. The innovation of the early twentieth century gave way to a period during which the design of soccer boots changed little.[3]

6.2 (Above left) Cert soccer boots, Walker, Kempson & Stevens advertisement, 1909.

6.3 (Above right) Steve Bloomer's Lucky Goal Scorers soccer boots, M. J. Rice & Son advertisement, 1948.

6.4 (Opposite) Wolverhampton Wanderers goalkeeper Bert Williams shows soccer boots in his Bilston sports shop, 1950.

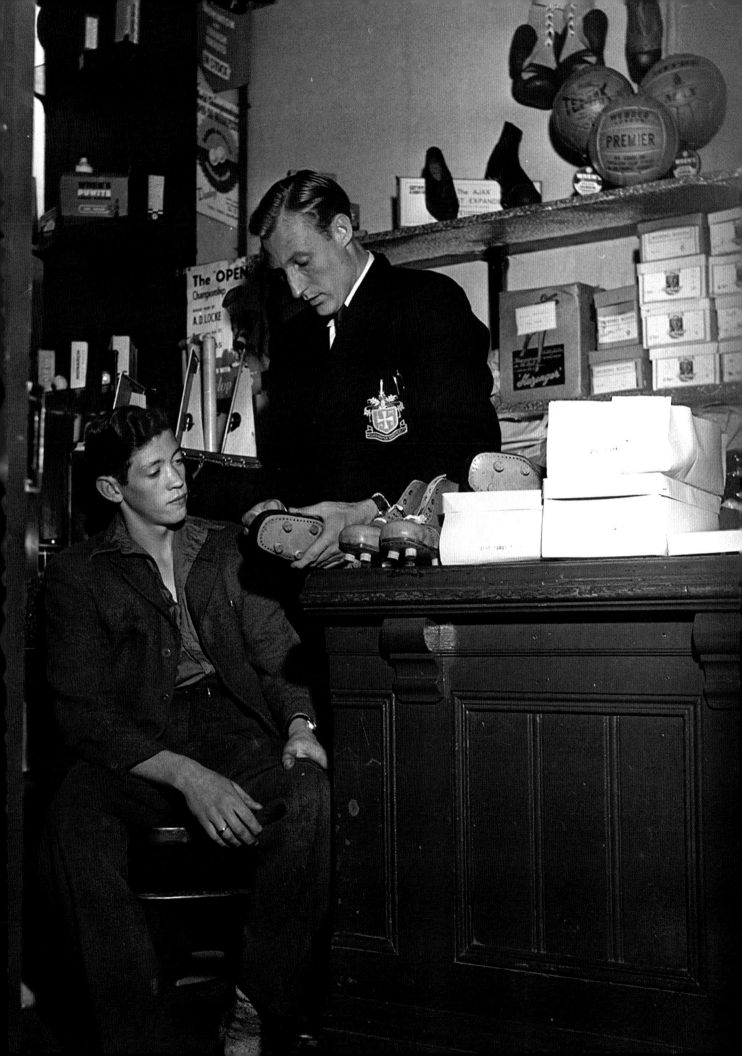

Manufacturers were out of step with those at the top of English soccer, who in the late 1940s began to question the orthodoxy in British boot design. Traditional boots provided protection against violent play and weighty leather balls, but were cumbersome, had to be worn-in, and restricted players' ability to feel and control the ball. Leather soles and studs became heavy and misshapen when wet. In 1949, the English Football Association (FA) began to consider how the situation might be improved. In the hope of finding ways to make lighter, better-fitting boots, it asked researchers at the British Boot, Shoe and Allied Trades Research Association to investigate. By talking to players and collecting data to make better lasts, the researchers produced a handful of lightweight designs that were received favorably by English internationals. The FA, however, admitted it "would be some time before the results of the long-term research are seen in the boots used by the ordinary club player."[4]

Others within British soccer also recognized that improvements were needed to players' boots if they were to keep up with the modern game. In 1950, Stanley Matthews, the most celebrated player in Britain, returned from England's brief World Cup campaign in Brazil so impressed by the lightweight, low-cut boots worn by South American players that he asked the Co-operative Wholesale Society (CWS), one of the country's largest soccer boot manufacturers, to copy a pair he brought back with him. CWS went on to launch a range of flexible, lightweight, boots that incorporated many of the features Matthews advocated. Advertising in popular soccer magazines and the shoe trade press described them as "lighter, more flexible, ... modern, speed-making" and promised they would "cause a sensation in British football circles". They would "streamline a player's speed, put an edge to his skill, and cut out foot fatigue." The boots proved a success and were worn by amateur and professional players. Over half a million pairs were sold in the early 1950s by CWS stores around the country. Yet despite these attempts to better cater to players' requirements, the majority of boots produced and worn in Britain stayed true to a template established in the Edwardian period.[5]

The calls for British soccer boots to change intensified after England's defeats to Hungary in 1953 and 1954. (England lost 3-6 at Wembley in November 1953, their first home defeat against a team from outside the British Isles, and 7-1 in Budapest in May 1954.) British players were urged by Stanley Rous, the secretary of the FA, to adopt the "Continental" approach, with "more intensive training, more skilful ball control, [and] longer pre-match get togethers". Players' boots seemed to symbolize

6.5 Stanley Matthews soccer boots, Co-operative Wholesale Society advertisement, 1955.

the arrogant conservatism that some felt had overtaken the game. Members of the FA wrung their hands, and in 1955 wrote "[u]ntil recently boots were something we took very much for granted," and that "[f]or many years few changes occurred in their design; it was accepted by everyone that they should be heavily built, have reinforced toes and ankles, and be fitted with the customary type of straps and studs." The much lighter boots "worn by several of the Continental sides who have played here since the war … caused many trainers and others to ask if we were not being too complacent." The emphasis European sides placed on speed and agility—and the way they outpaced British opponents—forced the FA to consider if British boots were light enough, and whether manufacturers were making the most of the new synthetic materials that had become available since the war; should British footballers really "be wearing the same sort of boots as their fathers (or grandfathers) wore", the organization wondered. Many in the shoe trade seemed to think so. Although the success of continental sides stimulated demand for CWS's Stanley Matthews boots, most manufacturers were unwilling or ill-equipped to change. While continental manufacturers embraced new synthetic materials, the FA reported that leading British producers "did not think the new materials were necessary or … had come to the conclusion that the manufacturing difficulties would be too great." As the game became faster and more skilled, British manufacturers were left behind, producing boots that rather than aiding athletic performance, actually hindered it. Their reluctance to change would eventually contribute to the demise of soccer bootmaking in Britain.[6]

<p style="text-align:center">✳ ✳ ✳</p>

In Germany, the Dasslers had long been instrumental in setting new standards for soccer footwear. Adolf played as an amateur and recognized that most of a match was spent running, not kicking the ball, and that heavy footwear increased fatigue. He therefore used lighter leathers to reduce weight, and removed the heavy toe-cap to increase players' ability to feel and control the ball. During the 1930s, Gebrüder Dassler supplied the German national team, and after 1948 the rivalry between adidas and Puma prompted a series of innovations as each attempted to capture the vast German soccer market. Both firms made lightweight models, and in the early 1950s, both introduced screw-in studs that could be changed to suit ground conditions and extended boots' life; repeatedly nailing replacements into leather soles created large holes that made stud placement impossible. They also introduced plastic and rubber soles, which did not absorb water. The Dassler firms supplied many of

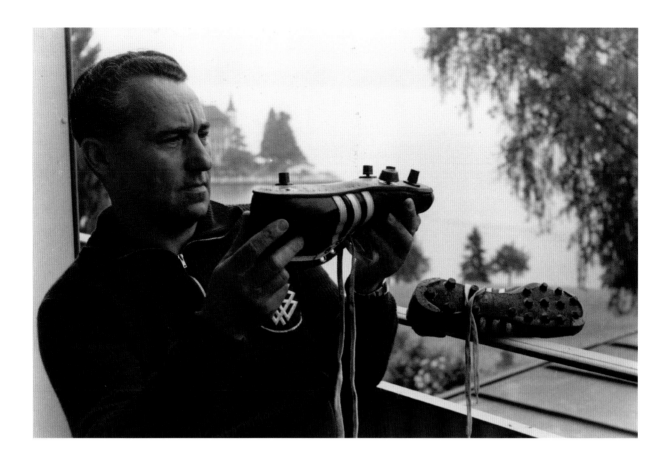

6.6 Adolf Dassler showing adidas soccer boots with screw-in and molded rubber studs, 1954.

the top West German teams, and capitalized on their connections with the elite as a way to drive mass sales. After Rudolf fell out with Josep "Sepp" Herberger, however, Adolf cultivated a close relationship with the national coach and created a series of individually tailored experimental boots for West German players. Thereafter, the national team became an advertisement for adidas boots.[7]

The 1954 soccer World Cup offered an opportunity to showcase adidas on a world stage. It was the first postwar contest to which a German side was admitted, and the first to be broadcast extensively across Europe. Dassler accompanied the West German squad through the tournament. Shortly before the team took to the pitch for a rain-soaked final against the favorites, Hungary, he decided to use longer studs more suited to the sodden turf. It was an important decision. In a match celebrated in Germany as "*das Wunder von Bern*", West Germany overcame a two goal deficit to win 3-2. Their success was partially ascribed to Dassler's last-minute stud change, and, more generally, to the technical superiority of their adidas footwear. Dassler joined Herberger and the exhausted players on the pitch after the match and was dubbed "*der Schuh-Marschall*" by the German press. The victory was popularly interpreted as proof of West Germany's postwar rehabilitation and revival, with Dassler's products evidence of German technical ingenuity and manufacturing prowess. Adidas milked the publicity, which generated interest in the firm's products among

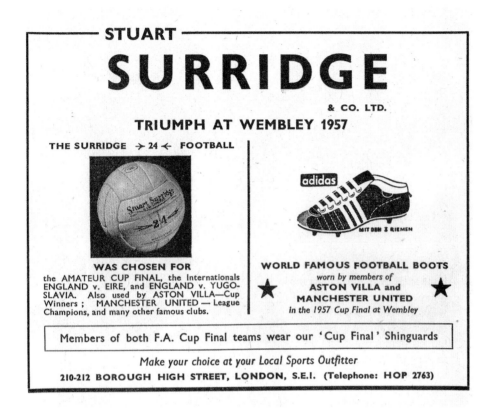

Inside the advertisement:

STUART
SURRIDGE
& CO. LTD.
TRIUMPH AT WEMBLEY 1957

THE SURRIDGE → 24 ← FOOTBALL

adidas

MIT DEN 3 RIEMEN

WAS CHOSEN FOR
the AMATEUR CUP FINAL, the Internationals
ENGLAND v. EIRE, and ENGLAND v. YUGO-
SLAVIA. Also used by ASTON VILLA—Cup
Winners ; MANCHESTER UNITED — League
Champions, and many other famous clubs.

★ **WORLD FAMOUS FOOTBALL BOOTS**
worn by members of
**ASTON VILLA and
MANCHESTER UNITED**
in the 1957 Cup Final at Wembley ★

Members of both F.A. Cup Final teams wear our 'Cup Final' Shinguards

Make your choice at your Local Sports Outfitter
210-212 BOROUGH HIGH STREET, LONDON, S.E.I. (Telephone: HOP 2763)

6.7 (Left) Stuart Surridge advertisement, 1957.

6.8 (Opposite) England players Tom Finney, Maurice Setters, Billy Wright and Bobby Charlton (with Jeff Hall in the rear) in three-striped shoes, 1958.

a global constituency of players, coaches, soccer federations, and the sporting goods merchants that supplied them. Business roughly doubled between 1954 and 1955. By 1961 adidas was the largest producer of soccer boots in the world and exported to sixty-six countries. The firm's workforce increased from fifty in 1948 to five hundred.[8]

* * *

Adidas boots arrived in Britain just as concerns began to be voiced about the quality of British manufactures. When the world champions played in England in late 1954, the failings of British boots became too obvious to ignore. The adidas Oberliga, a model worn by West German players in their match against England at Wembley in December 1954, was one of the continental boots scrutinized by the FA. The organization noted that "[t]he soles appear to be composed of a natural rubber compound hardened and reinforced with high styrene resin." The boot also drew the attention of the *Daily Sketch*, which, in a piece headlined "What a Dassler!" before the England v West Germany match, pointed out that the "German specialty" weighed only half as much as "the orthodox English football boot." The newspaper listed the boot's innovative features, including "screw-in studs which can be adapted to ground conditions, cut-away ankles, front lacing almost right down the front of the boot, a soft toe, and foam rubber interior." Readers were told they were "on sale in London, retail

The Sports Shoe

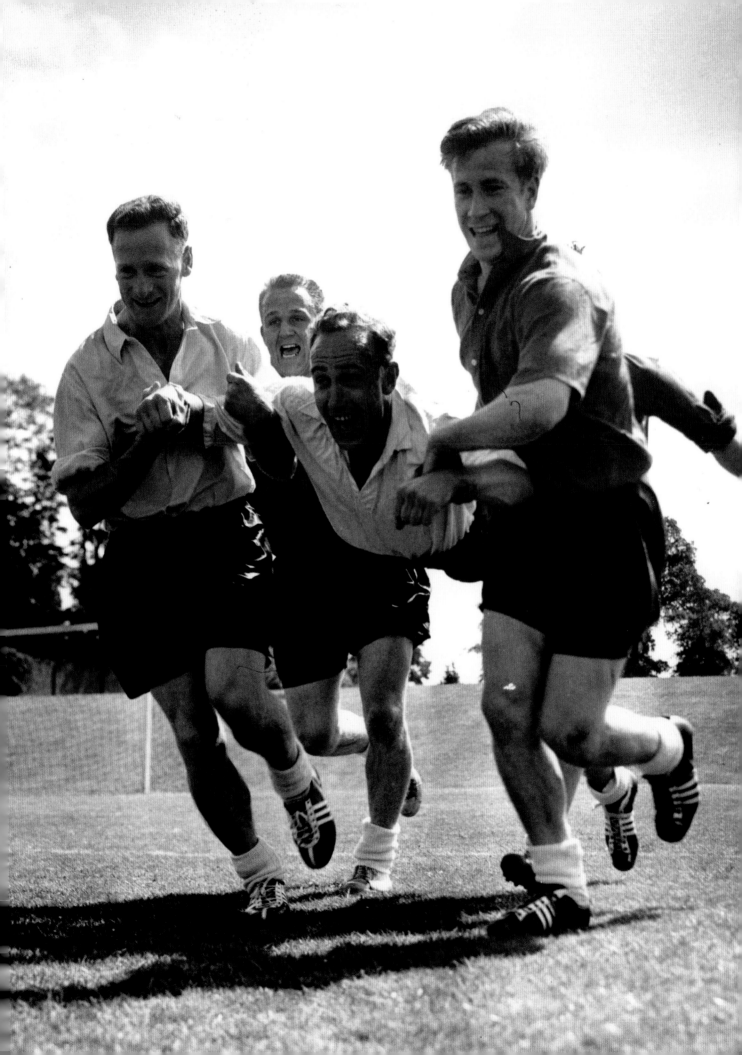

price 98s," twice the price of "[t]he average British-made boot." Key sports retailers like Barney Goodman and Stuart Surridge in London imported and promoted adidas, which led to the expensive boots being adopted by many leading professionals. After the 1957 FA Cup final, Surridge advertised that Aston Villa and Manchester United players wore adidas's "WORLD FAMOUS FOOTBALL BOOTS," the three white stripes of which could be seen clearly in pre-match photographs. The popularity of "continental" boots was demonstrated by the speed with which British firms produced copies of their own, and by the sudden appearance of adidas-style stripes on British-made boots. As the writers of *The Shoe and Leather Record* noted in 1961, "in the last four/five years there has been a revolution. When the Continental players started showing their speed and mobility, it was soon realised that this was due, in part at any rate, to the light flexible boots they wore. Almost overnight, the old established boot was out and the football boot of today is almost as light as a running shoe." By the late 1950s traditional boots were consigned to history.[9]

In 1961, adidas entered into a distribution deal with Umbro, a British sportswear manufacturer that had close relationships with many sporting goods retailers and soccer clubs. Adidas boots were soon on the feet of almost the entire English First Division and could be bought in sports shops around the country. Advertising in soccer magazines proclaimed adidas "the world's finest sports shoes..." and showed

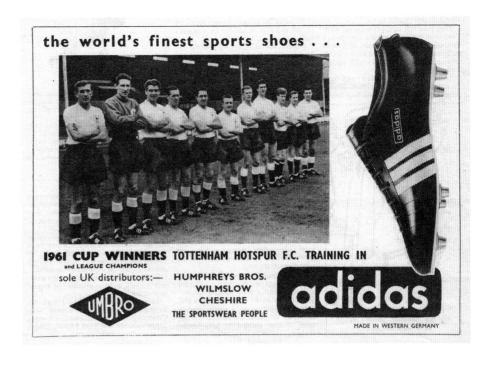

the world's finest sports shoes . . .

1961 CUP WINNERS TOTTENHAM HOTSPUR F.C. TRAINING IN
and LEAGUE CHAMPIONS
sole UK distributors:— HUMPHREYS BROS.
WILMSLOW
CHESHIRE
THE SPORTSWEAR PEOPLE

UMBRO

adidas

MADE IN WESTERN GERMANY

them worn by Tottenham Hotspur, league champions and FA Cup winners in 1961. The English team at the 1962 World Cup in Chile, like many of its rivals, wore adidas boots almost to a man. At the 1966 World Cup in England, Umbro provided clothing for the opening ceremony, ensuring the schoolchildren who took part wore adidas shoes, the white stripes clearly visible in press coverage. During the tournament, adidas and Puma doled out secretive cash payments to players to persuade them to wear their boots. Most opted for adidas, which was a constant presence on the pitch. In the England v West Germany final twenty-two players wore adidas, ensuring the German firm was forever connected to English soccer's greatest triumph.[10]

By the early 1970s, most top players wore adidas or Puma, a fact that would have been obvious to anyone watching the game. Domestic boot manufacturers largely disappeared from elite soccer in Britain. Prominent manufacturers that dated to the Edwardian era vanished, part of the wider decline of the British footwear industry in the 1960s. Through endorsement deals, a willingness to give shoes away, and the quality of their products, adidas—and to a lesser extent Puma—ensured schoolboy soccer magazines like *Jimmy Hill's Football Weekly* and *Goal* were filled with photographs of players in distinctively striped boots. Media coverage acted as unofficial advertising, building the appeal of German firms among young fans into the 1970s and 1980s. As M. J. Rice realized, a connection to star players helped generate mass

sales; professionals wore the kit to which many amateur and young players aspired. Crucially, adidas and Puma, like their British rivals, offered inexpensive children's versions of the boots worn by professionals. Advertising in *Goal* stressed that adidas boots were "Worn by 75% of the world's top stars" and linked the top-of-the-range "AD 2000" to cheaper models "for young and junior players." Like Umbro's replica soccer shirts, adidas's mass market models allowed young soccer fans to inhabit the aura of their heroes.[11]

* * *

In Sampson's memory, the fashion for sportswear among soccer fans emerged in 1976. He has written of how, as a fourteen-year-old Liverpool supporter at the Charity Shield match against Southampton, he saw a small group of sixteen- and seventeen-year-old Liverpool fans outside Wembley stadium "dressed down" in straight jeans, adidas t-shirts, and adidas training shoes. Against a "sea of flapping denim, feathered barnets and silk scarves," these young trendsetters were a striking contrast. The style broke sharply with the terrace fashions of the recent past. From the late 1960s, as older men deserted the game in favor of other leisure activities, British soccer became increasingly linked to violent disorder between young fans, many of whom adopted outlandish costumes to emphasize club allegiances and intimidate rivals. A report prepared for the government in 1968 noted that "[m]uch of the disorderly behaviour on the terraces arises from numbers of teenagers who ... are distinctively dressed with long scarves, favours, banners, painted slogans, etc." The "most enthusiastic fans," the authors found, "adopt more striking forms of dress." In 1974, an article in *New Society* described the elaborate dress of two "Cockney Reds," London-based Manchester United supporters: one wore "a brown overall patched with tartan, no shirt or vest, baggy brown pants and a red and white bob cap," the other a "crew cut, brass earrings, bead necklace, blue cardigan, vast khaki trousers held up with thin braces ... inscribed with the team's names, Union Jack worn like a saree and shiny white boots." These displays were part of a culture in which Britain's crumbling Edwardian soccer stadiums became sites for the cultivation of adolescent, working class masculinities. Regional and tribal identities attached to soccer teams were expressed in ritualistic—though very real—violence. As the authorities began to target those fans making the most overt demonstrations of support, by dressing respectably in smart sportswear, fans could avoid policing measures and remain free to cause mayhem. The new style represented a cyclical shift within terrace fashion

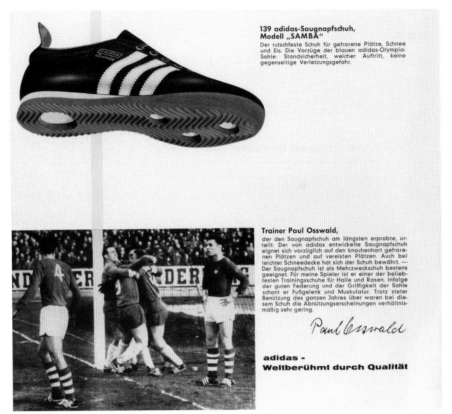

6.11 (Above left) adidas training shoes and soccer boots, J. W. Ramsbotham advertisement, 1970.

6.12 (Above right) Samba training shoes, adidas catalogue (West Germany), 1962.

and an unwillingness on the part of some fans to dress in a way that saw them classed as mindless thugs, while at the same time it allowed the violent feuds that characterized British soccer support to continue.[12]

The first shoe to be linked with this new style was the adidas Samba, a staple of the adidas range. It was worn by teenagers in Liverpool in 1978, but its popularity soon spread around the country. The model was derived from shoes introduced in 1949 for use on hard or frozen pitches. The name, perhaps ironically given the shoe's intended purpose, may have been a nod toward the 1950 World Cup in Brazil. It looked much like adidas's other soccer boots, with lightweight black leather uppers and three white stripes, with a foam rubber sole instead of studs. Updates in the years that followed mirrored changes in soccer boot design, but with the introduction of molded rubber studs for hard outdoor pitches, the Samba gradually evolved into a multi-purpose indoor training shoe, positioned within the range as suitable for football, handball, and other school sports. In the early 1970s, the model was given a molded "3-zoned sole" with "Stop-Turn-Grip zones" developed especially for indoor sports, a move that indicated how the shoe was being used.[13]

The Samba was one of the few adidas training shoes sold in Britain through the 1960s. It was described in 1969 as "[t]he famous shoe with the suction-type sole which permits quick movement in play no matter what the ground condition," and

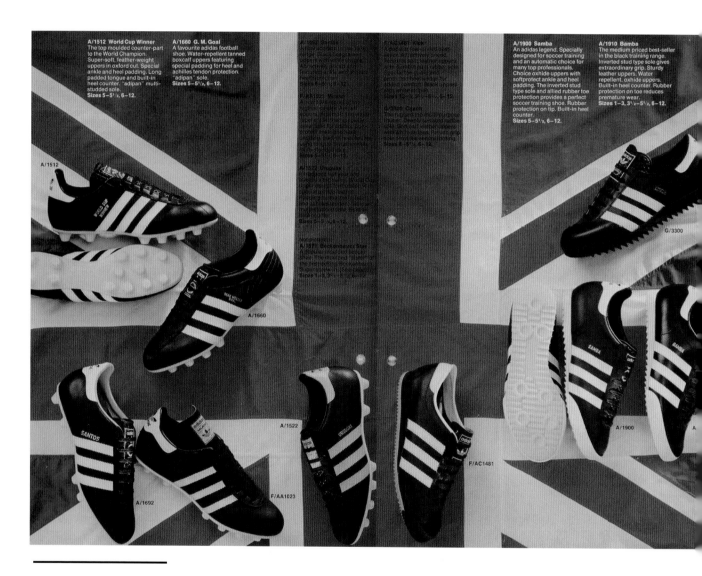

6.13 Soccer boots and
training shoes, adidas
catalogue (UK), 1976.

"[p]articularly well suited for use on hard and frozen grounds, snow and ice—and perfect for indoors." British retailers sold a version made in Austria. This meant that in the 1970s the version available to British buyers was different from that sold in West Germany: while the German version had evolved into an indoor shoe, in Britain it had a serrated sole and thick white rubber toe protector more appropriate for outdoor use. These differences were connected to international trade arrangements and the machinery installed in different factories, but also pointed to divergent sporting traditions, which in turn led to different perceptions of how the shoe could be used. In Germany the Samba was perceived as a multi-purpose gym shoe; in Britain it remained closely connected to soccer. As the 1976 British catalogue suggested, it was "[a]n adidas legend," "[s]pecially designed for soccer training and an automatic choice for many top professionals." Mass participation in the game in Britain, and the growth in the 1970s of indoor five-a-side soccer meant the model was likely to have been available at sporting goods stores around the country. The shoe's adaptability to other sports made it an attractive sales option, while its cheaper variants the Bamba and Kick made the adidas brand available to a broader constituency. As it was in Germany, the Samba was an ideal, if expensive, multipurpose shoe that could be worn for school sports.[14]

For British teenagers who had grown up with replica kits and popular soccer magazines, the Samba offered a way to dress like their heroes. Looking back in 1995, the journalist and soccer fan Gavin Hills wrote "[t]hose who possessed this shoe [in the late 1970s] felt not as mortals do," instead "[t]hey strutted the playgrounds, youth clubs, and football terraces like the champions of Troy." The Liverpool fans who wore the model at the end of the 1970s were among the first to have grown up watching professional soccer dominated by adidas and Puma. The Samba's popularity was linked to the desirability of adidas soccer boots connected to sporting idols, while the sports-casual wardrobe with which it was associated indicated a boredom with the prevailing custom of scarves and colors, trends in music, fashion and popular culture, and the desire among fans to outfox the police. By early 1978, hundreds of teenagers in Liverpool dressed in a similar fashion. As fans travelled to matches around the country they inspired a wave of imitators. By autumn 1979, Sampson wrote, "the Liverpool look [had been] popularized to a national level."[15]

Almost as soon as the Samba became nationally popular, trendsetters in the north-west began to look to other adidas models. The reputation the brand had within soccer spread to models designed for other sports, and what Sampson described as the fashion "merry-go-round ... of experiment-adopt-abandon" started to spin

more rapidly. During 1979, the Samba was replaced by the Stan Smith as the most sought-after model in Liverpool and Manchester. Like the Samba, it had long been available to English retailers. By the late 1970s it no longer topped the tennis range, but remained a core product, popular with serious players. After this, sports shoes were absorbed into the rivalries of British soccer, with fans competing over who had the best, the rarest, or most expensive models. As Peter Hooton, one of the editors of the fanzine, *The End*, later wrote, they received "hundreds [of letters] about the training shoes the different football crews were wearing," and a "crew's reputation could be severely damaged ... if a fatty was seen wearing a bad pair of trainers by the opposing team's fashion spotters."[16]

When shoes like the Samba and Stan Smith became ubiquitous, trendsetters began to look further afield. As *The End* wrote in its 1984 account of terrace fashions, when the styles of 1978 and 1979 "became played out it was decided by all to broaden ones [*sic*] horizons, and the cry went up Europe!" Britain's accession to the European Economic Community and the arrival in the 1970s of package holidays, inexpensive European rail and ferry schemes, and the relaxation of currency restrictions together made overseas travel a realistic possibility for many working class Britons. For soccer fans, European competition provided a reason to visit towns and cities that might otherwise have remained off the beaten track. Liverpool fans were some of

The Sports Shoe

the best travelled in Europe. The team won the UEFA cup in 1973 and 1976, the European Super Cup in 1977, and the European Cup in 1977, 1978, 1981, and 1984. This unprecedented winning streak, together with a series of pre-season tours and friendlies, meant Liverpool played in continental Europe more often and in more places than any other British team. Travelling fans visited sports stores in what *The End* called "un-explored territory," with many "bringing home ... smart looking garments with strange sounding names." According to Hooton, in the early 1980s, "training shoe addicts would never dream of getting a pair you could buy in the city centre in Liverpool." Sports shoes from abroad, especially adidas models that were unavailable in Britain, became highly prized.[17]

There were several reasons why shoes that sold in continental Europe were not on sale in Britain. Adidas and Puma catered primarily to German consumers, with many products made solely for the German market. By 1985, adidas made around sixteen million pairs of shoes a year, with 85 percent of them destined for West Germany. Different sporting traditions and well-established "sport for all" schemes, particularly in West Germany, created a mass market for sports clothing and a demand for models that were not needed in Britain. Sports stores were independent, responsible for ordering their own stock, and catered to regional sporting preferences. In the case of adidas, the shoes offered to retailers were determined by the rivalries between adidas France and its parent in Germany. International territories were split between the two sides of the firm: some nations received products from adidas France, some

6.15 Joe Wag and younger brother in European sports shoes, *The End*, 1982.

from Germany, and some from both. This internal competition also resulted in huge
product duplication. In 1979, for instance, two tennis catalogues were published, one
German, the other French. The shoes listed in each were entirely different; not one
appeared in both publications. In total, adidas offered twenty-three models just for
tennis. On top of this, the nature of footwear production, in which upper materials
can be changed easily and soles attached to different uppers, allowed for almost
infinite variation as sports shoes became increasingly specialized. Perhaps the most
significant factor, however, were contrasting wealth levels across Europe. British
travelers were often astonished at the range available overseas. Jay Allan, an Aberdeen
fan, recalled having heard "how good the sports shops were" in Germany. On finally
visiting a "huge sports shop" in Hamburg in 1983, he was astounded; the "selection
of trainers and sportswear was unbelievable." Higher living standards, levels of
private consumption, and per capita disposable income in continental Europe, most
especially in West Germany, France, and the low countries, meant markets there
could sustain far more higher value products than could Britain.[18]

In their desire to acquire high-end European sportswear, working-class British
teenagers showed ingenuity and a willingness to bend or break the law. British fans
were often astonished at the lack of security they encountered abroad: shoes were
displayed in pairs without security tags; shops lacked cameras; and security staff were

rare. Hooton remembered that Liverpool fans in Paris for the 1981 European Cup final indulged in such a shoplifting spree that by match day "sports shops ... were locked, with staff supervising the doors, allowing only two people at a time into the shop." In an interview with the *New Musical Express* in 1982, Phil Jones, an editor of *The End*, claimed "younger scals" in Liverpool wore "trainees ... 'zapped' from Europe." Allan recounted bumping into two Tottenham fans in Hamburg, "over for the sole purpose of thieving ... as much trendy gear as they could in a few days ... to flog to their mob." He and his friends made off with a holdall full of expensive tracksuits.[19] Unofficial, small-scale imports like this were initially common. European inter-rail tickets allowed the more enterprising to travel to smaller towns and cities in their quest for shoes and clothing that were unavailable in Britain; a popular scam was to erase the handwritten destination and simply add in another, granting the holder almost unlimited European travel. It has been estimated that in Liverpool there were around 2000 regular travelers, and about five hundred traders who sold shoes and clothes acquired in Europe. In Manchester's Oasis market one youth set up a stall from which he sold trainers brought back from Germany. He specialized in rare models that were not available elsewhere and charged accordingly high prices. Even if only a few had the drive or means to acquire shoes in this manner, the secondary market in dubiously-obtained goods fueled a wider desire for European models.[20]

By moving them from one country to another, British soccer fans gave new meaning to many European models. Shoes brought back by traveling fans were perceived in ways not imagined by manufacturers or consumers in Europe. In itself, this process was not unusual but at times it resulted in wildly varied perceptions of individual shoes. This was most apparent in the case of the adidas Trimm Trab, a shoe associated with British soccer style more than any other. For many, it was an indicator that the wearer was involved in the violent subculture that existed around soccer. Allan recounted a visit to Leicester in 1984 in which he and his friends drew hostile stares from rival fans, because they "were obviously trendies, with Trim[m] Trab ... trainers." Looking back in 1991, the fanzine *Boy's Own* listed it with "top clobber" and noted it enjoyed nationwide popularity. It is frequently mentioned in memoirs, and has been described as "the ultimate soccer-terrace classic ... *the* shoe to have in the mid-1980s." Hooton described it as a "much sought-after, exclusive" model.[21]

In reality, the Trimm Trab was anything but exclusive. It was introduced in 1975, and had lightweight green and blue or blue and red suede uppers. Its most distinctive

feature was an innovative injection molded polyurethane sole that had been developed with Semperit, the Austrian rubber firm. German catalogues described the sole as "a sensational adidas development" that was "light as a feather, extremely flexible, cushioned, and would guarantee excellent grip on all surfaces." Adidas was among the first shoe firms to adopt this technology and invested heavily in it. In the years afterward, similar soles were attached to several other models. In 1982, when computerized machinery capable of making a thousand pairs of shoes a day was installed at the firm's Scheinfeld plant, adidas acknowledged in its internal newsletter that polyurethane played "an ever more important role" in the firm's success. The Trimm Trab was made using some of the most advanced production methods in the shoe industry, but from the outset it was designed with the everyday athlete in mind. The shoe was tied to the Federal Republic's "*Trimm Dich durch Sport*" campaigns. It was launched to coincide with a drive to promote jogging and the introduction of a new slogan: "*Trimm-Trab: Das neue Laufen ohne zu Schnaufen*." An advertisement for the shoe appeared in the DSB's campaign brochure. The hardwearing, lightweight sole was ideally suited to the woodland exercise stations and running trails constructed in the 1970s. The model was positioned as a reasonably priced multi-purpose shoe for the mass market and was aimed at health-conscious recreational athletes, not sports professionals.[22]

British adidas distributors received the Trimm Trab in 1976. Without the government campaign and woodland running trails that gave the shoe meaning in West Germany, they struggled to make sense of it in a British context. In catalogs, it was described as "stunning, [a] fabulous new training/leisure shoe" and a "fashionable shoe, attractively priced and incorporating all of the adidas expertise." The "supremely comfortable foamed polyurethane sole" was "[r]evolutionary." Although it was claimed that "adidas leisure shoes have made a dramatic penetration of the consumer market in 1975," with jogging yet to arrive in any meaningful way, British buyers were perhaps not ready for an oddly shaped green and blue shoe with a plastic sole, even if it had been "orthopaedically tested for a wide range of activities." Without a clear market and unlike anything else available at the time, the shoe quickly vanished from the range available to British retailers.[23]

In West Germany, Switzerland, and Austria, by contrast, the Trimm Trab remained in the range for several years. Produced in a wide variety of colors, it was hugely popular. In *adidas News*, the folksy newsletter adidas produced and distributed through sporting goods stores, the firm printed letters from customers who sung the praises

of their adidas shoes. Between 1980 and 1982, several were about the Trimm Trab. Martin Holzworth from Stuttgart said he was "very satisfied" with his pair, and that "nothing was too much for these shoes, whether running in the woods, in the gym or on the road, – even an eleven weeks" trip through the USA in extreme conditions (e.g. a tough walk through the Grand Canyon)." He would "never again be at a loss choosing from the great range of sports shoes." Oliver Konze wrote from Weiden to say he found "'Trimm-Trab' shoes simply fantastic," and that since discovering them two years earlier he had worn them almost every day. He "would never have believed that sneakers could have such a long life" and would "be buying them again." In Essen, Silke Droste "noticed more and more sports fans are wearing the adidas Trimm-Trab shoe," and while on holiday in the north of Holland, she "managed to get a photo of six people who find their Trimm-Trabs absolutely fantastic." The model was so popular that she made up a poem: "On the beach and in the dunes / Trimm-Trab shoes were everywhere / For young and old, big and small, / They're what all want to wear." She later remembered that at the time, all her friends and family had worn Trimm Trab.[24]

Accounts suggest Liverpool fans became aware of the Trimm Trab in April 1981 when Liverpool played Bayern Munich in the European Cup. The model was an exotic novelty in Britain, and soon became highly desirable, available only to those with the knowledge of where it could be found and the ability to travel to obtain it, or connections to those who did. Its reputation was possibly increased by its unusual colours, the odd-sounding German name, and its strange appearance—it was part of a trend toward "ugly" shoes in the late 1970s. Yet the high status it was accorded in Britain was at odds with how it was presented in West Germany. Indeed, its very ordinariness may have contributed to its British success. Because it was a widely available, mid-range shoe, not thought of as particularly special, it was perhaps one of the easiest models to acquire on foreign trips, whether illegally or legally. British soccer fans were unaware of the mundane reality of the shoe in Germany, where it was more likely to be worn by a middle-aged athlete puffing around a woodland trail than a fashionable young man. Ironically, it was perhaps one of the least desirable models among older, more fashion-conscious West German teenagers.[25]

<center>❊ ❊ ❊</center>

The terrace styles of the early 1980s developed against a backdrop of rising sports shoe sales, at a time when adidas was becoming more widely available in Britain. Adidas renegotiated its distribution deal with Umbro in 1971. To increase British

Uwe Seeler ist von „Trimm-Trab" begeistert – und Sie?

Uwe Seeler:
„Seit ich mit dem großen
Fußball aufgehört habe,
treibe ich viel Ausgleichssport.
„Trimm-Trab" macht mir
großen Spaß!"

Für „Trimm-Trab"
brauchen Sie keine
besondere Ausrüstung.
T-Shirt, Sporthose oder Trai-
ningsanzug von adidas – und schon
kann's losgehen. Besonders wichtig
aber sind die richtigen Schuhe. adidas
entwickelte das Modell „Trimm-Trab",
einen Spezial-Trainingsschuh aus
extrem weichem Velours-Oberleder und
einer superleichten und elastischen
PU-Sohle. Genau das Richtige für alle
„Trimm-Trab"-Freunde. Mit adidas
macht „Trimm-Trab" noch mehr Spaß.

15

adidas sales a separate unit, known as Umbro International, was created in Poynton, Cheshire. Adidas was moving away from its founder's focus on the manufacture of high quality sports footwear toward Horst Dassler's vision of adidas as a mass market maker and seller of a variety of athletic leisurewear. The new unit was effectively an adidas subsidiary that pushed adidas at the expense of Umbro. Poynton oversaw the introduction of new lines as the range grew on the back of the 1972 Munich Olympics, the 1974 World Cup, and the Federal Republic's "sport for all" policies. In 1969, six adidas training shoes were available in Britain. By 1974, there were thirty-three. The 1976 catalogue noted that "[d]uring the past three years the adidas division at Poynton ... expanded at an extraordinary level," and that the team entered "1976 with confidence and determination—confidence that the quality and width of its range is unsurpassed on the British market—and determined to continue its past and present success." It listed forty-five adidas training shoes. As sportswear became more prevalent, retailers and buyers in Britain supported the growth of adidas's market share.[26]

With rising demand, adidas's arrangement with Umbro proved ill-suited to shifting market conditions. In the early 1970s a deal was therefore struck with Peter Black Holdings, a large manufacturer of bags, slippers, and ladies sandals in Yorkshire, and a major supplier to the British high street chain, Marks and Spencer. Peter Black's

6.17 (Above) Trimm Trab training shoes, West German adidas advertisement, 1975.

6.18 (Opposite) Trimm Trab booklet, Deutscher Sportbund, 1975.

The Sports Shoe

bosses were looking for ways into the sports business and, seeing that adidas was less popular in Britain than in Europe, negotiated a distribution deal with the Dassler family. Peter Black already supplied the British Shoe Corporation, a conglomerate that dominated shoe retailing in Britain, and offered to use its connections to bring adidas footwear to a wider consumer base. A new division, Peter Black Leisurewear, was established in Yorkshire for the British distribution of adidas footwear and clothing. Umbro International continued to supply sports shops, but Peter Black took responsibility for distribution to everywhere else: shoe shops, mail order catalogues, department and menswear stores. *The Shoe and Leather News* reported in July 1973 that "[f]or the first time British independent shoe retailers and multiple retailers can buy the world's foremost range of Adidas sports and leisure shoes." British buyers were offered "two medium-priced football boots … leather training shoes, canvas training shoes in white and colours, canvas tennis shoes and a range of suede leisure shoes," all of which had "the distinctive three stripes and Adidas labels." The following year, company directors reported that the new casual shoes had been "well received," and that they were responsible for a sharp increase in Peter Black's profits. According to Gordon Black, one of the brothers who ran the business, "[s]ales went through the roof."[27] In the late 1970s, an advertising campaign in the British shoe trade press sought to persuade even more stores to stock adidas training shoes. Full-colour, full-page advertisements urged retailers to capitalize on the "trend to active leisure" and promised adidas would appeal to buyers with little interest in sports:

In all popular sports, adidas provides the very best in footwear and clothing. For your less sports-inclined customers too, adidas offers a wide selection of casual shoes as well as popular training shoes that are equally suitable as all-round footwear for any leisure activity. So no matter how active your customers really are, you're sure to score with adidas.[28]

These changes had a profound impact. At the start of the 1970s British sales were around £600,000 a year. By the end of the decade they were worth more than £15,000,000. The 1972 Umbro International catalogue called adidas training shoes "the shoe for all seasons, … super light, comfortable and smartly styled," and said that "[m]any prefer these good looking shoes for leisure and casual wear." *Footwear World* noted that sales of sports shoes were the one growth area in a moribund market. Terrace fashions should therefore be seen as part of a wider trend. With involvement in active leisure pursuits and sports on the rise, sportswear was becoming more acceptable as general purpose leisurewear, something adidas did much to encourage.[29]

adidas-Indoor-Kollektion
Die modischen Hemden,
Shorts, Hosen und Röcke
erfreuen sich bei Hallen-
sportlern immer größerer
Beliebheit. Tischtennis,
Badminton, Hockey und
Hallentennis sind beliebte
Sportarten für diese
Kollektion. Die Farben rot,
blau, grün, gelb und
orange sind Grundelemente
für nahezu unbegrenzte
Kombinationsmöglichkeiten.

adidas-Schwimm-
bekleidung ¤swim wear¤
Für Weltrekordler und
Hobbykrauler präsentiert
adidas ideale Schwimm-
bekleidung. Frei von
modischen Extravaganzen
wird die sportlich-
funktionelle Linie von drei
verschiedenen, hoch-
wertigen Materialien
bestimmt: Nylon-
Charmeuse für angenehm
leichte Schwimm-
bekleidung, Lycra bi-
elastisch für den verwöhn-
ten Freizeitschwimmer und
Skin-fit, die Topmodelle für
Weltrekordler und
Olympiasieger.
Die Schwimmanzüge für
Damen in den Größen
38–44, für Herren von 1–7
und für die Jugend ab
Größe 140 erhältlich.

43

6.19 Leisure clothing and
Trimm Trab training shoes,
adidas catalogue (West
Germany), 1976.

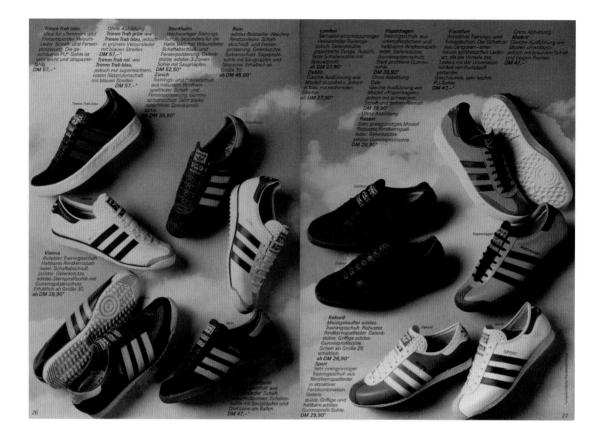

6.20 Trimm Trab and other
training shoes, adidas
catalogue (West Germany),
1976.

Initially, the desire for shoes like the Trimm Trab was met by enterprising
individual travelers and small-scale entrepreneurs who blurred the distinction
between seller and consumer. It was not long, however, before more ambitious
players entered the market, making terrace fashions available to more mainstream
consumers. One of the first was Robert Wade-Smith, a former public schoolboy from
Yorkshire. In 1977 he joined Peter Black as a seventeen-year-old trainee. After a stint
working on the factory floor making bags, in 1979 he joined the team responsible
for adidas concessions in Top Man, a highly successful and recently-launched chain
that offered a new approach to men's fashion retailing. Adidas occupied between 5
percent and 10 percent of the floorspace in the top twenty Top Man stores, itself an
indication that sportswear was becoming fashionable. From his position working
with the concessions manager, Wade-Smith saw that sales were stronger in Liverpool
than anywhere else. At the time normal adidas sales were between £400 and £700
per concession per week. In Liverpool they were between £2,000 and £3,000; in
the months before Christmas 1979, as the popularity of the Stan Smith peaked, they
reached £3000, then £5,000 per week. Crucially, buyers in Liverpool were willing
to pay almost twice as much per pair as they were elsewhere. After the success of
the Stan Smith, through 1980 they embraced a succession of expensive adidas tennis
shoes. With stock topped up twice weekly by Wade-Smith, sales in the Liverpool

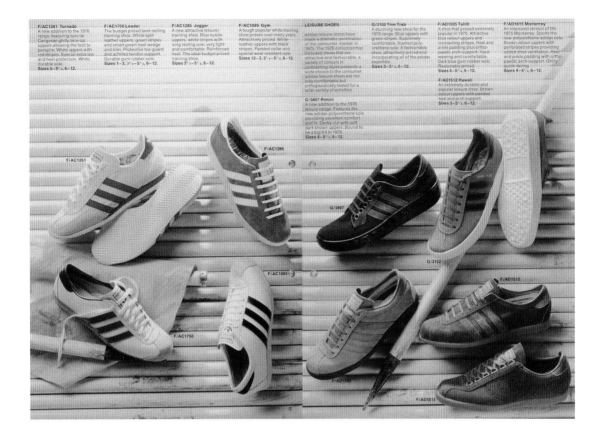

6.21 Trimm Trab and other training and leisure shoes, adidas catalogue (UK), 1976.

branch of Top Man accounted for roughly a third of Peter Black Leisurewear's adidas concession business.[30]

Proof of the booming demand in Liverpool for specialist, expensive adidas models came in the form of the Forest Hills, a top-of-the-range tennis shoe. Named after the home of the United States Open and introduced in 1976, it was a *"Superschuh"* designed for elite—or wealthy—players. German catalogues listed its special features: lightweight kangaroo leather uppers, a highly flexible sole made of a material developed with NASA, an orthopaedic footbed, and an innovative ventilation system to lower the temperature inside the shoe. At just 270 g, it was the lightest tennis shoe in the world. It was visually arresting, with white uppers, three gold stripes, and an eye-catching yellow sole. It was also expensive: DM 89 in 1976, and in the United States the first tennis shoe with a price over $100. Only the World Champion soccer boot, two elite running spikes, an insulated winter training boot, and a handful of alpine hiking boots cost more. The Rekord, a standard training shoe, cost DM 26.90. In Britain it was sold at some of the top tennis clubs. Despite the apparently limited market for such a highly priced model, Peter Black was forced by adidas to take five hundred pairs. These remained in a warehouse until October 1980, when, after the success of the Stan Smith, Wimbledon, and Grand Prix tennis shoes, Wade-Smith overcame the reluctance of his bosses and put the Forest Hills on sale in Liverpool.

The entire consignment sold by Christmas. Wade-Smith earned a bottle of Scotch as a reward from his impressed manager.[31]

Buoyed by successes like the Forest Hills and convinced a market existed for high-end sports shoes, in summer 1982 Wade-Smith left Peter Black to establish a shop in Liverpool. In its first weeks, the new venture was not a success. Although he stocked most of the British adidas range, teenagers came into the shop wearing and demanding models that Wade-Smith had not encountered. He was told the unusual shoes were from Brussels, and so, with disappointing sales, traveled to Belgium in hope of obtaining the stock his customers wanted. He was naively unaware of the secrecy among competitive trainer fans, or that "Brussels" was a deliberately deceptive answer to his enquiries, and so left the city empty-handed. On the return journey, however, he came across five Liverpudlian lads sitting in an Ostend café, drinking lager. They had spent three weeks traveling northern Europe and were returning home with holdalls full of trainers they intended to sell: highly sought-after models like the adidas Zelda, Grand Slam, and München, and the Trimm Trab in various colours. After receiving a barracking on the ferry, on the train from London to Liverpool Wade-Smith eventually negotiated to buy the entire haul of twenty-four pairs at £15 per pair. The following day he put them on sale at £35 each. By closing almost every pair had sold. In its first week, the shop had sold £141-worth of shoes; on the first Saturday after the trip to Brussels, it took £820. After this, Wade-Smith began driving to Germany and Austria where he worked with friendly retailers, regional dealers, and adidas representatives to obtain shoes not intended for the British market, bypassing adidas's British sales and distribution structures. Working with up to a dozen different suppliers across Europe, his shop stocked shoes that were unavailable anywhere else in Britain. During the first two months of business, it sold £27,000-worth of Trimm Trabs, and in 1983 sold nearly three thousand pairs of the popular model, over half of them in navy blue with pale blue stripes. From this start, Wade-Smith built a successful fashion business in Liverpool.[32]

Wade-Smith popularized a new approach to sports footwear. For him and his customers, these were not functional equipment to be worn in specific sporting environments, they were fashionable everyday clothing. In contrast to traditional sporting goods stores, where footwear was sold alongside a jumble of other equipment, the original Wade-Smith store in Liverpool was modeled on fashion boutiques. The original shopfront included adidas and Nike logos, Wade-Smith's name, and the word "SHOES." Inside, the focus was on the shoes that neatly lined the walls. Customers

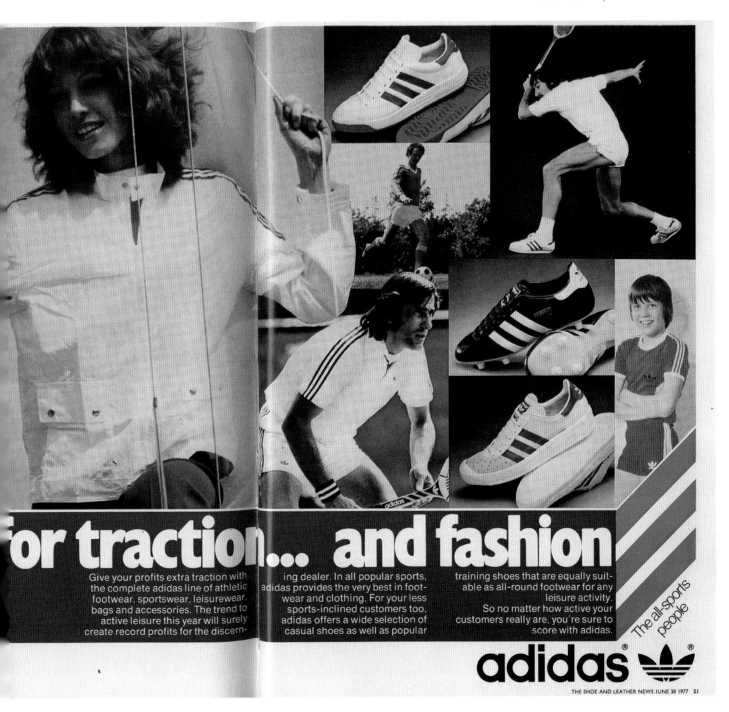

or traction... and fashion

Give your profits extra traction with the complete adidas line of athletic footwear, sportswear, leisurewear, bags and accessories. The trend to active leisure this year will surely create record profits for the discern-

ing dealer. In all popular sports, adidas provides the very best in footwear and clothing. For your less sports-inclined customers too, adidas offers a wide selection of casual shoes as well as popular

training shoes that are equally suitable as all-round footwear for any leisure activity. So no matter how active your customers really are, you're sure to score with adidas.

The all-sports people

adidas

THE SHOE AND LEATHER NEWS JUNE 30 1977 21

6.23 Forest Hills and other tennis shoes, adidas catalogue (West Germany), 1976.

6.24 Wade Smith interior, Liverpool, c. 1984.

were invited to consider them on an aesthetic level, not as performance-enhancing or specialist products for sports. Highly technical sports models were divorced from their intended use and were perceived simply as shoes, judged on their aesthetic and rarity value, or as part of larger brand ranges. When Wade-Smith opened a shop in Birkenhead in December 1984, an advertisement in the *Liverpool Echo* borrowed the popular Carlsberg advertising slogan and claimed it had "[p]robably the best range of sports shoes in the world." It was illustrated with photographs of the Nike, adidas and Diadora models on sale. This was a fashion shop; the connection with sport was almost invisible.[33]

Wade-Smith was among the first to realize the commercial possibilities of soccer fashions. Once his business took off, the culture of traveling to Europe for shoes declined. Models that were previously rare became commonplace, available to anyone with the money to buy them. Others soon followed his lead. By 1985 Trimm Trab and other shoes popular with soccer fans were available for mail order in the Peter Craig mail order catalogue. Sports shoes were included on the youth fashion pages. The autumn/winter collection included a spread of "streetlife" style that included much of the European leisurewear popularized by football fans. One young model was pictured wearing Puma Set tennis shoes with stonewash Wrangler jeans and an American-style sweatshirt, while another wore adidas Grand Slam with Levi's and a

Fred Perry shirt. The Grand Slam was launched by adidas as a "top model" in 1982, and was designed for professional and elite tennis players. It was Steffi Graf's favourite adidas shoe. White with silver stripes, it had "Super soft kangaroo leather uppers," a "new nylon mesh tongue with an 'air shaft' [for] maximum ventilation," a molded polyurethane sole designed to grip and to "facilitate turning," and a new adjustable shock absorption system in the heel, said by adidas to be "particularly important on impact and during the long, lunging steps characteristic of tennis." A few years earlier it would have been difficult to sell in Britain. Its availability as a fashion shoe through a mail order catalogue, its high cost spread over twenty or thirty-eight weeks, was testament to soccer's influence on British attitudes to sports shoes.[34]

<p style="text-align:center">* * *</p>

By the mid-1980s, the sports shoe market in Britain had been transformed. Specialist models that in the 1970s struggled to find buyers were sold by a variety of retailers as fashion items. Shoes were perceived in ways that had not been anticipated by manufacturers, or, indeed, by retailers. In some respects, these changes were driven by the actions of young consumers linked to soccer, but in others they were the result of broader commercial and cultural shifts. The popularity of adidas among soccer fans in the early 1980s can be linked to adidas's infiltration of professional soccer in Britain two decades earlier. That shoes like the Samba were worn away from the soccer pitch, however, was an effect of adidas's expansion in Britain in the 1970s, the wider availability of sports shoes, and the repositioning of sports clothing as casual leisurewear. The spread of fashions allied to soccer can be explained by the rivalries between supporters. The popularity of obscure models was testament to increasing opportunities for travel and to regionally specific production and management structures. It can also be linked to the contemporary fashions in 1980s Britain: the popularity of European food, design, clothes, lager. Terrace fashions were part of a relatively self-contained culture that existed around soccer, yet they were affected by changes to the way sports shoes were marketed, mediated, and sold during the 1970s and 1980s. The sports shoes of the postwar era were becoming fashionable casualwear, a trajectory that echoed that taken by the sports shoes of the late nineteenth and early twentieth centuries. Across the industry, manufacturers and retailers began to make overtures to a consumer concerned with aesthetics and style, as sportswear was absorbed into popular fashions in a way not seen before.

6.25 Youth fashion, Peter
Craig catalogue, 1985.

7

Athleisure, global production, and the postmodern sports shoe

The actions of American skateboarders, b-boys and b-girls, and British soccer fans were part of a wider trend. Starting in the late 1970s, athletic footwear moved gradually into the mainstream wardrobe, worn as a fashionable alternative to traditional shoe styles. Across the western world, as people adopted more informal, leisured lifestyles, the popularity of casual, sports-inspired clothing increased. *The New York Times* called it "The Locker Room Look," and in 1977 reported that despite having little intention of playing sports many New Yorkers had started wearing branded sportswear, much to the disapproval of "fusty employers accustomed to a certain decorum in attire." The trend began, the paper suggested, "when the first joggers decided it was too much trouble to go home and change when they could just as easily jog right on to the office." By the late 1970s, there existed a large market serving people who did not necessarily engage in sports, but liked to dress as though they did. As previous generations had found, flat-soled sports shoes, whether they were designed for tennis, basketball, or running, were equally suited to simply walking around.[1]

The route from sports field to everyday fashion was by this point well trodden. *The New York Times* reporter's comments echoed those of his predecessor half a century before. Yet new patterns of consumption arose from historically specific conditions. Rising levels of wealth and leisure combined with public fitness campaigns to increase demand for sports footwear, while the growing prominence of mediatized international sporting events prompted the rise of global brands. Increasing sales were accompanied by significant shifts within the industry, as new ways of doing business emerged. The spread of specialist sports footwear led to it being used for more mundane purposes, yet the dominant producers of specialist sports footwear were established to cater to niche consumer groups. The rise of sports fashions therefore presented a problem: how best to address the large market interested in style and aesthetics while also appealing to one more concerned with performance, and how best to do that without damaging brand images carefully associated with elite sports? The way the big names of the global sporting goods industry resolved the seeming contradictions between performance and aesthetics, sport and fashion, laid the foundations for the postmodern sports shoe and the approach that characterizes the sports footwear industry of the early twenty-first century.

❉ ❉ ❉

As *The New York Times* suggested, the sports fashions of the late twentieth century grew from a new culture of physical fitness. In the United States, the most visible expression

of this was jogging, which in the 1970s grew from a niche pursuit into a nationwide phenomenon. As participation rates increased, the athletic clothing associated with jogging became more socially acceptable, even desirable. Running and other sports shoes began to be worn outside of sports. *The New York Times* wrote in 1973 that sneakers were "no longer simply the lowly rubber shoes worn by athletes or kids too poor to buy proper shoes," but had moved to the "heights of fashion." They were worn by "middle-aged women," and had become "the latest rage in teen-age fashion circles." A sporting goods retailer interviewed by the newspaper claimed shoe sales had jumped from 10 to 15 percent of his business to 52 percent over the previous five years. This changing market was described by the owner of a shoe store in Middletown, Connecticut: "people seem to be wearing sneakers all year round, not just in summer," he said; "[t]he brand-name sneaker manufacturers are really catering to the casual market and everyone is buying them." There was, of course, good reason for this; the ergonomic designs, soft materials, and cushioning used on sports models meant they offered a level of comfort not felt in more traditional shoes. In 1983, the *Boston Globe* quoted Bruce Katz, the president of Rockport, a New England firm that combined running shoe technology with more conventional styles: "Running was never the lifeblood of running shoe sales. Comfort was. And anyone who tried on a running shoe was reluctant to step back onto a less comfortable conventional shoe. No wonder women want to walk to work with

high heels under their arms and running shoes on their feet." And, as the footwear buyer of a chain of discount stores told *The New York Times*, "Dollar for dollar, sneakers are the best footwear buy there is. They're economical, practical, and long-wearing." Like previous generations of sports footwear, the modern, specialized designs of the postwar era proved popular beyond sports.[2]

7.2 Jogging fashion, *Paris Match*, 1982.

Rising demand affected all producers, but Blue Ribbon Sports, which in the late 1970s was renamed Nike, caught the spirit of the times better than any rival. The company was steeped in American running culture. By providing shoes tailored to the needs and desires of American joggers it rode the boom to massive success. Between 1972, when the first Nike-branded shoes were sold, and 1982, after the company went public, sales increased from $2 million to $694 million. Net income grew from $60,000 to $49 million. By the late 1970s it dominated the American market, displacing long-established American sneaker makers like Keds and Converse and the world's leading manufacturer of modern sports shoes, adidas. Phil Knight, the company founder, described it in 1982 as a "race across the athletic scene."[3]

A novel operating model underpinned Nike's success. As Blue Ribbon Sports, the company imported shoes made by the Japanese manufacturer Onitsuka and sold them for less than comparable, harder to obtain adidas models. The relationship quickly became more collaborative, with Onitsuka manufacturing shoes to specifications and designs provided by Bowerman and others that were tailored to American running habits. When the relationship with Onitsuka ended acrimoniously in the early 1970s, Blue Ribbon began placing orders with Nippon Rubber, one of Japan's largest shoe producers, as a way to stay in business. The Nike name and swooping checkmark—designed by a local art student for $35—were adopted as a way to differentiate Blue Ribbon's new shoes from those made by Onitsuka. Like its predecessor, Nippon Rubber made shoes designed and specified by Blue Ribbon; most notably, it produced the Waffle Trainer, a model with a sole of raised nubs that grew from Bowerman's attempts to replicate the shape of a waffle iron in rubber, and which provided a foundation for the new Nike brand. When the value of the Japanese yen increased against the dollar in the mid-1970s, Nike production was moved to factories in Taiwan and South Korea, which by the early 1980s together accounted for 90 percent of Nike production, and to others in Malaysia, Thailand, the Philippines, Hong Kong, and China. By exploiting rivalries between contractors, Nike could extract the keenest price. Relying on cheap Asian labor, production costs were kept low and Nike avoided the need for large-scale investment in production infrastructure. The arrival

The Sports Shoe

in the late 1960s of standardized container shipping lowered transportation costs and made it easier to move huge quantities of footwear across the Pacific.

Nike's production model was a significant development within the sports shoe industry. Of course, adidas had expanded into lower wage markets as it became more successful through the 1960s. A second factory opened in Scheinfeld, a small Bavarian town, in 1959; a third opened in Dettwiller, France in 1960. By 1964 there were three more in France and West Germany, and at the end of the decade adidas products were manufactured in Canada, Norway, Switzerland, Austria, Yugoslavia, Australia, and Mexico.[4] At the start of the 1970s adidas began working with a Taiwanese manufacturer, which produced basic canvas and rubber leisure shoes reminiscent of the cheap Asian tennis shoes that flooded western markets in the 1930s. By the mid-1980s around half of all adidas footwear production was manufactured by the Taiwanese Riu brothers in factories in Taiwan and China. Yet adidas retained tight control, and most of its shoes were made in facilities at least part-owned by the firm. German technicians were employed to oversee production at plants in South Korea, Malaysia, Thailand, and China.[5] The firm created a complex web of licensing agreements and third party production as it grew, but at heart it remained a traditional German manufacturing business, albeit with technical infrastructure and staff spread across the globe. In the United States, the principal sneaker manufacturers and smaller firms like Van Doren

NO SPEED LIMIT.

The Nike Elite. This magazine ranked it the best racing flat in the world. Bar none.
We think you'll agree, the moment you step into a pair.
The Elite gives you our famous waffle sole for incredible traction on any surface.
The wide, flared heel spreads impact and gives you greater stabilization.
And the electric blue nylon uppers have a seamless toe pocket for blister-free racing.
The Nike Elite. Built with the concern for quality you'll find in a Porsche.
With no speed limit.

NIKE

8285 SW Nimbus Ave., Suite 115
Beaverton, Oregon 97005

all relied on domestic production: Converse's main factory was in North Carolina, Van Doren's in California. Nike, by contrast, relied almost entirely on low-overhead foreign factories for production.

By ceding manufacturing responsibilities to its Asian contractors, Nike could focus instead on design and marketing. Like adidas, the company worked to associate itself closely with serious sports. During the 1970s, it provided shoes to promising athletes, sponsored local running events, and sealed endorsement deals. (The first was in 1972 with the Romanian tennis professional Ilie Nastase, but Nike also supported Steve Prefontaine, the amateur American running star, before his death in 1975.) As it moved into the 1980s, Nike funded Athletics West, a world class athletics club, and signed large numbers of professional sports stars. Money was ploughed into advertising targeted at final consumers, first in specialist magazines like *Runner's World* but later in more general publications and from 1982 on television. Although early advertisements concentrated on the physical properties of the company's products, in the late 1970s advertising began instead to communicate ideas that could be associated with the Nike brand as whole. With jokey copy and slogans like "There is no finish line," Nike tapped into a set of popular values: hipness, irreverence, individualism, narcissism, self-improvement, gender equality, racial equality, competitiveness, and health. All this marketing developed the Nike brand from the name and the "swoosh" checkmark into

something less tangible; with little connection to the practical business of shoemaking, it took on symbolic meaning, coalescing around a series of vague aspirational goals. Unlike the other sports shoe brands, which retained a residual connection to production and the physical properties of the shoes, the Nike brand floated free of the product to gain a life of its own.[6]

Nike had few illusions about what drove its success. The company estimated that 60 to 70 percent of its sales were for non-athletic purposes. The business was conceived as a pyramid, with a small peak of serious athletes and a far broader base of consumers who wore sports shoes for casual or everyday wear. The millions of people who in the 1970s and 1980s adopted Nike for what in 1982 the company called "all-purpose active use or casual purposes" were a significant factor in the company's astonishing growth. Top-of-the-range, specialized shoes were loss leaders that could stimulate consumer desire for simpler, less expensive models. A presence among serious athletes was used to drive mass sales and build the brand reputation further down the pyramid. Casual wearers, however, were more concerned with color, styling, and general comfort than the small performance gains offered by top models. The company tailored its range to ensure success with as many buyers as possible. Knight has said that after noticing in the mid-1970s that people were wearing his shoes casually, he ordered the Waffle Trainer to be made in blue so it went better with jeans. Basic models like the Oceania running shoe or canvas Bruin basketball sneaker resembled those intended for elite performance—and crucially had the same swoosh on their sides—but were not

7.6 Nike / Ron Hill
advertisement (UK), 1979.

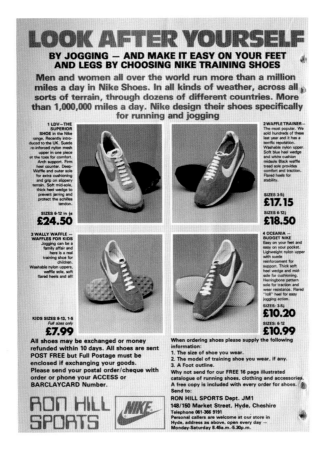

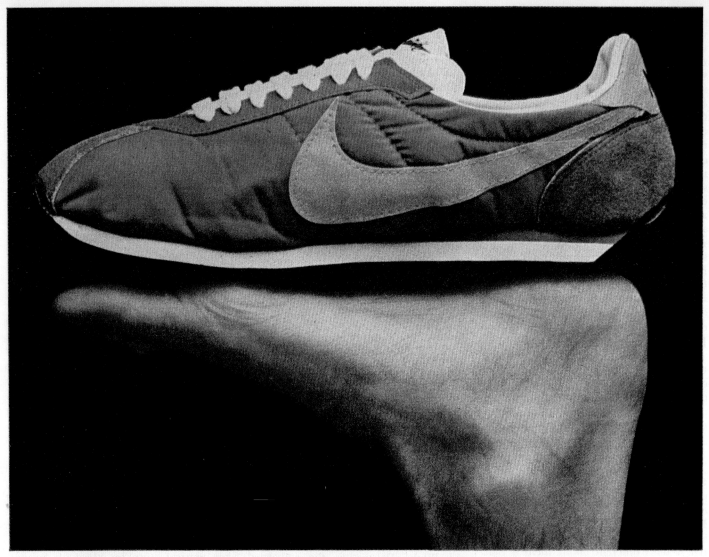

MADE FAMOUS BY WORD OF FOOT ADVERTISING.

The Nike Waffle Trainer is one of the most popular running shoes of all time.

Serious runners started wearing them years ago, for two or three good reasons.

First, the shoe has a patented Waffle sole that's designed for superior traction and cushioning of the foot when you run.

Secondly, the nylon uppers made it an extremely lightweight and comfortable shoe.

Finally, it was word of foot advertising that helped make the Nike Waffle Trainer so popular: Runners seeing other runners wearing them.

Join them.

Bring your athlete's feet to The Athlete's Foot, and tell them you want to start training on Waffles.

No one knows the athlete's foot like

The Athlete's Foot.

NIKE

272 stores...nationwide

After you've seen all the shoes in this magazine, I'll tell you which one is best for you.

There are now so many great running shoes to choose from, you need a scorecard to keep track of them.

Or an expert.

Well, you've got one. The sales pro at Foot Locker. He's as serious about running shoes as you are about running. It's his business to know all about the latest models. He's into shoe design and construction. He's up on which shoes are best for asphalt, for gravel, for cross country.

Best of all, the guy in the striped shirt doesn't play favorites. Foot Locker, you see, carries all the top name running shoes for men, women and kids. Names like New Balance, Nike, Adidas, Puma, Saucony, Tiger and Etonic.

So before you buy running shoes from just anybody, check with somebody who knows what he's talking about.

The Sales Pro at Foot Locker.

Major Credit Cards Accepted.

foot Locker
America's Most Complete Athletic Footwear Store.

intended to be worn for anything other than the lightest of physical activities. Some stalwart models, notably Bowerman's Cortez, remained available long after they were abandoned by serious athletes.[7]

Innovations in shoe retailing and distribution brought Nike to the attention of consumers across the United States. The company's growth coincided with the rise of national retail chains focused on the sale of sports footwear. The Athlete's Foot opened its first franchise in 1971. Foot Locker, a branch of the Woolworth's empire, opened its first store in California in 1974 and by 1984 had six hundred nineteen outlets across the United States. Unlike independent sporting goods specialists, these were mainstream conglomerates, often in prime retail spaces, that offered a simplified consumer experience in a welcoming environment. Many customers were bewildered by the range of shoes available by the 1970s: *The New York Times* noted that "the sneaker seeker is confronted with nearly 40 styles in many stores" and suggested the experience could be "a little overwhelming." As if in answer, Foot Locker portrayed its staff as experts able to guide customers to shoes attuned to their needs. Print advertisements showed sales assistants in their uniform of referees' black-and-white-striped jerseys—a symbol of knowledge and authority—and described how they "make it their business to know as much about sports shoes as they do about individual sports." These national chains bought their products centrally, an approach that lent itself well to Nike's mode

of business. Adidas, by contrast, had three American distributors, each responsible for a different part of the country, and was plagued by delivery problems; it had a business model in the United States better suited to the market conditions of the 1960s. Nike seized the opportunity offered by the chains, and in the early 1980s, to prevent inventory and financial problems, developed an advance order system they called "futures." This required retailers to commit to large orders six months in advance but gave them valuable (5 to 7 percent) discounts and a guaranteed delivery window. In a sector characterized by supply issues, especially from the German firms, American retailers welcomed Nike's approach. Foot Locker was one of the first to sign up to the program and became Nike's most significant distributor. The close relationship between the two companies was enhanced by Nike's willingness to alter designs and specifications in response to Foot Locker's requests, an approach that contrasted with adidas's more fixed ideas about its shoes.[8]

The athleisure market, however, posed problems for companies that cultivated brand identities linked to serious athletic endeavor. In the early 1980s, fearing the lucrative fashion for sports shoes might end, Nike attempted to introduce more casual and fashion-oriented products. In 1982, the "Air-Leisure series" was launched, five models "specifically designed for casual wear" that the company said "should offer a positive alternative for those who spend many hours every day walking or standing." According to the company's catalogues, Nike-branded brown leather shoes with sports soles offered "all the support and performance features an athlete would expect" but with "classic styling which makes [them] perfect for work or casual wear." The range was not a success. The Nike name was associated with athleticism, not work or weekend lounging. By becoming too closely associated with fashion or mass street sales, Nike risked weakening its identity as an "authentic" sports company, and thereby damaging its appeal in the core sports market that helped drive mass sales.[9]

Nike executives realized the commercial dangers of the casual market in the mid-1980s. Facing falling sales in the United States and intense competition from younger rivals like Reebok and L. A. Gear, the company publicly restated its sporting roots. In the 1985 Annual Report, Knight told shareholders that Nike had "let [its] product line wander too far into an area we call 'athleisure.' We have now intentionally pulled back from this area." He went on to outline his vision of the future: "NIKE is a sports company. Our innovation, our technology, and our talents are best suited for the needs and demands of athletes. We didn't belong in the fashion industry, outside of sports, and some of our attempts there just didn't work. We no longer will

PHOENICIAN **9225**

Sizes	6-13		*Polycushion:* A unique polyurethane midout-sole™ compound for cushioning, traction and durability.
Upper	Cocoa		
	Full-Grain Leather: Rich, stylish leather both attractive and durable.		*Octowaffle Pattern:* The eight-sided waffles provide traction even on slick surfaces yet minimize tracking of debris.
	T-Moc Styling: Provides better fit and support through midfoot.	*Profile*	The Phoenician has combined the unique Air-Sole® unit with an all leather upper for the best in both function and style. This system cradles the foot with a cushion of "air" that reduces fatigue and discomfort from standing and walking. The midoutsole™ unit will maintain its efficiency and will not compress with wear, ensuring long-term comfort. The Phoenician combines athletic performance features with the popular deck shoe look.
	Nylon Speed Laces: Allows for quick and easy lacing adjustments.		
Sockliner	*Foam-Backed Cambrelle®:* With built-in arch support. Absorbent, durable and comfortable.		
Midoutsole™	*Air-Sole®:* A dot pattern chamber of pressurized gas encapsulated within a polycushion midoutsole™, providing a cushion of "air" which saves energy, reduces foot fatigue and improves circulation.		

3/82

NIKE®

be chasing fashion—style and attractiveness will follow from a functional approach." By dropping outdated models, focusing on the development of technically advanced sports shoes, and establishing connections with major sports stars, Nike reiterated a brand image rooted in athletic performance. This did not mean it disavowed the mass market, rather, that it would build on the fashionable appeal of sports as a route to popular, non-sports sales.[10]

The connections between elite sport and street desirability were highlighted by the Air Jordan, a shoe that played a significant part in Nike's success in the mid-1980s. When Nike signed him, Michael Jordan was already one of the most promising prospects in basketball. As a freshman at the University of North Carolina he scored the game winning shot in the 1982 NCAA championships; in November 1983, he appeared on the cover of *Sports Illustrated*, which declared him "merely the finest all-round amateur player in the world"; and in 1984 he co-led the United States to gold at the Los Angeles Olympics. On leaving college early in summer 1984, he signed a professional contract with the Chicago Bulls. He agreed to a lucrative deal with Nike at the same time. Jordan wanted initially to work with adidas, but their offer of $100,000 and the same shoe as other players seemed derisory against Nike's offer of a five-year contract estimated to be worth $2.5 million, a signature range of shoes

and clothing, and a royalty on every additional Nike basketball shoe sold above 1983 levels. Nike, meanwhile, was in the process of rearranging its promotional approach. For several years it had paid sponsorship money to vast numbers of professional athletes, including many NBA players, to ensure Nike shoes were worn at the highest levels of sport. In the mid-1980s the company changed tack and instead opted to focus promotional spending on a handful of major stars, including Jordan, and to provide free equipment to others who wanted it.[11]

After the deal was struck, a signature Jordan shoe was designed in collaboration with Nike's Korean manufacturers. From a technological perspective, it offered little of novelty. It was surpassed by other Nike models and lagged behind those made by adidas. A small Nike-Air cushioning unit, so small as to have no real benefit, was crammed into the sole to ensure the name Air Jordan could be legitimately applied. The most striking thing about it was the black and red color scheme. When Jordan wore shoes in the new proposed colors during preseason games they immediately attracted attention. The NBA said they violated their "uniformity of uniforms" rule, meaning they were too different from other players' predominantly white footwear, and threatened to fine the Bulls £1,000 if Jordan wore them. Steve Aschberner, a journalist for the *Chicago Journal*, wrote: "Michael Jordan is not the most incredible, the most colorful, the most amazing, the most flashy, or the most mind-boggling thing in the NBA. His shoes are." *Sports Illustrated* reported the Bulls were "worried about how Jordan would be perceived—both around the NBA and by his teammates" and "had reservations about the shoes' gaudiness." The controversy was a gift to Nike, which vowed to pay any fines and "to sell the red-and-black shoe even if Jordan isn't permitted to wear it in games." The NBA ruling was exploited in clever television advertising. In a thirty-second advertisement, a camera panned slowly down Jordan's body while he aggressively bounced a basketball; a solemn voice intoned: "On September 15th, Nike created a revolutionary new basketball shoe. On October 18th, the NBA threw them out of the game." At this point black bars were superimposed over Jordan's shoes. The voiceover continued: "Fortunately, the NBA can't stop you from wearing them. Air Jordans. From Nike." It was a marketing success, even if Jordan never actually wore the black and red model in competitive games.[12]

Jordan was an immediate sensation in the NBA. His high-flying dunks and aggressive, skillful play attracted sell-out crowds and television viewers across the country. In December 1984 he appeared again on the cover of *Sports Illustrated*, which hailed the birth of a superstar. Jordan's appeal stretched beyond the narrow confines of basketball.

7.10 Michael Jordan in Nike Air Jordan, 1984.

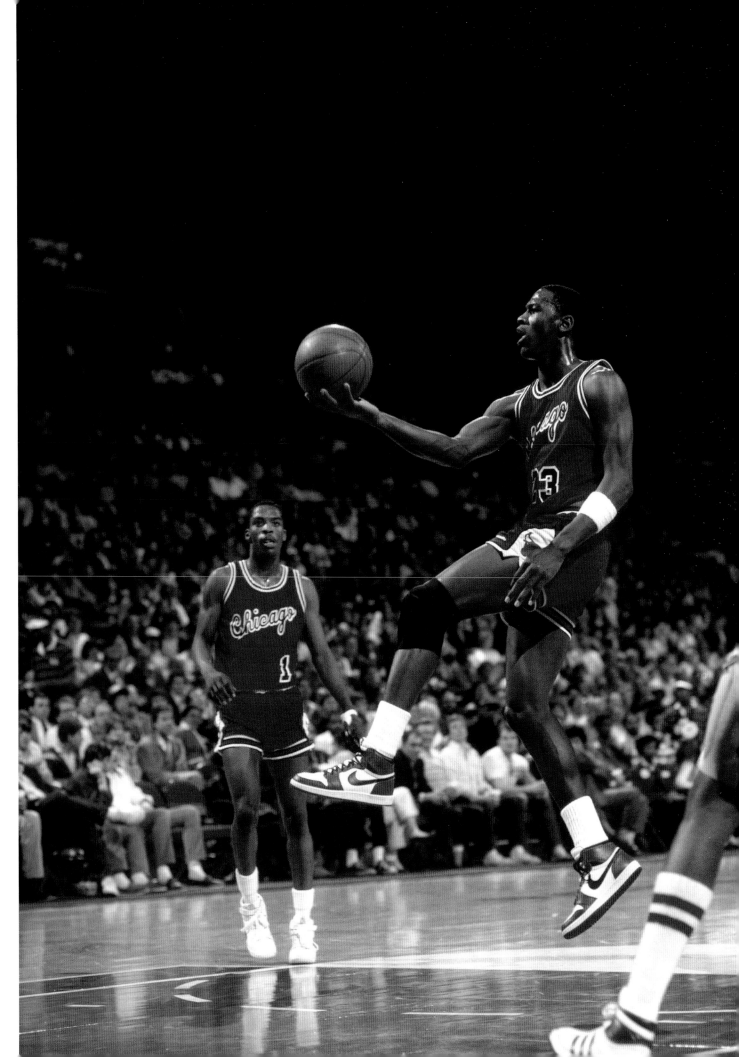

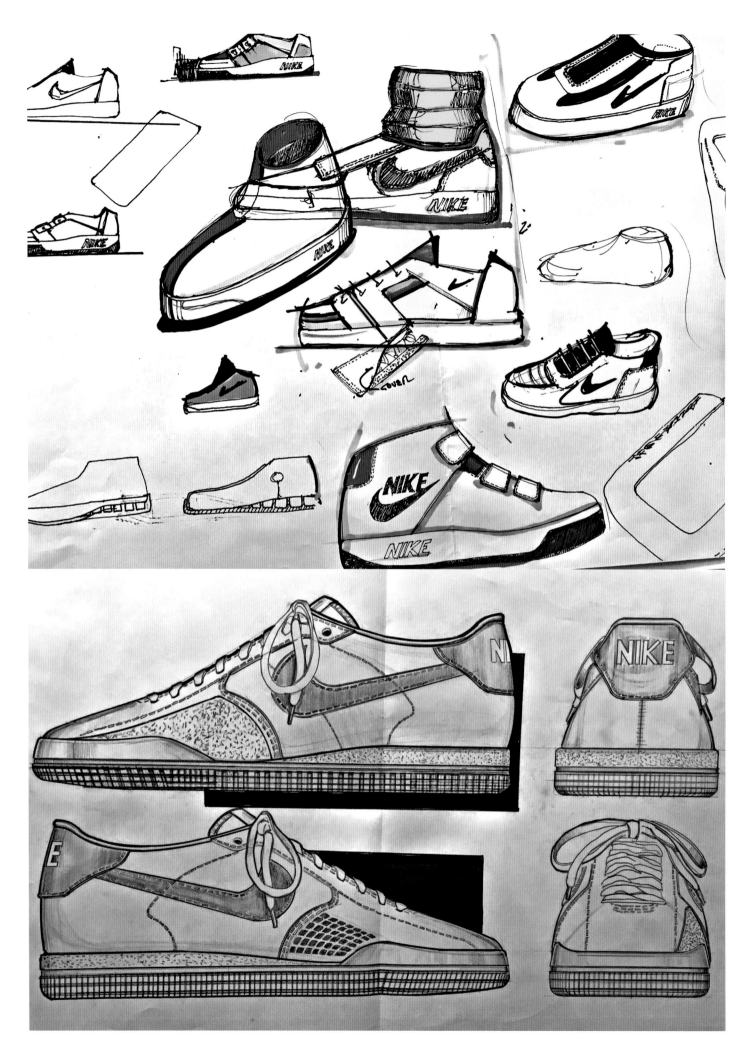

He became a celebrity hero, worshipped by kids across the country and beyond. This appeal generated massive demand for his signature shoes, which went on sale in April 1985, several months after his NBA debut, and were available in several color schemes. Like Walt Frazier's Puma Clyde a decade before, the model was closely linked to an individual's public persona, style of play, and success. Nike marketing was complemented by work Jordan did for other sponsors and by media attention that resulted in free advertising worth millions of dollars. Stores sold out of the Air Jordan in days. Scarcity created demand, and shoes were resold privately for $100, more than the $65 retail price. Foot Locker ordered 100,000 pairs to meet the demand. Over the next eighteen months, Nike sold 2,300,000 pairs, worth $110 million. In the 1985 Annual Report, Knight wrote, "The Air Jordan™ line of shoes and apparel named after rookie NBA star Michael Jordan met with unprecedented market success and was acclaimed as the perfect balance of quality product, marketing, and athletic endorsement." He called the shoe "the hottest selling product the athletic footwear industry has ever seen." Yet relatively few of the millions sold would have been used for basketball. Although this was a performance shoe designed for a top athlete, the shoe had an appeal that went far beyond its intended sport, linked to a new generation of sports celebrity that crossed into the entertainment world. Together, Nike and Jordan became transnational brands that embodied the rise of globalized, neoliberal capitalism.[13]

While Jordan provided Nike shoes with celebrity appeal, Nike also moved to make its shoes desirable on an aesthetic level. In the early 1980s, Nike began to involve industrial designers in the process of bringing new models to market. Ray Tonkel was the third employed by the company. Despite having thought he would pursue a career in consumer products or furniture design, in early 1980 Tonkel found himself designing shoes. As he described it, the job required "exploring new ideas, conceptualizing, drawing shoes and working on new synthetic materials, leathers, moulding techniques, etc." Crucially, although shoe design involved "figuring out the needs of the athlete/consumer," Tonkel and his fellow industrial designers "would take influence from non-traditional footwear sources, other industries and the world around us." Until this point, Nike had followed the approach embodied by Bowerman and Adolf Dassler, both of whom crafted functional shoes for their athletes. Advances in shoemaking technology, including molded sole units and computerized cutting and stitching, enabled designers to introduce new elements that took shoes beyond the simply practical. Tonkel and others conceived of sports

shoes as fully designed objects, looking beyond shoes and clothing for inspiration, seeking to make them work on an aesthetic and functional level.[14]

Two models demonstrated the success of this new approach: the Air Max and the third Air Jordan, both designed by Tinker Hatfield. Like Tonkel, Hatfield had no experience in shoe design or making. He trained with Bowerman while studying at the University of Oregon, but qualified as an architect. Nike employed him in 1981 to help design new office space. The flexible, entrepreneurial nature of Nike management allowed him to move into shoe design in 1985. The Nike Air Max was one of his first projects. It was an attempt to make the most of Nike's investment in a patented sole cushioning technology. The gas-filled plastic bladders Nike-Air relied on were developed by Marion Franklin Rudy and Bob Bogert, two former aerospace engineers, and had been rejected by most sports shoe producers before they came to Knight's attention. Nike licensed the technology and, in collaboration with the inventors and supplier factories, established a way to incorporate the technology into the foam midsoles used on its shoes. The first Nike-Air shoe, the Tailwind, was launched in 1978. Although Nike made much of the new cushioning system, the shoes failed to excite runners in the way hoped. Models with Nike-Air looked virtually identical to those without, and its benefits were hard to articulate. After scientific testing, the best that could be said was that it did not degrade over time like the plastic foams more commonly used, a moot point, given that it had to be encapsulated in a plastic foam midsole to be usable. It was also cumbersome; many elite distance runners preferred not to wear Nike-Air shoes in competitive events as they were heavier than conventional running shoes. Nevertheless, Nike, keen to demonstrate that it had technological credentials comparable to adidas, stood by Nike-Air. Product engineers toyed with various ideas as to how the technology could be developed to increase sales: one was to increase the size of the air unit, another was to somehow make the air unit visible. When the two ideas were combined, the Air Max project was born.[15]

The Air Max was revealed in the 1986 Annual Report. The new shoe had white, gray, and red fabric uppers with a thick foamed plastic midsole and black rubber sole. Its most distinctive feature, however, was a clear plastic window that exposed the internal structure of the Nike-Air unit in the heel. Backlit so a light shone through it, the window was like nothing else in the sports shoe market, a futuristic vision of walking on air that made an unusual concept immediately comprehensible. The evolution of molding technology allowed more sculptural sole units to be created, and for the midsole to become a more integral part of the overall design, rather than

NIKE-AIR IS NOT A SHOE.

CUSHIONING: A SIDE-BY-SIDE COMPARISON.

The Nike Air Max has 22% more cushioning than any other running shoe. Plus stability you'd never expect in such a well-cushioned shoe. All thanks to a | system for which there's really no comparison. Nike-Air. A revolution in motion.

something attached to the upper. Hatfield conceived the shoe as an aesthetic whole, designed to be visually appealing as well as functional. He took inspiration from Richard Rogers's and Renzo Piano's Centre Georges Pompidou in Paris, a building that had similarly exposed interior workings. The striking color scheme—bright red for men, bright blue for women—reflected his desire for the shoe to stand out from the gray, white and navy models then popular, but also echoed the color-coded ducts attached to the Pompidou Centre: blue for air, red for movement and flow. It also harked back to the colored leathers favored by adidas in the 1950s and 1960s. In an interview several years later, Hatfield explained that he conceived of the shoe as a something that was "technically innovative but . . . also an object of design and desire." The window in the heel performed primarily as a stimulus for the imagination. It offered no tangible benefit to a runner. Bowerman dismissed the shoe as a gimmick.[16]

The Air Max and other Nike-Air models designed by Hatfield were launched in spring 1987. They were promoted throughout 1987 by a $20 million television, magazine, and billboard advertising campaign that was the most expensive in the history of the industry. *Runner's World* readers received an eight-page advertising feature, the first page of which showed the Air Max with light streaming through the sole's window. It was hailed as a new dawn: "NIKE-AIR IS NOT A SHOE. IT'S A REVOLUTION." Despite four pages of pseudo-scientific talk of innovation, research

7.13 Air Max, Nike advertisement, 1987.

and development, and "[c]ushioning that reduces the chance of shock-related injury to the bones, muscles, and tendons of the foot and lower leg [and] that can reduce the muscular energy it takes to run, walk, or jump," it was the window that was the real draw. Television commercials emphasized the revolutionary theme. Soundtracked by the Beatles' 1968 song "Revolution," the minute-long spot jumped between brief, grainy, black-and-white footage of everyday and star athletes and laboratory-style film of an Air Max striking the ground. The shoe appeared four times. The commercial ended abruptly with the Nike Swoosh logo. The Air Max was the company's flagship running shoe and the foundation upon which the entire Nike image and brand were built. No mention was made of its technical characteristics or of the Nike-Air technology that underpinned it. Rather, the commercial linked Nike to much broader social changes and the growing significance and desirability of health and fitness in American (and global) life. The Nike brand became a lifestyle option, not just a shoe, linked to idealized images of health and fitness.[17]

Hatfield designed the Air Jordan III shortly after the Air Max. As *Sports Illustrated* noticed, after the success of the original Air Jordan, in 1986 Nike started to "aim for a more exclusive market" with a second, more expensive model. It was made in Italy of white leather and had what the magazine described as a "swatch of fake iguana skin on the side." Hatfield continued the move upmarket but introduced themes that took the Air Jordan even further beyond traditional sports shoe design. In an interview with *The Face* in 1999, he explained how Jordan "was just starting to wear beautiful suits" and that

7.14 Michael Jordan and Spike Lee as Mars Blackmon both in Air Jordan III, Nike advertisement, 1988.

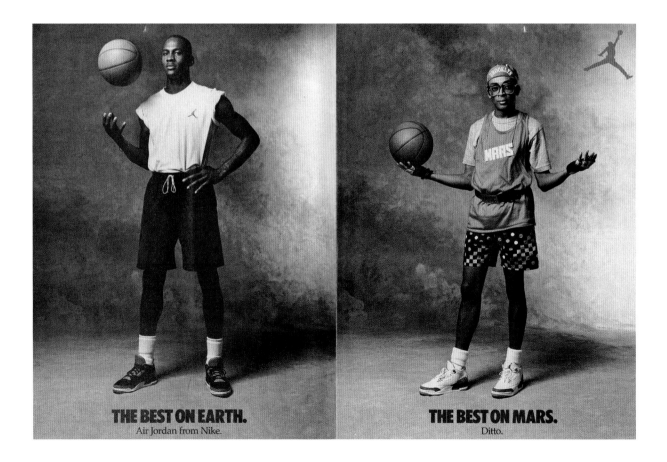

as a designer he "wanted to capture that in a shoe." The shoe "wasn't hardcore athletic in its looks" so "you could play sport in it *and* wear it off the court with an outfit." His sketch notes suggested "a sophisticated yet subtle shoe" with "a unique yet tastefull [*sic*] look" to suit a more mature Jordan. It moved away from the brash colors of the first version and had soft white leather uppers made up of sweeping panels, and a small window in the molded polyurethane midsole. Most strikingly, an unusual gray textured leather in an "elephant" print was used as trim around the heel and toe. Hatfield explained his approach in 1993: "I do see our shoes as unique and uniquely American contributions to contemporary design. . . . Adidas certainly pioneered the development of athletic footwear but . . . they regard these shoes as equipment. They still don't understand how to go beyond that and design in romance and imagery and all of those subliminal characteristics that make an object important to people in less utilitarian ways." The Air Jordan III's flowing lines, blend of materials, and logo-free uppers gave it an elegance rare among 1980s basketball shoes and were testament to Hatfield's desire to create a shoe that could function on the court while having a wider appeal.[18]

The Air Jordan line was accompanied by a Wieden and Kennedy advertising campaign directed by and starring Spike Lee, the young black filmmaker. In it, Lee reprised the role of Mars Blackmon, a fast-talking bicycle messenger he played in his low-budget debut feature film, *She's Gotta Have It*. The character was an affectionate caricature of the mid-1980s b-boy, constructed from cultural signifiers associated with hip hop: an arrow shaved into his hair, a gold name plate and belt buckle, a Georgetown t-shirt, an Izod Lacoste polo shirt, and Air Jordan sneakers. The television commercials—shot in black and white like the film, scripted by the agency, and directed by Lee—paired Blackmon with his hero, Jordan, and ran between 1987 and 1991. The irreverent tone neatly upended, while simultaneously endorsing, many of the usual claims of celebrity endorsement. The commercials linked the shoe to Jordan, the superstar athlete, but also introduced a more complex layering of cultural associations. Through them, the Air Jordan was associated with urban African American street culture and the political activism Lee expressed in his movies. For some, this was cultural appropriation: a brand previously associated with a largely white running culture became linked to black America, and drew on these connections to build wider, whiter commercial appeal. Paul Gilroy, the British sociologist, criticized Lee for "set[ting] the power of the street to work not just in the service of an imagined racial community, but to foster the idea of an imaginary blackness which exists exclusively to further the interests of corporate America." The commercials were notable for the lack of information they

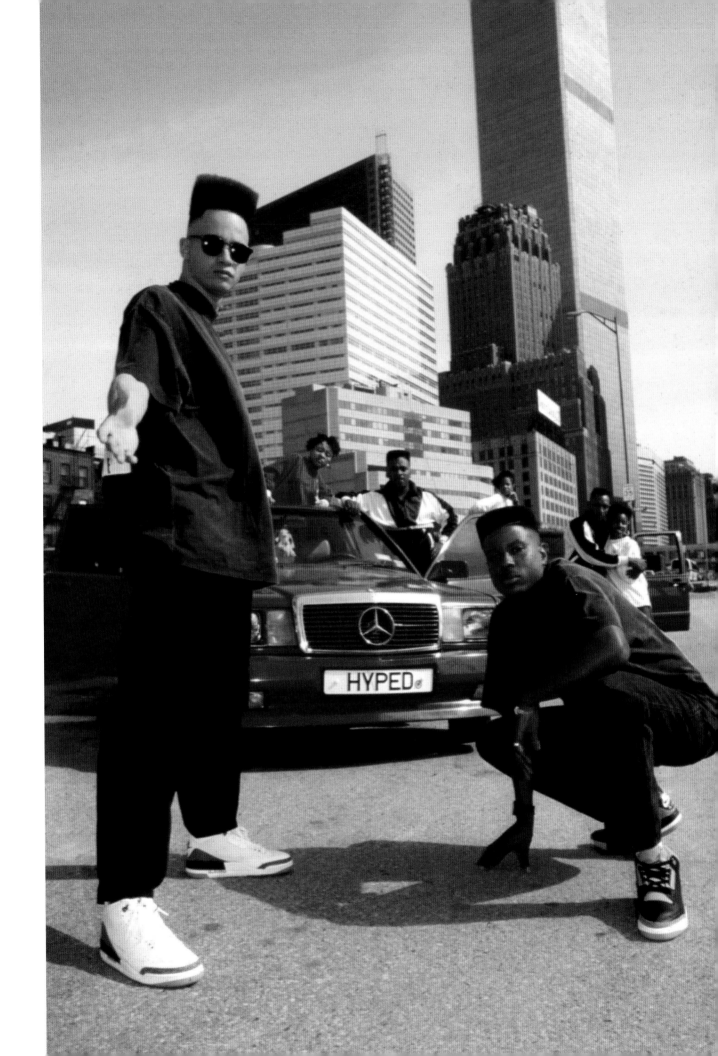

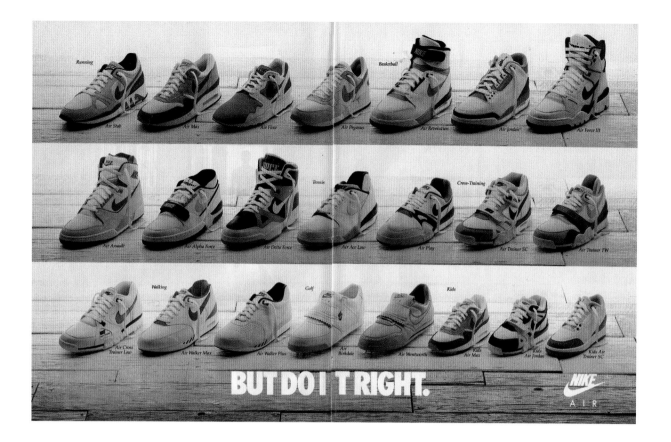

7.16 Nike-Air shoes, including several Tinker Hatfield designs, Nike advertisement, 1988.

provided about the shoes themselves. In contrast to much sports footwear advertising of the time, no mention was made of how well the shoes functioned in a sporting environment, nor of how the shoes were constructed. The viewer was shown only that they were worn by Blackmon and Jordan, and was assured "these sneakers be housin' . . . and every homeboy be bumrushing to get some." By adopting the language and imagery of hip hop–influenced street culture, the Air Jordan was presented by Nike as a racially charged, fashionable sports shoe, even while the company claimed only to be interested in athleticism.[19]

Advertising stimulated demand and underpinned Nike's success from the late 1980s. Hatfield remembered the Air Max as an immediate success. Retailers pre-ordered over six hundred thousand pairs.[20] It was accepted as a serious running shoe by industry reviewers but was also worn casually. "The gimmick of its peekaboo midsole aside, the Air Max has more cushioning air than you'll find in any other Nike shoe," wrote a *Runner's World* reviewer in April 1987. "In limited wear-testing, we've found the Air Max to have exceptional cushioning," he concluded. In the accompanying photographs, the shoe's bright red trim was a sharp contrast to the gray and blue models sold by rival companies, just as Hatfield had intended. The magazine later said the model "received immediate market acceptance" but noted that "runners are buying [it] for more than just the see-through midsole," apparently aware that the window was key to the shoe's

wider success.[21] Other models sold in similarly huge numbers. Successive iterations of the Air Jordan were enormously popular, their desirability enhanced, in part, by their popularity among a new generation of African American rap artists. Air Jordans and other models appeared on the sleeves of rap singles and albums, while the launch of *Yo! MTV Raps*, a two-hour music program broadcast weekly between 1988 and 1995, provided further exposure for Nike and African American style. In a similar way, the popular sitcom *The Fresh Prince of Bel-Air* brought a family-friendly vision of hip hop style to worldwide, mainstream audiences and worked as an unofficial promotion vehicle for Nike: across three seasons the star, Will Smith (rapper The Fresh Prince), wore forty Nike models.[22] The Air Jordan and other models were linked to hip hop in the same way as adidas and Puma were in the early 1980s, and as hip hop's popularity grew, Nike shoes became associated with popular, hip hop–influenced style as much as sports. Appealing to the broad athleisure base was essential for Nike's financial success. The company was established as a business, not a shoemaker. Understanding the appeal of sports shoes for a more mundane wearer, and if necessary creating shoes that appealed to their needs, was integral to Nike's rise.

<p style="text-align:center">❊ ❊ ❊</p>

There was a similar move toward more casual styles of dress in Europe, though it was at first less extensive than in the United States. In West Germany, government-backed "sport for all" campaigns stimulated the market for sports shoes, and adidas

7.17 Trimm Star and Trimm Master training shoes, adidas catalogue, 1970.

and others began to cater to occasional athletes for whom appearance was important. The Trimm Star, the first adidas shoe linked explicitly to the Deutscher Sportbund (DSB) *Trimm Dich durch Sport* campaigns, was launched in 1970. Officially licensed by the DSB, the model used construction techniques and plastic sole units first seen in the early 1960s. It was a basic shoe, intended for gentle exercise. Its most significant innovation was cosmetic: unlike other adidas models, the Trimm Star was brown. It was designed to coordinate with informal casualwear rather than colorful sports team uniforms; the suede uppers were intended to blend into the background, not stand out in a sports arena. Adidas described it as a "high value allround shoe for sports and recreation." Through the 1970s, basic training models and those categorized under the "Freizeit" rubric became ever more significant in the adidas range, a reflection of rising wealth levels and increased leisure time.[23]

Adolf Dassler's death in September 1978 and the gradual accession of his son Horst to the head of the firm occasioned a more spirited push into the fashion-oriented leisure market. Horst was instrumental in moving adidas into clothes production at the end of the 1960s, and during the 1970s adidas garments incorporated elements of popular fashion, with flared trousers, winged collars, and printed patterns all becoming common. Horst's approach for the 1980s was outlined in 1979 in *adidas News*, a promotional newsletter produced in Herzogenaurach. Focusing on performance was insufficient, its writer claimed. Buyers expected "sports and leisure products . . . to be highly fashionable," because sport itself had become fashion: "functionality and quality alone does not satisfy the sportsman." The "designers of Herzogenaurach" would satisfy the public's desire for "perfect functionality, high quality elegance and fashionable sports design" with a new line of "adidas-Sports-Couture." Horst duly recruited fashion designers, and the firm embraced the language of popular fashion. At the autumn 1983 International Sporting Goods Fair, "adidas presented exciting new shoe, swimwear, tenniswear and leisurewear collections" that promised to make 1984 "the most fashionable adidas summer ever – with scintillating colours, attractive cuts and new patterning." The "key word" was "mix n match . . . not only with textiles but also with the shoes that come in colours designed to go well with the apparel." Adidas followed the twists and turns of mainstream fashion, introducing cues and stylistic motifs from popular styles into products aimed at the sports and leisure market.[24]

The goal of "adidas-Sports-Couture" was clear from the firm's tennis products. Horst Dassler had long seen tennis as a key market, and in the early 1980s put Ivan

7.18 Deutscher Sportbund fashion advice, West Germany, 1975.

Keine Mode probleme!

Um zu laufen, braucht man nicht sehr viel an Ausrüstung. Fürs erste genügen ein paar alte Jeans, Shirts, Pullis, das findet sich in jedem Kleiderschrank. Nur eins muß man sich auf jeden Fall anschaffen: ein paar richtige Laufschuhe.

Die Mütze
Man braucht sie nur, wenn die pralle Sonne scheint. Im Winter hält eine zünftige Pudelmütze die Ohren warm.

Das Trikot
Fröhliche T-Shirts sind im Sommer besonders gut geeignet. Es gibt sie jetzt sogar mit der Trimm-Trab-Fußspur. Kaufen Sie sie nicht zu kurz.

Der Trainingsanzug
Für alle, die ihre Laufstrecke nicht vor der Tür haben, ist er besonders nützlich. Aber auch immer dann, wenn die Temperaturen unter 20° gesunken sind.

Je nach Witterung die richtige Zusatzbekleidung
Der Anorak schützt auch den Läufer vor dem Regen. Und wenn es mal richtig kalt ist, sorgen Unterziehanzug, Pullover und Handschuhe dafür, daß das Laufen auch im Winter Spaß macht.

Die Schuhe
Leichte Laufschuhe mit durchgehender profilierter Sohle sind der wichtigste Teil Ihrer Lauf-Ausrüstung. Achten Sie darauf, daß sie groß genug, weich, geschmeidig und atmungsaktiv sind.

Die Socken
Tragen Sie Baumwollsocken, die schweißaufsaugend sind und nicht rutschen.

Athleisure, global production, and the postmodern sports shoe

7.19 (Opposite) Stefan
Edberg in adidas, 1985.

7.20 (Above) Reebok
technologies, c. 1990.

Lendl, Stefan Edberg, and Steffi Graf at the forefront of the firm's move toward popular fashion. At the start of 1985, *adidas News* showed Lendl modeling shirts, sweaters, and shorts with a preppy, geometric motif and a series of signature shoes with complementary blue and red trim. The firm said the Czech player was "becoming even more stylish" and asked "who wouldn't like to be as smart as Ivan?" The following year, the launch of an "extremely stylish" range of clothing and "a newly developed top tennis shoe" associated with Edberg was announced. Each item bore a stylized "SE" over a swatch of yellow, red, and green Miro-esque doodles. The white leather shoe was trimmed in the same colors. Lendl received a new "up-to-the-minute" design at the same time: a stylized face that looked to have been copied from a psychedelic rock album cover. An "extremely fashionable" Graf collection was launched in 1987. The clothing bore a motif of checkerboard, lime green and pink stars, and a lightning flash "SG." The collection's two shoes were designed to match. The Steffi Graf SC had pink stripes, green lining, silver-starred laces, and a Steffi Graf logo on the tongue. The "tennis court and leisure sport" Steffi Graf SE had silver stars on the side, pink trim, and lime green laces. According to *adidas News*, the "complete range was developed with 18-year-old Steffi [who] contributed ideas and suggestions of her own for the design of the shoes." The new models contrasted sharply with the more overtly functional, technically advanced Grand Slam that Graf

wore before her signature shoe was created. With their stars and bright trim, they looked like a marketing man's idea of what should appeal to a typical 1980s teenager and were intended to have an appeal beyond the tennis court.[25]

<p style="text-align:center">❋ ❋ ❋</p>

While adidas attempted to add elements of fashion to its shoes, Nike set new standards in sports shoe design and marketing. The success of the revived Nike-Air range and Nike's aspirational advertising campaigns prompted a slew of gimmicky technologies from rival producers, and in the late 1980s, sports shoes were transformed by the addition of patented space age wizardry. Much of it was of questionable benefit or necessity from a performance perspective. Its function was to establish differences between ostensibly similar products, thereby providing a basis for consumer marketing, to appeal to enthusiasm for futurist technologies, and to stimulate consumption. In contrast to the innovations introduced by adidas and Puma in the 1960s and 1970s, which were highlighted in promotional literature but remained relatively discreet on the shoes themselves, the post–Nike-Air generation of athletic technologies were heavily branded and highly visible. Several forms of sole cushioning were launched: adidas had the Soft Cell; Reebok, the Energy Return System and Hexalite; Puma, Trinomic; Asics (Onitsuka's brand), Gel; and Converse, the Energy Wave System. Other technologies were more complex, and attempted to "solve" issues that were harder to communicate. Adidas introduced the Torsion bar, a yellow plastic device embedded in shoes' soles intended to provide greater stability. Puma launched the Disc, a circular ratchet that replaced laces and pulled the shoe tight. Perhaps the most notable, however, was Reebok's Pump. This was a system of plastic air bladders inserted into the upper that could be inflated and deflated to provide "a custom fit." The shoes were widely advertised, with celebrity endorsers including basketball player Dennis Rodman, tennis player Michael Chang, and golfer Greg Norman appearing in television commercials with the slogan "Pump up, and air out." A $170 price tag on the earliest models ensured they were immediate status symbols. Yet like Puma's Disc, the Pump did a job previously done by laces. These developments were made possible by changing production techniques, but also by the spread of low-cost Asian production, which provided the labor necessary for the manufacture of increasingly complex shoes. On an aesthetic level, sports shoes became bigger, brasher, and bulkier than ever before.[26]

At the same time, the speed of change within the sports shoe industry accelerated. Nike replaced the first Air Max in 1990. The second generation lasted until 1991, the

The latest contenders in the trainers war, all available from Cobra Sports except Giorgio Brutini trainers, available from 4 Star General, 16 Carnaby St, London W1. Below left: basketball star Michael Jordan of Air Jordan fame

In the States the trainers war has reached fierce proportions, with companies such as Nike bringing out a new style every two months, selling out each time. Current favourites are Nike Air Jordans, bearing the logo of the Chicago Bulls' Michael Jordan, America's number one basketball player and probably raking in a few quid by now, judging by the massive Air Jordan range of merchandise sweeping the States (tracksuits, shell suits, shorts and vests). Air Jordan trainers will be available over here this month with clothes to follow. Back on the trainers battleground, Britain is fast following suit with the competition getting hotter and hotter. Here to fuel the fire are Intro's top ten best-selling trainers. Next month: top ten Kickers colours chart. *LB*

Chart supplied by Cobra Sports, 111 Oxford Street, London W1. Cobra has branches in Richmond, Kingston, High Wycombe, Hounslow, Walthamstow, Cambridge and Essex

7.21 Trainer fashion, *The Face*, 1989.

third until 1993. A new Air Jordan was released each season to massive fanfare. Before this, shoes had remained in the range for many years, updated and altered as new production technologies became available. Adolf Dassler worked on four-year cycles, with new elite models launched in time for the Olympics and soccer World Cup. As modern sports shoes became desirable consumer goods, the industry embraced the fashion industry's rapid turnover of design as a way to encourage consumption. In the early 1970s the average life of a Nike model was seven years; by 1989 it was ten months. Like changing fashions, constant technological innovation compelled consumers to buy shoes more frequently. Consumption was further encouraged by the rapidity with which models disappeared. Desirable shoes had to be bought as soon as they were released; the alternative was to risk missing out altogether. By restricting supply, most notably of the Air Jordan models, which were produced in limited quantities and sold in selected outlets, Nike stimulated demand. Potential buyers were encouraged to act by the knowledge that buying would be impossible in the near future.[27]

As new models came and went in quick succession and the industry embraced techno-futurism, small groups of fashionable consumers began to turn away. In Britain, Japan, and the United States, hip trendsetters abandoned the most up-to-date shoes in favor of models from the 1970s. Basic designs deemed obsolete by

producers keen to establish brand identities tied to innovation suddenly became highly desirable. In late 1989, the style magazine, *The Face*, reported that in Britain "[t]he more obsessive end of the trainer-buying public, increasingly frustrated in their attempts to stay ahead of the pack, has turned to deleted lines for that hard-to-come-by touch." Among the magazine's "top ten deleted trainers (in order of unobtainability)" were the adidas Superstar and Gazelle, the Puma States (the Clyde renamed), and the Nike Bruin. These were "likely to be found under a thick layer of dust at cheap sports stores, usually off the beaten track, by the dedicated only." The growth of large chain stores and the fast turnover of models meant many older, independent sporting goods stores were left with excess, unwanted shoes that were out-of-date from a sports perspective. Neal Heard, a trader who went searching for old shoes, traveled Europe and America to "raid the stock rooms" of independent sports shops in search of "old models which were not around at that time." He later described finding "stacks of little sports shops [with] lots of deadstock which the owner had no idea that other people would want." Shoes in "smelly damp rooms" among "piles of crap" were bought cheaply and resold to Japanese collectors or fashionable market stalls or boutiques. When a stall on Camden market began selling adidas Superstar bought for £5 from a "ropey old sports shop," for example, it helped kick-start the fashion for old shoes among a wider audience. In the United States, during the early 1990s shops like Hysterics on the Lower East Side of New York and X-Large in East Hollywood similarly provided old models to the style cognoscenti.[28]

In an industry built on continuous innovation, consumer nostalgia was almost inevitable. The name "Old School" that became attached to these models reflected the fact that the teenagers and twenty-somethings who embraced them as fashion in the 1990s would have worn shoes like these for school sports ten or more years before. This was the first generation of young people to have grown up in a world in which adidas, Puma, and other brands were notable presences. Yet this nostalgic appropriation of childhood styles could also be interpreted as a reaction against the direction the industry took in the 1980s. As poor working conditions in Asian factories were exposed and criticism of the globalized production model employed by companies like Nike mounted, vintage models perhaps became a means by which antipathy to materialist consumerism could be expressed. By reviving goods that were deemed obsolete by the dominant model of consumption, hip consumers implicitly challenged the globalized system of consumerism exploited by the large sports shoe producers. More prosaically, the return to older models represented a rejection of the aesthetic overload and high

7.22 Liam Gallagher of Oasis in adidas Rom, 1994.

7.23 (Left) Beastie Boys, *Check Your Head*, Capitol Records, 1992.

7.24 (Opposite) The Beastie Boys in adidas Campus, 1994.

price of many current models. With their loud logos, bright colors and patterns, and complicated design, the models of the late 1980s screamed for attention. As Peter Hooton, the former editor of *The End*, suggested in 1990, "[t]he main reason people have been wearing Adidas Shell-toes [Superstar] and Puma States in the past year or so is because [sports shoe companies] are producing some of the silliest, shittiest trainers known to man (and woman). . . . The frantic search for trainers past is simply a reaction against shit trainers syndrome!" For people like Hooton, shoes like the Reebok Pump were too expensive and too complicated for everyday wear, their visual noise too loud to blend successfully as part of a wider outfit.[29]

The Old School style was promoted by a wave of pop musicians. In London, vintage styles were embraced by a variety of acid jazz and new wave groups. Their shoes reflected their base in London, with its many markets and secondhand stores, but also the retrogressive musical influences of both scenes. When Jamiroquai, the most famous acid jazz group of the early 1990s, achieved mainstream success in 1992, the singer, Jay Kay, frequently appeared in public in old adidas shoes. Similarly, the vintage training shoes, skinny jeans, and T-shirts worn by Elastica, These Animal Men, and other punk-influenced guitar bands provided a sartorial template for mid-1990s Britpop. The same look was taken to a wider audience by Blur. In Manchester, meanwhile, Oasis dressed in a manner inspired by northern soccer terrace

Athleisure, global production, and the postmodern sports shoe

fashions. As these groups became more successful, their style was communicated to mass, mainstream audiences via record sleeves, music videos, television appearances, and magazine photoshoots.

In the United States, classic sports styles were brought to wider attention by the New York group the Beastie Boys. Old adidas and Puma basketball models were a visual expression of their respect for and connection to the hip hop culture of the late 1970s and early 1980s; like the old records sampled in their music, the shoes were an echo of a bygone era. They also represented their connection to skateboarding: the rise of highly technical street skating in the early 1990s meant many skaters took to inexpensive, low-cut sports shoes as a functional and inexpensive alternative to high-cut skate shoes.[30] Asked about their clothing choices for an episode of MTV's *House of Style*, they likened the search for shoes to record collecting; for them, finding shoes was a display of subcultural capital, a way of demonstrating their knowledge of past styles (in the interview they quote knowingly from *Graffiti Rock*) and ability to unearth forgotten yet desirable consumer goods.[31] Mike D (a.k.a. Michael Diamond) explained: "a lot of the stuff that we're into, it's not, like, stuff that you can get anywhere. You gotta kind of search and seek. That's part of the whole thing of wearing it. . . . It's kind of about, y'know, the search, the long haul, the hunt, the thrill of the hunt." He outlined the group's sneaker preferences: "the stuff that we kind of lean towards is the stuff that doesn't happen to be in production today, because some of our favorite styles for some reason people have left behind and are ignoring some of these classic, simple, very functional designs that they used to manufacture. So the key is finding those original, very functional, utilitarian, beautifully functional designs. Sealed, brand new, in the box."[32] The Beastie Boys' postmodern adoption of outdated functionality found expression on the sleeve of their 1992 album, *Check Your Head*. The black and white cover image, of the group sitting on a curb with vintage Puma Clyde and adidas Campus on conspicuous display, took their style into homes around the globe.[33]

Producers and mainstream retailers were taken unawares by the sudden change of direction. For over a decade, consumers had embraced modern designs for both sports and fashionable wear. The retro style was a complete turnaround in an industry that presented an image of constant technological progress. Looking back in 1995, Hussein Omer, the assistant manager of Cobra Sports, one of London's big sports chain stores, told *The Face*: "when retro first came through in a big way, everyone was desperate for it and manufacturers couldn't deliver." To meet demand, he said, "[t]here were people going to backend shops up north buying up old stock." Wary of being seen to cater too

overtly to the everyday, athleisure market, producers were reluctant to meet a demand that stood in opposition to carefully cultivated brand identities. Heard remembers how he and others "used to contact the brands and tell them the whole scene and ask them to re-issue certain models and they just did not want to know." Karl-Heinz Lang, an adidas manager in the early 1990s, recalled fierce arguments between pragmatists who recognized the growing market for old models that could be easily produced and marketing staff who feared reintroducing obsolete shoes might damage the firm's brand. Unlike previous forays into fashion, which were based on current designs, retro style presented a fundamental rupture: there was no getting away from the fact that these shoes were worn only for fashionable everyday dress. To address the demand openly meant acknowledging that sports shoes were worn for fashion, something the big sports brands remained reluctant to do.[34]

The sports shoe companies resolved the apparent contradiction between fashion and performance by deploying the language of heritage and authenticity. Adidas was the first and most successful to do this. In the early 1990s, the firm was reeling from a spectacular fall from grace. After the unexpected death of Horst Dassler in 1987, losses of £72,000,000 almost destroyed the business. In part, these were blamed on the firm's poor performance in the United States and on its deviance from its sporting core; the pursuit of fashion was thought to have alienated many sports-oriented customers and damaged the adidas brand. With the help of Rob Strasser, one of the men who built the Nike brand in the 1980s, adidas rebuilt itself in Nike's image. The firm's European factories were closed, production licenses were revoked, and responsibility for manufacturing was passed to contractors in Asia. Like Nike, adidas became a design and marketing company. A document, probably written by Strasser, circulated inside the company in 1991. It explained that the famous trefoil logo was being abandoned, because "in many countries it stands for fashion and style only." A new brand—adidas Equipment—was to be created that "will not be dictated by the whims of fashion" but would "build on [adidas's] roots, on its traditional strengths." Equipment shoes would have "no unnecessary fashion features or technical gimmicks." Yet this allowed scope for the revival of old models, which could be sold on the basis of adidas's authentic sporting heritage. Originals, a fashion-oriented sub-brand, was launched quietly in 1991 at the same time as Equipment. Shoes like the Superstar, Gazelle, Samba, Rom, and Stan Smith were made available in their original colors but also in a range of muted blacks, browns, greens, and blues. They offered a route into the casual market that required little in the way of investment. They were

Samba Classic Original

Samba Classic Original

Samba Classic Original

Samba Classic Original

Samba Classic Original
An adidas Original. This classic Samba for the 90's was inspired by the original black-and-white shoe worn by nearly every serious soccer player around the world.
Uppers: Available in either soft, full-grain leather or full-grain waxed leather upper with brushed nylon lining. Chrome leather inlay sole for comfort.
Midsole/Outsole: Natural rubber shell sole with three-zone profile for maximum grip and durability.

034468	Oakwood/White	7 - 12, 13
034469	Ocean/Black	7 - 12, 13
034467	Pewter/Black	7 - 12, 13
034448	Black/White	1 - 12, 13

VIP

VIP

Stan Smith Original

Official Original

VIP
An adidas Original. This legendary coaching shoe, though re-styled for the 90's, continues to provide lasting comfort and support.
Uppers: Full-grain waxed leather upper with chrome leather inlay sole for comfort.
Midsole/Outsole: Soft EVA midsole provides added cushioning. Rubber outsole with saw profile for maximum grip and durability. Reinforced rubber toe provides optimal protection.

| 034479 | Oakwood/Black | 7 - 12, 13 |
| 034480 | Pewter/Black | 7 - 12, 13 |

Stan Smith Original
An adidas Original. This updated version of the legendary Stan Smith tennis shoe still symbolizes what sportsmanship is all about.
Uppers: Soft, full-grain leather upper with chrome leather inlay sole for comfort.
Midsole/Outsole: Rubber shell sole with stitched forefoot shell in multi-grip profile for optimum stability, durability and grip.

| 034449 | White/Green | 6½ - 12, 13, 14 |

Official Original
An adidas Original. This classic referee shoe has been updated for the 90's with optimal comfort in mind.
Uppers: Soft, full-grain leather upper with chrome leather inlay sole for comfort.
Midsole/Outsole: Rubber shell sole with herringbone profile for stability and durability.

| 034446 | Black | 6½ - 12, 13, 14 |

72

73

simple to make and with only the most basic performance expectations upon them could be made from cheaper materials. The use of colored materials enabled basic designs to be produced in infinite variety. Despite initial concerns, in the 1990s other firms embraced retro fashion. Omer told *The Face* in 1995 that "[t]he manufacturers are filling the orders and you've got Gazelles, Campus, Puma Baskets all over the place." Nike reacted more slowly, possibly because it was bound more closely than any other company to its image of sporting modernity, but in 1994 reintroduced limited runs of the first Air Jordan models. Basic models became available in the years that followed and a more extensive reissue program began toward the end of the decade. In the early 2000s many forgotten models were resurrected for the fashion market and sports shoe marketing took on many of the same characteristics as high street fashion.[35]

7.25 Originals, adidas catalogue, 1992.

❊ ❊ ❊

The deadstock hunters and style connoisseurs of the late 1980s showed it was again possible to appreciate modern sports shoes in ways producers did not anticipate. The rise of retro sports fashions in the 1990s demonstrated the power of music and media to shape popular tastes and that the functional lines of many postwar models were aesthetically appealing in and of themselves. This postmodern approach

Marathon Trainer

An adidas Original. This classic performance running shoe has been reinterpreted for the 90's with styling and comfort in mind.
Uppers: Full-grain, waxed leather upper for comfort, durability and water repellancy. Chrome leather inlay sole for added comfort.
Midsole/Outsole: Shock absorbing EVA midsole. Solid rubber outsole with heel and forefoot shell for added protection and stability. "Spoiler" sole extension provides maximum shock absorption.

034464	Vintage/Black	7 - 12, 13
034465	Old Moss/Black	7 - 12, 13

Country Original

An adidas Original whose classic design and comfort still endures today.
Uppers: Soft, full-grain leather upper.
Midsole/Outsole: EVA midsole for added comfort. Rubber outsole with toe bumper for durability.

034450	White/Green	6½ - 12

Superstar

An adidas Original. This legendary lo-cut performance basketball classic has now been updated into an adidas Original.
Uppers: Available in either soft leather upper or full-grain waxed upper with chrome leather insole.
Midsole/Outsole: Rubber shell sole with herringbone profile and rubber toe cap for protection and style.

034451	White/Black	6½ - 12, 13, 14
034463	Gaucho/Black	7 - 12, 13
034462	Blue Ice/Black	7 - 12, 13
034458	Black/White	6½ - 12, 13, 14

to sports footwear provided producers with a route into mainstream fashions, and by deploying the language of heritage and authenticity, they could distinguish between products aimed at serious sports users from those intended to be worn in less strenuous circumstances. Yet by the 1990s, millions of people around the globe had already adopted modern sports footwear as a comfortable form of everyday or leisure footwear. Types of shoes that in the 1960s and 1970s were largely confined to the sports field were routinely worn on the streets. This shift was underpinned by structural changes in western societies, which became wealthier and more leisured, but it was accompanied by profound changes to the way in which sports shoes were produced and sold. With the rise of Nike in the 1970s and 1980s, the everyday sports shoe became almost by definition an item produced in a developing country. Marketing took precedence over manufacture. How or where a shoe was made became of little significance; what mattered more were the brand values attached to a shoe. Inexpensive, Asian-produced shoes were wrapped with vague, aspirational ideas conveyed through product endorsement and sophisticated marketing campaigns. Yet the majority of "sports shoes" were, in effect, nothing of the sort; rather, they were inexpensive shoes designed to look like sports footwear, but intended to be worn casually. Consumers embraced these shoes—whether on grounds of fashion, comfort, cost, or sheer practicality.

Conclusion

In 2004, adidas marked thirty-five years since the birth of the Superstar, one of its most enduringly popular models. Although seldom celebrated, the anniversary was used as the basis for a wide-ranging marketing effort. Produced with the British enthusiasts behind the Crooked Tongues sneaker website, the campaign emphasized the shoe's heritage and foregrounded associations it had accumulated beyond sport.[1] The Superstar was hailed as a popular fashion icon, a product that had transcended its origins in basketball to become significant within hip hop, graffiti, punk, skateboarding, Britpop, and street style. Thirty-five special versions of the shoe were released, each tailored to a different consumer niche, with the basic design recreated in colored, printed, and embossed leathers. Some were linked to famous pop musicians, including Run-D.M.C. (naturally), Missy Elliot, Red Hot Chilli Peppers, and Ian Brown, while others paid homage to visual artists such as Andy Warhol, Walt Disney, and the graffiti writer Lee Quinones. A handful were designed in collaboration with cult streetwear labels and boutiques. All were available only in limited numbers. The centrepiece of the range was a recreation of the 1969 original distinguished by an imprint of Adolf Dassler's face on the heel, despite his lack of involvement with the model's initial design and manufacture. The company founder's commitment to sport and practical ingenuity were invoked in promotional materials, which combined old marketing images, the thoughts of his assistant, and interviews with musicians, DJs, and collectors. A series of parties and events, a website, and a book all pushed the same theme. It was the first time an adidas shoe had been so comprehensively repackaged and was instrumental in establishing a revised vision of the adidas brand. The three stripes were now as much about fashion and modern lifestyles as they were about sports and technical expertise.[2]

The Superstar 35th Anniversary campaign embodied a marketing model that took shape in the early 2000s. Puma celebrated the Clyde in 2005, and in 2007 Nike marked the twenty-fifth birthday of its own basketball legend, the Air Force One. As the major sports brands embraced fashion and began to target consumers concerned more with style than performance, designs from the '60s, '70s, '80s, and '90s were dusted off and put back into production. Similar campaigns followed for a host of other shoes. The vibrant colors and unusual materials used on these new "retro" models, however, often contrasted sharply with earlier incarnations, and in most cases, the shoes of the 2000s were subtly reworked simulacra of the originals. Industrial regulations meant some past production techniques and materials could no longer be used, while careful value engineering reduced production and sale costs by removing constituent elements that had been aimed at sports buyers but which were deemed unnecessary for the mass

8.1 Superstar 35th, adidas leaflet, 2005.

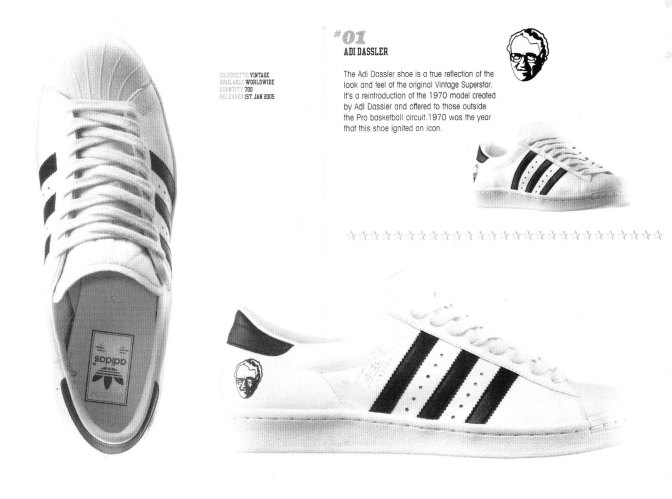

SILHOUETTE **VINTAGE**
AVAILABLE **WORLDWIDE**
QUANTITY **700**
RELEASED **1ST JAN 2005**

#01
ADI DASSLER

The Adi Dassler shoe is a true reflection of the look and feel of the original Vintage Superstar. It's a reintroduction of the 1970 model created by Adi Dassler and offered to those outside the Pro basketball circuit. 1970 was the year that this shoe ignited an icon.

TECHNICAL BREAKDOWN

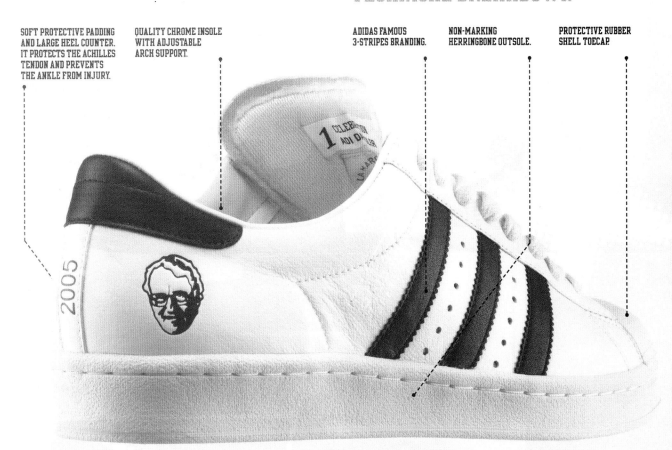

SOFT PROTECTIVE PADDING AND LARGE HEEL COUNTER. IT PROTECTS THE ACHILLES TENDON AND PREVENTS THE ANKLE FROM INJURY.

QUALITY CHROME INSOLE WITH ADJUSTABLE ARCH SUPPORT.

ADIDAS FAMOUS 3-STRIPES BRANDING.

NON-MARKING HERRINGBONE OUTSOLE.

PROTECTIVE RUBBER SHELL TOECAP

casual market. Shifting consumer tastes in fit, comfort, and styling prompted further alterations. Clever marketing similarly reworked history. The sporting heritage of these shoes was emphasized, but so too were more general cultural associations. Small groups of hip consumers—often linked to music, fashion, art, and design—that had long celebrated sneakers were co-opted, in most cases willingly, by the major brands to add street credibility and stimulate the desires of a wider, less well-informed market. Collaborations in which older shoes were redesigned with other hip brands, stores, collectives, and individuals became commonplace; at its most basic, the process little more than a coloring-in exercise, simply selecting new colors and materials. From a manufacturing perspective, these collaborations extracted value from existing designs, tooling, and production expertise. For the brands involved, they added commercial cachet through association and breathed life into well-established models. There was little doubt that these shoes were intended for casual wearers, not serious athletes.

Shoes like the Superstar 35th grew out of a sneaker culture that began to emerge at the start of the 2000s. Just as it had in other areas of business, the internet transformed sports shoe marketing, but new communications technology also gave rise to a community of self-identified "sneakerheads." Fans, collectors, and amateur sneaker historians congregated around websites and discussion forums like Crooked Tongues, Hypebeast, Niketalk, and the digital presence of *Sneaker Freaker*, an Australian fanzine that debuted in 2002. These allowed the interested to share stories, photographs, and information on current and past shoe releases. Around the same time, books by Milk Collective, Robert "Bobbito" Garcia, Scoop Jackson, and Neal Heard, and Thibaut De Longeville and Lisa Leone's documentary *Just for Kicks*, provided a primer on the history of sneakers and helped shape ideas of what it meant to be a collector or fan.[3] The proliferation of books, online material, and heritage marketing allowed anyone into what was once a niche pursuit and was instrumental in defining a new sneaker culture.[4] Toward the end of the decade, the landscape was transformed further by social media. Where once there had been small, relatively isolated groups of aficionados, collectors, and obsessives, now these were a globally connected community. Ebay and other sales sites took the "search and seek" out of buying and collecting, enabling the determined to find models that previously would have remained unobtainable, or those with the financial means to buy sought-after shoes at inflated resale prices. Real world sneaker conventions allowed fans and collectors to gather to buy and sell hard-to-find models. These developments were monitored and, with increasing sophistication, encouraged by the major brands. Forgotten models that were celebrated online were put back into

production; hip brands were identified for potential collaboration. Today, a slow drip-feed of releases, produced in deliberately restricted numbers and distributed in a strictly limited manner, is used to build desire and encourage buyers. By manufacturing scarcity, the main brands add luster to certain products and ensure demand always outstrips supply. Today's sneaker culture exists largely in symbiosis with the major brands.

Changes to the marketing and design of sneakers in the early 2000s were the culmination of trends that had been in development for at least a decade. After the tentative steps of the 1970s and 1980s, during the 1990s the major sports brands became increasingly at ease with mainstream fashion. Ways were found in which products aimed squarely at the fashion-conscious could be sold alongside those for more sports-oriented buyers. Adidas and Puma relied on sales to casual wearers to stay afloat during difficult times, and while their performance products struggled, older models like the adidas Superstar, Stan Smith, and Gazelle, and the Puma Suede and Basket became stalwarts of casual style.[5] Sophisticated, niche marketing ensured that brand identities linked to sports were not tainted by the association with fashion. Adidas created Sports Style and Sports Performance as separate corporate divisions in the early 2000s, and in 2002 it launched adidas Originals as a fashion-oriented sub-brand. Building on the success of retro models since 1991, Originals shoes were presented as being from the same sporting heritage as performance models, but were aimed at the casual market. At the same time, adidas blurred the distinction between performance and style by working with the designers Yohji Yamamoto and Stella McCartney on sports products, and in 2008 it allowed Jeremy Scott to create the first in a series of outlandish reworkings of older models. Nike, meanwhile, developed an aesthetic language that moved beyond sporting function toward design conceptualism. Sergio Lozano's Air Max 95 was inspired by geological stratification, Christian Tresser's futuristic Air Max 97 by the Japanese bullet train, and Eric Avar's Foamposite basketball shoe by a beetle's shell. Working in partnership with product engineers and developers at Nike's supplier manufacturers in South Korea and China, these shoes combined technical and manufacturing ingenuity with stylistic innovation, continuing the move established by Tinker Hatfield and other designers in the late 1980s.[6] Whether they were aimed at the style-conscious or performance-oriented, or, indeed, whether there was a distinction between the two, could be questioned; what was less in doubt was their success and their role as signatures for the entire brand. Peter Fogg's 1997 motorcycle-inspired trail running shoe, the Air Terra Humara, for instance, became so fashionable it drew the attention of *Vogue*.[7] Despite corporate divisions and differentiated marketing, there is now considerable

exchange between consumer segments. Products aimed at serious athletes incorporate elements of fashion. Products aimed at the style and fashion market incorporate the latest technological innovations. It is as artificial now as it was in the nineteenth and twentieth centuries to speak of a rigid dichotomy between sports and fashion.

The sports shoes celebrated by the fashion industry or within contemporary sneaker culture are the tip of a much larger business. It would seem fair to suggest that most sneaker purchases are based on a loose combination of factors: thoughts about where the shoes will be worn, comfort, color, aesthetics, brand associations, cultural connections, cost, what is in fashion and what is not. The forces that motivate sneakerheads are not those of the mass market; many consumers have little interest in the stories behind their shoes. In most cases, sports shoes are sold and worn as mainstream, casual clothing. Where once they were available only from sporting goods stores in secondary locations, now they are sold by prime retailers in town centers and shopping malls. Models are released in seasonal cycles, colors and shapes are dictated by popular trends. Sports shoes grace the fashion pages of popular magazines and websites. Forecasters try to determine what will be the next big thing. Yet even this perhaps obscures a wider truth: that many sports shoes are bought as practical footwear and that "fashion" has little impact. Each year vast quantities of non-descript, mid-range shoes are sold. Sales of products branded by the main sports companies are accompanied by those of countless inexpensive, unbranded shoes. The success of a shoe like the adidas Stan Smith, for instance, can most likely be attributed to a comfortable, simple design that goes well with a range of outfits. The success of the sports shoe perhaps points to the enduring appeal of comfortable, affordable footwear, and to its suitability for the everyday activities of modern life.

<div align="center">* * *</div>

The movement of sports performance brands into the mainstream wardrobe and these companies' overt targeting of the fashion market were nothing new. Rather, they were the latest installments in a story that began in the late nineteenth century. The sports shoe has blended sporting performance with fashion since the 1870s. Sports-inspired style has been popular for over a century. The history of the sports shoe before and after the Second World War showed how consumers refused to be bound by the categories of use suggested by manufacturers. Footwear thought suitable primarily for sport gradually seeped into wider use and in the process became understood in more varied ways. Producers embraced and encouraged new ways of thinking about

sports shoes, perhaps unsurprisingly given the financial rewards on offer. The major sports performance brands now operate largely as did the big rubber firms in the 1930s. Despite marketing campaigns that stress their connection to elite sports, their main business is in simple, inexpensive shoes for mass casual wear. Shoes created and worn for sports are a small fraction of the whole. Sports shoes—and sports clothing—are part of the fashion or casual footwear industries, affected by similar cycles and patterns of demand. As William Dooley recognized in 1913, the term "sports shoe" encompasses a vast array of specialist and casual footwear. It represents a stylistic category as well as an intended use.

The history of the sports shoe is about accumulating cultural associations and the interplay between sports and popular fashion. But it is also about technological and commercial change, globalized production, and the industrialization of shoemaking. An alternative timeline might not list shoes, but the machines, materials, and people that made these shoes possible. Sport has developed alongside the modern shoe industry and has consistently provided a locus for technical experimentation. The focus on performance and the emphasis sport places on competitive advantage have encouraged entrepreneurial manufacturers to innovate. In a product category in which ideas of how shoes ought to look are secondary to how they perform, shoemakers have turned repeatedly to emerging technologies and developments in material and industrial science as a way to gain commercial advantage. Victorian lawn tennis shoes were characterized by newly developed vulcanized rubber. The canvas and rubber-soled shoes of the 1920s and 1930s grew from improved techniques of rubber cultivation and new manufacturing methods. The sports shoes of the later twentieth century were made possible by new plastics and synthetic materials, changes in the way soles could be made and attached, and developments in mass production technology. This application of new materials and manufacturing methods to the needs of athletes continues; Boost, a recent urethane cushioning material, is the result of a collaboration between adidas and scientists at BASF, the German chemical company.[8] The big sports companies invest heavily in research and product development, using laboratory testing to create models attuned to the requirements of athletes in various sports, constantly pushing the boundaries of what is possible in a shoe. In this sense, the spirit of Adolf Dassler lives on.

Viewed from a technical perspective, the history of sports shoes shows the diffusion of shoemaking technology and new materials. Almost every major innovation since the late nineteenth century is still available, and features that were created for elite sport have slowly passed into wider and everyday use. Shoes and production techniques that

8.2 Nike Flyknit, 2012.

have outlived their usefulness within sport find an afterlife as casualwear. Canvas and rubber sneakers like the Converse All Star, Dunlop Green Flash, and Keds are still produced by the million, but are worn now as casual shoes, not as sporting equipment. Perhaps more significantly, as manufacturers have adopted and adapted production techniques first used for sports, less obvious technologies, including molded foam and rubber soles, plastic heel supports, padded uppers, and shaped insoles, have been incorporated into more traditionally styled formal, casual, and work footwear. Every rubber and plastic soled shoe is, in some respect, a descendant of the Victorian lawn tennis shoe. Comfort has spread from sports to the everyday. Sport has long provided a product category in which new materials and techniques could be applied before being used by the wider shoe trade.

The development of sports shoes tracks the rise of mass production within the shoe industry, revealing the ongoing simplification and automation of manufacturing. The tennis shoes of the 1920s, on which rubber soles were bonded to canvas uppers in vast ovens rather than stitched in place with human-operated machines, significantly reduced the time and labor needed for production. So too did the use in the 1960s of sole units that could be glued in place, or the adoption in the 1980s of injection molded polyurethane soles like those on the adidas Trimm Trab. This trend continues. Traditionally, the most labor intensive part of shoemaking has been the production

of uppers, which requires skilled machinists to stitch together several small, intricate parts. The complex shoes of the 1980s and 1990s were perhaps only affordable to western consumers because the wages of those who made them in South Korea, Taiwan, and China were so low. Computerized sewing machinery reduced the need for human labor, while the move toward more pared-back aesthetics, as seen on shoes like Nike's 2000 Air Presto, 2004 Free, and 2012 Roshe Run, or adidas's 2014 ZX Flux and 2016 NMD (a shoe made from twelve constituent pieces), has reduced the complexity of shoe uppers and, in some instances, soles.[9] Perhaps more significantly, advances in knitting technology remove the need for machinists altogether. Nike's Flyknit, which was introduced in 2012 for elite running shoes and has since spread across the range, involves knitting a single piece upper, varying the density of the weave at certain points to provide support. This benefits the wearer, in that it removes seams and results in a lighter product, but it also has significant advantages for producers: the process is almost entirely automated and production waste is reduced. Adidas launched a similar technology known as Primeknit the same year, and in 2017 unveiled a largely automated "Speedfactory" in Bavaria.[10] These developments, as well as advances in 3D printing, point to a future in which shoes can be produced with minimal human involvement, in which the large labor force currently required becomes redundant.[11]

The moves toward more automated production suggest a desire among producers to reduce their reliance on outsourced human labor, and also to rising manufacturing costs in Asia. For over a generation, the sports shoe has been inseparable from the rise of a neoliberal, globalized world order. Since the 1960s, Asian factories have churned out shoes at relatively low cost for consumers in wealthier western markets. The reduction of trade barriers and the rise of international shipping made it possible to transport millions of shoes around the world, and enabled producers to exploit discrepancies in economic development. These shifts brought cheap shoes to western consumers, but encouraged the decline of shoemaking in developed nations. Sneaker factories played an important role—albeit at a human cost—in the development of Japan, Taiwan, South Korea, China, and other Asian economies, but as inexpensive, comfortable sports shoes replaced traditional styles for casual wear, footwear factories in Britain, the United States, and elsewhere struggled to compete. From the 1970s, mass market shoemaking slowly shifted away from many western economies. *Business Week* in 1986 cited Nike as an example of the "hollow corporations" contributing to the demise of manufacturing in the United States.[12] Yet the sports shoe has always been a globalized product. Lawn tennis shoes were first made in Britain using Brazilian rubber. Later, they used rubber

grown on plantations in southeast Asia. Western manufacturers first competed with those in Asia in the 1920s. The sports shoe has long been tied to international trade and to the ability of manufacturers to combine materials and labor from around the globe into a single product.

Global trade has been an important factor in the development of sports shoes, but it is to the rise of sport in western societies that they are most closely tied. They are a corollary to the birth of modern sports and games, and to widening participation in recreational physical activities since the end of the nineteenth century, particularly in Britain, the United States, and Germany. It is this that caused the sports shoe to exist as a product: with no sports, there would be no sports shoes. Sporting practice created needs that were pondered by designers and makers, and which were met by the application of new and existing technologies, materials, and designs. Lawn tennis players needed lightweight, comfortable shoes that gripped slippery grass courts. Basketball players needed shoes that provided ankle support and prevented them sliding on wooden gymnasium floors. The popularity of different activities in the 1960s and 1970s, notably jogging, called for shoes with different characteristics and inspired the innovations of designers, shoemakers, and athletes. As sports have changed, so too have the shoes made for it. Demand for this type of footwear has been stimulated by an explosion of interest in sports; as more people have engaged in sports of all kinds, the market in sports shoes (and in other types of sports clothing and equipment) has grown to meet the enlarged demand. The routines of sports shaped sports shoes, and how manufacturers believed their products would be used within sport dictated their design.

Throughout this period there has been considerable interplay between the realm of sport and popular fashion. Because of this, sports shoes have always carried a rich repertoire of cultural associations. At first these were based on the values with which sport was associated: youth, fitness, informality, modernity, wealth, success. But as sports shoes became more commonplace and were worn in a wider range of contexts they became more symbolically powerful. Yet the cultural associations carried by sports shoes are not always immediately apparent, and are by no means universal. They mean one thing to one group of people and something else to another. How they have been imagined and reimagined by consumers has fed back into the process of design, sale, and consumption and has shaped future shoes.

The sports shoe has been in existence for over one hundred fifty years. During that time, it has been worn in all its varieties by millions of people all around the world. Sports shoes have been used for countless activities, many of them far removed

8.3 adidas NMD with Boost soles, 2015.

from the sports field. Their ubiquity shows the centrality of sports, leisure, and physical recreation in modern lifestyles. Yet they have also been incorporated into new forms of identity that have accompanied the development of new modes of industrial leisure and consumer culture, their endless variety allowing them to be appreciated in infinitesimal ways. As a manufactured product, the sports shoe highlights processes that drive modern, industrial economies. It reveals the ingenuity of producers and their ability to apply technical and material expertise to solve physical needs and stimulate consumer desire. Its diffusion beyond the sports field shows how maverick producers and small groups of consumers have the power to influence and shape wider trends and patterns of consumption. It shows how things are embedded in social practices, and how goods can become rich in symbolic meanings. Sports shoes and brands have become complex signifiers of youth, fitness, strength, success, rebelliousness, conformity, victory, and cultural affinity. Yet they are also simply comfortable footwear, indicators of the enduring appeal of relaxed, sporting styles. It is perhaps odd that shoes first intended to be used in physically extreme circumstances have become so common, worn for the mundane activities of everyday existence. What will become of the sports shoe and what future generations will make of our love for this type of footwear can be debated. What is clear, is that these shoes were shaped by and reflect all the contradictions and complexities of the modern world.

Notes

Introduction

1. The NPD Group, *Global Sport Estimate* (Port Washington, NY: NPD, 2015).
2. Matt Powell, "What Americans Are Really Doing With Their Athletic Shoes, And What It Means For The Shoe Biz," *Forbes*, 14 June 2016, accessed 23 April 2017, https://www.forbes.com/sites/mattpowell/2016/06/14/sneakernomics-why-people-wear-sneakers/#31a5a59021c7.
3. This approach takes inspiration from, among others, Mary Douglas and Baron Isherwood, *The World of Goods: Towards and Anthropology of Consumption* (London: Allen Lane, 1979); Arjun Appadurai, ed., *The Social Life of Things: Commodities in Cultural Perspective* (Cambridge: Cambridge University Press, 1986); Stephen Harold Riggins, ed., *The Socialness of Things: Essays on the Socio-Semiotics of Objects* (Berlin: Mouton de Gruyter, 1994); John Brewer and Frank Trentmann, eds. *Consuming Cultures, Global Perspectives: Historical Trajectories, Transnational Exchanges* (Oxford: Berg, 2006); Daniel Miller, *Stuff* (Cambridge: Polity Press, 2010).
4. On the nature of social practices, see Andreas Reckwitz, "Toward a Theory of Social Practices: A Development in Culturalist Theorizing," *European Journal of Social Theory* 5, no. 2 (May 2002): 243–263. My thinking has been influenced by scholarship that stresses the role of goods in the creation of social practices, and which argues that design is shaped by use. See Donald A. Norman, *The Design of Everyday Things* (London: MIT Press, 1998); Jukka Gronow and Alan Warde, eds., *Ordinary Consumption* (London: Routledge, 2001); Elizabeth Shove, *Comfort, Cleanliness and Convenience: The Social Organization of Normality* (Oxford: Berg, 2003); Elizabeth Shove, Matthew Watson, Martin Hand, and Jack Ingram, *The Design of Everyday Life* (Oxford: Berg, 2007); Elizabeth Shove, Matt Watson, and Mika Pantzar, *The Dynamics of Social Practice: Everyday Life and How It Changes* (London: Sage, 2012); Alan Warde, *Consumption: A Sociological Analysis* (London: Palgrave Macmillan, 2016).
5. In this, it follows Dick Hebdige, "Object as Image: The Italian Scooter Cycle," in his *Hiding in the Light: On Images and Things* (London: Comedia, 1988), 77–115; Paul du Gay, Stuart Hall, Linda Janes, Anders Koed Madsen, Hugh Mackay, and Keith Negus, *Doing Cultural Studies: The Story of the Sony Walkman*, 2nd edition (London: Sage, 2013, 1st edition 1997).
6. See, e.g., Steven Langehough, "Symbol, Status, and Shoes: The Graphics of the World at Our Feet," in *Design for Sports: The Cult of Performance*, ed. Akiko Busch (London: Thames and Hudson, 1998), 20–45; Celia Lury, "Marking Time with Nike: The Illusion of the Durable," *Public Culture* 11, no. 3 (Fall 1999): 499–526; Alison Gill, "Limousines for the Feet: The Rhetoric of Sneakers," in *Shoes: From Fashion to Fantasy*, eds. Giorgio Riello and Peter McNeill (Oxford: Berg, 2006), 372–385.
7. My thoughts on innovation have been influenced by Wiebe E. Bijker, *Of Bicycles, Bakelites, and Bulbs: Toward a Theory of Sociotechnical Change* (Cambridge MA: MIT Press, 1995): Harvey Molotch, *Where Stuff Comes From: How Toasters, Toilets, Cars, Computers and Many Other Things Come to Be As They Are* (New York: Routledge, 2003).
8. "Interview with President & Chairman, Philip H. Knight," in Nike, *Nike, Inc. Annual Report 1985*, (Beaverton OR: Nike, 1985), 4.
9. Julian Marshall, *The Annals of Tennis* (London: "The Field" Office, 1878), 91.

Chapter 1

1. "Lawn-Tennis Appliances, etc.,," *Pastime*, 2 May 1888, 264; 1 May 1889, 276; 7 May 1890, 297–298.
2. On sport in Britain, see Richard Holt, *Sport and the British: A Modern History* (Oxford: Oxford University Press, 1989); Tony Mason, ed., *Sport in Britain: A Social History* (Cambridge: Cambridge University Press, 1989); John Lowerson, *Sport and the English Middle Classes, 1870–1914* (Manchester: Manchester University Press, 1993); Derek Birley, *Sport and the Making of Britain* (Manchester: Manchester University Press, 1993), 317; Derek Birley, *Land of Sport and Glory: Sport and British Society 1887–1910* (Manchester: Manchester University Press, 1995). On the United States, see Donald J. Mrozek, *Sport and American Mentality 1880–1910* (Knoxville: University of

Tennessee Press, 1983); Stephen A. Reiss, *City Games: The Evolution of American Urban Society and the Rise of Sports* (Urbana: University of Illinois Press, 1989); Allen Guttman, *Games and Empires: Modern Sports and Cultural Imperialism* (New York: Columbia University Press, 1994); Allen Guttman, *From Ritual to Record: The Nature of Modern Sports* (New York: Columbia University Press, 2004); Benjamin G. Rader, *American Sports: From the Age of Folk Games to the Age of Televised Sports*, 5th edition (Upper Saddle River: Pearson Education, 2004).

3. On the history of tennis, see Julian Marshall, *The Annals of Tennis* (London: "The Field" Office, 1878); Tom Todd, *The Tennis Players: From Pagan Rites to Strawberries and Cream* (Guernsey: Vallancey Press 1979); Elizabeth Wilson, *Love Game: A History of Tennis, From Victorian Pastime to Global Phenomenon* (London: Serpent's Tail, 2014); Robert J. Lake, *A Social History of Tennis in Britain* (Abingdon: Routledge, 2015); Alexis Tadié, "The Seductions of Modern Tennis: From Social Practice to Literary Discourse," *Sport in History* 35, no. 2 (June 2015): 271–295; Heiner Gillmeister, *Tennis: A Cultural History*, 2nd edition, (Sheffield: Equinox Publishing, 2017, 1st ed. 1997).

4. "Lawn Tennis," *Illustrated London News*, 24 July 1880, quoted in George W. Hillyard, *Forty Years of First Class Lawn Tennis* (London: Williams and Norgate, 1924), 3; *Lawn Tennis for 1883* (London: L. Upcott Gill, 1883), iii.

5. Robert Durie Osborn, *Lawn Tennis: Its Players and How to Play with the Laws of the Game* (London: Strahan and Company, 1881), 11–12; Arthur James, First Earl of Balfour, *Chapters of Autobiography*, ed. Mrs. Edgar Dugdale (London: Cassell, 1930), 223–226; Thorstein Veblen, *The Theory of the Leisure Class: An Economic Study of Institutions* (New York: Macmillan, 1899).

6. *The Sporting Gazette* quoted in Walter Wingfield, *Sphairistikè or Lawn Tennis*, 2nd edition (London: French and Co., 1874), 21, Kenneth Ritchie Wimbledon Library WTM:3883; *The Graphic* cited in "Wednesday, June 25, 1884," *Pastime*, 25 June 1884, 410; "Our Ladies Column," *The Bristol Mercury and Daily Post*, 12 September 1885, 6; *Lawn-Tennis*, 15 September 1886, 1. On the mixed double, see Kathleen E. McCrone,

Sport and the Physical Emancipation of English Women, 1870–1914 (London: Routledge, 1988), 162–163; Robert J. Lake, "Gender and Etiquette in British Lawn Tennis 1870–1939: A Case Study of 'Mixed Doubles,'" *The International Journal of the History of Sport* 29, no. 5, (2012): 696–700.

7. On rubber, see Henry Hobhouse, *Seeds of Wealth: Four Plants That Made Men Rich* (London: Macmillan, 2003), 125–188; John Loadman, *Tears of the Tree: The Story of Rubber* (Oxford: Oxford University Press, 2005).

8. Wingfield, *Sphairistikè or Lawn Tennis*, 2nd ed., 37; *Lawn Tennis: Its Laws and Practice* (London: "The Bazaar" Office, 1877), 14, in *Tracts Published at "The Bazaar" Office*, British Library 1147 e16. On masculine body ideals, see Richard Holt, "The Amateur Body and the Middle-Class Man: Work, Health and Style in Victorian Britain," *Sport in History* 26, no. 3 (December 2006): 352–369; Dave Day and Samantha-Jayne Oldfield, "Delineating Professional and Amateur Athletic Bodies in Victorian England," *Sport in History* 35, no. 1 (March 2015): 19–45.

9. Herbert W. W. Wilberforce, *Lawn Tennis* (London: George Bell and Sons, 1891), 19.

10. "Novelties and Improvements in Lawn-Tennis Implements," *Pastime*, 29 April 1885, 266; "Slazenger & Sons," advertisement in Robert Durie Osborn, *The Lawn-Tennis Player* (London: "Pastime" Office, 1888), n.p. Further reviews of the Renshaw appeared in *Lawn Tennis for 1885* (London: L. Upcott Gill, 1885), 151; "Round the Manufactories," *The Lawn Tennis Magazine*, June 1885, 30; "Lawn-Tennis Appliances," *Pastime*, 21 April 1886, 255; 4 May 1887, 289; 2 May 1888, 268. The Renshaw was advertised widely; see, e.g., "Wm. Hickson and Sons," advertisement, *Pastime*, 4 May 1887, 307.

11. "The Pastime Album," *Pastime*, 2 June 1886, n.p.; "Lawn-Tennis Appliances, etc.," *Pastime*, 2 May 1888, 268. On young men and sport, see Holt, "The Amateur Body," 354–358; Michael Heller, "Sport, Bureaucracies and London Clerks 1880–1939," *The International Journal of the History of Sport* 25, no. 5 (April 2008): 579–606; Geraldine Biddle-Perry, "Fashioning Suburban

Aspiration: Awheel with the Catford Cycling Club, 1886–1900," *The London Journal* 39, no. 3 (November 2014): 187–204.

12. "Dress for Lawn-Tennis," *Pastime*, 20 July 1887, 53. On women in Victorian sport, see Jennifer A. Hargreaves, "Playing Like Gentlemen While Behaving Like Ladies: Contradictory Features of the Formative Years of Women's Sport," *Journal of British Sports History* 2, no. 1 (May 1985): 40–52; J. A. Mangan and Roberta J. Park, eds., *From "Fair Sex" to Feminism: Sport and the Socialization of Women in the Industrial and Post-Industrial Eras*, (London: Routledge, 1987); Jihang Park, "Sport, Dress Reform and the Emancipation of Women in Victorian England: A Reappraisal," *The International Journal of the History of Sport* 6, no. 1 (May 1989): 10–30; McCrone, *Sport and the Physical Emancipation of English Women*; Jennifer A. Hargreaves, *Sporting Females: Critical Issues in the History and Sociology of Women's Sports* (London: Routledge, 1994); Patricia Campbell Warner, *When The Girls Came Out to Play: The Birth of American Sportswear* (Amherst: University of Massachusetts Press, 2006).

13. "Slazenger and Sons," advertisement, *Pastime*, 21 April 1886, 278; *Victorian Shopping: Harrod's Catalogue 1895* (Newton Abbot: David & Charles, 1972), 802; "Harrod's Stores, Court Boot and Shoe Makers," *Hearth and Home*, 3 June 1897, 128; "At Mr. J. Bird's, 19 & 21, Martineau Street," *The Birmingham Pictorial and Dart*, 7 July 1899, 14.

14. "Fashion's Oracle," *The Hampshire Telegraph and Sussex Chronicle*, 1 September 1888, 9; "H. Kelsey, Ladies' and Children's Boot and Shoe Maker," advertisement, *Hearth and Home*, 26 July 1894, 376; "Harrod's Stores," advertisement, *Hearth and Home*, 3 June 1897, 127; "The New Patent Tennis Shoe. 'The El Dorado,'" advertisement, *Pastime*, 3 May 1889, 299; "Fashion's Oracle," *The Hampshire Telegraph and Sussex Chronicle*, 1 September 1888, 9; "Things worth buying," *The Ladies' Monthly Magazine, Le Monde Élégant, or the World of Fashion*, 1 June 1889, 100. On high heels, see Elizabeth Semmelhack, "A Delicate Balance: Women, Power and High Heels," and Valerie Steele, "Shoes and the Erotic Imagination," in *Shoes: A History From Sandals to Sneakers*, in eds. Giorgio Riello and Peter McNeil, (Oxford: Berg, 2006), 224–249, 251–254.

15. Lottie Dod, "Ladies' Lawn Tennis," in *The Encyclopaedia of Sport*, ed. The Earl of Suffolk and Berkshire Hedley Peck and F.G. Aflalo, vol. 1 (London: Lawrence and Bullen, 1897), 618. On sport in girls' schools, see Kathleen E. McCrone, "Play Up! Play Up! and Play the Game! Sport at the Late Victorian Girls' Public School," *Journal of British Studies* 23, No. 2 (Spring, 1984): 106–134.

16. *Rules for Lawn Tennis, 1883* (New York: I. E. Horsman, 1883), 1, 30; Peck & Snyder, *Sporting Goods: Sports Equipment and Clothing, Novelties, Recreative Science, Firemen's Supplies, Magic Lanterns and Slides, Plays and Joke Books, Tricks and Magic, Badges and Ornaments* (1886, repr., Princeton: Pyne Press, 1971), n.p.; Fred L. Israel, ed., *1897 Sears Roebuck Catalogue* (New York: Chelsea House Publishers, 1976), n.p. On the arrival of lawn tennis in America, see Donald J. Mrozek, *Sport and American Mentality 1880–1910* (Knoxville, University of Tennessee Press, 1983), 125; Henry Hall, ed., *The Tribune Book of Open-Air Sports, Prepared by The New York Tribune with the Aid of Acknowledged Experts* (New York: The Tribune Association, 1887), 105–106.

17. "Hides and Leather," *The Times*, 4 January 1894, 13.

18. "Home Markets," *The Times*, 26 February 1894, 13; "Hides and Leather," *The Times*, 2 January 1895, 13.

19. On the development of the shoe trade, see Peter Mounfield, "Boots and Shoes," in *The Victoria History of the County of Northampton: Volume VI, Modern Industry*, ed. Charles Insley (London: Boydell and Brewer, 2007), 71–95; Peter Mounfield, "The Footwear Industry of the East Midlands (III): Northamptonshire, 1700–1911," *East Midland Geographer* 3, no. 24 (1965): 434–453; Peter Mounfield, "The Footwear Industry of the East Midlands (IV): Leicestershire to 1911," *East Midland Geographer* 4, no. 25 (1966): 8–23; James A. Schmiechen, *Sweated Industries and Sweated Labor: The London Clothing Trades, 1860–1914* (London: Croom Helm, 1984), 29–32. For an earlier period, see Giorgio Riello, *One Foot in the Past: Consumers, Producers and Footwear in the Long Eighteenth Century* (Oxford: Oxford University Press, 2006).

20. Quotation from H. E. Randall, *Export Catalogue* (Northampton: H. E. Randall, c.1910), n.p., Northampton Museum and Art Gallery, 1984.193.1. Biographical note on Henry E. Randall; *The Shoe and Leather (and Allied Trades) News Illustrated Biographic Directory of British Shoe and Leather Traders* (London: The Shoe and Leather News, c.1916), vii; H. E. Randall, "H. E. Randall's List of Shops," advertisement, c.1890; all Northampton Museum and Art Gallery, all unnumbered.

21. "H. Randall, Patentee, The 'Tenacious' Lawn Tennis Shoe," advertisement, *Pastime*, 21 May 1884, 335; "Lawn-Tennis Appliances, etc.," *Pastime*, 7 May 1890, 298.

22. "A Tip-Top Show," *The Shoe and Leather Record*, 15 May 1896, 1127; H. E. Randall, *Victory of the Tenacious Lawn Tennis Shoes: A Romance*, promotional booklet, British Library, Evan 5257. For advertisements, see, e.g., "'Tenacious' Lawn-Tennis Shoes," *Boots and Shoe Trades Journal*, 4 July 1885, 1; "'Tenacious' Lawn-Tennis

Shoes," *Boots and Shoe Trades Journal*, 5 September 1885, 139; "'The Tenacious' Lawn-Tennis Shoe," *Boots and Shoe Trades Journal*, 17 October 1885, 231; Randall advertisement in Julian Marshall, *Lawn Tennis with Laws of the Game and Illustrated Price List for 1885* (Horncastle: Lunn and Co., 1885), 26. Randall's shops are illustrated in Randall, "H. E. Randall's List of Shops.." Another promotional card is H. E. Randall, *H. Randall the Noted Anatomical Boot Maker*, British Library, Evan 4189. On Victorian advertising, see E. S. Turner, *The Shocking History of Advertising* (Harmondsworth: Penguin, 1965, orig. 1952), especially 77–115, 132–165.

23. "A Pleasing Ceremony," *The Graphic*, 26 June 1886, 707.

24. "Correspondence," *Pastime*, 30 April 1884, 278.

25. "Correspondence," *Pastime*, 7 May 1884, 295; 14 May 1884, 313; "H. Randall, Patentee, The 'Tenacious' Lawn Tennis Shoe," advertisement, *Pastime*, 21 May 1884, 335.

26. "A Pleasing Ceremony," *The Graphic*; "Lawn-Tennis Appliances, etc.," *Pastime*, 7 May 1890, 298; "Randall's 'Tenacious' Lawn-Tennis Shoes," advertisement, *Pastime*, 21 May 1890, 337; "H.E. Randall," advertisement, *Pastime*, 4 May 1892, 285. H. E. Randall declined rapidly after the death of its founder and in 1953 was taken over by a rival. Few records survive.

27. "Correspondence," *Pastime*, 7 May 1884; 14 May 1884, 313.

28. "The Alleged Prize Fight," *The Times*, 13 May 1882, 6; "The Wide World," *Cycling*, 6 August 1892, 36; "Hints for Ladies," *The Derby Mercury*, 22 August 1894, 6; "Duel Between Experts," *Daily News*, 18 March 1897, 7; "Tee Shots," *Golf Illustrated*, 15 December 1899, 256; "Amateur Walking Match at Leamington," *Bell's Life in London and Sporting Chronicle*, 1 September 1883, 296; J. E. Dixon, "Cross-Country Running," *Physical Culture* 1, no. 6 (1898): 412; Experto Crede, "Sport in Other Lands: Shooting in Bengal, and How to Obtain It," *Country Life Illustrated,* 27 May 1899, 650; Dolf Wyllarde, "Sport in Other Lands: Goat Shooting in Madeira," *Country Life Illustrated*, 16 December 1899, 774.

29. "BASKET BALL SHOES," A. G. Spalding advertisement in Luther Halsey Gulick, *How to Play Basket Ball* (London: British Sports Publishing Company, 1907), 71.; Robert W. Peterson, *Cages to Jumpshots: Pro Basketball's Early Years* (Lincoln NE: University of Nebraska University Press, 1990), 41.

30. "An Ascent of the 'Pieter Both' Mountain, Mauritius," *The Graphic*, 5 July 1879, 18; "An Ascent of the 'Pieter Both' Mountain, Mauritius," *Manchester Times*, 12 July 1879, 222.

31. "Golding, Bexfield & Co.," advertisement, *Pastime*, 21 September 1883, 271; "Wm. Hickson and Sons' Tennis Shoes," advertisement, *Pastime*, 1 May 1889, 284; "Scafe's Patent Leather and Rubber Combination Boots," *The Fishing Gazette and Railway Supplies Journal*, 11 February 1888, 78.

32. "Holiday Haunts," *Daily News*, 6 December 1884, 3; "Failure of the Strike Negotiations," *Lloyd's Weekly Newspaper*, 8 September 1889, 1. On male fashions, see Christopher Breward, *The Hidden Consumer: Masculinities, Fashion and City Life 1860–1914* (Manchester: Manchester University Press, 1999), especially 198; Brent Shannon, *The Cut of His Coat: Men, Dress, and Consumer Culture in Britain, 1880–1914* (Athens OH: Ohio University Press, 2006), especially 186, 189.

33. "Yesterday's Inquests," *Reynolds's Newspaper*, 13 September 1896, 1; "What Men Wear," *Daily News*, 3 September 1889, 3. The incident was also reported in "Yesterday's Inquests," *Lloyd's Weekly Newspaper*, 13 September 1896, 3; "Killed By a Scythe Cut," *Daily News*, 14 September 1896, 6; "Killed By a Scythe Cut," *Liverpool Mercury*, 17 September 1896, 7; "Shocking Accident Near Cromer," *The Ipswich Journal*, 19 September 1896, 5.

34. Shannon, *Cut of His Coat*, 179–182; "London Letter," *Western Mail*, 11 August 1893, 4; "London Correspondence," *Freeman's Journal and Daily Commercial Advertiser*, 12 August 1895, 5; "From Our London Correspondent," *The Leeds Mercury*, 13 June 1900, 4.

Chapter 2

1. William H. Dooley, *A Manual of Shoemaking and Leather and Rubber Products* (London: Gay and Hancock, 1913), 238–239.

2. *Lawn Tennis for 1883* (London: L. Upcott Gill, 1883), 96; Henry Hobhouse, *Seeds of Wealth: Four Plants That Made Men Rich* (London: Macmillan, 2003), 129.

3. The origins of Asian rubber are described in Warren Dean, *Brazil and the Struggle for Rubber: A Study in Environmental History* (New York: Cambridge University Press, 1987), 7–35; Hobhouse, *Seeds of Wealth*, 129–141; John Loadman, *Tears of the Tree: The Story of Rubber* (Oxford: Oxford University Press, 2005), 81–107; Joe Jackson, *The Thief at the End of the World: Rubber, Empire, and the Obsessions of Henry Wickham* (New York: Viking Penguin, 2008). Earlier accounts include P. W. Barker, *Rubber: History, Production, and Manufacture* (Washington D.C.: United States Government Printing Office, 1940); Herbert McKay, *Rubber and Its Many Uses* (Oxford: Oxford University Press, 1940); Charles Morrow Wilson, *Trees and Test Tubes: The Story of Rubber* (New York: Henry Holt, 1943).

4. Hobhouse, *Seeds of Wealth*, 134, 141, 161; Loadman, *Tears of the Tree*, 99, 102.

5. H. P. Stevens and William Henry Stevens, *Rubber: Production and Utilization of the Raw Product* (London: Isaac Pitman and Sons, 1934), 27.

6. William C. Geer, *The Reign of Rubber* (New York: Century, 1922), 45–46. Geer joined B. F. Goodrich as Chief Scientist in 1907 and in 1918 was appointed Vice President in charge of research. His influence is discussed in Mansel G. Blackford and K. Austin Kerr, *B. F. Goodrich: Tradition and Transformation 1870–1995* (Columbus: Ohio State University Press, 1996), 65.

7. "New Kind of Sport Shoe," *New York Times*, 6 November 1921, 40; "Consumption of Raw Rubber," *The Rubber Age* (UK), November 1921, 470.

8. Photographs of the posters are in *The Crepe Rubber Sole (Plantation Finished): Handbook for Repairers* (London: Rubber Growers' Association, 1929), back cover, British Library, W35/8335 DSC. Photographs of Association exhibition stands are in *The Rubber Age* (UK), November 1927, 367; February 1928, 486; October 1928, 281; November 1928, 332. Promotional statistics are on "The Victory of the Crepe Rubber Sole," Rubber Growers' Association advertisement, *Shoe and Leather Record*, 6 July 1923, 13.

9. "Crude Rubber Soles," *The Rubber Age* (UK), August 1922, 291; "The Victory of the Crepe Rubber Sole," Rubber Growers' Association advertisement, *The Shoe and Leather Record*, 6 July 1923, 13; *Rubber and Footwear: Being a Short Account of the Preparation and Properties of Rubber with Particular Reference to Its Uses in the Boot and Shoe Industry* (London: Rubber Growers' Association, 1926), 28. British Library, W53/7660 DSC.

10. John Carter and Sons, *General Price List, Spring 1930* (London: John Carter and Sons, 1930), 117-118, 187-188, 190-94, 198, 200, 203. British Library, YD.2005 b.1734; William T. Tilden, *Footwork in Tennis* (London: Dominion Rubber Company, 1926), 20, British Library, YA.2003.a.15130(2); Alan Mirken, ed., *The 1927 Edition of the Sears, Roebuck Catalogue* (New York: Bounty Books, 1970), 338, 524; "Cubo Sports Oxford" and "Jai-Alai Sports Shoe," *The Rubber Age* (US), May 1934, 89; "Hood Jai Alai Shoe," *The Rubber Age* (US), May 1935, 98.

11. "Rubber at the Shoe and Leather Fair," *The Rubber Age* (UK), October 1924, 475; "The Shoe and Leather Fair 1930," *The Rubber Age* (UK), November 1930, 343; *The Crepe Rubber Sole (Plantation Finished): Handbook for Repairers*, 3, 19.

12. "The Rubber Footwear Industry in America," *The Rubber Age* (UK), September 1922, 333; "Announcing Dunlop Sports Shoes," *The Shoe and Leather Record*, 3 October 1930, supplement. On Dunlop, Geoffrey Jones, "The Growth and Performance of British Multinational Firms before 1939: The Case of Dunlop," *The Economic History Review* 37, no. 1 (February 1984): 35–53; James McMillan, *The Dunlop story: The Life, Death and Re-Birth of a Multi-National* (London: Weidenfeld and Nicolson, 1989).

13. "Notes on Novelties," *The Rubber Age* (UK), April 1920, 80. Advertisements for Gutta Percha and Rubber, Dominion Rubber, and Miner Rubber in *The Shoe and Leather Record*, 16 February 1934, supplement, ix; 10 May 1935, supplement, v, viii; 7 June 1935, 25; 12 July 1935, 12.

14. "The Rubber Footwear Industry in America," *The Rubber Age* (UK), September 1922, 335; "Conveyor Speeds Footwear Manufacture," *The Rubber Age* (US), April 1936, 30; Bert Jasper Morris and Charles H. Paull, *Opportunities for Handicapped Men in the Rubber Industry* (New York: Red Cross Institute for Crippled and Disabled Men, 1919), 45–46; Dunlop Rubber Company, *Dunlop Sports Shoes—Watch Them Made at Liverpool*, c.1930, accessed 18 April 2017, https://www.youtube.com/watch?v=usVLR1aBTQs.

15. Geer, *The Reign of Rubber*, 179–180; "The Rubber Footwear Industry in America," 333; Anon., *Rubber and Footwear: Being a Short Account of the Preparation and Properties of Rubber with Particular Reference to Its Uses in the Boot and Shoe Industry* (London: Rubber Growers' Association, 1926), 19, British Library, W53/7660 DSC; "World Trade in Rubber Footwear," *The Incorporated Federated Associations of Boot and Shoe Manufacturers of Great Britain and Ireland Federation Journal* 10 (November 1928–October 1929): 492, Northampton Museum and Art Gallery, 2005.64.28; "Announcing Dunlop Sports Shoes," *The Shoe and Leather Record*, 3 October 1930, supplement; David Baptie, "The Progress and Future of Rubber Footwear," *The Rubber Age* (UK), February 1928, 485–486.

16. Richard Holt, *Sport and the British: A Modern History* (Oxford: Oxford University Press, 1989) 127.

17. Michael Heller, "Sport, Bureaucracies and London Clerks 1880–1939," *The International Journal of the History of Sport* 25, no. 5 (April 2008): 582, 607.

18. "Army of Indoor Sportsmen Grows Rapidly in New York," *New York Times*, 13 February 1927, XX22.

19. "Wear the Clothes, But Shun the Game," *New York Times*, 17 June 1923, E3. On sportswear and the movies, see Patricia Campbell Warner, "The Americanization of Fashion: Sportswear, the Movies and the 1930s," in *Twentieth-Century American Fashion*, eds. Linda Welters and Patricia A. Cunningham (Oxford: Berg, 2005), 79–98.

20. F. Scott Fitzgerald, *This Side of Paradise* (New York: Penguin, 1996, orig. 1920) 34–35; "Use Canvas Footwear," *New York Times*, 7 October 1923, F8; "What

The Sports Shoe

the Smith College Girls Are Wearing," *New York Times*, 1 June 1930, X10; "Smith College Fashions," *New York Times*, 30 November 1930, X14; "Vassar: A Bright Jewel in U.S. Educational Diadem," *Life*, 1 February 1937, 24-31; "Bennington: An Experiment in Progressive Education That Works," *Life*, 22 November 1937, 36–43; *Life*, 7 June 1937, quotation at 24. For a similar phenomenon in Britain, see Laura Ugolini, "Clothes and the Modern Man in 1930s Oxford" in *The Men's Fashion Reader*, eds. Peter McNeil and Vicki Karaminas (Oxford: Berg, 2009), 299–309. On nascent youth culture more generally, see Jon Savage, *Teenage: The Creation of Youth Culture* (London: Viking, 2007).

21. "The Business World: Favor High Shoes for Sports," *New York Times*, 13 May 1927, 40; Mickey Mouse shoe in *Samuel Americus Walker, Sneakers* (New York: Workman Publishing, 1978), 29; "Protect Their Active Feet with FLEXIBLE SHOES Child Specialists Advise," Hood Rubber advertisement, *Good Housekeeping*, July 1930, 198; "Sure-footed, speedy, in the shoe that Champions wear," United States Rubber advertisement, *American Boy*, April 1927, 37. "No offensive perspiration odor when they wear HOOD CANVAS SHOES"; "Get him the kind of Canvas Shoes that Prevent this"; "Prevent this! with Hood Canvas Shoes"; "No Offensive Sneaker Smell with the HOOD HYGEEN INSOLE"; Hood Rubber advertisements, c.1930, author's collection. "When you plan your boy's future the place to start is right here"; "Don't risk your boy's feet in Shapeless Sneakers . . . fit them in SCIENTIFICALLY LASTED Keds"; "Have you seen this new KIND of Canvas Shoe?"; United States Rubber advertisements, 1934, author's collection.

22. Gina Holdar, *A–Z of Classic American Clothing* (n.p.: Gina Holdar, 2010) 67; "Smith College Fashions," *New York Times*; "What the Smith College Girls Are Wearing," *New York Times*; "Jersey Girl Wins Wardrobe Contest," *New York Times*, 2 November 1937, 28; *Life*, 7 June 1937, front cover. Saddle shoes can be seen being worn in, e.g., "Vassar: Its girls have a sense of humor" and "Girl's goal: still a home," *Life*, 6 June 1938, 54–56; "Subdebs," *Life*, 27 January 1941, 74–79; "Teen-age Girls," *Life*, 11 December 1944, 91–99; "Life visits 'Heidelberg High,'" *Life*, 1 July 1947, 92–97.

23. Reprinted as Chester C. Burnham, "What Is Wanted in Rubber Soles: Hints Manufacturers Might Adopt," *The Rubber Age* (UK), August 1922, 263–265.

24. Anon., *Rubber and Footwear*, 25–26; Max Cohen, *I Was One of the Unemployed* (London: Victor Gollancz, 1945), 107; John Carter and Sons, *General Price List, Spring 1930*, 187–8, 199; Tanners Shoe Manufacturing Company, *Footwear of Supreme Quality: Spring and Summer 1927*

(Boston: Tanners Shoe Manufacturing Company, 1927), 21, Northampton Museum and Art Gallery, 1991.65.1.

25. "A complete line with a type for every summer need," United States Rubber advertisement, *The American Magazine*, c.1920, author's collection.

26. "From the country schoolboy to the Yacht Club Commodore," United States Rubber advertisement, *The American Magazine*, 1922, author's collection.

27. "Insuring Comfort in Summer Footwear"; "Once the custom of a lucky few—Today the summer habit of all America"; "Today twenty million people have a new idea of summer footwear," United States Rubber advertisements, c.1920; "A striking change in American life brings a new comfort in summer dress," United States Rubber advertisement, *The Saturday Evening Post*, 1923; "How to be comfortable and modish," United States Rubber Company advertisement, *Cosmopolitan*, August 1917, 108; "His Feet Are As Relaxed As His Soul," United States Rubber advertisement, *The Saturday Evening Post*, 1939; all author's collection.

28. John Carter and Sons, *General Price List, Spring 1930*, 190; "How 24 'U.S.' Laboratories Helped Bring Glory to Heroes of Air and Land," United States Rubber advertisement, *Saturday Evening Post*, 1931, author's collection. On the notion of the "modern wonder" see Bernhard Rieger, *Technology and the Culture of Modernity in Britain and Germany 1890–1945* (Cambridge: Cambridge University Press, 2005).

Chapter 3

1. Greg Donaldson, "For Joggers and Muggers, the Trendy Sneaker," *New York Times*, 7 July 1979, 17.

2. "Dunlop Sports Shoes on Duty!," advertisement, *The Shoe and Leather Record*, 3 October 1940, supplement, xi; "100 Million Pairs Arrears," *The Shoe and Leather Record*, 4 April 1945, 24.

3. "Dunlop will set the quality standard in post-war footwear," advertisement, *The Shoe and Leather Record*, 26 July 1945, supplement, ii; "Sports," in Anon., *Presenting British Shoes and Leather* (London: The Shoe and Leather News, c.1948), 1–9, Northampton Museum and Art Gallery, 1972.188.

4. "Why your customers insist on buying Dunlop," advertisement, *The Shoe and Leather Record*, 17 March 1949, 40; "North British Sports Lines," North British Rubber Company advertisement, in Harper and Co., *Harpers Guide to the Sports Trade 1951* (London: Harper and Co., 1951), 23, British Library, PP.2489.ZCN.

5. "World Trade in Rubber Footwear," *The Incorporated Federated Associations of Boot and Shoe Manufacturers of Great Britain and Ireland Federation Journal* 10 (November

1928–October 1929): 492. Northampton Museum and Art Gallery, 2005.64.28.; "Rubber Footwear Exports of Various Countries Compared," *The Incorporated Federated Associations of Boot and Shoe Manufacturers of Great Britain and Ireland Federation Journal* 12 (November 1930–October 1931): 359–360. Northampton Museum and Art Gallery, 2005.64.28; "Announcing Dunlop Sports Shoes," *Shoe and Leather Record*, 3 October 1930, supplement; Directors Meeting, 10 October 1955, Greengate and Irwell minute book, 408, London Metropolitan Archives, B/BTR/GIRC/03; *Chairman's Speech at the 58th Annual General Meeting of the Company*, 17 June 1957, 9, Dunlop Rubber Company Reports and Balance Sheets 1956 no. 1, London Metropolitan Archives, Acc 2166/61.

6. 41st Annual General Meeting of the Members, 21 July 1959, Greengate and Irwell minute book, 148, London Metropolitan Archives, B/BTR/GIRC/01; Directors Meeting (Special), 19 March 1958, Greengate and Irwell minute book, 520, London Metropolitan Archives, B/BTR/GIRC/03; Meeting to discuss accountants' report, 27 April 1959, Greengate and Irwell minute book, 580, London Metropolitan Archives, B/BTR/GIRC/03;"Everyone's going for GREENGATE Sports Footwear," advertisement, *The Shoe and Leather Record*, 27 September 1956, 195; Directors Meetings, 19 July 1966, 19 August 1966, 19 September 1966, Greengate and Irwell minute book, 1087, 1093, 1098, London Metropolitan Archives, B/BTR/GIRC/04.

7. *Chairman's Speech at the 54th Annual General Meeting of the Company*, 15 June 1953, 8, Dunlop Rubber Company Reports and Balance Sheets 1952 no. 1, London Metropolitan Archives, Acc/2166/045; *Chairman's Speech at the 55th Annual General Meeting of the Company*, 14 June 1954, 8, Dunlop Rubber Company Reports and Balance Sheets 1953 no. 1, London Metropolitan Archives, Acc/2166/049; *Chairman's Speech at the 58th Annual General Meeting of the Company*, 17 June 1957, 9, Dunlop Rubber Company Reports and Balance Sheets 1956 no. 1, London Metropolitan Archives, Acc/2166/061; *Chairman's Speech at the 56th Annual General Meeting of the Company*, 13 June 1955, 9, Dunlop Rubber Company Reports and Balance Sheets 1954 no. 1, London Metropolitan Archives, Acc/2166/053.

8. *Dunlop Annual Report 1964* (London: Dunlop Rubber Company, 1965), 20. Dunlop Rubber Company Reports and Balance Sheets 1964 no. 1, London Metropolitan Archives, Acc/2166/097. "For Sport and Country," *The Shoe and Leather Record*, 26 September 1957, 37; "Most Wimbledon Players Choose Dunlop Sports Shoes,"

advertisement, *The Shoe and Leather Record*, 3 July 1958, 59; *Directors' Report and Accounts of Dunlop Rubber Company Limited for the year ended 31st December 1961* (London: Dunlop Rubber Company, 1962), 27. Dunlop Rubber Company Reports and Balance Sheets 1961 no. 1, London Metropolitan Archives, Acc/2166/082; *Dunlop Annual Report 1963* (London: Dunlop Rubber Company, 1964), 24–27. Dunlop Rubber Company Reports and Balance Sheets 1963 no. 1, London Metropolitan Archives, Acc/2166/092.

9. P. Long, "Sports Footwear," in "Out and About," supplement to *The Shoe and Leather Record*, 12 May 1955, 4, 6, 12. On postwar sports, see Martin Polley, *Moving the Goalposts: A History of Sport and Society Since 1945* (London: Routledge, 1998); Richard Holt and Tony Mason, *Sport in Britain 1945–2000* (Oxford: Blackwell, 2000); Jeffrey Hill, *Sport, Leisure and Culture in Twentieth-Century Britain* (Basingstoke: Palgrave, 2002).

10. The principal sources for the history of adidas are: Detlef Vetten, *Making a Difference* (Herzogenaurach: adidas-Salomon, 1998); Klaus-Peter Gäbelein, "adidas—Eine Erfolgsstory aus Herzogenaurach," *Herzogenauracher Heimatblatt*, 2 November 2000, accessed 10 September 2017, https://www.herzogenaurach.de/fileadmin/user_upload/Content/Stadtgeschichte/HB_adidas.PDF; Barbara Smit, *Pitch Invasion: Adidas, Puma and the Making of Modern Sport* (London: Allen Lane, 2006); Rolf-Herbert Peters, *The Puma Story: The Remarkable Turnaround of an Endangered Species into One of the World's Hottest Sportlifestyle Brands* (London: Cyan, 2007); Barbara Smit, *Sneaker Wars: The Enemy Brothers Who Founded adidas and Puma and the Family Feud that Forever Changed the Business of Sports* (New York: HarperCollins, 2008); Keith Cooper, *Adidas: The Story As Told By Those Who Have Lived and Are Living It* (Herzogenaurach: adidas, 2011). The adidas name was registered and is used by the firm in lower case letters.

11. Peters, *The Puma Story*, 21–23.

12. John Underwood, "No Goody Two-Shoes," *Sports Illustrated*, 10 March 1969, 14.

13. adidas catalogue, 1949, DC-279, 3–5, author's translation; adidas catalogue, 1950, DC-281, 7–18. All adidas catalogues were consulted in the adidas archive.

14. See Raymond G. Stokes, *Opting For Oil: The Political Economy of Technological Change in the West German Chemical Industry, 1945–1961* (Cambridge: Cambridge University Press, 1994); John E. Lesch, ed., *The German Chemical Industry in the Twentieth Century* (Dordrecht: Kluwer Academic Publishers, 2000).

15. Underwood, "No Goody Two-Shoes," 16.

16. adidas catalogue, 1950, DC-281, 12.

17. adidas catalogue, 1956, DC-278, 4–5.

18. adidas/Umbro catalogue, 1962, DC-3, 9; adidas catalogue, 1965, DC-290, 11.

19. adidas catalogue, 1965, DC-290, 9; adidas catalogue, c.1965, DC-265, 7.

20. adidas catalogue, 1965, DC-290, 10, 15.

21. William Joseph Baker, *Sports in the Western World* (Totowa NJ: Rowman and Littlefield, 1982), 310; "A Spectacle of Olympian deeds," *Life*, 10 December 1956, 34–49; the Hurst photograph is reproduced in Peter Robinson, Doug Cheeseman, and Harry Pearson, *1966 Uncovered: The Unseen Story of the World Cup in England* (London: Mitchell Beazley, 2006), 200–201.

22. These figures were quoted routinely in adidas promotional material during the 1960s and 1970s.

23. John Sugden and Alan Tomlinson, "FIFA and the Marketing of World Football," in *The Production and Consumption of Sport Cultures: Leisure, Culture and Commerce*, eds. Udo Merkel, Gill Lines, and Ian McDonald (Eastbourne: Leisure Studies Association, 1998), 57.

24. Underwood, "No Goody Two-Shoes," 17, 22–31.

25. See Roland Naul, "History of sport and physical education in Germany, 1800–1945," in *Sport and Physical Education in Germany*, eds. Roland Naul and Ken Hardman (London: Routledge, 2002), 15–23.

26. Ilse Hartmann-Tews, "Sport for all: System and policy," in *Sport and Physical Education in Germany*, 153–164.

27. Peters, *The Puma Story*, 45.

28. Ken Hardman and Roland Naul, "Sport and physical recreation in the two Germanies, 1945–90," in *Sport and Physical Education in Germany*, 42–43.

29. Frieder Roskam, "Sports facilities," in *Sport and Physical Education in Germany*, 193–195.

30. Hartmann-Tews, "Sport for all," 162.

31. adidas catalogue, 1972, DC-350, n.p.; adidas-France brochure, 1989, adidas archive, unnumbered item, 29.

32. John F. Kennedy, "The Soft American," *Sports Illustrated*, 26 December 1960, 15–17; Julie Sturgeon and Janice Meer, "The First Fifty Years 1956–2006: The President's Council on Physical Fitness and Sports Revisits Its Roots and Charts Its Future," in *President's Council on Physical Fitness & Sports: The First 50 Years: 1956–2006*, ed. Janice Meer (Tampa FL: President's Council on Physical Fitness & Sports, 2006), 43–63, accessed 14 July 2016, http://www.fitness.gov/pdfs/50-year-anniversary-booklet.pdf.

33. Mansel G. Blackford and K. Austin Kerr, *B. F. Goodrich: Tradition and Transformation 1870–1995* (Columbus: Ohio State University Press, 1996), 283–4.

34. The principal sources for the history of Blue Ribbon Sports/Nike are J. B. Strasser and Laurie Becklund, *Swoosh: The Unauthorized Story of Nike and the Men Who Played There* (New York: HarperBusiness, 1993); Donald Katz, *Just Do It: The Nike Spirit in the Corporate World* (New York: Random House, 1994); Jackie Krentzman, "The Force Behind the Nike Empire," *Stanford Magazine*, January/February 1997, accessed 14 July 2016, http://www.stanfordalumni.org/news/magazine/1997/janfeb/articles/knight.html; Kenny Moore, *Bowerman and the Men of Oregon: The Story of Oregon's Legendary Coach and Nike's Cofounder* (Emmaus, PA: Rodale, 2006); Geoff Hollister, *Out of Nowhere: The Inside Story of How Nike Marketed the Culture of Running* (Maidenhead: Meyer and Meyer Sports, 2008); Phil Knight, *Shoe Dog: A Memoir by the Creator of Nike* (London: Simon and Schuster, 2016).

35. Quoted in Strasser and Becklund, *Swoosh*, 35.

36. "19th Hole: The Readers Take Over," *Sports Illustrated*, 24 March 1969, 81; Benjamin G. Rader, *American Sports: From the Age of Folk Games to the Age of Televised Sports*, 5th edition (Upper Saddle River NJ: Pearson Education, 2004), 244–249; Strasser and Becklund, *Swoosh*, 62–63; Hollister, *Out of Nowhere*, 28–41; Arthur Lydiard, "Why I Prescribe Marathons for Milers," *Sports Illustrated*, 19 March 1962, 40–51; William J. Bowerman and W. E. Harris, *Jogging: A Physical Fitness Program For All Ages* (New York: Grosset and Dunlap, 1967); William Knowlton Zinsser, "The Pious Pad-Pad-Pad of Jogging," *Life*, 22 March 1968, 12; Pamela G. Hollie, "Race Is On for Running-Shoe Money," *New York Times*, 24 October 1977, 45.

37. Cynthia Jabs, "Nike: The Shoes That Go Swoosh," *New York Times*, 19 August 1979, F5; Janet Newman, "Hot Off Bowerman's Waffle Iron," *Runner's World*, January 1973, 8.

38. Andrew D. Gilman, "Pity the Sneaker: Its Era Is Ended," *New York Times*, 18 December 1977, 202; "All About: Sneakers," *New York Times*, 2 March 1977, 59; Donaldson, "For Joggers and Muggers," 17.

Chapter 4

1. Paul Stewart and Jack Tobin, "Shopwalk," *Sports Illustrated*, 18 May 1964, 8–10.

2. McCandlish Phillips, "Pavement Surfing Makes Splash," *New York Times*, 3 March 1965, 43. Michael Brooke, *The Concrete Wave: The History of Skateboarding* (Toronto: Warwick Publishing, 1999), 21. On the development of skateboards and skateboarding, see Brook, *The Concrete Wave*, 16–31; Iain Borden, *Skateboarding, Space and the City: Architecture and the Body* (Oxford: Berg, 2001), 13–18; Stewart and Tobin, "Shopwalk," 8–10.

3. Marylin Bender, "Shift to Low Sneakers Still Plagues Mothers," *New York Times*, 26 October 1962, 48; Joan

Cook, "Today's Schoolboy and the New Fashions: He Hasn't Lost His Buttons," *New York Times*, 1 April 1966, 22; "Skateboard Mania," *Life*, 14 May 1965, 126–8; Bernard Weinraub, "Skateboards Take the Spotlight at Wesleyan," *New York Times*, 3 May 1965, 35.

4. *Skaterdater*, short film, dir. Noel Black (Los Angeles: Byway Productions, 1965); "Skateboard Mania," *Life*, 132; Patrick McNulty and Ron Stoner, "International Skateboard Championships," *Skateboarder Magazine*, August 1965, 1, 16–37.

5. "FOR SIDEWALK SURFING . . . Randy '720' SKATEBOARDER Sneaker," advertisement, *Skateboarder Magazine*, August 1965, 3; Jürgen Blümlein, Daniel Schmid, Dirk Vogel, and Holger von Krosigk, *Made for Skate: The Illustrated History of Skateboard Footwear* (Hamburg: Gingko Press, 2008), 26–27.

6. McNulty and Stoner, "International Skateboard Championships," 1, 39; South East Bay Skateboard Club c.1965, photograph, author's collection.

7. Randy Mighty Mouse, rubber-soled printed canvas sneaker, Randolph Rubber Company c.1960, Northampton Museum and Art Gallery, 2011.144.1.; Randy Batman, rubber-soled printed canvas sneaker, Randolph Rubber Company c.1966, Northampton Museum and Art Gallery, 2009.57.20; Adam Tschorn, "How Vans tapped Southern California skate culture and became a billion-dollar shoe brand," *Los Angeles Times*, 12 March 2016, accessed 19 April 2017, http://www.latimes.com/fashion/la-ig-vans-turns-50-20160312-story.html.

8. "Step on it . . . it's alive!" Vita-Pakt advertisement, *Skateboarder Magazine*, August 1965, 56.

9. Borden, *Skateboarding, Space and the City*, 17.

10. Tony Kornheiser, "Whoosh! Skateboards Zip Back Into Big Time," *New York Times*, 19 June 1976, 35.

11. Tony Hiss and Sheldon Bart, "Free as a board," *New York Times*, 12 September 1976, 40.

12. Kornheiser, "Whoosh!," 35.

13. Judith A. Davidson, "Sport and Modern Technology: The Rise of Skateboarding, 1963–1978," *Journal of Popular Culture* 18, no. 4 (March 1985): 149.

14. On polyurethane wheels, see Sarah Pileggi, "Wheeling and Dealing," *Sports Illustrated*, 1 September 1975, 22; Eric M. Weiss, "A Reinvention Of the Wheel," *Washington Post*, 17 August 2004, B01.

15. Borden, *Skateboarding, Space and the City*, 5–6.

16. Kornheiser, "Whoosh!" 35; Frank Deford, "Promo Wiz In Kidvid Bid," *Sports Illustrated*, 7 February 1977, 31; *The World About Us: Skateboard Kings*, television film, dir. Horace Ové (London: BBC, 1978).

17. "Alpine Sports Pro Skateboard Shop," mail order supplement, *Skateboard!*, August 1977.

18. The articles and photographs are collected in Glen E. Friedman and C. R. Stecyk III, *Dog Town: The Legend of the Z-Boys* (New York: Burning Flag Press, 2000).

19. John Smythe, "Dead Dogs Never Lie," *SkateBoarder*, February 1979, 39. The Z-Boys' influence is the focus of *Dogtown and Z-Boys*, documentary film, dir. Stacy Peralta (Culver City: Sony Pictures Classics, 2001).

20. "THE DYNAMIC DUO!" Hang Ten advertisement, *SkateBoarder*, June 1976, 142; "RADIALS," Makaha Sportswear advertisement, *SkateBoarder*, November 1978, 47; "New From Hobie," Hobie Athletic Footwear advertisement, *SkateBoarder*, August 1978, 10; Blümlein et al. *Made For Skate*, 36–43, 46–57, 60–61.

21. Pictured in Blümlein et al. *Made For Skate*, 43.

22. Doug Schneider, "Skate Safe: Skate Shoes," *SkateBoarder*, October 1979, 21; Howard Reiser, *Skateboarding* (New York: Franklin Watts, 1978), 16; LaVada Weir, *Skateboards and Skateboarding: The Complete Beginner's Guide* (London: Pan Books, 1978), 23; Adrian Ball, *How to Skateboard: A Beginner's Guide to the World's Fastest Growing Sport* (Homewell: Kenneth Mason Publications, 1977), 30; Glenn Bunting and Eve Bunting, *Skateboards: How to Make Them How to Ride Them* (New York: Harvey House, 1977), 28.

23. The principal sources on the history of the Van Doren Rubber Company/Vans are Jason Le, "California Dreaming: The Vans Story" in *Sneaker Freaker: The Book 2002–05*, ed. Simon Wood (New York: Riverhead Freestyle, 2005), n. p.; Doug Palladini, *Vans Off the Wall: Stories of Sole From Vans Originals* (New York: Abrams, 2009), 6, 11–17; "Vans, Inc.," *International Directory of Company Histories* 47 (2002): 423–426.

24. Brooke, *The Concrete Wave*, 124; "Footprints from The House of Van," promotional leaflet c.1972, reproduced in Palladini, *Vans Off the Wall*, 86.

25. Alva quoted in Palladini, *Vans Off the Wall*, 27; Schneider, "Skate Shoes," 21. The Zephyr uniform is discussed by Wentzl Ruml in *Dogtown and Z-Boys*; it should be noted that the film was supported by Vans and the director, Stacy Peralta, was sponsored by Van Doren in the 1970s and 1980s.

26. Jim Van Doren quoted in Mary Horowitz, "Design Symposium: Protective Equipment," *SkateBoarder*, July 1978, 173; Palladini, *Vans Off the Wall*, 13, Alva quoted at 27; "OFF THE WALL," Van Doren advertisement, *SkateBoarder*, July 1977, 135.

27. "Van's world's number one skateboard shoes," Van Doren advertisement, *SkateBoarder*, April 1978, 142 ; "HI-POWERED HI-TOPS!" Van Doren advertisement, *SkateBoarder*, November 1979, 6.

28. Horowitz, "Design Symposium: Protective Equipment," 173.

29. J. B. Strasser and Laurie Becklund, *Swoosh: The Unauthorized Story of Nike and the Men Who Played There* (New York: HarperCollins, 1993), 117; Schneider, "Skate Shoes," 21; Interview With Tony Alva, *SkateBoarder*, July 1978, 79; *Skateboard*, feature film, dir. George Gage (Los Angeles: Blum Group, 1978); *The World About Us: Skateboard Kings*; *Thrasher*, January 1981, front cover.

30. Strasser and Becklund, *Swoosh*, 234–43, 246–7; "Consenting Adults," *Charlie's Angels*, television show, dir. George McCowan (Los Angeles: Spelling-Goldberg Productions, 1976), first aired 8 December 1976; Nike advertisements reproduced in Robert Jackson, *Sole Provider: 30 Years of Nike Basketball* (New York: powerHouse books, 2002), 22–3.

31. "Sporting '78," *Footwear World*, May 1978, 4; Gregg Haythorpe, *Skateboard Annual* (London: Brown Watson, 1978), 26–27.

32. ". . . enter Plastak skateboards . . ." *Footwear World*, August 1976, 9; "YOUR SKATEBOARD. A DOWNHILL SLALOM. AND DUNLOP." Dunlop advertisement, reproduced in Blümlein et al., *Made For Skate*, 79; "CATCH THIS FAST MOVING MARKET WITH SKATEBOARDER SPEEDRITES," Marbot advertisement, *Footwear World*, December 1977, 2; "These Boots are made for Skateboarding," Clarks advertisement, *Skateboard!*, June 1978; "Sporting '78," *Footwear World*, 4.

33. "Sporting '78," *Footwear World*, 4–5; Dave Goldsmith and Micky B., "Skata Data: Choosing Shoes," *Skateboard!*, October 1978, 36–39.

34. Goldsmith and Micky B., "Skata Data: Choosing Shoes," *Skateboard!*, 36; "Sales of Champions—with the DUNLOP FLASH of Brilliance," Dunlop advertisement, *Footwear World*, April 1977, 8; "Alpine Sports Pro Skateboard Shop," mail order supplement, *Skateboard!*, August 1977.

35. *Collections 1979*, adidas catalogue, France, 1979, DC-782, 82–83.

36. Brian S. Duffield, Jon P. Best, and Michael F. Collins, *A Digest of Sports Statistics* (London: The Sports Council, 1983), 68–69; Tony Hawk quoted in Sean Mortimer, *Stalefish: Skateboard Culture from the Rejects Who Made It* (San Francisco: Chronicle Books, 2008), 110; *Rollin' Through The Decades*, documentary film, dir. Winstan Whitter (London: Beaquarr Productions, 2005).

37. For the history of Items International/Airwalk, see "Items International Airwalk Inc.," *International Directory of Company Histories* 17 (1997): 259–261.

38. Blümlein et al. *Made for Skate*, 95, 97, 110–125.

39. For the history of skate footwear, see Blümlein et al. *Made for Skate*, 126–309.

40. See Malcolm Gladwell, *The Tipping Point: How Little Things Can Make a Big Difference* (Boston: Little, Brown and Company, 2000), 193–215.

Chapter 5

1. Various artists, *Christmas Rap*, Profile Records, PRO-1247, 1987.

2. On the early history of basketball see Robert W. Peterson, *From Cages to Jump Shots: Pro Basketball's Early Years* (New York: Oxford University Press, 1990), 15-31; Keith Myerscough, "The game with no name: The invention of basketball," *International Journal of the History of Sport* 12, no. 1 (April 1995): 137-52; Pamela Grundy, Murray Nelson, and Mark Dyreson, "The Emergence of Basketball as an American National Pastime: From a Popular Participant Sport to a Spectacle of Nationhood," *The International Journal of the History of Sport* 31, nos. 1–2 (March 2014): 135–141.

3. The Rucker Playground is discussed in Robert Garcia, *Where'd You Get Those? New York City's Sneaker Culture: 1960–1987* (New York: Testify Books, 2003), 33; Walt Frazier interviewed in "Clyde: Legend," DVD extra, *Just For Kicks*, documentary film, dir. Thibaut De Longeville and Lisa Leone (New York: Caid Productions, 2005); Grundy, Nelson, and Dyreson, "The Emergence of Basketball as an American National Pastime," 145.

4. Peterson, *Cages to Jump Shots*, 41.

5. "The Shoe of Champions," United States Rubber advertisement, c.1925; "A.A.U. National Champions—in Keds," United States Rubber advertisement, c.1926; "SCORE!," United States Rubber advertisement, 1954; all author's collection.

6. *Converse Basketball Year Book 1924* (Malden, MA: Converse Rubber Shoe Company, 1924), 4; *Converse Basketball Year Book 1927* (Malden, MA: Converse Rubber Shoe Company, 1927), supplement S1-S5; Wallace R. Lord, ed., *Converse Basketball Yearbook 1965* (Malden, MA: Converse Rubber Company, 1965), back cover. On Charles "Chuck" Taylor, see Abraham Aamidor, *Chuck Taylor, All Star: The True Story of the Man Behind the Most Famous Athletic Shoe in History* (Bloomington: Indiana University Press, 2006), especially 43–131.

7. John Wooden quoted in Jackie MacMullen, "The shoe fits," *Ultrasport Review*, April 1987, 77–81, quoted in Aamidor, *Chuck Taylor, All Star*, 139. On changes in basketball, see John Christgau, *The Origins of the Jump Shot: Eight Men Who Shook the World of Basketball* (Lincoln: University of Nebraska Press, 1999); Benjamin G. Rader, *American Sports: From the Age of Folk Games to the Age of Televised Sports* (Upper Saddle River, NJ: Pearson Education, 2004), 276, 289–92.

8. Karl-Heinz Lang interviewed in adidas, *Superstar 35th Anniversary PR Book* (Herzogenaurach: adidas, 2005), 10, B/AD/23, adidas archive; adidas catalogue, France, 1968, DC-312, 32. On the rise of adidas France, see Barbara Smit, *Pitch Invasion: Three Stripes, Two Brothers, One Feud: Adidas and the Making of Modern Sport* (London: Allen Lane, 2006), 69–78, 99–104; Barbara Smit, *Sneaker Wars: The Enemy Brothers Who Founded Adidas and Puma and the Family Feud that Forever Changed the Business of Sports* (New York: HarperCollins, 2008), 55–62, 87–98.

9. Smit, *Pitch Invasion*, 106–8; Smit, *Sneaker Wars*, 94–97; adidas catalogue, 1965, DC-290, 13; adidas catalogue, France, 1968, DC-312, 24. See also, Jason Coles, *Golden Kicks: The Shoes That Changed Sport* (London: Bloomsbury, 2016), 76–79.

10. Smit, *Pitch Invasion*, 104–6; Smit, *Sneaker Wars*, 92; Adidas catalogue, France, 1968, DC-312, 22; Karl-Heinz Lang interviewed in adidas, *Superstar 35th Anniversary PR Book*, 10; Chris Severn in conversation with author, 12 April 2017.

11. Smit, *Pitch Invasion*, 91–8, 105–6; Smit, *Sneaker Wars*, 93; Coles, *Golden Kicks*, 62–65; adidas catalogue, United States, 1968, DC-319, 15; adidas catalogue, United States, 1971, DC-341, n.p.; adidas catalogue, 1970, DC-339, 41; adidas catalogue, United States, 1970/71, DC-4139, 12.

12. John Underwood quoted in G. Valk, "Letter from the Publisher," *Sports Illustrated*, 10 March 1969, 4; Rudolf Dassler quoted in John Underwood, "No goody two shoes," *Sports Illustrated*, 10 March 1969, 24–5; Rolf-Herbert Peters, *The Puma Story: The Remarkable Turnaround of an Endangered Species into One of the World's Hottest Sportlifestyle Brands* (London: Cyan, 2007), 36–41.

13. Barbara Smit, *Sneaker Wars: The Enemy Brothers Who Founded adidas and Puma and the Family Feud That Forever Changed the Business of Sports* (New York: HarperCollins, 2008), 85; Walt Frazier, "Clyde: Legend," Longeville and Leone, *Just For Kicks*; Walt Frazier quoted in Puma, *Legend 01: Walt "Clyde" Frazier* (n.p.: Puma, 2005), 9.

14. Walt Frazier and Ira Berkow, *Rockin' Steady: A Guide to Basketball and Cool* (Englewood Cliffs, NJ: Prentice-Hall, 1974), 11–26, 133–159. On African American style, see Shane White and Graham White, *Stylin': African American Expressive Culture from Its Beginnings to the Zoot Suit* (Ithaca, NY: Cornell University Press, 1998).

15. Sam Koperwas, "Schoolyard Basketball: A Primer of Styles and Wiles," *New York Times*, 24 August 1975, 170; Puma catalogue, 1972, 22–23, reproduced in Puma, *Legend 01*, 86; *Beconta '74/'75*, Puma/Beconta catalogue, United States, 1974, 16–17, John Brolly collection; "Clyde is wearing Pumas to play. And for play." Puma advertisement, c.1972, reproduced in Puma, *Legend 01*, 12; "Clyde Frazier plays in Pumas," Puma advertisement, 1973, author's collection.

16. John Underwood, "No goody two shoes," *Sports Illustrated*, 10 March 1969, 24–5; adidas catalogue, United States, c.1970, DC-4022, n.p.; "Introducing a Leather Basketball Shoe That Isn't Stuck Together with Glue," Pro-Keds advertisement, 1970, author's collection; "All Stars for All Stars" and "Now Basketball's More Colorful Than Ever," Converse advertisements, in Wallace R. Lord, ed., *Converse Basketball Yearbook 1970* (Malden, MA: Converse, 1970), 1, back cover; "All Pro Line-up," Pro-Keds advertisement, in *Pro-Keds Coaches Digest* (New Haven, CT: Uniroyal, 1971), n.p.; Thomas W. Ricker, ed., *Converse 1976 Basketball Yearbook* (Malden, MA: Converse, 1976), front cover; "Take Your Next Shot in the Pros," Pro-Keds advertisement, in *Pro-Keds Coaches Digest* (New Haven, CT: Uniroyal, 1977), 18; Garcia, *Where'd You Get Those?*, 40–6, 60–1; adidas footwear and accessories catalogue, United States, 1979, DC-260, n.p.; "Rick Barry, Inventor," adidas advertisement, 1979, reproduced in Garcia, *Where'd You Get Those?*, 99.

17. Garcia, *Where'd You Get Those?*, 47; Koperwas, "Schoolyard basketball," 170.

18. Smit, *Pitch Invasion*, 102; Smit, *Sneaker Wars*, 88–91; Garcia, *Where'd You Get Those?*, 45–7.

19. Frazier, "Clyde: Legend," Longeville and Leone, *Just for Kicks*; Smit, *Sneaker Wars*, 63–64, 85. The scope of Beconta's network is apparent from *Beconta Sports Division, Catalog no. 60, Dealer's Price List, 1974–1975*, John Brolly collection. See also Smit, *Pitch Invasion*, 245.

20. "I steal for a living," Puma advertisement, 1977, reproduced in Puma, *Legend 01*, 12; Richard Flaste, "For Eighth-Graders, the Sneaker Is More Than Sum of Its Parts," *New York Times*, 12 May 1973, 38; Greenhouse, "Sneaking Up On Status," 145; Garcia, *Where'd You Get Those?*, 48, 57. For photographs, see, e.g., Jamel Shabazz, *Back in the Days* (New York: PowerHouse Books, 2002); Martha Cooper, Akim Walta, and Nika Kramer, *Martha Cooper Hip Hop Files: Photographs 1979–1984* (Cologne: From Here to Fame Publishing, 2004); Johan Kugelberg, ed., *Born in the Bronx: A Visual Record of the Early Days of Hip Hop* (New York: Rizzoli International Publications, 2007). Of course, in environments in which $25 did not represent a considerable expense, shoes like these were less likely to be viewed as luxury items and carried less weight as status symbols.

21. Garcia, *Where'd You Get Those?*, 89; Puma/Beconta catalogue, United States, 1976, 3, John Brolly collection; Puma/Beconta catalogue, United States, 1977, 3, John Brolly collection.

22. Michael Holman, *Breaking and the New York City Breakers* (New York: Freundlich Books, 1984), 122. The birth of hip hop is described in "1. Close to the edge," *The Hip Hop Years*, television show, dir. David Upshal (London: RDF/Channel 4, 1999); Alex Ogg and David Upshal, *The Hip Hop Years: A History of Rap* (London: Channel 4 Books, 1999), 13-71; Jeff Chang, *Can't Stop Won't Stop: A History of the Hip-Hop Generation* (London: Ebury Press, 2005), 7–211. Hip-hop culture is examined in Joseph G. Schloss, *Foundation: B-boys, B-girls, and Hip-Hop Culture in New York* (New York: Oxford University Press, 2009). The concept of fashion is taken from Georg Simmel, "Fashion," *International Quarterly* 10 (October 1904), 130–155.

23. *Graffiti Rock*, television show, dir. Craig Santee (New York: Skywise Productions, 1984); Holman, *Breaking*, 1, 122–9, 132–3, 174; Michael Holman interviewed by Jarrell Mason for WUAG-FM "The Time Machine," 2008, accessed 19 April 2017, http://www.youtube.com/watch?v=qXvMUi_iB3A&feature=BFa&list=ULgeBmb2M23Y4&lf=channel.

24. Malcolm McLaren and The World's Famous Supreme Team, "Buffalo Gals," Charisma Records, 6000-914, 1982; The Rock Steady Crew, "(Hey You) The Rock Steady Crew," Virgin Records, RSC 1-12, 1983; *Style Wars*, documentary film, dir. Tony Silver (New York: Public Art Films, 1983); *Wild Style*, feature film, dir. Charlie Ahearn (New York: Pow Wow Productions, 1982); Martha Cooper and Henry Chalfant, *Subway Art* (London: Thames and Hudson, 1984); *Beat Street*, feature film, dir. Stan Lathan (Los Angeles: Orion Pictures, 1984); William H. Watkins and Eric N. Franklin, *Breakdance!* (Chicago: Contemporary Books, 1984), 10. On the diffusion and commodification of subcultural style, see Dick Hebdige, *Subculture: The Meaning of Style* (London: Methuen, 1979), especially 94–96.

25. Bill Adler interviewed in *Just for Kicks*; Bill Adler, *Tougher Than Leather: The Rise of Run-D.M.C.* (Los Angeles: Consafos Press), 79–82.

26. Dan Field, "Their adidas: Interview with Run-D.M.C.," *Grand Royal* 3 (1996): 107; Smit, *Pitch Invasion*, 245–246; Puma catalogue, 1985, 87, reproduced in Puma, *Legend 01*.

27. Karl-Heinz Lang in conversation with author, 18 August 2011.

28. Run-D.M.C., "My Adidas/Peter Piper," Profile Records, PRO-7102, 1986. On the adidas-Run-D.M.C. deal, see Field, "Their adidas," 106–7; Naomi Klein, *No Logo* (London: Flamingo, 2000), 74–75; and interviews with key players in *Just for Kicks*. Smit's account varies considerably from that put forward by the group and is probably incorrect; see Smit, *Pitch Invasion*, 218; Smit, *Sneaker Wars*, 194–195.

29. Karl-Heinz Lang, in discussion with the author, 18 August 2011.

30. J. B. Strasser and Laurie Becklund, *Swoosh: The Unauthorized Story of Nike and the Men Who Played There* (New York: HarperBusiness, 1993), 234–243.

31. L. Williams, "Smaller athletic firms pleased at super show," *Footwear News*, 16 February 1987, 2, cited in Naomi Klein, *No Logo* (London: Flamingo, 2000) 74–5; adidas, Advertising Bulletin 2/86, unnumbered item, adidas archive; "Run-D.M.C./adidas," television commercial, c. 1987, accessed 19 April 2017, http://www.youtube.com/watch?v=T4QDigdVvnI&feature=related; "We are fans of Run DMC," *Pop 9*, *adidas News* 42 (1987), Z-1-214, adidas archive.

32. Rodney P. Jerome, Mr. Normski, Goldie, quoted in Puma, *Legend 01*, pp. 75, 77. For photographs of how New York style translated to Europe, see RosyOne and Dopepose Posse, eds., *Cause We Got Style!: European Hip Hop Posing from the 80s and Early 90s* (Årsta: Dokument Press, 2011).

33. De La Soul, "Take It Off," *3 Feet High and Rising*, Tommy Boy, TBLP 1019, 1989; De La Soul, "Me, Myself and I," music video (New York: Tommy Boy Records, 1989).

Chapter 6

1. Kevin Sampson, "The Ins and Outs of High Street Fashion," *The Face*, July 1983, 22–23; Steve Redhead and Eugene McLaughlin, "Soccer's Style Wars," *New Society*, 16 August 1985, 225–228.

2. Manfield Figures quoted in Jean Williams, "Given the Boot: Reading the Ambiguities of British and Continental Football Boot Design," *Sport in History* 35, no. 1 (March 2015), 87; THE 'CONTROLLER' FOOTBALL BOOTS," James Percival and Company advertisement, *The Shoe and Leather Record*, 23 March 1906, supplement, lxxviii; "THE NON-STRETCH CERT FOOTBALL BOOT," Walker, Kempson & Stevens Ltd. advertisement, *The Shoe and Leather Record*, 26 March 1909, supplement, lxxi; "For Footballers," *The Shoe and Leather Record*, 26 March 1909, 629; "STEVE BLOOMER'S LUCKY GOAL SCORER," M. J. Rice & Son advertisement, *The Shoe and Leather Record*, 5 February 1909, 260–1.

3. "M. J. Rice & Son Ltd." advertisement, *The Shoe and Leather Record*, 8 October 1920, supplement lxxiv-lxxv; "The Boot that never fails to Score!," M. J. Rice & Son advertisement, *The Shoe and Leather Record*, 26 August 1948, 32; "Manfield-Hotspur," Manfield & Sons

advertisement in *The Football Association Year Book 1950–1951* (London: Naldrett Press, 1950), n. p.

4. "Perfect Football Boot," *The Shoe and Leather Record*, 20 October 1949, 32; "Improving the Football Boot" in *The Football Association Year Book 1950–1951*, 118–120.

5. "Matthews makes soccer boot history!" Co-operative Wholesale Society advertisement, *Charles Buchan's Football Monthly*, September 1951, back cover; "THERE'S MATTHEWS' MAGIC IN THESE BOOTS!," Co-operative Wholesale Society advertisement, *The Shoe and Leather Record*, 5 August 1954, 41; "Letter to the Editor: Lightweight Football Boots," *The Shoe and Leather Record*, 29 September 1955, 226; Barbara Smit, *Pitch Invasion: Three Stripes, Two Brothers, One Feud: Adidas and the Making of Modern Sport* (London: Allen Lane, 2006), 52.

6. Stanley Rous, "An Open Letter to John Bull," in *The Football Association Year Book 1954–1955* (London: Naldrett Press, 1954), 5; "Boots in the Backroom," in *The Football Association Year Book 1955–1956* (London: William Heinemann, 1955), 77–78.

7. Rolf-Herbert Peters, *The Puma Story: The Remarkable Turnaround of an Endangered Species into One of the World's Hottest Sportlifestyle Brands* (London: Cyan, 2007), 27–29.

8. Press clippings reproduced in Detlef Vetten, *Making a Difference* (Herzogenaurach: adidas-Salomon, 1998), 113; adidas catalogue, 1961, DC-2, 2. See Smit, *Pitch Invasion*, 48–53; Smit, *Sneaker Wars*, 34–37; Cooper, *Adidas*, 174–175.

9. "Boots in the Backroom," 78; "What a Dassler!," *Daily Sketch*, 30 November 1954, reproduced in Vetten, *Making a Difference*, 112; "STUART SURRIDGE & CO. LTD. TRIUMPH AT WEMBLEY 1957," advertisement, "Aston Villa: The Cup Winners," and "Manchester United: The Losers," in *The Football Association Year Book 1957–1958* (London: William Heinemann, 1957), 6, 29, 30; R. L. Shaw, "Makers Are on the Ball," *The Shoe and Leather Record*, 20 January 1961, 44.

10. Smit, *Pitch Invasion*, 78–90; "The Choice of Champions," Umbro/adidas advertisement, *Charles Buchan's Football Monthly*, 1961, author's collection.

11. "Worn by 75% of the world's top players," Umbro International/adidas advertisement, *Goal*, 8 August 1970, 11. On replica kits, see Christopher Stride, Jean Williams, David Moor, and Nick Catley, "From Sportswear to Leisurewear: The Evolution of English Football League Shirt Design in the Replica Kit Era," *Sport in History* 35, no. 1 (March 2015): 156–194.

12. Kevin Sampson, "The Cult with No Name," in *Awaydays*, adidas promotional booklet (2009), n. p.; G. Dickens, H. Halsted, E. Grant, N. Imlah, N. G.

Lambert, J.A. Harrington, and W. H. Trethowan, *Soccer Hooliganism: A Preliminary Report to Mr. Denis Howell, Minister of Sport by a Birmingham Research Group* (Bristol: John Wright and Sons, 1968), 12; Paul Harrison, "Soccer's Tribal Wars," *New Society*, 5 September 1974, 603. On soccer fashions, see Phil Thornton, *Casuals: Football, Fighting and Fashion: The Story of a Terrace Cult* (Lytham: Milo Books, 2003); Dave Hewitson, *The Liverpool Boys Are in Town 1978/82: Where D'ya Get Yer Trainees From?* (Liverpool: Dave Hewitson, 2004); Dan Rivers, *Congratulations, You Have Just Met the Casuals* (London: John Blake, 2005); Robert Elms, *The Way We Wore: A Life in Threads* (London: Picador, 2005), 241–246; Ian Hough, *Perry Boys: The Casual Gangs of Manchester and Salford* (Wrea Green: Milo Books, 2007); Stanley Smith, *Dressers: The Life and Times of the Motherwell Saturday Service* (n. p.: Colours Music, 2011). For an overview of British soccer in the early 1970s, see Dominic Sandbrook, *State of Emergency: The Way We Were: Britain 1970–1974* (London: Allen Lane, 2010), 538–575.

13. adidas catalogue, 1972, DC-350, 12; adidas catalogue, Germany, 1977, DC-760, 9.

14. Umbro/adidas, *Umbrochure* catalogue, UK, 1969, DC-331, 26; adidas/Umbro International catalogue, UK, 1976, DC-4167, n. p. Participation rates are tracked in Brian S. Duffield, Jon P. Best, and Michael F. Collins, *A Digest of Sports Statistics* (London: The Sports Council, 1983), 28.

15. Gavin Hills, "Diary of a trainer spotter," *The Guardian*, 22 November 1995, reprinted in *Bliss to Be Alive: The Collected Writings of Gavin Hills*, ed. Sheryl Garratt (Harmondsworth: Penguin, 2001), 185–186; Sampson, "The Ins and Outs," 22.

16. Sampson, "The Ins and Outs," 22; Peter Hooton, "The Good, The Rad and The Ugly," *The Face*, November 1990, 98.

17. "In Search of the Casuals," *The End*, no. 14, April 1984, reproduced in *The End: Every Issue of the Groundbreaking 80's Fanzine*, ed. James Brown (n.p.: Sabotage Times, 2011) 279; Hooton, "The Good, The Rad and The Ugly," 98.

18. "Bis zu 100000 Paar Schuhe gleiten täglich in alle Welt," *adidas Intern*, August 1985, 5, Z-2-6, adidas archive; adidas, tennis catalogue, Germany, 1979, DC-778; adidas, tennis catalogue, France, 1979, DC-781; Jay Allan, *Bloody Casuals: Diary of a Football Hooligan* (Ellon: Famedram Publishers, 1989), 39.

19. Hooton, "The Good, The Rad and The Ugly," 98; E. I. Adenoids, "Scaling the Heights of Normality," *New Musical Express*, 24 April 1982, 7; Allan, *Bloody Casuals*, 39–40. Tales of European thieving are common, but should be treated with caution. They can perhaps be

considered part of the culture of macho posturing that surrounds soccer. See Sir Norman Chester Centre for Football Research, Fact Sheet 1: Football and Football Hooliganism, University of Leicester, 2001, accessed 20 April 2017, http://www.furd.org/resources/fs1.pdf; Steve Redhead, "Hit and Tell: A Review Essay on the Soccer Hooligan Memoir," *Soccer and Society* 5, no. 3 (Autumn 2004), 392–403.

20. The Liverpool estimates are from Robert Wade-Smith, who entered the sports shoe business in Liverpool around this time; Hough, *Perry Boys*, 46.

21. Allan, *Bloody Casuals*, 66; "Boy's Own Top Footie Fives," *The Face*, December 1990, 76; Unorthodox Styles, *Sneakers: The Complete Collectors' Guide* (London: Thames and Hudson, 2005), 36; Hooton, "The Good, The Rad and The Ugly," 99.

22. adidas, Sport & Freizeit catalogue, Germany, 1975, DC-5263, 20; adidas catalogue, Germany, 1977, DC-760, 15; adidas catalogue, Germany, 1979, DC-774, 8; "Modernstes Tanklager der Welt steht in Scheinfeld," *adidas Intern*, December 1982, 3, Z-2-1, adidas archive; Walter Umminger, *Trimm Trab: Das neue Laufen ohne zu schnaufen* (Frankfurt am Main: Deutscher Sportbund, 1975), 15. Author's translations. The slogan translates roughly as "jogging: the new running without panting."

23. adidas/Umbro International catalogue, UK, 1976, DC-468, n. p.

24. "Our Postbag," *adidas News*, no. 12, April 1980, 9, Z-1-43, adidas archive; "Our Postbag," *adidas News*, no. 13, July 1980, 9, Z-1-46, adidas archive; "Our Postbag," *adidas News*, no. 22, October 1982, 15, Z-1-101, adidas archive; Silke Heine, née Droste, correspondence with author. The English translations were by adidas. The German original of Silke Droste's poem read: "*Ob in den Dünen oder am Strand / überall man Trimm-Trab fand / ob groß, ob klein, wir tragen sie immer / und wollen andere haben nimmer!*": "Post an uns," *adidas News*, no. 22, October 1982, 15, Z-1-104, adidas archive.

25. Hewitson, *The Liverpool Boys Are in Town*, n. p. I am grateful to Bernhard Rieger for sharing his memories of the Trimm Trab's place in German teenage fashions with me.

26. Smit, *Pitch Invasion*, 121–123; Umbro/adidas, *Umbrochure* catalogue, UK, 1969, DC-331, 26, 31; Adidas/Umbro International catalogue, UK, 1974, DC-5220, n. p.; adidas/Umbro International catalogue, UK, 1976, DC-4167, 2.

27. Gordon Black, *From Bags to Blenders: The Journey of a Yorkshire Businessman* (London: Icon Books: 2016), 28–31; Smit, *Pitch Invasion*, 123; "Distinctive styles from adidas," *The Shoe and Leather News*, 5 July 1973, 25; "Peter Black Profits Boom," *The Shoe and Leather News*, 7

February 1974, 54; "Peter Black Turnover Up," *The Shoe and Leather News*, 8 August 1974, 26.

28. "adidas for traction . . . and fashion," Peter Black Leisurewear/adidas advertisement, *Footwear World*, December 1977, 20–21.

29. Smit, *Pitch Invasion*, 122; adidas/Umbro International catalogue, UK, 1972, DC-5235, n. p.; "Clarks launch sports range," *Footwear World*, August 1976, 9.

30. I am grateful to Robert Wade-Smith for his assistance in writing this and the following section. For a published interview, see "Robert Wade-Smith: Before the Boom," *Proper*, no. 11, 2011, 64–70.

31. adidas catalogue and price list, Germany, 1976, DC-758, 14; adidas tennis catalogue, Germany, 1979, DC-778, 19; Robert Wade-Smith in conversation with author, 26 January 2017. The story is told in Hewitson, *The Liverpool Boys Are in Town*, n. p.; Hooton, "The Good, The Rad and The Ugly," 99; Neal Heard, *Trainers* (London: Carlton Books, 2003), 16.

32. Robert Wade-Smith in conversation with author, 26 January 2017.

33. "THE NEW WADE SMITH SPORTS SHOE SHOP," Wade-Smith advertisement, *The Liverpool Echo*, December 1984, author's collection. Photographs are in Wade-Smith, "Before the Boom," 65–66, 69; Hewitson, *The Liverpool Boys Are in Town*, n. p.

34. Peter Craig catalogue, autumn/winter 1985, 350–351, 484; Keith Cooper, *Adidas: The Story As Told by Those Who Have Lived It and Are Living It* (Herzogenaurach: adidas, 2011), 302; adidas catalogue, 1982, DC-804, 30.

Chapter 7

1. Enid Nemy, "It's the Locker Room Look," *New York Times*, 27 June 1977, 42.

2. Steven Greenhouse, "Sneaking Up on Status," *New York Times*, 16 June 1974, 145; Bruce A. Mohl, "Shoemakers: Casual Is In," *Boston Globe*, 15 February 1983, 54.

3. Nike, *Nike, Inc. 1982 Annual Report* (Beaverton: Nike, 1982), 2. The principal sources on Blue Ribbon Sports/ Nike are J. B. Strasser and Laurie Becklund, *Swoosh: The Unauthorized Story of Nike and the Men Who Played There* (New York: HarperBusiness, 1993); Donald Katz, *Just Do It: The Nike Spirit in the Corporate World* (New York: Random House, 1994); Kenny Moore, *Bowerman and the Men of Oregon: The Story of Oregon's Legendary Coach and Nike's Cofounder* (Emmaus, PA: Rodale, 2006); Geoff Hollister, *Out of Nowhere: The Inside Story of How Nike Marketed the Culture of Running* (Maidenhead: Meyer and Meyer Sports, 2008); Phil Knight, *Shoe Dog: A Memoir by the Creator of Nike* (London: Simon and Schuster, 2016).

4. adidas catalogue, USA, c.1965, DC-265, 8; adidas catalogue, 1968, DC-311, 36.

5. Barbara Smit, *Pitch Invasion: Three Stripes, Two Brothers, One Feud: Adidas and the Making of Modern Sport* (London: Allen Lane, 2006), 236.

6. Miguel Korzeniewicz, "Commodity Chains and Marketing Strategies: Nike and the Global Athletic Footwear Industry," in *Commodity Chains and Global Capitalism*, eds. Gary Gereffi and Miguel Korzeniewicz (Westport, CT: Praeger, 1994), 258. On the Nike brand, see Ian Skoggard, "Transnational Commodity Flows and the Global Phenomenon of the Brand," *Consuming Fashion: Adorning the Transnational Body*, eds. Anne Brydon and Sandra Niessen (London: Berg, 1998), 57–70; Naomi Klein, *No Logo* (London: Flamingo, 2000), esp. 50–61, 195–202.

7. Mohl, "Shoemakers: Casual Is In," 54; Nike, *1982 Annual Report*, 8; Knight, *Shoe Dog*, 284.

8. Smit, *Pitch Invasion*, 222; "All About: Sneakers," *New York Times*, 2 March 1977, 59; "We major in athletic footwear," Foot Locker advertisement, c. 1977, author's collection; Korzeniewicz, "Commodity Chains and Marketing Strategies," 255.

9. Nike, *1982 Annual Report*, 15; Nike, casual shoes catalogue, 1984 John Brolly collection.

10. Nike, *Nike, Inc. Annual Report 1985* (Beaverton: Nike, 1985), 4.

11. Curry Fitzpatrick, "A Towering Twosome," *Sports Illustrated*, 28 November 1983, 53. For an account of Nike's deal with Jordan see Strasser and Becklund, *Swoosh*, 421-436, 448-457.

12. Steve Aschberner quoted in Strasser and Becklund, *Swoosh*, 451; Alexander Wolff, "In The Driver's Seat," *Sports Illustrated*, 10 December 1984, 44–45; Nike, "Air Jordan," television commercial, 1985, accessed 3 December 2016, http://www.youtube.com/watch?v=zkXkrSLe-nQ; Marvin Barias, "The True Story Behind the Banned Air Jordan," *Sole Collector*, 18 October 2016, accessed 20 April 2017, https://solecollector.com/news/2016/10/the-true-story-behind-the-banned-air-jordan.

13. *Sports Illustrated*, 10 December 1984; Craig Neff, "Leaping Lizards, It's Almost Iguana," *Sports Illustrated*, 17 November 1986, 21; Nike, *Annual Report 1985*, 2–3. Vintage Air Jordan shoes are pictured in Lightning, *Nike Chronicle Deluxe 1971–1980s* (Tokyo: EI Publishing Co., 2016), 171–179. On global capitalism, see Walter LaFeber, *Michael Jordan and the New Global Capitalism* (New York: Norton, 1999).

14. Interview with Raymond Tonkel, July 2016, accessed 3 December 2016, Soleseek, http://soleseek.co.uk/interviews/ray/. See also John Brolly, "I Hope My Legs Don't Break, Walking on the Moon," *Proper*, no. 21, Winter 2016, 71–76.

15. "Tinker Hatfield: Footwear Design," *Abstract: The Art of Design*, television documentary, dir. Brian Oakes (Los Angeles: Netflix, 2017); Strasser and Becklund, *Swoosh*, 274–285.

16. Nike, *Nike, Inc. 1986 Annual Report*, 4–5; Tinker Hatfield interviewed in *Respect the Architects: The Paris Air Max 1 story*, short film, dir. Thibaut De Longeville (360 inc., 2006), accessed 3 December 2016, https://www.youtube.com/watch?v=yU_k83I7BSY; "Interview with Tinker Hatfield," SNKR, 2008, accessed 3 December 2016, http://www.youtube.com/watch?v=gpwLkIrsNNc&NR=1; Strasser and Becklund, *Swoosh*, 502.

17. "Get Fit: Up the Revolution," *Runner's World*, June 1987, 9; "NIKE-AIR IS NOT A SHOE. IT'S A REVOLUTION," advertisement, *Runner's World*, March 1987, 47–54. The remaining Beatles, who did not hold publishing rights to the song, objected to its use in an advertisement and initiated legal proceedings against Nike. In a statement, their attorney said: "The Beatles' position is that they don't sing jingles to peddle sneakers, beer, pantyhose or anything else. . . . They wrote and recorded these songs as artists and not as pitch-men for any product." The case was resolved in 1988, when Nike stopped showing the commercials. See "Nike and the Beatles 1987–1989," The Pop History Dig, accessed 3 December 2016, http://www.pophistorydig.com/topics/nike-and-beatles-1987-1989/.

18. Neff, "Leaping Lizards," 21; Fraser Cook and Jennifer Kabat, "The Jordan Years," *The Face*, August 1999, 89; Hatfield quoted in Katz, *Just Do It*, 130. Hatfield's sketches are reproduced in Robert Jackson, *Sole Provide: 30 Years of Nike Basketball* (New York, PowerHouse Books: 2002), 82–83.

19. Robert Goldman and Stephen Papson, *Nike Culture: The Sign of the Swoosh* (London, Sage: 1998), 26–28, 47–51; Paul Gilroy, "Spiking the Argument," *Sight and Sound*, November 1991, 30; Nike, "Air Jordan from Nike.," television commercial, 1989, accessed 3 December 2016, http://www.youtube.com/watch?v=q9vDhqcYB6M. See also Dylan A. T. Miner, "Provocations on Sneakers: The Multiple Significations of Athletic Shoes, Sport, Race, and Masculinity," *CR: The New Centennial Review* 9, no. 2 (Fall 2009): 89–95.

20. Strasser and Becklund, *Swoosh*, 509.

21. "The 13th Annual Shoe Survey," *Runner's World*, April 1987, 58; "The 1987 Fall Shoe Survey," *Runner's World*, October 1987, 63.

22. Brandon Edler, "A Complete Guide to the Fresh Prince of Bel-Air's Sneakers," *Complex*, 14 September 2011, accessed 20 April 2017, http://www.complex.com/sneakers/2011/09/a-complete-guide-to-the-fresh-prince-of-bel-airs-sneakers.

The Sports Shoe

23. adidas catalogue, 1970, DC-339, 28.

24. "Sports Fashion Changing with the Times," *adidas News*, no. 8, April 1979, 14–15, Z-1-86, adidas archive; "adidas is all set for the summer of '84," *adidas News*, no. 26, April 1983, 2, Z-1-124, adidas archive; Smit, *Pitch Invasion*, 235.

25. "Serving in style—who wouldn't like to be as smart as Ivan?," *adidas News*, no. 31, January 1985, 9, Z-1-153, adidas archive; "Ivan and Stefan serve aces in style," *adidas News*, no. 39, January 1986, 8-9, Z-1-199, adidas archive; "Steffi—No. 1 in new style," *adidas News*, no. 42, October 1987, 3, adidas Z-1-214, archive.

26. On Reebok Pump, see Jason Coles, *Golden Kicks: The Shoes That Changed Sport* (London: Bloomsbury, 2016), 132–135. On Puma Disc, see Rolf-Herbert Peters, *The Puma Story: The Remarkable Turnaround of an Endangered Species into One of the World's Hottest Sportlifestyle Brands* (London: Cyan, 2007), 95–96.

27. Skoggard, "Transnational Commodity Flows," 59.

28. "Intro," *The Face*, November 1989, 116–17; "Neal Heard [Trainers Book] Interview," 80s Casuals, accessed 20 April 2017, http://80scasualsblog.blogspot.co.uk/2011/05/neal-heard-trainers-book-interview.html; Derick Procope quoted in Liz Farrelly, ed., *Sneakers: Size Isn't Everything* (London: Booth-Clibborn Editions, 1998), 150; "Fashion News," *The Face*, August 1992, 32.

29. Peter Hooton, "The Good, the Rad and the Ugly," *The Face*, November 1990, 99. On nostalgia, see Simon Reynolds, *Retromania: Pop Culture's Addiction to Its Own Past* (London: Faber and Faber, 2011); Gary Cross, *Consumed Nostalgia: Memory in the Age of Fast Capitalism* (New York: Columbia University Press, 2015). On retro and vintage fashions, see Angela McRobbie, "Second-Hand Dresses and the Role of the Ragmarket," in *Zoot Suits and Second-Hand Dresses: An Anthology of Fashion and Music*, ed. Angela McRobbie (Basingstoke: Macmillan, 1989), 23–49; Louise Crewe, Nicky Gregson, and Kate Brooks, "The Discursivities of Difference: Retro Retailers and the Ambiguities of 'The Alternative,'" *Journal of Consumer Culture* 3, no. 1 (March 2003), 61–82; Nicky Gregson and Louise Crewe, *Second-Hand Cultures* (Oxford: Berg, 2003).

30. See Jürgen Blümlein, Daniel Schmid, Dirk Vogel, and Holger von Krosigk, *Made for Skate: The Illustrated History of Skateboard Footwear* (Stuttgart: FauxAmi Exhibitions, 2008), 200–201.

31. On subcultural capital, see Sarah Thornton, *Club Cultures: Music, Media and Subcultural Capital* (Cambridge: Polity Press, 1995).

32. Mike D (Michael Diamond) and Adrock (Adam Horowitz) of the Beastie Boys interviewed for MTV's *House of Style*, 1992, accessed 3 December 2016, https://www.youtube.com/watch?v=lsQPKkaagP8.

33. Beastie Boys, *Check Your Head*, Capitol Records 798938, 1992.

34. Cliff Jones, "This Sporting Life," *The Face*, August 1995, 59; "Neal Heard [Trainers Book] Interview," 80s Casuals; Karl-Heinz Lang in conversation with author, 18 August 2011.

35. adidas Equipment brand manual, 1991, n. p., unnumbered item, adidas archive; adidas footwear catalogue, United States, 1991, DC-103, 70-75; Jones, "This Sporting Life," 59.

Conclusion

1. Christian Hilton, "Word of the Law," *Proper*, no. 11, winter 2016, 110–113.

2. Thomas Marecki, *Superstar 35* (adidas, Herzogenaurach, 2005).

3. Liz Farrelly, ed., *Sneakers: Size Isn't Everything* (London: Booth-Clibborn Editions, 1998); Robert Jackson, *Sole Provider: 30 Years of Nike Basketball* (New York: PowerHouse Books, 2002); Neal Heard, *Trainers* (London: Carlton Books, 2003); Robert Garcia, *Where'd You Get Those? New York City's Sneaker Culture: 1960–1987* (New York: Testify Books, 2003).

4. On sneaker culture, see Yuniya Kawamura, *Sneakers: Fashion, Gender, and Subculture* (London: Bloomsbury, 2016).

5. Keith Cooper, *Adidas: The Story As Told by Those Who Have Lived It and Are Living It* (Herzogenaurach: adidas, 2011), 352.

6. See, for example, Russ Bengston, "20 Things You Didn't Know About Nike Foamposites," *Complex*, 7 February 2013, accessed 26 April 2017, http://uk.complex.com/sneakers/2013/02/20-things-you-didnt-know-about-nike-foamposites.

7. Robert Sullivan, "The Soul of a Shoe," *Vogue* (New York), 1 May 1998, 115–120.

8. Turnschuh.tv International, "What Is Adidas 'Boost'?" 2 June 2016, accessed 26 April 2017, https://www.youtube.com/watch?v=pt8-0fFwue8; Jacques Slade, "What Is Adidas Boost . . ." 11 January 2017, accessed 26 April 2017, https://www.youtube.com/watch?v=6icItMrGasY.

9. The genesis of these shoes is discussed in "Free 5.0 Tobie Hatfield Interview," in *Sneaker Freaker: The Book 2002–05*, ed. Simon Wood (New York: Riverhead Freestyle, 2005), n. p.; Aron Phillips, "The Story Behind the Nike Roshe Run," *How to Make It*, 16 April 2012, accessed 26 April 2017, http://www.howtomakeit.com/2012/04/exclusive-the-story-behind-the-nike-roshe-run; Matt Welty, "Nic Galway, the adidas Designer of the Yeezy Boost, Has a New Sneaker for the Future," *Complex*, 10 December 2015, accessed

26 April 2017, http://uk.complex.com/sneakers/2015 /12/nic-galway-adidas-nmd-interview; Drake Baer, "We talked with the Adidas designer behind the year's coolest sneaker—and that Kanye collaboration," *Business Insider*, 25 January 2016, accessed 26 April 2017, http://uk.businessinsider.com/we-talked-with-the -adidas-designer-behind-the-sneaker-of-the-year-and -working-with-kanye-2016-1; Matt Welty, "Tobie Hatfield Explains What It Was Like to Design the Nike Air Presto," *Complex*, 13 April 2016, accessed 26 April 2017, http://uk.complex.com/sneakers/2016/04 /tobie-hatfield-interview.

10. "Adidas's high-tech factory brings production back to Germany," *The Economist*, 14 January 2017, accessed 21 September 2017, https://www.economist.com /news/business/21714394-making-trainers-robots -and-3d-printers-adidass-high-tech-factory-brings -production-back; Rowland Manthorpe, "To make a new kind of shoe, adidas had to change everything," *Wired*, November 2017, accessed 6 September 2018, https://www.wired.co.uk/article/adidas -speedfactory-made-for-london-trainers.

11. See Astrid Lang and Stefan Tamm, "How Primeknit was born—'There are no books we could have referred to for this project,'" adidas group blog, 10 August 2012, accessed 26 April 2017, http://blog.adidas-group. com/2012/08/how-primeknit-was-born-there-are-no -books-we-could-have-referred-to-for-this-project; "Interview: adidas Head of Design for Sport Performance James Carnes Talks Primeknit," *Complex*, 8 August 2012, accessed 26 April 2017, http:// uk.complex.com/sneakers/2012/08/interview-adidas -head-of-design-for-sport-performance-james-carnes -talks-primeknit; "Material Matters: Nike Flyknit," *Sneaker Freaker*, 3 August 2016, accessed 26 April 2017, https://www.sneakerfreaker.com/articles/material -matters-nike-flyknit.

12. Quoted in Donald Katz, *Just Do It: The Nike Spirit in the Corporate World* (New York: Random House, 1994), 10.

List of illustrations

Chapter 2

2.1 Plantation rubber, United States Rubber advertisement, 1926. © Keds. Taken from John Martin, ed., *The Romance of Rubber* (New York: United States Rubber Company, 1926). Image: Author's collection.

2.2 Crepe rubber soles, Rubber Growers' Association advertisement, *The Shoe and Leather Record*, 6 July 1923. © Unknown. Image courtesy of EMAP archive/ London College of Fashion Archives.

2.3 Fleet Foot Wimbledon tennis shoe, Dominion Rubber advertisement, *The Shoe and Leather Record*, 7 June 1935. © Unknown. Image courtesy of EMAP archive/London College of Fashion Archives.

2.4 Dunlop sports shoes, marketing photographs, 1930. Photo: Chaloner Woods/Getty Images.

2.5 Dunlop sports shoes, marketing photographs, 1930. Photo: Chaloner Woods/Getty Images.

2.6 Dunlop sports shoe production, Liverpool, 1931. Photo: Fox Photos/Getty Images.

2.7 Dunlop sports shoe production, the vulcanizing cylinder, Liverpool, 1931. Photo: Fox Photos/Getty Images.

2.8 Dominion Rubber Fleet Foot sports shoes, 1930. © Unknown. Taken from John Carter and Sons, *General Price List, Spring 1930* (London: John Carter and Sons, 1930). Image courtesy of The British Library.

2.9 Tennis shoes, Gutta Percha & Rubber advertisement, *The Shoe and Leather Record*, 16 February 1934. © Unknown. Image courtesy of EMAP archive/London College of Fashion Archives.

2.10 Sports shoes, Sears, Roebuck catalogue, 1927. Image: Author's collection.

2.11 Scientifically Lasted Keds, United States Rubber advertisement, 1934. © Keds. Image: Author's collection.

2.12 'Sneaker Smell', Hood Rubber advertisement, 1934. © Unknown. Image: Author's collection.

2.13 Williams College students picnic in Vermont, 'Life Goes to a Party', *Life*, 7 June 1937. Photo: Peter Stackpole/The LIFE Picture Collection via Getty Images.

2.14 Couple in tennis shoes, with man in saddle Oxfords, c. 1930. Photo: H. Armstrong Roberts/Getty Images.

2.15 Saddle shoes, *Life*, 7 June 1937, front cover. Photo: Alfred Eisenstaedt/Pix Inc./The LIFE Premium Collection/Getty Images.

2.16 British plimsolls, Victoria Rubber Co. advertisement, *The Shoe and Leather Record*, 26 March 1909. Image courtesy of EMAP archive/London College of Fashion Archives.

2.17 Jesse Owens meets sneaker-wearing fans, Chicago, 1936. Photo: Bettmann/Getty Images.

2.18 United States Rubber advertisement, *Saturday Evening Post*, 9 June 1923. © Keds. Image: Author's collection.

Chapter 3

3.1 Dunlop sports shoes advertisement, *The Shoe and Leather Record*, 3 October 1940. © Dunlop International Europe. Image courtesy of the EMAP archive/London College of Fashion Archives.

3.2 Dunlop sports shoes advertisement, *The Shoe and Leather Record*, 17 June 1948. © Dunlop International Europe. Image courtesy of EMAP archive/London College of Fashion Archives.

3.3 Gymbo sports shoes, Ashworth's Ltd. advertisement, *The Shoe and Leather Record*, 5 September 1946. © Unknown. Image courtesy of EMAP archive/ London College of Fashion Archives.

3.4 Sports footwear, Greengate and Irwell advertisement, *The Shoe and Leather Record*, 27 September 1956. © Unknown. Image courtesy of EMAP archive/ London College of Fashion Archives.

3.5 Dunlop Green Flash production, closing room, 1960s. Taken from *Dunlop Annual Report 1963* (London: Dunlop Rubber Company, 1964). © Dunlop International Europe. Image courtesy of London Metropolitan Archives.

3.6 Dunlop Green Flash production, quality control, 1960s. Taken from *Directors' Report and Accounts of Dunlop Rubber Company Limited for the year ended 31st December 1961* (London: Dunlop Rubber Company, 1962). © Dunlop International Europe. Image courtesy of London Metropolitan Archives.

3.7 Dunlop Green Flash production, sole moulding machinery, 1960s. Taken from *Dunlop Annual Report*

Selected bibliography

On sports shoes

Aamidor, Abraham, *Chuck Taylor, All Star: The True Story of the Man Behind the Most Famous Athletic Shoe in History* (Bloomington: Indiana University Press, 2006)

Blümlein, Jürgen, Daniel Schmid, Dirk Vogel, and Holger von Krosigk, *Made for Skate: The Illustrated History of Skateboard Footwear* (Hamburg: Gingko Press, 2008).

Cardona, Melissa, *The Sneaker Book: 50 Years of Sports Shoe Design* (Atglen PA: Schiffer Publishing, 2005).

Cheskin, Melvyn P., Kel J. Sherkin, and Barry T. Bates, *The Complete Handbook of Athletic Footwear* (New York: Fairchild Publications, 1987).

Coles, Jason, *Golden Kicks: The Shoes that Changed Sport* (London: Bloomsbury Sport, 2016).

Cook, Fraser and Jennifer Kabat, 'The Jordan Years', *The Face*, August 1999, 88–93.

Cooper, Keith, *Adidas: The Story As Told By Those Who Have Lived It And Are Living It* (Herzogenaurach: adidas, 2011).

De Longeville, Thibaut, and Lisa Leone, dirs., *Just For Kicks*, documentary film (New York: Caïd Productions, 2005).

Farrelly, Liz, ed., *Sneakers: Size Isn't Everything* (London: Booth-Clibborn Editions, 1998).

Field, Dan, 'Their adidas', *Grand Royal 3* (1996), 106–107.

Frazier, Walt, and Ira Berkow, *Rockin' Steady: A Guide to Basketball and Cool* (Englewood Cliffs, NJ: Prentice-Hall, 1974).

Fryer, Daniel, *The Gola Years: 1905–2005* (Rossendale: Jacobson Group, 2005).

Gäbelein, Klaus-Peter, 'adidas – Eine Erfolgsstory aus Herzogenaurach', *Herzogenauracher Heimatblatt*, November 2, accessed September 8, 2017, https://www.herzogenaurach.de/fileadmin/user_upload/Content/Stadtgeschichte/HB_adidas.PDF

Garcia, Robert, *Where'd You Get Those? New York City's Sneaker Culture: 1960–1987* (New York: Testify Books, 2003).

Gill, Alison, 'Belonging with the Swoosh: On cyborg clothing and part-objects', *Form/Work* 1, no. 4, (March 2000): 93–124.

Gill, Alison, 'Limousines for the Feet: The Rhetoric of Sneakers', in *Shoes: From Fashion to Fantasy*, eds. Giorgio Riello and Peter McNeill (Oxford: Berg, 2006), 372–385.

Gill, Alison, 'Sneakers', in *Design Studies: A Reader*, eds. Hazel Clark and David Brody (Oxford: Berg, 2009), 516–519.

Goldman, Robert, and Stephen Papson, *Nike Culture: The Sign of The Swoosh* (London: Sage, 1998).

Heard, Neal, *Trainers* (London: Carlton Books, 2003).

Hewitson, Dave, *The Liverpool Boys Are in Town 1978/82: Where D'ya Get Yer Trainees From?* (Liverpool: Dave Hewitson, 2004).

Hills, Gavin, 'Diary of a trainer spotter', *The Guardian*, 22 November 1995, reprinted in *Bliss to be Alive: The Collected Writings of Gavin Hills*, ed. Sheryl Garratt (Harmondsworth: Penguin, 2001), 185–186.

Hollister, Geoff, *Out of Nowhere: The Inside Story of How Nike Marketed the Culture of Running* (Maidenhead: Meyer and Meyer Sports, 2008).

Jackson, Robert, *Sole Provider: 30 Years of Nike Basketball* (New York: PowerHouse Books, 2002).

Jones, Dylan, 'The Golden Fleece', in *Winning: The Design of Sports*, ed. Susan Andrew, (London: Lawrence King, 1999), 85–109.

Katz, Donald, *Just Do It: The Nike Spirit in the Corporate World* (New York: Random House, 1994).

Krentzman, Jackie, 'The Force Behind the Nike Empire', *Stanford Magazine*, January/February 1997, accessed 14 July 2016, http://www.stanfordalumni.org/news/magazine/1997/janfeb/articles/knight.html

Kawamura, Yuniya, *Sneakers: Fashion, Gender, and Subculture* (London: Bloomsbury, 2016).

Knight, Phil, *Shoe Dog: A Memoir by the Creator of Nike* (London: Simon and Schuster, 2016).

Korzeniewicz, Miguel, 'Commodity Chains and Marketing Strategies: Nike and the Global Athletic Footwear Industry', in *Commodity Chains and Global Capitalism* eds. Gary Gereffi and Miguel Korzeniewicz (Westport CT: Praeger, 1994), 247–266.

LaFeber, Walter, *Michael Jordan and the New Global Capitalism* (New York: Norton, 1999).

Langehough, Steven, 'Symbol, Status, and Shoes: The Graphics of the World at Our Feet', in *Design for Sports: The Cult of Performance*, ed. Akiko Busch (London: Thames and Hudson, 1998), 20–45.

Lightning, *Nike Chronicle Deluxe 1971–1980s* (Tokyo: EI Publishing Co., 2016).

Lury, Celia, 'Marking Time with Nike: The Illusion of the Durable', *Public Culture* 11, no. 3 (Fall 1999): 499–526.

Marecki, Thomas, *Superstar 35* (adidas, Herzogenaurach, 2005).

Miner, Dylan A. T., 'Provocations on Sneakers: The Multiple Significations of Athletic Shoes, Sport, Race, and Masculinity', *CR: The New Centennial Review* 9, no. 2 (Fall 2009): 73–108.

Moore, Kenny, *Bowerman and the Men of Oregon: The Story of Oregon's Legendary Coach and Nike's Cofounder* (Emmaus, PA: Rodale, 2006).

Onitsuka, *The True Story of Onitsuka Tiger* (Tokyo: Pie Books, 2005).

Palladini, Doug, *Vans Off the Wall: Stories of Sole From Vans Originals* (New York: Abrams, 2009).

Peters, Rolf-Herbert, *The Puma Story: The remarkable turnaround of an endangered species into one of the world's hottest sportlifestyle brands* (London: Cyan, 2007).

Semmelhack, Elizabeth, *Out of the Box: The Rise of Sneaker Culture* (New York: Rizzoli, 2015).

Skoggard, Ian, 'Transnational Commodity Flows and the Global Phenomenon of the Brand', in *Consuming Fashion: Adorning the Transnational Body*, eds. Anne Brydon and Sandra Niessen (Oxford: Berg, 1998), 57–70.

Smit, Barbara, *Pitch Invasion: Three Stripes, Two Brothers, One Feud: Adidas, Puma and the Making of Modern Sport* (London: Allen Lane, 2006).

Smit, Barbara, *Sneaker Wars: The Enemy Brothers Who Founded Adidas and Puma and the Family Feud that Forever Changed the Business of Sports* (New York: HarperCollins, 2008)

Strasser, J. B., and Laurie Becklund, *Swoosh: The Unauthorized Story of Nike and the Men Who Played There* (New York: HarperBusiness, 1993).

Turner, Thomas, 'The Production and Consumption of Lawn Tennis Shoes in Late Victorian Britain', *Journal of British Studies* 55, no. 3 (July 2016): 474–500.

Turner, Thomas, 'Transformative improvisation: The creation of the commercial skateboard shoe, 1960–1979' in *Skateboarding: Subcultures, Sites, and Shifts*, ed. Kara-Jane Lombard, (Abingdon: Routledge, 2016), 182–194.

Turner, Thomas, 'German Sports Shoes, Basketball, and Hip Hop: The Consumption and Cultural Significance of the adidas "Superstar", 1966–88', *Sport in History* 35, no. 1 (March 2015): 127–155.

Unorthodox Styles, *Sneakers: The Complete Collectors' Guide* (London: Thames and Hudson, 2005).

Vanderbilt, Tom, *The Sneaker Book: Anatomy of an Industry and an Icon* (New York: The New Press, 1998).

Vetten, Detlef, *Making a Difference* (Herzogenaurach: adidas-Salomon, 1998).

Walker, Samuel *Americus, Sneakers* (New York: Workman Publishing, 1978).

Wood, Simon, ed., *Sneaker Freaker: The Book 2002–05* (New York: Riverhead Freestyle, 2005).

On related topics

Adams, Vernon, and Gavin Hills, *Skateboarding Is Not a Book*, (London: Fantail, 1989).

Ahearn, Charlie, *Wild Style The Sampler* (New York: PowerHouse Books, 2007).

Allan, Jay, *Bloody Casuals: Diary of a Football Hooligan* (Ellon: Famedram Publishers, 1989)

Appadurai, Arjun, ed., *The Social Life of Things: Commodities in Cultural Perspective* (Cambridge: Cambridge University Press, 1986).

Baker, William Joseph, *Sports in the Western World* (Totowa NJ: Rowman and Littlefield, 1982).

Barker, P.W., *Rubber: History, Production, and Manufacture* (Washington D.C.: United States Government Printing Office, 1940).

Baynes, Ken, and Kate Baynes, *The Shoe Show: British Shoes Since 1790* (London: Crafts Council, 1979).

Biddle-Perry, Geraldine, 'Fashioning Suburban Aspiration: Awheel with the Catford Cycling Club, 1886–1900', *The London Journal* 39, no. 3 (November 2014): 187–204.

Bijker, Wiebe E., *Of Bicycles, Bakelites, and Bulbs: Toward a Theory of Sociotechnical Change* (Cambridge MA: MIT Press, 1995).

Birley, Derek, *Sport and the Making of Britain* (Manchester: Manchester University Press, 1993).

Birley, Derek, *Land of Sport and Glory: Sport and British Society 1887–1910* (Manchester: Manchester University Press, 1995)

Black, Gordon *From Bags to Blenders: The Journey of a Yorkshire Businessman* (London: Icon Books: 2016).

Blackford, Mansel G., and K. Austin Kerr, B. F. Goodrich: *Tradition and Transformation 1870–1995* (Columbus: Ohio State University Press, 1996).

Borden, Iain, *Skateboarding, Space and the City: Architecture and the Body* (Oxford: Berg, 2001).

Bowlby, Rachel, *Carried Away: The Invention of Modern Shopping* (New York: Columbia University Press, 2001).

Breward, Christopher, *The Hidden Consumer: Masculinities, Fashion and City Life 1860–1914* (Manchester: Manchester University Press, 1999).

Brewer, John, and Frank Trentmann, eds., *Consuming Cultures, Global Perspectives: Historical Trajectories, Transnational Exchanges* (Oxford: Berg, 2006).

Brooke, Michael, *The Concrete Wave: The History of Skateboarding* (Toronto: Warwick Publishing, 1999).

Brown, James, ed., *The End: Every Issue of the Groundbreaking 80's Fanzine* (n. p.: Sabotage Times, 2011).

Brydon, Anne, and Sandra Niessen, eds., *Consuming Fashion: Adorning the Transnational Body* (Oxford: Berg, 1998).

Chang, Jeff, *Can't Stop Won't Stop: A History of the Hip-hop Generation* (London: Ebury Press, 2005).

Christgau, John, *The Origins of the Jump Shot: Eight Men Who Shook the World of Basketball* (Lincoln: University of Nebraska Press, 1999).

Cooper, Martha, Akim Walter, and Nika Kramer, *Hip Hop Files: Photographs 1979–1984* (Cologne: Here To Fame Publishing, 2004).

Crewe, Louise, Nicky Gregson, and Kate Brooks, 'The Discursivities of Difference: Retro Retailers and the Ambiguities of "The Alternative"', *Journal of Consumer Culture* 3, no. 1 (March 2003), 61–82.

Cross, Gary, *Consumed Nostalgia: Memory in the Age of Fast Capitalism* (New York: Columbia University Press, 2015).

Davidson, Judith A., 'Sport and Modern Technology: The Rise of Skateboarding, 1963–1978', *Journal of Popular Culture* 18, no. 4 (March 1985): 145–157.

Day, Dave, and Samantha-Jayne Oldfield, 'Delineating Professional and Amateur Athletic Bodies in Victorian England', *Sport in History* 35, no. 1 (March 2015): 19–45.

Dean, Warren, *Brazil and the Struggle for Rubber: A Study in Environmental History* (New York: Cambridge University Press, 1987).

De Certeau, Michel, *The Practice of Everyday Life*, trans. Steven Rendall (Berkley: University of California Press, 1984).

du Gay, Paul, Stuart Hall, Linda Janes, Anders Koed Madsen, Hugh Mackay, and Keith Negus, *Doing Cultural Studies: The Story of the Sony Walkman*, 2nd edition (London: Sage, 2013, 1st edition 1997).

Dunning, Eric, Patrick J. Murphy, and John Williams, *The Roots of Football Hooliganism: An Historical and Sociological Study* (London: Routledge, 1988).

Douglas, Mary, and Baron Isherwood, *The World of Goods: Towards and Anthropology of Consumption* (London: Allen Lane, 1979).

Elms, Robert, *The Way We Wore: A Life In Threads* (London: Picador, 2005).

Frank, Thomas, *The Conquest of Cool: Business Culture, Counterculture, and the Rise of Hip Consumerism* (Chicago: University of Chicago Press, 1997).

Geer, William C., *The Reign of Rubber* (New York: Century, 1922).

Gillmeister, Heiner, *Tennis: A Cultural History, 2nd edition*, (Sheffield: Equinox Publishing, 2017, 1st edition 1997)

Gilroy, Paul, 'Spiking the Argument', *Sight and Sound*, November 1991, 28–30.

Gladwell, Malcolm, 'The Coolhunt', in *The Consumer Society Reader*, ed. Martyn J. Lee, (Malden, PA: Blackwell, 2000), 360–374.

Gladwell, Malcolm, *The Tipping Point: How Little Things Can Make a Big Difference* (Boston: Little, Brown, 2000).

Gregson, Nicky, and Louise Crewe, *Second-Hand Cultures* (Oxford: Berg, 2003).

Gronow, Jukka, and Alan Warde eds., *Ordinary Consumption* (London: Routledge, 2001).

Grundy, Pamela, Murray Nelson, and Mark Dyreson, 'The Emergence of Basketball as an American National Pastime: From a Popular Participant Sport to a Spectacle of Nationhood', *The International Journal of the History of Sport* 31, nos. 1–2 (March 2014): 1135–141.

Guttman, Allen, *Games and Empires: Modern Sports and Cultural Imperialism* (New York: Columbia University Press, 1994).

Guttman, Allen, *From Ritual to Record: The Nature of Modern Sports* (New York: Columbia University Press, 2004).

Hall, Stuart, and Tony Jefferson, eds., *Resistance Through Rituals: Youth Subcultures in post-war Britain* (Birmingham: Centre for Contemporary Cultural Studies, 1975).

Hargreaves, Jennifer A., 'Playing Like Gentlemen While Behaving Like Ladies: Contradictory Features of the Formative Years of Women's Sport', *Journal of British Sports History* 2, no. 1 (May 1985): 40–52.

Hargreaves, Jennifer A., *Sporting Females: Critical Issues in the History and Sociology of Women's Sports* (London: Routledge, 1994).

Hebdige, Dick, *Subculture: The Meaning of Style* (London: Methuen, 1979)

Hebdige, Dick, *Hiding in the Light: On Images and Things* (London: Comedia, 1988).

Heller, Michael, 'Sport, Bureaucracies and London Clerks 1880–1939', *The International Journal of the History of Sport* 25, no. 5 (April 2008): 579–606.

Hill, Jeffrey, Sport, *Leisure and Culture in Twentieth-Century Britain* (Basingstoke: Palgrave, 2002).

Hobhouse, Henry, *Seeds of Wealth: Four Plants That Made Men Rich* (London: Macmillan, 2003).

Holdar, Gina, *A-Z of Classic American Clothing* (n. p. : Gina Holdar, 2010).

Holt, Richard, *Sport and the British: A Modern History* (Oxford: Oxford University Press, 1989).

Holt, Richard, and Tony Mason, *Sport in Britain 1945–2000* (Oxford: Blackwell, 2000).

Holt, Richard, 'The Amateur Body and the Middle-Class Man: Work, Health and Style in Victorian Britain', *Sport in History* 26, no. 3 (December 2006): 352–369.

Hough, Ian, *Perry Boys: The Casual Gangs of Manchester and Salford*, (Wrea Green: Milo Books, 2007).

Jackson, Joe, *The Thief at the End of the World: Rubber, Empire, and the Obsessions of Henry Wickham* (New York: Viking Penguin, 2008).

Jones, Geoffrey, 'The Growth and Performance of British Multinational Firms before 1939: The Case of Dunlop', *The Economic History Review* 37, no. 1 (February 1984): 35–53.

Klein, Naomi, *No Logo* (London: Flamingo, 2000).

Kotro, Tanja, and Mika Pantzar, 'Product Development and Changing Cultural Landscapes—Is Our Future in 'Snowboarding'?', *Design Issues* 18, no. 2 (2002): 30–45.

Kugelberg, Johan, ed., *Born In The Bronx: A Visual Record of the Early Days of Hip Hop* (New York: Rizzoli, 2007).

Lake, Robert J., 'Gender and Etiquette in British Lawn Tennis 1870–1939: A Case Study of "Mixed Doubles"', *The International Journal of the History of Sport* 29, no. 5, (2012): 691–710.

Lake, Robert J., *A Social History of Tennis in Britain* (Abingdon: Routledge, 2015).

Lash, Scott, and Celia Lury, *Global Culture Industry: The Mediation of Things* (Cambridge: Polity Press, 2007).

Lesch, John E., ed., *The German Chemical Industry in the Twentieth Century* (Dordrecht: Kluwer Academic Publishers, 2000).

Levine, Peter, A. G. *Spalding and The Rise of Baseball: The Promise of American Sport* (New York: Oxford University Press, 1985).

Loadman, John, *Tears of the Tree: The Story of Rubber* (Oxford: Oxford University Press, 2005).

Lombard, Kara-Jane, *Skateboarding: Subcultures, Sites and Shifts* (Abingdon: Routledge, 2016).

Lowerson, John, *Sport and the English Middle Classes, 1870–1914* (Manchester: Manchester University Press, 1993).

Lloyd, Deborah, 'Assemblage and Subculture: The Casuals and Their Clothing' in Juliet Ash and Lee Wright, eds., *Components of Dress: Design, Manufacturing, and Image-Making in the Fashion Industry* (London: Routledge, 1988), 100–106.

Lury, Celia, *Consumer Culture* (Cambridge: Polity Press, 1996).

Mangan, J. A., and Roberta J. Park, eds., *From "Fair Sex" to Feminism: Sport and the Socialization of Women in the Industrial and Post-Industrial Eras* (London: Routledge, 1987).

Marshall, Julian, *The Annals of Tennis* (London: 'The Field' Office, 1878).

Mason, Tony, ed., *Sport in Britain: A Social History* (Cambridge: Cambridge University Press, 1989).

McCrone, 'Kathleen E., Play Up! Play Up! and Play the Game! Sport at the Late Victorian Girls' Public School', *Journal of British Studies* 23, No. 2 (Spring, 1984). 106–134.

McCrone, Kathleen E., *Sport and the Physical Emancipation of English Women, 1870–1914* (London: Routledge, 1988).

McDowell, Colin, *Shoes: Fashion and Fantasy* (London: Thames and Hudson, 1989).

McKay, Herbert, *Rubber and Its Many Uses* (Oxford: Oxford University Press, 1940).

McMillan, James, *The Dunlop story: The Life, Death and Re-Birth of a Multi-National* (London: Weidenfeld and Nicolson, 1989).

McRobbie, Angela, 'Second-Hand Dresses and the Role of the Ragmarket', in *Zoot Suits and Second-Hand Dresses: An Anthology of Fashion and Music*, ed. Angela McRobbie (Basingstoke: Macmillan, 1989), 23–49.

Miller, Daniel, *Stuff* (Cambridge: Polity Press, 2010).

Molotch, Harvey, *Where Stuff Comes From: How Toasters, Toilets, Cars, Computers and Many Other Things Come to Be As They Are* (New York: Routledge, 2003).

Mounfield, Peter, 'Boots and Shoes', in *The Victoria History of the County of Northampton: Volume VI, Modern Industry*, ed. Charles Insley (London: Boydell and Brewer, 2007), 71–95.

Mounfield, Peter, 'The Footwear Industry of the East Midlands (III): Northamptonshire, 1700–1911', *East Midland Geographer* 3, no. 24 (1965): 434–453.

Mounfield, Peter, 'The Footwear Industry of the East Midlands (IV): Leicestershire to 1911', *East Midland Geographer* 4, no. 25 (1966): 8–23.

Mort, Frank, *Cultures of Consumption: Masculinities and Social Space in Late Twentieth Century Britain* (London: Routledge, 1996).

Mortimer, Sean, *Stalefish: Skateboard Culture from the Rejects Who Made It* (San Francisco: Chronicle Books, 2008).

Mrozek, Donald J., *Sport and American Mentality 1880–1910* (Knoxville: University of Tennessee Press, 1983).

Myerscough, Keith, 'The game with no name: The invention of basketball', *International Journal of the History of Sport* 12, no. 1 (April 1995): 137–52.

Naul, Roland, and Ken Hardman, eds., *Sport and Physical Education in Germany* (London: Routledge, 2002).

Norman, Donald A., *The Design of Everyday Things* (London: MIT Press, 1998).

Ogg, Alex, and David Upshal, *The Hip Hop Years: A history of Rap* (London: Channel 4 Books, 1999).

Park, Jihang, 'Sport, Dress Reform and the Emancipation of Women in Victorian England: A Reappraisal', *The International Journal of the History of Sport* 6, no. 1 (May 1989): 10–30.

Peralta, Stacy, dir., *Dogtown and Z-Boys*, documentary film (Culver City: Sony Pictures Classics, 2001).

Persson, Helen, *Shoes: Pleasure & Pain* (London: V&A Publishing, 2015).

Peterson, Robert W., *From Cages to Jump shots: Pro Basketball's Early Years* (New York: Oxford University Press, 1990).

Polley, Martin, *Moving the Goalposts: A History of Sport and Society Since 1945* (London: Routledge, 1998).

Rader, Benjamin G., *American Sports: From the Age of Folk Games to the Age of Televised Sports*, 5th edition (Upper Saddle River: Pearson Education, 2004).

Reckwitz, Andreas, 'Toward a Theory of Social Practices: A Development in Culturalist Theorizing', *European Journal of Social Theory* 5, no. 2 (May 2002): 243–263.

Redhead, Steve, and Eugene McLaughlin, 'Soccer's Style Wars', *New Society*, 16 August 1985, 225–228.

Redhead, Steve, 'Hit and Tell: a Review Essay on the Soccer Hooligan Memoir', *Soccer and Society* 5, no. 3 (Autumn 2004), 392–403.

Riello, Giorgio, *One Foot in the Past: Consumers, Producers and Footwear in the Long Eighteenth Century* (Oxford: Oxford University Press, 2006).

Riello, Giorgio, and Peter McNeil, eds., *Shoes: A History From Sandals to Sneakers* (Oxford: Berg, 2006).

Reiss, Stephen A., *City Games: The Evolution of American Urban Society and the Rise of Sports* (Urbana: University of Illinois Press, 1989).

Reynolds, Simon, *Retromania: Pop Culture's Addiction to its Own Past* (London: Faber and Faber, 2011).

Rieger, Bernhard, *Technology and the Culture of Modernity in Britain and Germany 1890–1945* (Cambridge: Cambridge University Press, 2005).

Riggins, Stephen Harold, ed., *The Socialness of Things: Essays on the Socio-Semiotics of Objects* (Berlin: Mouton de Gruyter, 1994).

Rivers, Dan, *Congratulations, You Have Just Met the Casuals* (London: John Blake, 2005).

David Robey, ed., *Structuralism: An Introduction* (Oxford: Oxford University Press, 1973).

Rose, Tricia, *Black Noise: Rap Music and Black Culture in Contemporary America* (Middletown: Wesleyan University Press, 1994).

RosyOne and Dopepose Posse, eds., *Cause We Got Style!: European Hip Hop Posing from the 80s and Early 90s* (Årsta: Dokument Press, 2011).

Salazar, Ligaya, ed., *Fashion V Sport* (London: V&A Publishing, 2008).

Sandbrook, Dominic, *State of Emergency: The Way We Were: Britain 1970–1974* (London: Allen Lane, 2010).

Sampson, Kevin, *Awaydays* (London: Jonathan Cape, 1998).

Savage, Jon, *Teenage: The Creation of Youth Culture* (London: Viking, 2007).

Schloss, Joseph G., *Foundation: B-boys, B-girls, and Hip-hop Culture in New York* (New York: Oxford University Press, 2009).

Schmiechen, James A., *Sweated Industries and Sweated Labor: The London Clothing Trades, 1860–1914* (London: Croom Helm, 1984).

Shabazz, Jamel, *Back In The Days* (New York: PowerHouse Books, 2002).

Shannon, Brent, *The Cut of His Coat: Men, Dress, and Consumer Culture in Britain, 1880–1914* (Athens: Ohio University Press, 2006).

Shawcross, Rebecca, *Shoes: An Illustrated History* (London: Bloomsbury, 2014).

Shove, Elizabeth, *Comfort, Cleanliness and Convenience: The Social Organization of Normality* (Oxford: Berg, 2003).

Shove, Elizabeth, Matthew Watson, Martin Hand, and Jack Ingram, *The Design of Everyday Life* (Oxford: Berg, 2007).

Shove, Elizabeth, Matt Watson, and Mika Pantzar, *The Dynamics of Social Practice: Everyday Life and how it Changes* (London: Sage, 2012).

Simmel, Georg, 'Fashion', *International Quarterly* 10, (October 1904), 130–155.

Smith, Stanley, *Dressers: The Life and Times of the Motherwell Saturday Service* (n.p.: Colours Music, 2011).

Stokes, Raymond G., *Opting For Oil: The Political Economy of Technological Change in the West German Chemical Industry, 1945–1961* (Cambridge: Cambridge University Press, 1994).

Strasser, Susan, *Satisfaction Guaranteed: The Making of the American Mass Market* (New York: Pantheon Books, 1989).

Strasser, Susan, Charles McGovern and Matthias Judt, eds., *Getting and Spending: European and American Consumer Societies in the Twentieth Century* (Cambridge: Cambridge University Press, 1998).

Stride, Christopher, Jean Williams, David Moor, and Nick Catley, 'From Sportswear to Leisurewear: The Evolution of English Football League Shirt Design in the Replica Kit Era', *Sport in History* 35, no. 1 (March 2015): 156–194.

Sugden, John, and Alan Tomlinson, 'FIFA and the Marketing of World Football', in *The Production and Consumption of Sport Cultures: Leisure, Culture and Commerce*, eds. Udo Merkel, Gill Lines, and Ian McDonald (Eastbourne: Leisure Studies Association, 1998), 55–74.

Swann, June, *Shoemaking* (Princes Risborough: Shire Publications, 2003).

Tadié, Alexis, 'The Seductions of Modern Tennis: From Social Practice to Literary Discourse', *Sport in History* 35, no. 2 (June 2015): 271–295.

Thornton, Phil, *Casuals: Football, Fighting and Fashion: The Story of a Terrace Cult* (Lytham: Milo Books, 2003).

Thornton, Sarah, *Club Cultures: Music, Media and Subcultural Capital* (Cambridge: Polity Press, 1995).

Todd, Tom, *The Tennis Players: From Pagan Rites to Strawberries and Cream* (Guernsey: Vallancey Press 1979).

Trentmann, Frank, 'Materiality in the Future of History: Things, Practices, and Politics', *Journal of British Studies* 48, no. 2 (April 2009): 283–307.

Turner, E. S., *The Shocking History of Advertising* (Harmondsworth: Penguin, 1965, orig. 1952).

Ugolini, Laura, 'Clothes and the Modern Man in 1930s Oxford' in *The Men's Fashion Reader*, eds. Peter McNeil and Vicki Karaminas (Oxford: Berg, 2009), 299–309.

Ugolini, Laura, *Men and Menswear: Sartorial Consumption in Britain, 1880–1939* (Aldershot: Ashgate, 2007)

Warde, Alan, *Consumption: A Sociological Analysis* (London: Palgrave Macmillan, 2016).

Warner, Patricia Campbell, 'The Americanization of Fashion: Sportswear, the Movies and the 1930s', in *Twentieth-Century American Fashion*, eds. Linda Welters and Patricia A. Cunningham (Oxford: Berg, 2005), 79–98

Warner, Patricia Campbell, *When The Girls Came Out to Play: The Birth of American Sportswear* (Amherst: University of Massachusetts Press, 2006).

White, Shane, and Graham White, *Stylin': African American Expressive Culture From Its Beginnings to the Zoot Suit* (Ithaca: Cornell University Press, 1998).

Williams, Jean, 'Given the Boot: Reading the Ambiguities of British and Continental Football Boot Design', *Sport in History* 35, no. 1 (March 2015), 81–107.

Wilson, Charles Morrow, *Trees and Test Tubes: The Story of Rubber* (New York: Henry Holt, 1943).

Wilson, Elizabeth, *Adorned in Dreams: Fashion and Modernity*, revised edition, (New York: I.B. Tauris, 2003, 1st edition 1985).

Wilson, Elizabeth, *Love Game: A History of Tennis, From Victorian Pastime to Global Phenomenon* (London: Serpent's Tail, 2014).

Acknowledgments

The first seeds of this book were sown in 2005, at Birkbeck, University of London, when I wrote about adidas for an MA module on the role of consumers in history. That essay developed into a part-time PhD that was completed in 2013, which in turn grew into a book project. Over such a long period inevitably I received help and assistance from a great many people, all of whom deserve thanks. I am grateful to my PhD supervisors, Marybeth Hamilton and Frank Trentmann, for encouragement and wise commentary, and to my examiners, Frank Mort and Bernhard Rieger, for their thoughts on how my work could be developed. John Green and Tom Miller made it possible to undertake the initial research and writing. Birkbeck provided a travel grant that allowed me to research in the United States. In turning the thesis into a book, John H. Arnold, Gary Cross, and Giorgio Riello provided valuable advice. At Bloomsbury, Hannah Crump, Frances Arnold, and others made it happen. An anonymous reviewer suggested where the text might be improved. The committee of the Isobel Thornley Bequest provided a generous grant towards production costs. Elements of this book appeared first in 'The Production and Consumption of Lawn Tennis Shoes in Late Victorian Britain', *Journal of British Studies* 55, no. 3 (July 2016); 'Transformative improvisation: The creation of the commercial skateboard shoe, 1960–1979' in *Skateboarding: Subcultures, Sites, and Shifts*, edited by Kara-Jane Lombard (Abingdon: Routledge, 2016); and 'German Sports Shoes, Basketball, and Hip Hop: The Consumption and Cultural Significance of the adidas "Superstar", 1966–88', *Sport In History* 35, no. 1 (March 2015). I am grateful to the editors and anonymous reviewers of these earlier pieces for their suggestions on how to sharpen my work. Staff at several libraries and archives provided help with source material. I am especially indebted to: Audrey Snell, Robert McNicol, and Sarah Frandsen at the Kenneth Ritchie Wimbledon Library at the All England Lawn Tennis Club; Rebecca Shawcross at Northampton Museum and Art Gallery; Samuel Smallidge at the Converse archive; and the team at the adidas archive. I also received assistance at London College of Fashion archive, London Metropolitan Archives, the British Library, and the Library of Congress. Other people helped in other ways. John Brolly and Neil Selvey shared their knowledge of trainers and let me borrow from their collections of old marketing materials. Iain Borden shared his collection of rare skateboard magazines and scanned several images. Dave Hewitson provided photographs of Liverpool fans in the 1980s and made some important introductions. Alain Georges gave me material on Nike that he had guarded since studying at Harvard Business School in the 1980s. John Disley, Karl-Heinz Lang, Chris Severn, Ray Tonkel, and Robert Wade-Smith each took time to share personal memories of the sports shoe business with me. Over the course of the project, many people provided other kinds of help, advice, and support. I also enjoyed countless conversations about sports shoes, fashion, consumer culture, pop culture, and history in general that shaped my work. Special mentions therefore need to be made of: Uli Ackermann, Bob and Betty Andretta, Stephen Brogan, Amber Butchart, William Clayton, Jason Coles, Lucy Fulton, Alison Gill, Eleanor Glacken, Tony Glacken, Joe Goddard, Hélène Irving, Graham Johnston, Robert J. Lake, Ruth Lang, Tim Leighton-Boyce, Jan Logemann, Jörg Majer, Helen Musgrove, Kate Nichols, Charles L. Perrin, Matt Powell, Anne Schroell, Elizabeth Semmelhack, Ann Sloboda, Michael Tite, Laura Ugolini, Jean Williams, Daniel C. S. Wilson, and Tom Wright. Deep gratitude goes to my friends, to my parents, and to my sister Emily, who have been a consistent source of support and encouragement through the ups and downs. A final and very special thanks goes to Caroline Stevenson, who missed the start but who made the final stretch much better.

London, July 2018

Index